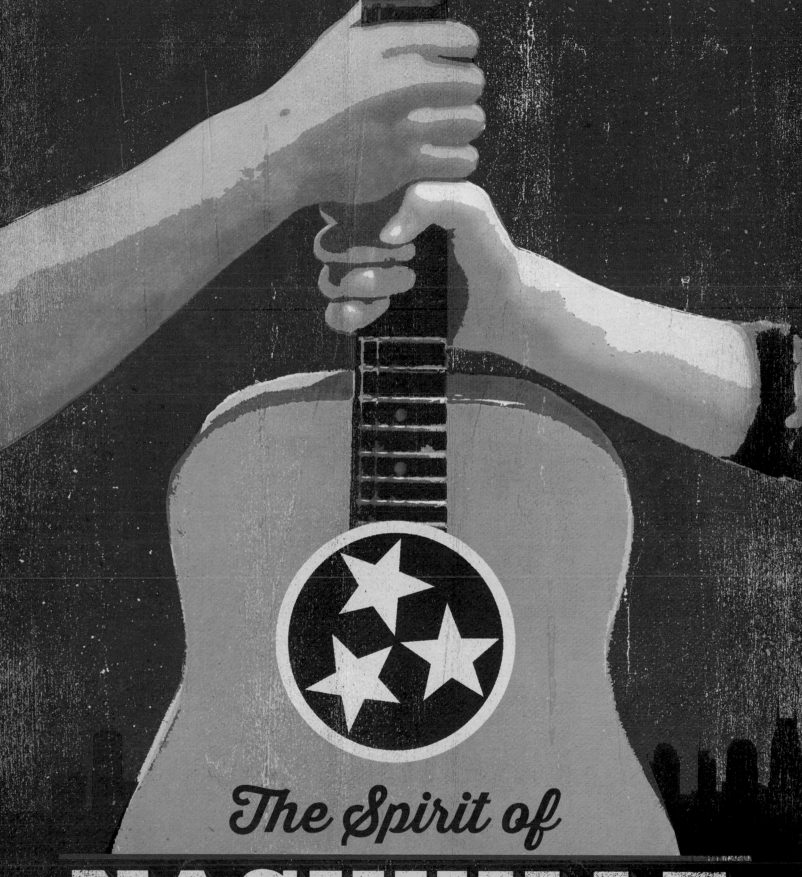

The Spirit of NASHVILLE™

★★ THE ART & SOUL OF MUSIC CITY ★★

by JOEL ANDERSON and ANGELA PATTERSON

Joel dedicates this book to the following talented friends who have helped to create such amazing art:

David Anderson	Andy Gregg	Matt Lehman	Kristi Carter Smith
Wayne Brezinka	Aaron Johnson	Taaron Parsons	Ligia Teodosiu
Abe Goolsby	Emily Keafer	Edward Patton	Darren Welch
	Michael Korfhage	Aruna Rangarajan	

A VERY SPECIAL THANKS TO:

Pinnacle Financial Partners: for underwriting the printing of this book and supporting the arts in Nashville.

THIS BOOK WAS DESIGNED, PRINTED, BOUND & FINISHED IN NASHVILLE, THANKS TO:

Lithographics: for working with us to provide the highest quality printing possible and doing it right here in Music City.

BindTech: for providing excellent local craftsmanship and attention to detail in binding and finishing.

Athens Paper: for providing the high-grade paper and great hometown service.

Scott Laminating & Finishing: for providing the beautiful laminated finish on the cover.

A GRATEFUL ACKNOWLEDGEMENT TO:

My wife, Patty Atlan Anderson: for your love, inspiration, support and partnership for over 28 years.

Dawn Verner: for many hours of research and proofreading while you helped me run the design firm.

Nathan Anderson: for editing and proofreading while giving our fans and customers a taste of Nashville.

Angela Patterson: for researching and writing over 30 great historical sketches for this book.

Beth Odle, Aimee James, Pam Reece & Amber Williams: for helping us find and publish photos from the Downtown Public Library Special Collections Center and the Nashville Room.

Debbie Cox, Leanne Garland & Friends of Metro Archives: for supplying us with historical photos of Nashville.

To purchase classic Music City prints and gifts, please visit:
www.SpiritOfNashville.com

Cover, interior design, and all posters created by Anderson Design Group.
116 29th Avenue North, Nashville, Tennessee 37203. Phone: 615-327-9894. www.AndersonDesignGroup.com.
All photos used by permission. Printed & produced with pride in Nashville, TN.
Published by Anderson Design Group, Inc.

A Word from the Author...

AS AN ARTIST, I find it much easier to speak with pictures than with words. If a picture is worth a thousand words, then this book really does say a lot about my favorite city in the whole world. I just can't seem to stop creating art that celebrates the history and charm of my adopted hometown. It's a labor of love, bordering on mad obsession. Every time I experience a new Music City moment, I feel compelled to capture the essence of the place, the history, and the stories that made this part of Nashville special to me and so many others.

After living in Dallas, New York, El Salvador, Curaçao, and a few other places, arriving in Nashville was strangely like coming home—as if I had always belonged here. So, in 1986, it was wonderful to begin sending down roots deep in Nashville's rocky, southern soil. Since then, my wife (a Parisian who I married the same year) has come to love Nashville as much as I do. And after living here all these years, we are both proud to call it our home. She became an American citizen here. Our three sons were born here (and our daughter flew to Nashville from Korea to join our family.) Our friends are here, our church is here, our business is here, our best memories are here—so our hearts will always belong here.

Over the years, I have had the privilege of collaborating with fabulously talented people. While working on the Spirit of Nashville Collection, I played the role of a conductor, coaxing beautiful visual melodies from a team of gifted designers and illustrators. I created more than 50 of the posters myself, but almost 100 more were done by my friends who worked under my direction to create this award-winning collection of prints. Without their dedication and cooperation, none of this would have been possible. Since the beginning, fourteen different artists have joined forces with me to create over 150 Music City poster designs that all fit together as one cohesive collection.

Combining text with the art was a much bigger job than I could handle alone. So in order to present interesting historical information about the Nashville

icons featured in this book, I called in a professional—someone I met at one of our exhibits who seemed to have an appreciation for the Spirit of Nashville Collection and a fondness for our city. Angela Patterson, a newspaper reporter and journalist, brought her research and writing skills to the rescue. She created over 30 historical sketches to tell the background stories of important landmarks and establishments depicted in many of our poster designs. With the help of the good folks at the Nashville Public Library's Special Collections Center and the Metro Archives, I was able to add beautiful historic photos to Angela's text. Finally, I sprinkled in memories and musings I collected from many people who wanted to express their affection for Nashville. Thanks to all who collaborated with me, this book (much like Music City) is a creative tapestry of art, history, love notes and personal stories.

Many of the places celebrated in our prints are not only historically important to this city, but for sentimental reasons, they are monuments to wonderful moments in Nashville life. And life in Music City just keeps on getting better! Our city consistently ranks among the top places to live in the U.S.A. Our economy is admired as one of the fastest-growing and most diverse in America. People from all over the world choose Nashville over other cities to study, conduct business, vacation or call home.

I'll be the first to admit that the Spirit of Nashville Collection does not cover every aspect of this great city. (I've lived and worked in the West End area, so the art focuses more on my "neck of the woods.") There are still dozens of other worthy landmarks and establishments to feature in future poster designs. Meanwhile, I hope you enjoy exploring Nashville through our art, through the history presented in the text, and through your own memories as you leaf through the pages of this book.

—Joel Anderson, *Founder of Anderson Design Group & creator of the Spirit of Nashville Collection*

"The "Spirit of Nashville" series pays tribute to our city's history and growth by showcasing the places we have come to cherish and love in our community. We celebrate this 10th Anniversary Edition and the more than 100 iconic poster designs that promote Nashville, our landmarks, our legends and our culture. These images help preserve our love for Nashville and all it has to offer." **—Karl Dean,** *Nashville's mayor 2008-2016*

A VISUAL TIMELINE: *200 Years of Nashville History*

1806
Nashville is incorporated as a city on September 11, 1806.

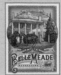

1807
Belle Meade Plantation is founded by John Harding.

1822
The first stone bridge is built across the Cumberland.

1824
Music publishing begins in Nashville with the publication of Western Harmony, a book of hymns and instructions for singing.

1828
Andrew Jackson is elected seventh President of the United States.

1843
Nashville is named the permanent capital of Tennessee.

1845
Construction of the Tennessee State Capitol begins.

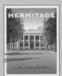

1845
Andrew Jackson dies at his home, The Hermitage.

1850
The first steam engine, the No. 1, ordered by the Nashville and Chattanooga Railroad, arrives in Nashville.

1851
The first gas street lamp is lighted at Second Avenue North and the Public Square.

1859
The Tennessee State Capitol is completed.

1862
Federal troops occupy Nashville, the first southern capital to fall to the Union Army.

1863
After 3 days of fighting, the Battle of Stones River ends.

1864
Union troops defeat Confederate forces in the Battle of Nashville, December 15 and 16.

1866
Fisk University founded.

1897
The Centennial Exposition opens with the Parthenon as its centerpiece.

1900
Union Station opens.

1902
Centennial Park is acquired by the city, marking the beginning of Nashville's public park system.

1904
The city's first Carnegie Library opens at the corner of 8th Avenue North and Union Street.

1904
Nashville's first skyscraper is constructed at the southeast corner of Fourth Avenue North and Church Street.

1905
Tennessee State Legislature adopts state flag designed by LeRoy Reeves, April 17th, 1905.

1907
Tony Sudekum opens the first movie theater, The Dixie, on 5th Avenue, North, next to the Arcade.

1910
The Marathon Motor Car is manufactured in Nashville.

1912
The Nashville Reservoir breaks, releasing 25 million gallons of water into the area.

1913
Radnor Lake is constructed by the L&N Railroad.

1916
East Nashville is devastated by fire on March 22, 1916.

1920
The first Nashville Symphony was organized.

1925 Grand Ole Opry begins.

1925
Hillsboro Theatre,

1946
Walter Sharp leads the founding of the Nashville Symphony.

1950
Capitol Records becomes the first major company to locate its director of country music in Nashville.

1951
Belmont College opens.

1957
The L&C Tower is completed.

1957
Cheekwood Botanical Garden & Museum of Art is founded.

1958
The Country Music Association is founded.

1961 The Pancake Pantry opens.

1962
Tennessee's first interstate highway, connecting Nashville to Memphis, arrives in Nashville.

1967
The Barn Dinner Theatre opens.

1967
The Country Music Hall of Fame opens on Music Row, on April 1st, 1967.

1968
Dale Evans and Roy Rogers cohost the CMA Awards.

1970
Percy Priest Lake opens.

1972
Opryland USA opens.

1973
Fox's Donut Den opens.

1990
The Nashville Chamber Orchestra is founded.

1991
Marathon Motor Company Building renovated and used for arts and business space.

1993
Bongo Java opens.

1994
Ryman Auditorium reopens as an entertainment venue June 1st, 1994.

1994
The BellSouth Tower ("the Batman Building") has its grand opening Oct. 20, 1994.

1994
Natchez Trace Parkway Bridge opens on March 22, 1994.

1995
Farmers Market is renovated.

1996
Tennessee Bicentennial Mall State Park opens May 31st. On June 1st, a celebration is held there for our state's 200th birthday.

1996
Frist Center for the Visual Arts named, and plans are drawn up to convert the old U.S. post office building on Broadway into the arts center.

1997
Opryland USA closes with Dec. 31st Christmas in the Park.

1998
April 16th tornado hits downtown Nashville, damaging homes in East Nashville and blowing down trees at The Hermitage.

1999
Nashville Zoo at Grassmere opens in stages with last animals making the

1867
John Berrien Lindsley founds Montgomery Bell Academy from funds left to the University of Nashville by Montgomery Bell at his death in 1855.

1871
The Jubilee Singers begin a series of singing tours to raise money for the struggling school.

1873
Vanderbilt University is founded.

1875
Hatch Show Print opens.

1875
The Fire Alarm Telegraph, with over 20 miles of wire, went into operation.

1876
Jubilee Hall, the first building in the U.S. constructed for the higher education of African Americans, is built.

1877
The city's first telephone call is made.

1880
Nashville celebrates the centennial year of its founding.

1882
Nashville sees its first electric light.

1885
Nashville's first professional baseball game is played in Athletic Park near the

Sulphur Spring Bottom north of downtown.

1891
David Lipscomb College begins as the Nashville Bible School.

1892
The Union Gospel

Tabernacle, now Ryman Auditorium, is completed.

1892
Joel Owsley Cheek develops Maxwell House Coffee blend.

1896
The first automobile is driven in Nashville.

later renamed the Belcourt, opens.

1926
Ezell's Dairy (Purity Dairies) was founded by Miles Ezell, Sr.

1927
Percy Warner Park, Tennessee's largest municipal park, is established.

1928
Candyland opens on West End Avenue.

1931
The Parthenon reopens in its permanent form.

1937
The present Davidson County Courthouse is completed and opened.

1939
Elliston Place Soda Shop opens.

1940
Cumberland River freezes enough on January 27th, 1940 that residents can walk across it.

1940
The Belle Meade Theatre opens.

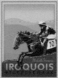

1941
The first Iroquois Steeplechase is run.

1943
The Grand Ole Opry moves to Ryman Auditorium.

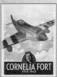

1943
Cornelia Fort becomes the first female pilot to die for her country during wartime.

1974
Station Inn opens.

1974
The Grand Ole Opry moves from Ryman Auditorium to Opryland.

1978
Amtrak passenger train service through Nashville ends.

1978
The Nashville Sounds bring professional baseball back to Nashville.

1980
Tennessee Performing Arts Center opens.

1982
The Bluebird Cafe opens.

1983
January 10th, Riverfront Park opens on Broadway riverfront.

1985
The General Jackson Showboat launches.

1986
Hog Heaven opens.

1986
Union Station reopens as a hotel.

1986
The Nashville Ballet is established.

1987
The Nashville Convention Center and the new airport open.

1987
The Nashville Shakespeare Festival is founded.

1988
The Parthenon reopens after a two-year renovation of the gallery space.

move to Grassmere in the fall.

1999
Ninety-year-old Shelby Street Bridge closes to vehicle traffic and reconstruction as a pedestrian bridge begins.

2000
Titans Parade on February 1st for American Football Conference Champion

Tennessee Titans after the Super Bowl.

2001
The Frist Center for the Visual Arts opens in what was formerly Nashville's historic main post office on April 8th.

2001
The Country Music Hall of Fame opens at a new downtown location at 222 Fifth Avenue South on May 17th.

2001
The Nashville Public Library opens a new downtown library at 615 Church Street on June 9th, completing a $125 million plan to build the new 315,000 sq. ft. main library and 5 regional branches.

2003
Shelby Street Bridge reopens as a pedestrian bridge linking downtown

and East Nashville on August 3.

2004
Gateway Bridge opens as a new link over the Cumberland River on May 19.

2006
Schermerhorn Symphony Center opens with ribbon cutting on September 7 and gala Nashville Symphony performance on September 9.

2006
Public Square dedication on October 1 kicks off "Celebrate Nashville" festivities to mark 200th anniversary of incorporation of the city and election of Nashville's first mayor.

LANDMARKS & *History*

1. Bicentennial Mall
2. Riverfront Park
3. View of skyline & bridges
4. The Parthenon in Centennial Park
5. Cornelia Fort Airpark (former site)
6. Natchez Trace Parkway bridge
7. The Hermitage
8. Belle Meade Plantation
9. Union Station
10. Tennessee State Capitol
11. General Jackson dock
12. Lane Motor Museum
13. Vanderbilt University
14. Fisk University
15. Belmont University
16. Lipscomb University
17. Watkins College of Art, Design & Film
18. Trevecca Nazarene University
19. Hume Fogg High School
20. Anderson Design Group Studio Store
21. Lower Broadway
22. John Seigenthaler Pedestrian Bridge
23. Music City Center

MUSIC & *Melody*

24. Country Music Hall of Fame & Museum
25. Bluebird Cafe
26. Station Inn
27. Nashville Symphony
28. Ryman Auditorium

ARTS & *Leisure*

29. Frist Center for the Visual Arts
30. Cheekwood Botanical Garden
 & Museum of Art
31. Nashville Ballet
32. Nashville Sounds Stadium
33. Adventure Science Center
34. Hatch Show Print
35. Nashville Zoo
36. Chaffin's Barn Dinner Theatre
37. Belle Meade Theatre Marquee
38. Belcourt Theatre
39. Shakespeare in the Park
40. Percy Priest Lake
41. Radnor Lake
42. Percy Warner Park
43. Iroquois Steeplechase
44. War Memorial Plaza & Auditorium
45. McCabe Golf Course
46. Fort Negley
47. Shelby Park
48. Hadley Park
49. Public Square Park
50. Cumberland Park
51. Bells Bend Park
52. Two Rivers Mansion
53. Fanny Mae Dees (Dragon Park)
54. Nashville Music Garden

FOOD & *Flavor*

55. Loveless Cafe
56. Nashville Farmers Market
57. Purity Dairies
58. Vandyland
59. Fox's Donut Den
60. Pancake Pantry
61. Elliston Place Soda Shop
62. Bongo Java
63. Hog Heaven
64. Arnold's Country Kitchen
65. Bobbie's Dairy Dip
66. Swett's
67. Mére Bulles
68. Mas Tacos
69. The Cupcake Collection
70. Fido
71. The Peanut Shop

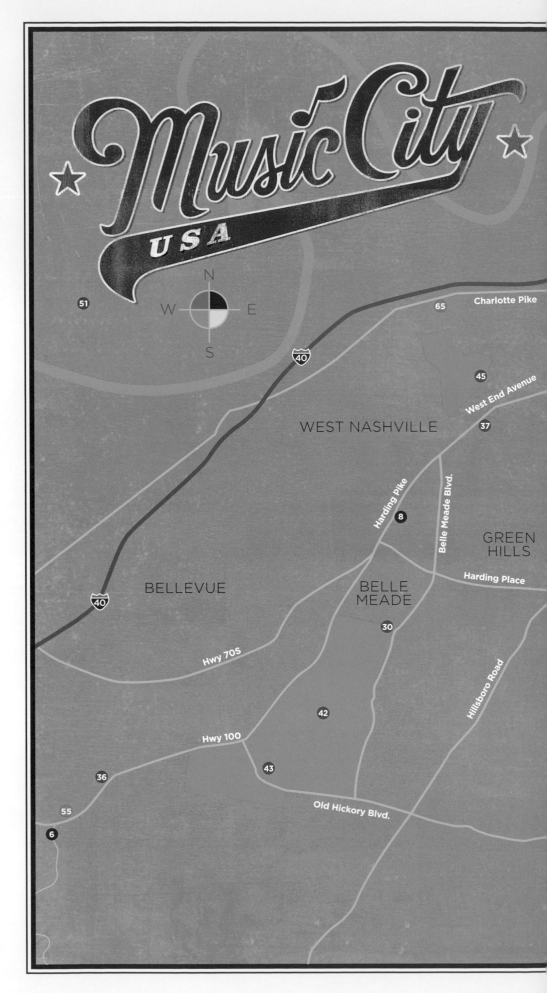

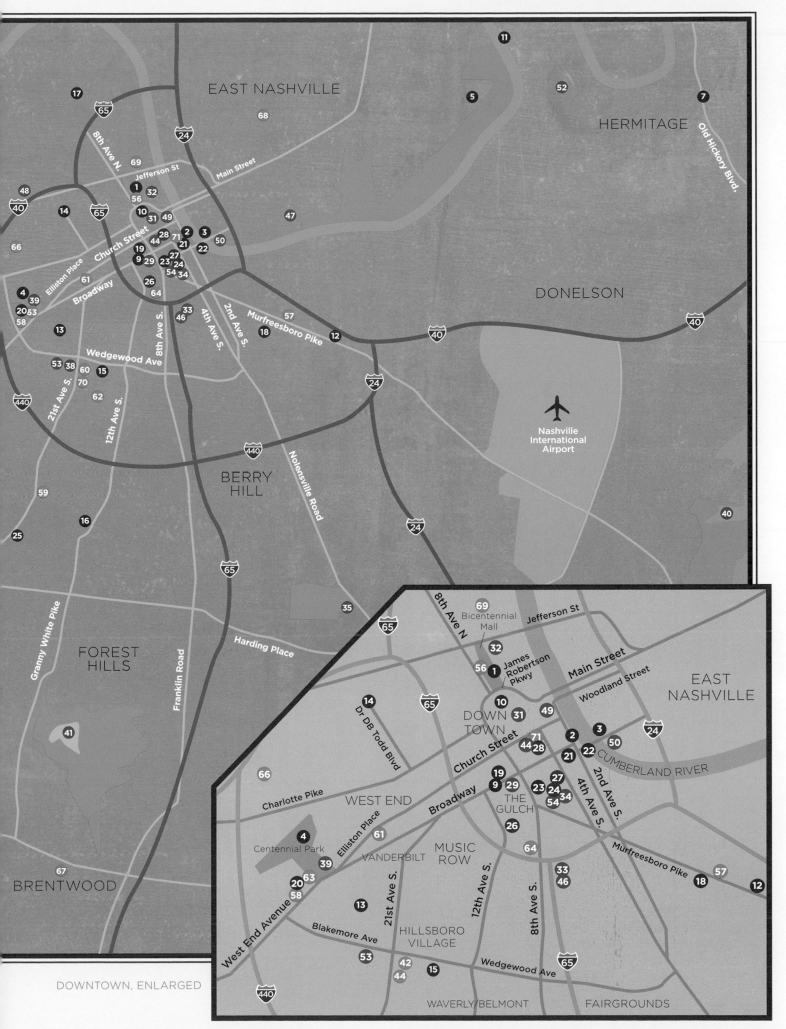

EAST NASHVILLE

HERMITAGE

DONELSON

Nashville
International
Airport

BERRY
HILL

FOREST
HILLS

BRENTWOOD

DOWNTOWN, ENLARGED

8th Ave N
Bicentennial
Mall
Jefferson St
James
Robertson
Pkwy
Main Street
Woodland Street
EAST
NASHVILLE
DOWN
TOWN
Church Street
CUMBERLAND RIVER
Dr DB Todd Blvd
Charlotte Pike
WEST END
Broadway
THE
GULCH
Centennial Park
Elliston Place
VANDERBILT
MUSIC
ROW
West End Avenue
Blakemore Ave
21st Ave S.
12th Ave S.
8th Ave S.
4th Ave S.
2nd Ave S.
Murfreesboro Pike
HILLSBORO
VILLAGE
Wedgewood Ave
WAVERLY/BELMONT
FAIRGROUNDS

8th Ave N.
Jefferson St
Main Street
Church Street
Elliston Place
Broadway
Wedgewood Ave
8th Ave S.
4th Ave S.
2nd Ave S.
Murfreesboro Pike
21st Ave S.
12th Ave S.
Nolensville Road
Granny White Pike
Franklin Road
Harding Place
Old Hickory Blvd.

Landmarks & History

NASHVILLE
TENNESSEE

THREE STARS punctuate the noonday sky. Set on a crimson banner waving above the Nashville skyline, these converging stars represent the union of East, Middle and West Tennessee. From the Great Smoky Mountains, to the rolling highlands and on to the western plains, three distinct regions of Tennessee are like patches stitched together onto the same quilt. This colorful union is personified by the spirit of Tennessee's capital city. What is the Spirit of Nashville? It is the rich heritage—the flavors, sights, sounds and stories of a vibrant 200-year-old community that has always been at the center of a quiltwork of cultures.

The historic capital of the Volunteer State is home to over a million people, many of whom have moved here from all over the USA to enjoy Nashville's booming economy, diverse culture and southern comfort. People from all walks of life—musicians, athletes, researchers, doctors, business people, educators, artists, clergy and students continue to come together under the state flag, making this middle-Tennessee town one of the most exciting places in the South.

But Nashville wasn't always such a big and bustling city. Originally founded as Fort Nashborough in 1779 by James Robertson, it was renamed in 1784 in honor of Francis Nash, a Revolutionary War soldier, when the fort grew enough to be established as a town. It became the capital of Tennessee in 1843 and has been growing ever since.

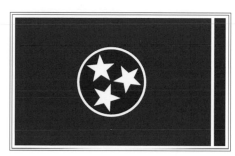

Tennessee State flag design by LeRoy Reeves

The Tennessee State Flag is considered by many graphic artists to be one of the best state flag designs in the union. It was designed by LeRoy Reeves, a member of the Third Regiment, Tennessee Infantry. It was officially adopted by the Tennessee State Legislature on April 17, 1905.

The geometric design symbolizes the geographical and cultural heritage of the state of Tennessee while echoing the colors of the national flag of The United States of America. The color white symbolizes purity. The blue symbolizes the love that Tennesseans feel for their state and the red symbolizes, that in times of war and peace, Tennesseans are true-blooded Americans.

Mr. Reeves explained his design: "The three stars are of pure white, representing the three grand divisions of the state. They are bound together by the endless circle of the blue field, the symbol being three bound together in one—an indissoluble trinity. The large field is crimson. The final blue bar relieves the sameness of the crimson field and prevents the flag from showing too much crimson when hanging limp. The white edgings contrast more strongly the other colors."

" When my parents announced, right before I started my junior year of high school, that we would be moving to Nashville from our home of 12 years outside Philadelphia, I thought my life was over. It was a difficult year for the whole family—switching schools, jobs, houses, neighborhoods—and let's face it—cultures! The move was five years ago and now, looking at the list of places featured in this book, I couldn't possibly pick just one to talk about: Bongo Java was where I had lunch with my mom and sister one day while looking at houses before we moved, and it became the place where my fiancé and I would meet every time he came through town; Vanderbilt is what brought us here in the first place for my father's job at the Children's Hospital; I've experienced some of the most awe-inspiring music from the lips and fingers of friends and strangers alike at the Bluebird Cafe, Station Inn and the Ryman; I saw foreign films at the Belcourt Theatre with my new high school friends; and I spent many a beautiful Southern summer day in Centennial Park by the Parthenon. I still sometimes stutter when people ask me where I'm from, not knowing which side of the Mason/Dixon line to claim, but when I see the Nashville skyline, I know I can say I am home." **— Emily Baldwin**

< STATE FLAG SKYLINE 18" x 24" Limited Edition Print created in 2003 by Joel Anderson

"This image was on the front of the first Spirit of Nashville calendar which included 14 full-size posters of Music City landmarks. Since Nashville is the capital of Tennessee, it made sense to create an iconic image that set the Nashville skyline on top of our state flag. This design has been one of our most popular prints—even before it was selected to be a permanent fixture on the set of the network TV show Nashville. (Look for it on the wall in scenes that take place in the mayor's office!)"

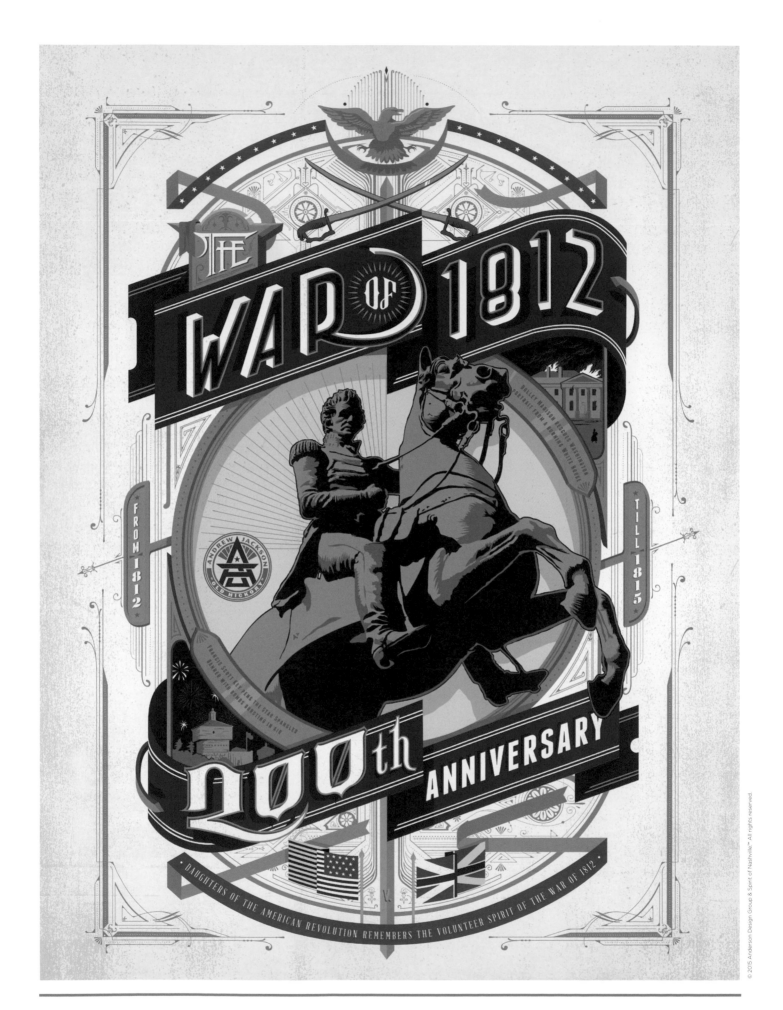

THE WAR OF 1812 (200th ANNIVERSARY PRINT) 18" x 24" Limited Edition Print created in 2012 by Andy Gregg

The War of 1812 was a defining period in the early history of Tennessee. On January 8, 1815, on a battlefield at Chalmette just below New Orleans, Andrew Jackson lead his troops to a shocking American victory in the final and pivotal battle of the War of 1812, ending the three-year war with Britain. General Jackson defeated a British invasion on American soil even though his ragtag army of 4,000 was outnumbered by 10,000 British. This victory forever solidified Andrew Jackson as an American military hero and laid the foundation for his eventual election to the presidency.

12

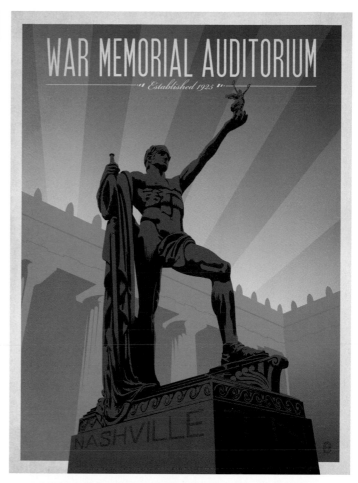

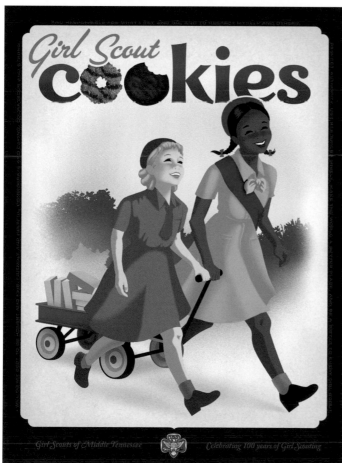

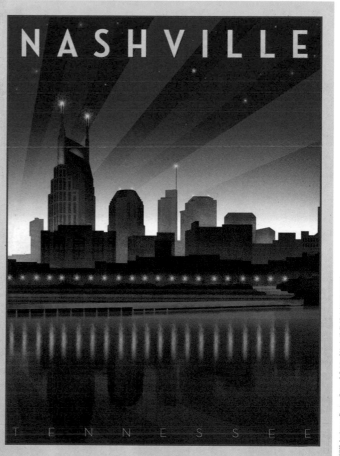

LEGACY BRIDGES OF NASHVILLE 18" x 24" Limited Edition Print created in 2005 by Joel Anderson

WAR MEMORIAL AUDITORIUM 18" x 24" Limited Edition Print created in 2011 by Andy Gregg

GIRL SCOUTS OF MIDDLE TENNESSEE (100 YEAR ANNIVERSARY) 18" x 24" Limited Edition Print created in 2011 by Ligia Teodosiu

NASHVILLE SKYLINE AT NIGHT 18" x 24" Limited Edition Print created in 2004 by Joel Anderson

NASHVILLE

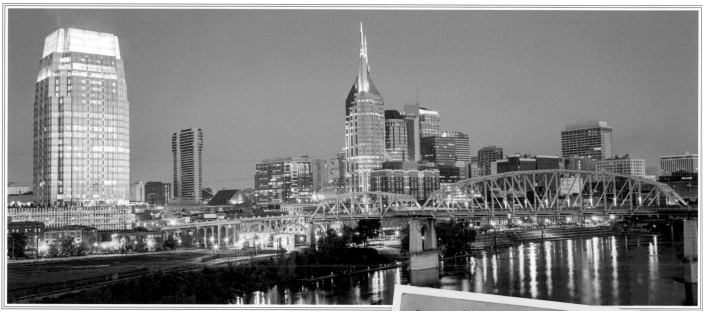

Photo by Deposit Photos

Photo courtesy of the Nashville Public Library, The Nashville Room

Postcard of the Sparkman Street Bridge circa early 1900s.

NASHVILLE'S SKYLINE is punctuated by a stunning 29 story glass structure which towers over the glittering SoBro riverfront district. Located across the street from the Schemerhorn Symphony Center, this mirrored landmark reflects the changing colors of the sky, causing it to appear differently every time you see it. The Pinnacle at Symphony Place was opened in 2010 and is now home to a vital Nashville institution which began operations in October 2000. Pinnacle Financial Partners has since grown to become one of the largest bank holding companies headquartered in Tennessee, providing a full range of banking, investment, trust, mortgage and insurance products. Pinnacle is very supportive in the local community, encouraging associates to volunteer and teach, to help build affordable housing, to promote and encourage the arts, and to beautify the communities they serve.

Pinnacle's majestic glass tower overlooks the historic John Seigenthaler Pedestrian Bridge which crosses over the Cumberland River. This bridge has been given several names over the years. Most recently known as the Shelby Street Pedestrian Bridge, it was originally called the Sparkman Street Bridge when it was completed in 1909. In recent years, it was converted into a walking bridge linking Downtown and East Nashville.

It has become a nighttime icon for the city with its brightly lit girders shining against the evening sky. Designers of the renovation project enhanced the original structure with art elements integrated into the railings at bridge overlooks and added other design features such as wood pavers and stained concrete patterns in the walkway. The Shelby Street Pedestrian Bridge is on the National Register of Historic Places for its significance as one of Nashville's best examples of modern technology and engineering at the turn of the century. It also happens to be one of the best spots in Nashville to enjoy the sparkle of the downtown skyline reflecting off of the Pinnacle at Symphony Place.

> *"Once upon a time, I met a man on the Shelby Street Bridge. It was the middle of January, bitterly cold, and we were decorating the bridge for a birthday party. From that moment on, I knew this man would either break my heart or I would marry him. Two weeks later, he brought me back for our first kiss. Nine months later, he brought me back and proposed. Four months after that, we walked down the aisle and now we are living happily ever after!"* — **Holly Biggs**

NASHVILLE

1806 ★ ANNIVERSARY ★ 2006

BICENTENNIAL CAPITOL MALL

NO ONE EXPECTS TO SEE an expanse of green grass on the edge of downtown Nashville.

But the Tennessee Bicentennial Capitol Mall State Park offers a majestic view of the state capitol building, and a lovely expanse of green space full of monuments to commemorate the state.

Although thousands of residents and visitors enjoy the park-like environment every year, the original suggestion was to use the space for a large sports stadium. New York urban planning firm Clarke, Rapuano and Holleran thought it would be the ideal use for the large, barren space between James Robertson Parkway and Jefferson Street.

But it was the idea of Knoxville architect Robert Church that would lay the foundation for the Tennessee Bicentennial Capitol Mall, a 19 acre urban park that's the focal point of the Capitol Area master plan.

While his 1969 proposal to create a grand parking structure was rejected, Church's thought to extend the green space and connect the previously detached urban areas would be integrated. Years would pass as more architects would study the land and make recommendations, trying to balance aesthetics with an existing railway path and need for more state office space. But 20 years later, Aladdin Industries employee John Bridges' detailed concept for a mall intrigued both Governor McWherter and Jim Hall, who was charged with directing the state's bicentennial celebration. It was Bridges' concept that would establish the creation of the mall with the historic event.

In 1991, Jerry Preston, assistant commissioner of the Department of Finance and Administration, called together a group of professors and planning professionals to devise a concrete plan for the mall. After reviewing past concepts and assessing present conditions, they created a plan the state accepted, and had a June 1, 1996 deadline, less than five years, in which to execute the project.

Ground was broken on the Mall June 27, 1994. The amphitheater was first constructed; the Mall itself was soon to follow. The many contractors had to work closely together through numerous obstacles, namely a complex construction plan and the watchful eye of CSX railroad officials.

In the end, the park would stretch from the base of Capitol Hill to James Robertson Parkway, where Tennessee Plaza features a fully accurate state map composed of granite. A new railroad trestle serves as the gateway to the Mall,

The 95-bell carillon representing Tennessee's 95 counties.

which includes the Walkway of the Counties, the Riverwall, etc. The ending feature of the Mall is the Court of Three Stars, near Jefferson Street, representing the state's musical heritage.

Although the park was not open, the simultaneous lowering of 95 time capsules—representing the state's 95 counties—on April 27 was the event that marked the Mall as the state's park. The Mall was completed hours before deadline, opening to the public at 8 a.m. May 31, 1996.

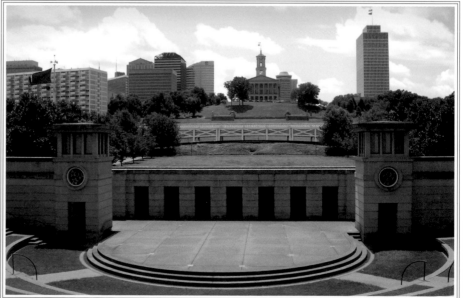

The amphitheater lies in front of the train trestle and a majestic view of the State Capitol.

< BICENTENNIAL CAPITOL MALL 18" x 24" Limited Edition Print created in 2006 by Joel Anderson

"When illustrating this view of the Bicentennial Mall with the majestic State Capitol and the downtown skyline set as a backdrop, I had to climb to the top of a building that faced the Mall. Even then, the vantage point was not high enough to make the State Capitol building stand above the skyline. To create a pleasing composition, a little artistic license was required. If you stand across the street from the Mall and look toward the Capitol, you will notice a few of the liberties I took to elevate the Capitol and squeeze the buildings closer together."

NASHVILLE

Enjoy Scenic Middle Tennessee

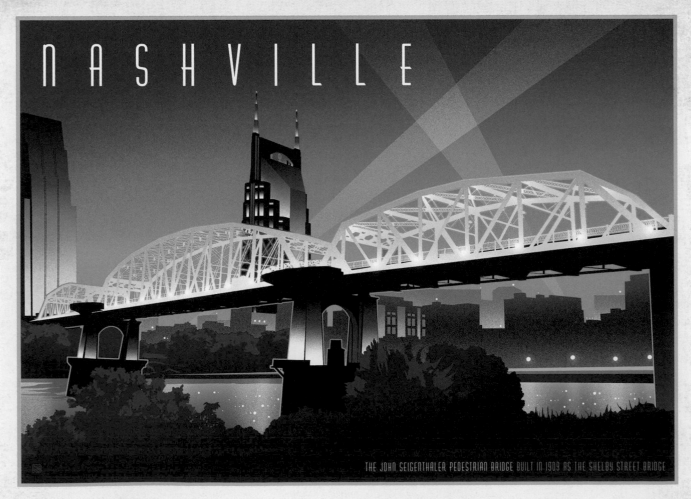

NASHVILLE

THE JOHN SEIGENTHALER PEDESTRIAN BRIDGE BUILT IN 1909 AS THE SHELBY STREET BRIDGE

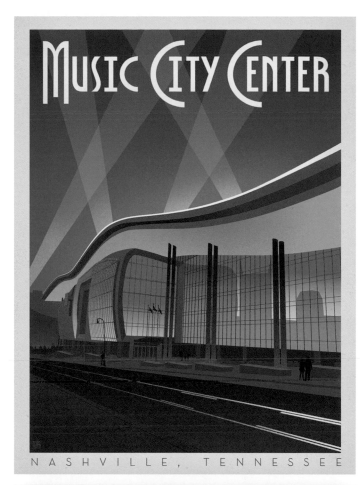

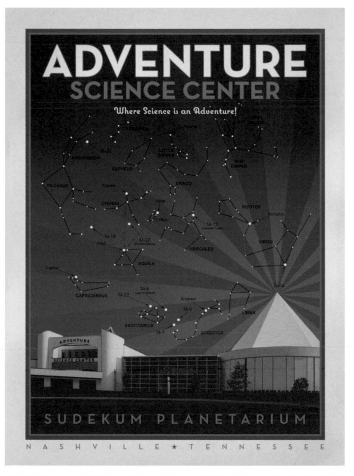

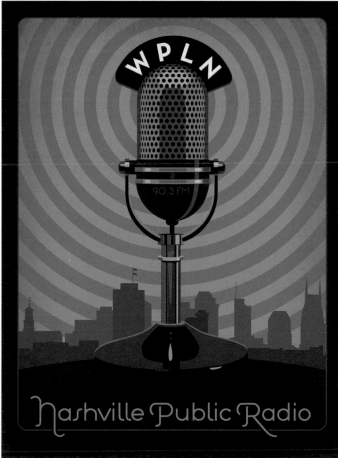

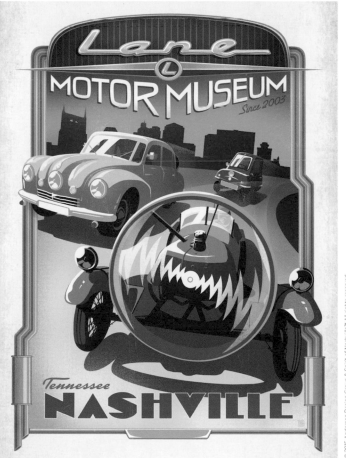

< **NASHVILLE SKYLINE (HORIZONTAL)** 24" x 18" Limited Edition Print created in 2012 by Michael Korfhage & Joel Anderson
< **SHELBY STREET PEDESTRIAN BRIDGE** 24" x 18" Limited Edition Print created in 2014 by Michael Korfhage & Joel Anderson
MUSIC CITY CENTER 18" x 24" Limited Edition Print created in 2013 by Michael Korfhage & Joel Anderson
ADVENTURE SCIENCE CENTER 18" x 24" Limited Edition Print created in 2010 by Joel Anderson
WPLN NASHVILLE PUBLIC RADIO 18" x 24" Limited Edition Print created in 2010 by Joel Anderson
LANE MOTOR MUSEUM 18" x 24" Limited Edition Print created in 2013 by Aaron Johnson

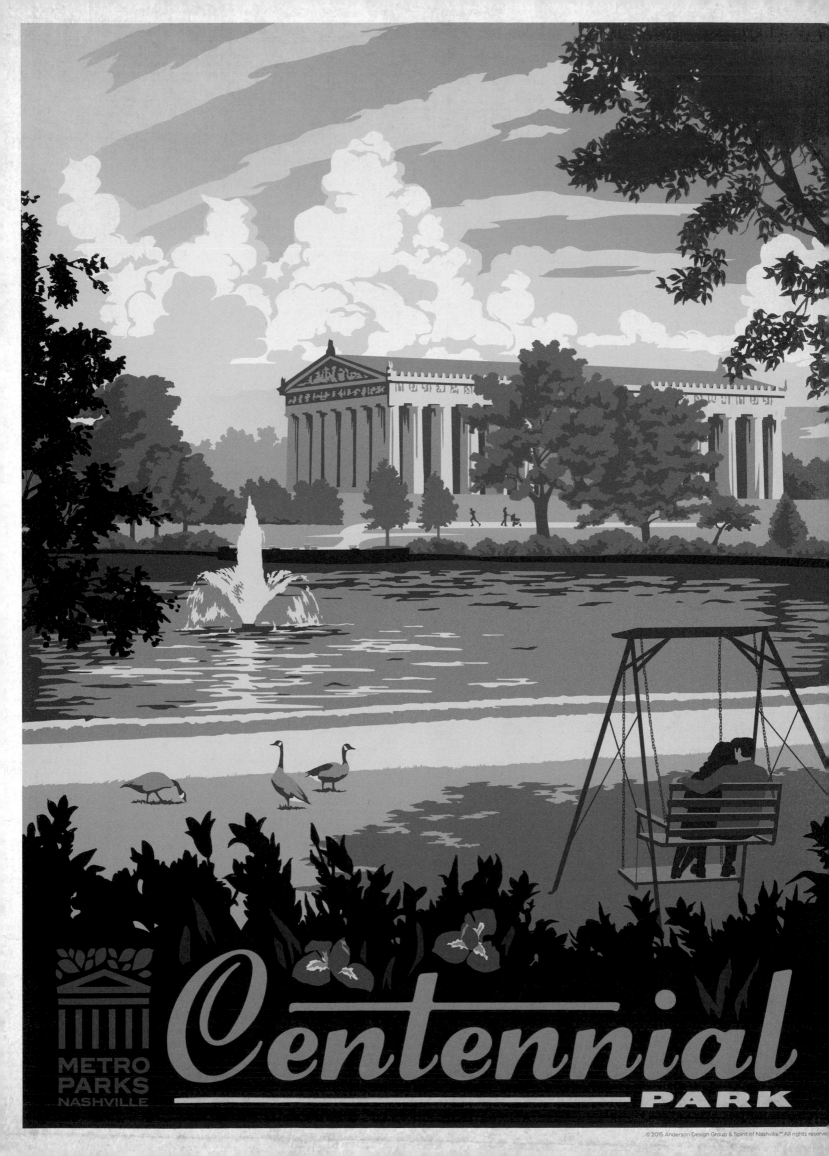

METRO
PARKS
NASHVILLE

Centennial

PARK

THE PARTHENON

A PIECE OF GREECE sits in a park in Nashville. To walk around it is a surreal experience, knowing that the grand columns and the detailed relief sculptures are almost exact replicas of the original Parthenon, and that what you see in front of you is the only full-scale replica of the world-famous building. Technically, it's the only remaining

piece of Tennessee's ornate Centennial Celebration in 1896. But the building's stature and prominence also represent the city's one-time image as the "Athens of the South".

In 1893, Colonel W. C. Smith dreamed up the idea of a Centennial Exposition in the hopes it would stimulate both the economy and Nashvillians' interest in their own city. Exposition Director E.C. Lewis would submit a plan in 1895 that included a reproduction of the Parthenon. To ensure the replica would be exact, Lewis requested the drawings and architectural studies from King George I of Greece.

A resolution was adopted by Exposition organizers in 1894 to convert the Parthenon into a fine arts building after the exposition. Over the years, the building deteriorated badly, and patching the exterior-grade plaster was no lon-

Program for the Centennial Exposition

ger enough. The city's parks board and architect Russell Hart set out to rebuild the structure in 1920. The exterior was completed in 1925, the interior in 1931. The replica was very close to being exact, but lacked one element: a statue of the goddess Athena. Creating such a statue had been discussed for decades, but the Parthenon remained without its goddess until the early 1980s when Alan LeQuire was commissioned to sculpt her. More than seven years later, in May 1990, a 12-ton, 41-feet-10-inch tall statue of Athena was finally unveiled to the public.

Today, the Parthenon remains as impressive as when it was first built. Featuring the largest set of matching bronze doors in the world (weighing 7.5 tons each,) this collossal monument not only welcomes visitors from around the world, but remains the focal point of Centennial Park, one of Nashville's most beautiful and historic public gathering places.

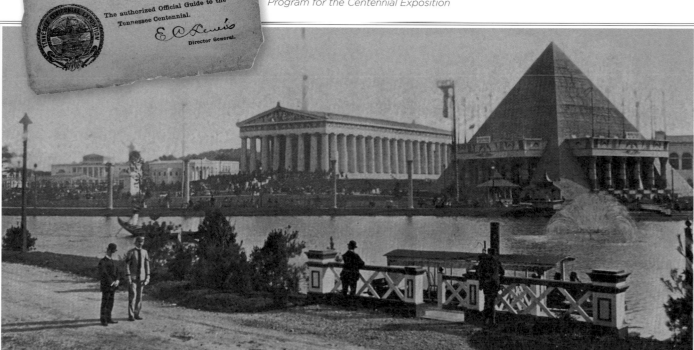

The Parthenon was originally one of many replicas of exotic architecture at the 1897 Tennessee Centennial Exposition.

< THE PARTHENON 18" x 24" Limited Edition Print created in 2012 by Ligia Teodosiu

"The Parthenon is only two blocks away from the Anderson Design Group studio where all of the Spirit of Nashville posters were created. This print was the 6th in a series of designs requested by Metro Parks to commemorate Nashville's favorite outdoor spaces. The design shows what the park looks like today—without the Egyptian pyramid and other temporary structures shown in the 1897 photo above."

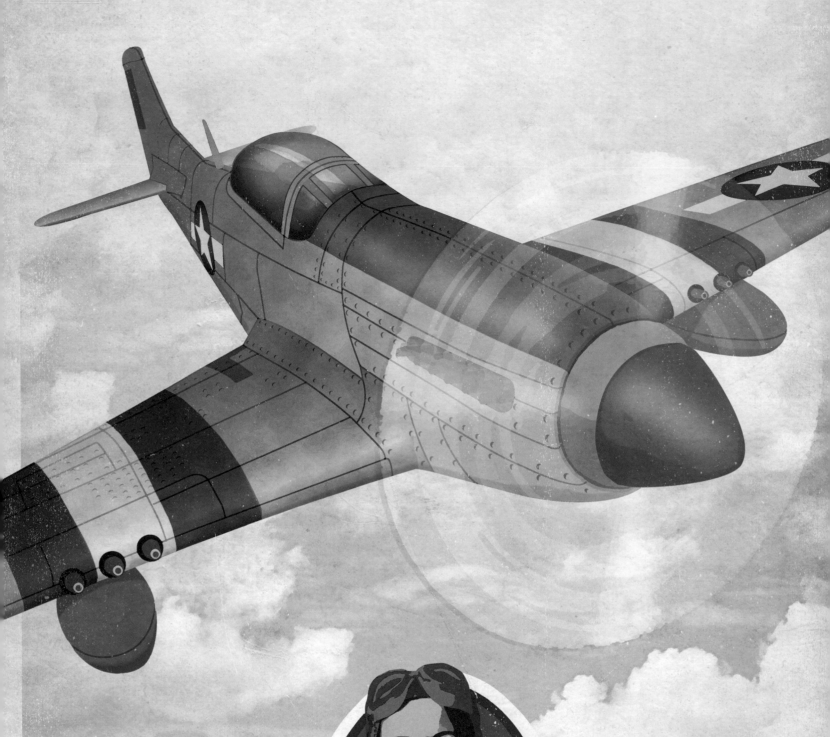

CORNELIA FORT
1919-1943
NASHVILLE TENNESSEE

CORNELIA FORT

AT THE TWILIGHT'S LAST GLEAMING

(Excerpts of an article written by Cornelia Fort, just a short time before she was killed in a midair collision over Texas, March 21, 1943. Reproduced from Women's Home Companion, *June 1943.)*

I KNEW I was going to join the Women's Auxiliary Ferrying Squadron before the organization was a reality, before it had a name, before it was anything but a radical idea in the minds of a few men who believed that women could fly airplanes. But I never knew it so surely as I did in Honolulu on December 7, 1941.

At dawn that morning I drove from Waikiki to the John Rodgers Civilian Airport right next to Pearl Harbor, where I was a civilian pilot instructor. Shortly after six-thirty I began landing and take-off practice with my regular student. Coming in just before the last landing, I looked casually around and saw a military plane coming directly toward me. I jerked the controls away from my student and jammed the throttle wide open to pull above the oncoming plane. He passed so close under us that our celluloid windows rattled violently and I looked down to see what kind of plane it was.

The painted red balls on the tops of the wings shone brightly in the sun. I looked again with complete and utter disbelief. Honolulu was familiar with the emblem of the Rising Sun on passenger ships, but not on airplanes.

I looked quickly at Pearl Harbor and my spine tingled when I saw billowing black smoke. Still, I thought hollowly, it might be some kind of coincidence or maneuvers, it might be, it must be. For surely, dear God...

Then I looked way up and saw the formations of silver bombers riding in. Something detached itself from an airplane and came glistening down. My eyes followed it down, down, and even with knowledge pounding in my mind, my heart turned convulsively when the bomb exploded in the middle of the harbor. I knew the air was not the place for my little baby airplane and I set about landing as quickly as ever I could. A few seconds later a shadow passed over me and simultaneously bullets spattered all around me.

Suddenly that little wedge of sky above Hickam Field and Pearl Harbor was the busiest, fullest piece of sky I ever saw.

We counted anxiously as our little civilian planes came flying home to roost. Two never came back. They were washed ashore weeks later on the windward side of the island, bullet riddled. Not a pretty way for the brave yellow Cubs and their pilots to go down to death.

When I returned, the only way I could fly at all was to instruct Civilian Pilot Training programs. Weeks passed. Then, out of the blue, came a telegram from the War Department announcing the organization of the WAFS (Women's Auxiliary Ferrying Squadron) and the order to report within twenty-four hours if interested. I left at once.

Because there were and are so many disbelievers in women pilots, especially in their place in the army, officials wanted the best possible qualifications to go with the first experimental group. All of us realized what a spot we were on. We had to deliver the goods or else. Or else there wouldn't ever be another chance for women pilots in any part of the service.

For all the girls in the WAFS, I think the most concrete moment of happiness came at our first review. Suddenly, and for the first time, we felt a part of something larger. Because of our uniforms which we had earned, we were marching with the men, marching with all the freedom-loving people in the world.

I, for one, am profoundly grateful that my one talent, my only knowledge, flying, happens to be of use to my country when it is needed. That's all the luck I ever hope to have.

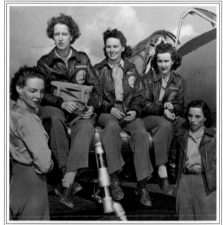

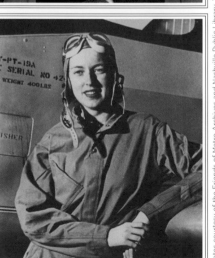

Cornelia and the WAFS posing for photos.

< CORNELIA FORT 18" x 24" Limited Edition Print created in 2005 by Darren Welch

"This poster was created to celebrate Cornelia Fort, the first female pilot in American history to die for her country. Fort was a pilot and flight instructor in WWII and was one of the few airborne witnesses to the attack on Pearl Harbor. Cornelia flew all sorts of planes, transporting them to and from various air bases. (This poster features a P-51 Mustang fighter plane.) Fort's achievements are commemorated by an airpark named in her honor."

NATCHEZ TRACE
PARKWAY
NASHVILLE TO NATCHEZ

NATCHEZ TRACE PARKWAY

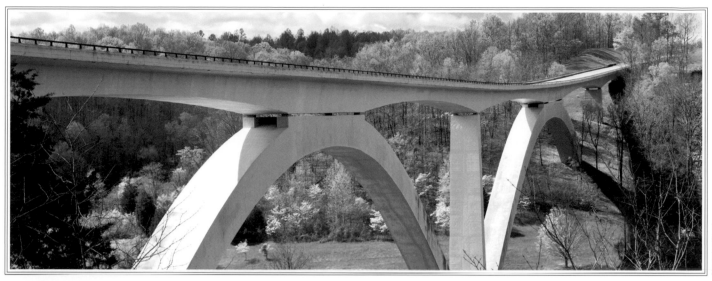

The 444-mile Natchez Trace Parkway commemorates an ancient trail that connected southern portions of the Mississippi River to central Tennessee. Today, visitors can experience this beautiful stretch of road through hiking, biking, horseback riding and camping.

IT'S AN UNEXPECTED SIGHT. Just a few short miles along the 444-mile Natchez Trace parkway, a sleek, white bridge appears, spanning the lush valley below.

The bridge is one of the first interest points along the Trace when traveling from Nashville. It has become a favorite subject for photographers and sightseers, who come from all across the country to travel the historic Natchez Trace.

The Trace itself first appeared as a Native American trade route between area tribes, and was further developed in the early 1800s as a postal route. Eventually, the trail became suitable for travel and trade between the ports of Louisiana, and the North. Settlements sprang up along its path, and many differing people—from circuit preachers to highway bandits —could

be found passing from town to town.

It was the introduction of the steamboat to the Mississippi River that eventually rendered the Natchez Trace obsolete; it was abandoned as an official road in 1830. However, just 100 years later, the government saw fit to commemorate the Trace by beginning construction on the Natchez Trace Parkway, which closely follows the original path of the Trace.

The Natchez Trace Parkway Bridge is the crowning jewel of the scenic roadway. Completed in 1994, its creation made engineering history. Designed by Figg Engineering Group and built by PCL Civil Constructors, Inc., the 1,648-foot-long bridge was the first in America to use precast segmented technology for an arched structure. Because of the design, the bridge has won 16 design awards,

including prizes from National Endowment for the Arts, the Presidential Award for Design Excellence, and the Eleventh Annual Bridge Conference, which named it the single most outstanding achievement in the bridge industry for 1994.

> *"What a great place to get away from the city lights and watch the stars. My dad has recently taken up astronomy and he and I took his telescope out there this past Thanksgiving. I saw Saturn through the scope with my very own eyes—it really does have rings!"* **— Rachel Paul**

< NATCHEZ TRACE PARKWAY 18" x 24" Limited Edition Print created in 2003 by Kristi Carter Smith

"The bridge is overwhelming in person—trying to capture it in a poster design just doesn't do it justice. You really have to see it in person to appreciate the scale and beauty of this bridge. And if you are not afraid of heights, be sure to walk across the bridge and look over the rail—the views of Birdsong Hollow below are stunning."

THE HERMITAGE

NASHVILLE, TENNESSEE

HOME OF

Andrew Jackson

7TH U.S. PRESIDENT, HERO OF THE WAR OF 1812, ETC.

THE HERMITAGE

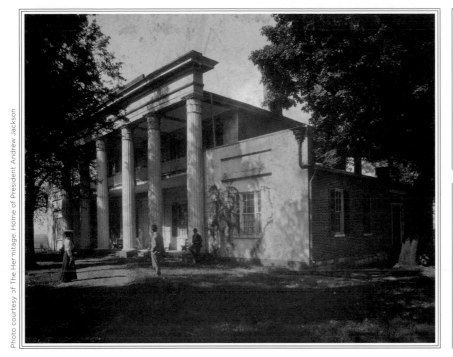

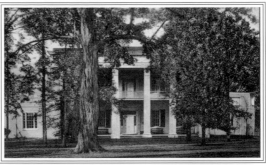

EACH YEAR, both tourists and locals file in and out of The Hermitage, the stately Greek Revival-style monument of famed Tennessean Andrew Jackson. People walk through the home that looks much like it did at the end of Jackson's second presidency, viewing his sword collection, library, and collection of family photos.

And while it may be a tourist attraction today, to Andrew Jackson, The Hermitage was much more than just the mansion—it was his refuge from the trials and frustrations of public life. Jackson's wife, Rachel, chose the site for the home and it was subsequently built in 1819 to her specifications. Jackson also commissioned a garden for Rachel; each day she brought fresh flowers from her beloved garden to decorate or to give to visitors.

By the time The Hermitage was built, Andrew Jackson was already an American historical figure. After helping to write the Tennessee constitution in 1796, Jackson was elected the Volunteer State's first congressman, serving a year in the House of Representatives and a year in the U.S. Senate. He later served as judge of the superior court in Tennessee, was elected major general of the Tennessee militia, and won national fame in 1815 with his amazing victory over the British in New Orleans. In 1821, he was appointed governor of Florida, paving his way to a run for the presidency.

Andrew Jackson took office as the seventh president of the United States in 1829. Although he was busy fulfilling duties, he kept close eye on his Tennessee home. After a chimney fire seriously dam-

aged the mansion in October of 1834, President Jackson hired noted Nashville architects and builders Joseph Reiff and William C. Hume to rebuild the mansion. He also had a Grecian-style "temple and monument" built for Rachel, who died in 1828.

In 1837, Jackson retired from the U.S. presidency and returned to The Hermitage. He died on June 8, 1845 and was laid to rest two days later in a tomb next to his wife Rachel. The State of Tennessee purchased the property from the Jackson family in 1855, and since 1889, the Ladies' Hermitage Association has cared for the property as a historic site on behalf of the State of Tennessee. Thanks to the Association's efforts, almost all of the mansion's contents are original. In 1960, the federal government recognized The Hermitage as a National Historic Landmark. Today, The Hermitage is a 1,120-acre property with museum, recreational and farming activities.

< THE HERMITAGE 18" x 24" Limited Edition Print created in 2004 by Abe Goolsby

"We decided to render this poster in a graphical style, simplifying details and the color palette. While this print turned out very nicely, in hindsight, this poster would have been a good one to attempt in the same pen and ink rendering style that I used to create the Union Station, State Capitol and the Belle Meade Plantation prints."

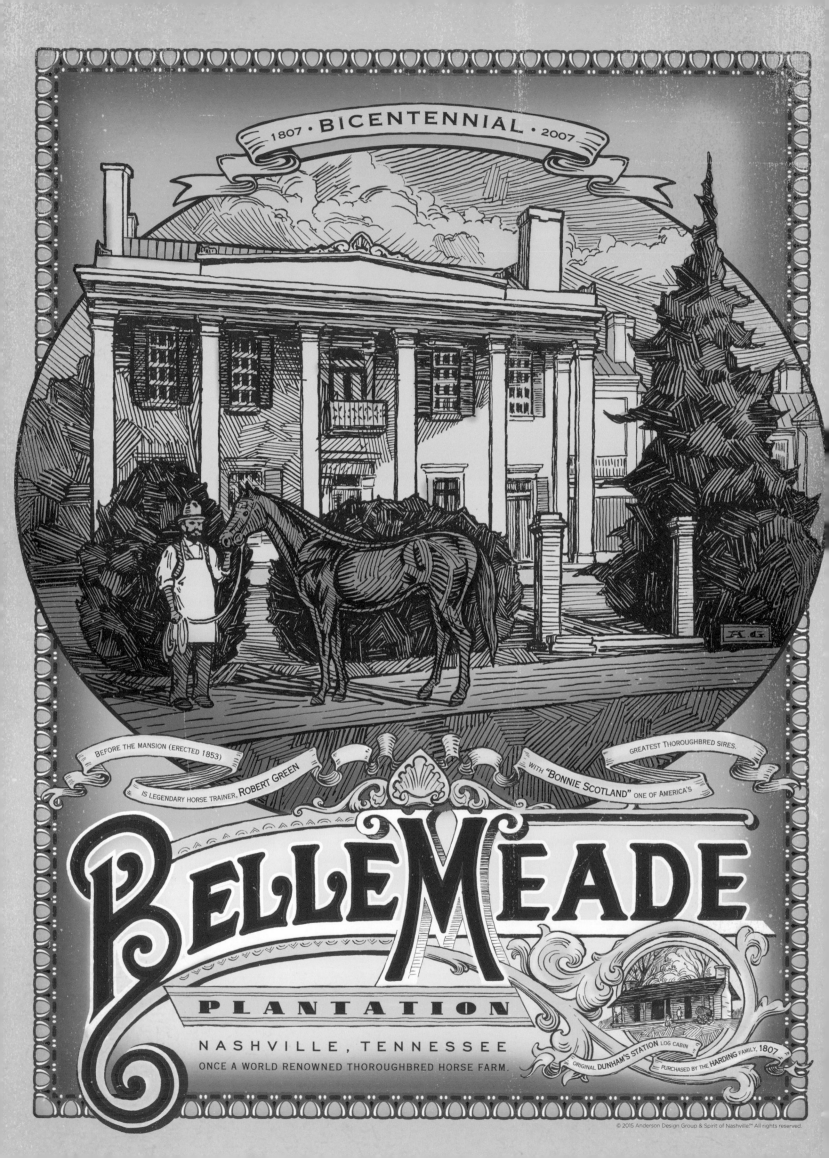

BELLE MEADE PLANTATION

ON A 30-ACRE TRACT of land six miles west of Nashville, it's still 1853.

Among Magnolia trees and stretches of green grass, there's a mausoleum, slave cabin, gardens and stables all surrounding a massive Greek Revival-style mansion.

And each year, visitors flock to Belle Meade Plantation to see this piece of Tennessee history frozen in time.

But what visitors see now is the plantation after 200 years of existence. When John Harding bought the 250-acre tract on the Natchez Trace, he and his wife, Susannah, lived in a small log cabin. The land was cleared, and with the help of slaves, Harding created a farm.

By 1816, the farm sprawled across 1,000 acres and had become a boarding house for thoroughbred horses. As the popularity of horse racing grew, and the farming operation prospered, Harding was able to build a Federal-style brick home for his family. He named his farm Belle Meade, or beautiful meadow.

Harding had been breeding horses at the farm, thanks to Montgomery Bell's stallion Boaster, but it was Harding's son, General William Giles Harding, that would establish the plantation as a well-known breeding facility. Years later, it

would be common knowledge that race horse greats such as Secretariat could trace their bloodlines back to Belle Meade. Much of the success is owed to Bob Green, a former slave and expert horse trainer, who worked at the farm his entire life. (He stayed on at the plantation after the Civil War as a freed man.)

Belle Meade thrived before the Civil War, and by the early 1860s, the farm spanned 5,400 acres. General Harding was a Confederate supporter, giving $500,000 to support the Southern cause. But after Nashville surrendered to Union forces in 1862, military governor Andrew Johnson had Harding arrested, and he was sent to Mackinaw Island in Michigan for six months. General Harding's wife Elizabeth handled affairs while he was jailed.

Harding had a stroke in 1883, and turned the farm over to his daughter Selene and her husband, William Hicks Jackson, a retired confederate general who'd commanded troops under General Lee. They managed the farm together,

and the farm gained national attention with Jackson's purchase of Iroquois, the first American winner of the English Derby. Iroquois stood stud at Belle Meade Plantation for several years and by the mid 1890s was commanding fees of $2,500 when the average stud fee of the time was $300.00.

After Selene and Billy passed away, the farm was managed by their children. They were ill equipped to operate the estate and after some personal tragedies, the plantation was put up for sale in 1906. The farm was subdivided and passed through the hands of several well-known Nashvillians until 1953 when the mansion and 25 acres of land was purchased by the State of Tennessee. Today, the 30-acre property includes the 1853 mansion and eight other outbuildings, and is operated by the Nashville Chapter of the Association for the Preservation of Tennessee Antiquities. The nonprofit organization is dedicated to the conservation and preservation of the property.

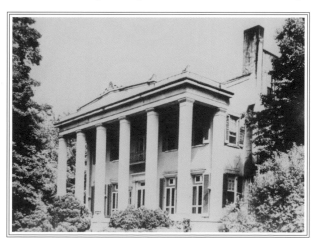

The front of the mansion as it looked around 1900.

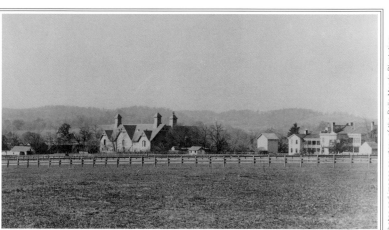

The back of the mansion and stables as seen from the surrounding pastures.

Photos and images courtesy of the Belle Meade Plantation

< BELLE MEADE PLANTATION 18" x 24" Limited Edition Print created in 2006 by Abe Goolsby

"In the same vein as the Union Station poster, this one was inspired by nineteenth century advertising, with a nod toward the illustrative work of Franklin Booth in the early twentieth century. I took my own reference photography, but also researched and relied on older photographs and paintings, including, of course, the one of Bob Green and Bonnie Scotland which still hangs in the mansion's main foyer."

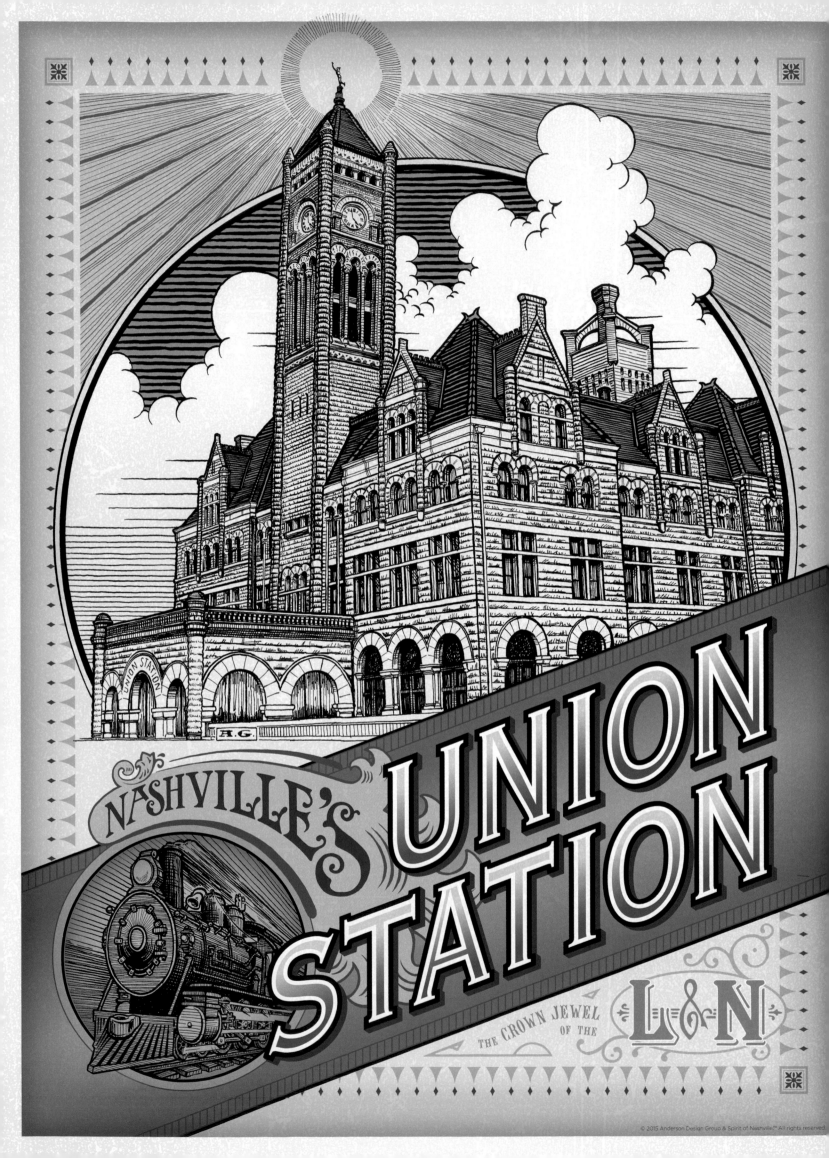

NASHVILLE'S **UNION STATION**

THE CROWN JEWEL OF THE L&N

UNION STATION

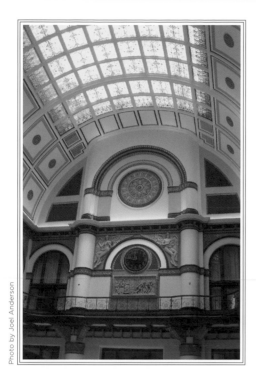

Photo by Joel Anderson

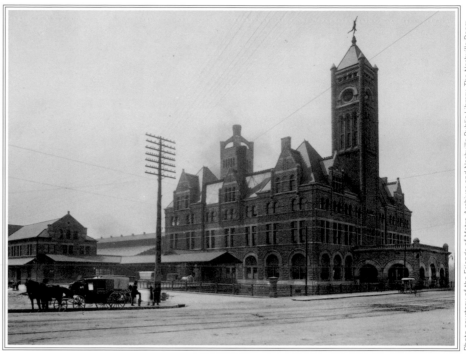

Photo courtesy of the Friends of Metro Archives and Nashville Public Library, The Nashville Room

UNION STATION was opened on October 9, 1900, by the Louisville and Nashville (L&N) and the Nashville, Chattanooga, and St. Louis (NC&StL) Railroads. Made of Kentucky limestone and Tennessee marble, the entire structure was built for $300,000.

Even to this day, most people would describe it as magnificent. To walk in Union Station is to enter a different era, one when travel was a glamorous event, and people put on their best clothing to come to the place that looked like a castle, marveling at the use of Italian marble, vaulted ceilings and stained glass so beautiful it seemed to glow.

And when it was built in 1900, Nashvillians were in awe. Major Eugene C. Lewis, a civil engineer for the NC&StL, was the force behind the building project. A majority of the interest in the NC&StL had been purchased by the L & N Railroad after the Civil War, and therefore they'd be ones financing the project. L&N engineer Richard Montfort designed the structure, and ground was broken on August 1, 1898. More than 200,000 cubic yards of ground were dug up and hauled off in wagons. As masons worked, adding stone after as each floor was built, the Romanesque-style building began to take shape. While pointed gables lined the top of the building, two towers rose above the roof line; the front one was topped with a statue of Mercury, which Lewis had kept from the state's Centennial Exposition.

On October 9, 1900, all of Nashville gathered along Broad Street for the parade and opening, which was more than just an event—it was the town's transition into the new century. The passenger train shed, which measured 250 by 500 feet, was quite the engineering feat in its time—it could hold up to 10 trains at once.

Over the next 70 years, countless amounts of people would file through the station: some to travel, some to eat at the famed restaurant, others just to watch, hoping they might catch a glimpse of a star like Mae West (who did once travel through the station) walking through. In 1977, the station was condemned. The city purchased the quickly declining structure in 1985. By 1986, the station was restored to its original grandeur and reborn as a hotel and restaurant.

Today, Union Station is still a Nashville landmark, attracting travelers and serving as the site for a number of weddings and other events. But the emotions the building evokes have not changed. As Dr. Kate Zerfoss said in one of the many books on the station:

"There was just a majesty about the building; you never felt as you went in and out of it that you hadn't had a lofty feeling by having viewed such a magnificent interior."

< UNION STATION 18" x 24" Limited Edition Print created in 2003 by Abe Goolsby

"This print was created by combining hand lettering with painstakingly detailed pen and ink drawings. I took reference photography, then did perspective drawings in pencil, and finally drew each tile, stone and window pane with a pen and ink. The inspiration for the lettering styles and colors came from old advertising art from the late nineteenth century. I've always been a train fanatic. As a child of four or five years, I boarded what was probably one of the last passenger trains to leave the Station, back in the twilight of its service as an actual railroad depot – a very fond memory."

Tennessee

State Capitol

NASHVILLE, TENNESSEE

COMPLETED 1859

WILLIAM STRICKLAND, ARCHITECT

TENNESSEE STATE CAPITOL

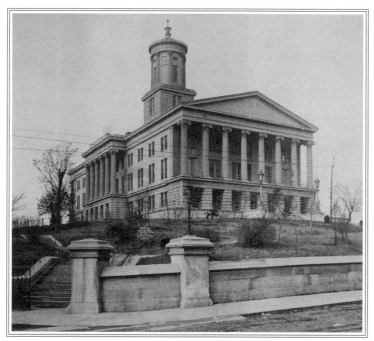

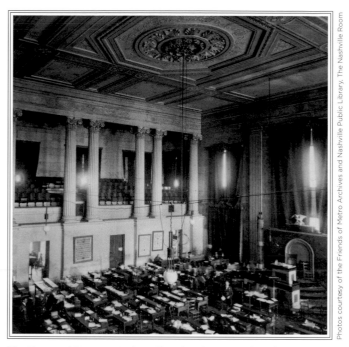

The State Capitol dominated the Nashville skyline in the early 1900s.

The House of Representatives Chamber is as grand as the exterior.

THE MAJESTIC Tennessee State Capitol stands proudly on a hill overlooking downtown Nashville. Upon its completion in 1859, it was considered one of the most magnificent public buildings of its time anywhere in the United States. The cornerstone of the State Capitol was laid on July 4, 1845, and the final stone was put in place on July 21, 1855, more than ten years later.

The architect, William Strickland, designed the distinctive tower after the monument of Lysicrates in Athens, Greece. The building is considered by many to be the masterpiece of Strickland's career, which began with his apprenticeship to Benjamin Latrobe, first architect of the U.S. Capitol. Strickland moved to Nashville from Philadelphia, believing that his stay would be only a few years. Instead, the construction of the Capitol

took more than 9 years to complete.

Construction was often delayed because of a shortage of funds. To make matters worse, Strickland had to deal with a man named Samuel Morgan, who was appointed by the Capitol Commission to oversee Strickland's work and make sure that it came in under budget. Legend has it that the two men hated one another and never agreed on anything, getting into heated arguments at the construction site, bickering over details such as cost, materials, and design.

In 1854, William Strickland died, long before the project was complete. In his memory, and according to his wishes, the state voted to construct a vault within the building's walls where his body would be interred. In its entire history, Tennessee has only honored one other man in such a manner; his name was Samuel Morgan!

Some believe even after the two men were interred within the walls of the Capitol, Strickland and Morgan have never stopping arguing. Over the years, police officers have reported strange night-time disturbances at the Capitol, hearing sounds of two men yelling and cursing, but upon investigation, finding the area completely vacant. Some Nashvillians go as far as to say that the Capitol is haunted.

Today, the Capitol is still in use by the state government. It features numerous works of art, historical murals and frescos, portraits, massive chandeliers, as well as the House and Senate chambers, library, and the Governor's Office. It is one of the oldest and most beautiful structures in downtown Nashville, and is open to the public at no charge—but only during the daytime!

< TENNESSEE STATE CAPITOL 18" x 24" Limited Edition Print created in 2004 by Abe Goolsby

"I took reference photography from the top of a nearby office building in an attempt to gain the right vantage point of the Capitol for this design. A few days later, we were surprised to have a pair of plain-clothed agents, apparently from some Bureau of Investigation or other, show up at our studio asking for a certain Abe Goolsby, who had been seen taking surveillance photos of a government building. After a very interesting conversation that lasted maybe fifteen minutes, I was finally able to convince the agents that I was not a terrorist, and merely an artist who was trying to create a nice poster that featured our State Capitol."

HOW THE ART WAS CREATED

State Capitol 18" x 24" pen and ink by Abe Goolsby

1 To begin his poster design, artist Abe Goolsby chose a style that was typical for the late 1850s, the era in which the Tennessee State Capitol was completed. He found examples of the kind of elaborate lettering, borders and line art he wanted to emulate on old tobacco tins. The ornate hand-lettering rendered artfully with curves and embellishments would go perfectly with a detailed pen and ink drawing of the majestic building.

2 The next step was to gather some photographic reference of the State Capitol to aide in creating a pencil drawing that would be inked over to create the poster art of the building. Abe did some library research of archival photos, but the angle he really wanted was not from the street level, but from above the building. To get this angle, Abe got permission to go on the roof of a downtown building that overlooked the Capitol. He took several photos and returned to the studio to begin sketching. A few days later, some agents, assumed to be from the Tennessee Bureau of Investigation, dropped by to ask Abe why he was taking photos of a government building. Abe immediately became a celebrity among his peers for his brush with Homeland Security.

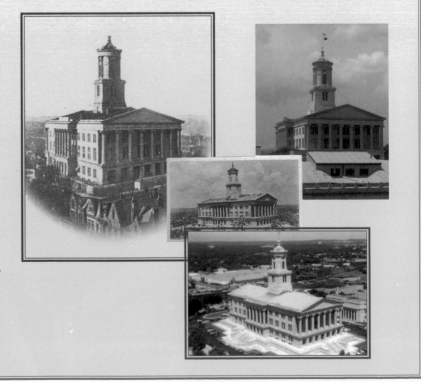

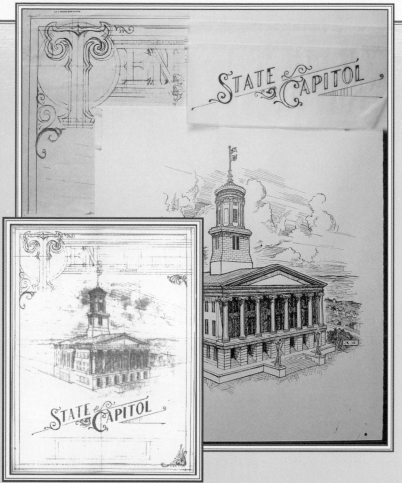

3 The sketching stage was laborious. The antique style of poster design Abe was emulating required the line art and typography to be rendered entirely by hand. So he did an old-fashioned perspective drawing, complete with vanishing points that were taped to scraps of paper several inches outside of the actual composition. He hand-lettered the type and drew every detail of the building, creating cross hatching for shadows and shading.

4 The final step was to digitize the line drawings. Abe scanned the type, border art and the ink drawing of the building and pieced them together on his computer, an Apple G4. He added color in Photoshop, turning the black pen and ink line art into blue and red line art to play off of the Tennessee state flag colors. He also scanned some old paper so he could overlay the yellowed edges and aged textures onto his art, giving the entire poster a vintage look.

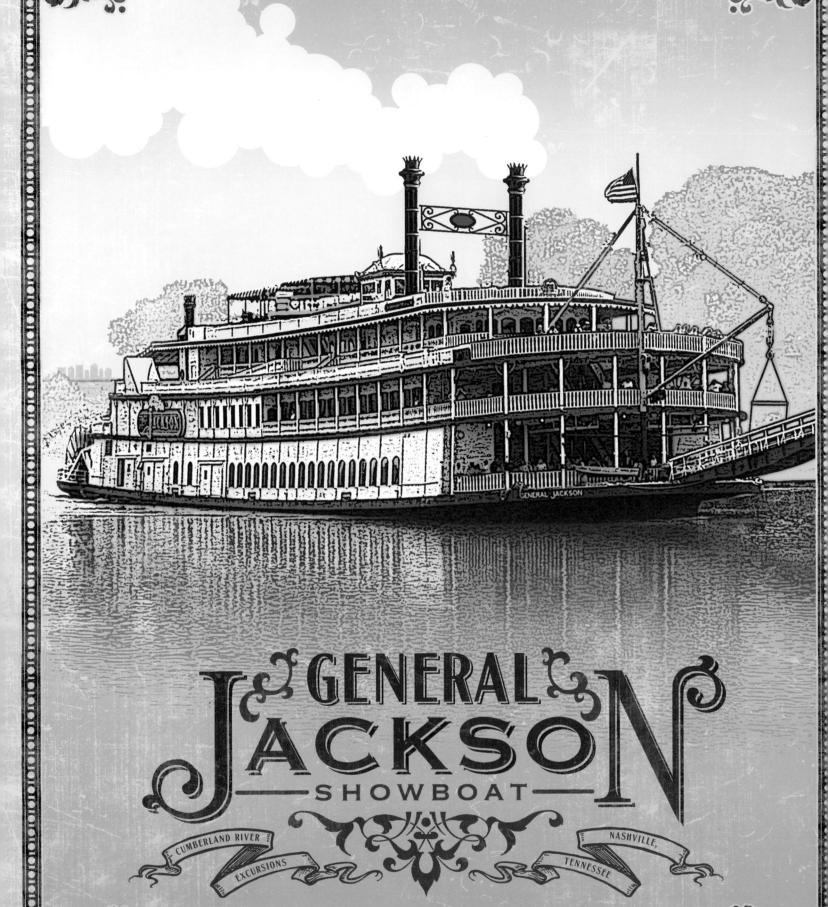

GENERAL JACKSON SHOWBOAT

CUMBERLAND RIVER EXCURSIONS

NASHVILLE, TENNESSEE

GENERAL JACKSON® SHOWBOAT

ON JUNE 23, 1985, thousands lined the riverbanks of the Cumberland to see a boat that's almost the length of a football field. Onlookers waved at the craft they'd heard so much about, the one painted red, white and blue with a theater that could hold 600 people.

The *General Jackson Showboat* was a sight to see that day, and for the past 22 years, the cruises have been a favorite of tourists and natives alike.

In 1983, Opryland USA, Inc. earmarked more than $12 million to build an elaborate showboat to use as another attraction. The Jeffersonville, Indiana company Jeffboat Inc., who also built the larger *Mississippi Queen*, was hired to construct the boat. About a year and a half later, a boat that measured 300 feet from gangplank to paddle wheel began its first sail down the Cumberland River. Named for the first steamboat to sail on the Cumberland River, the boat donned a 32-by-9 foot *General Jackson* logo on its exterior. The 1,489-ton boat's capacity can hold 1,200 passengers and 157 crew.

On the interior, 19th-century appeal was boosted by modern enhancements; the appearance and vibe of a

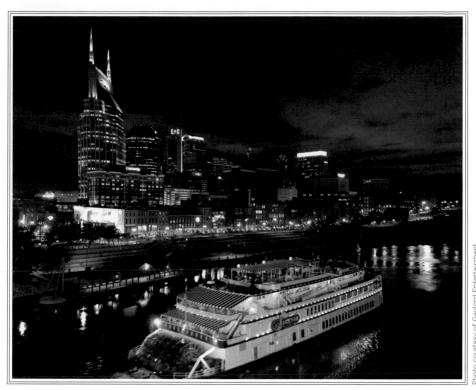

The *General Jackson Showboat* offers day and night cruises on the Cumberland River.

New Orleans Lounge, and the boat's showpiece, the Victorian Theatre, were reminiscent of the days of Mark Twain, but were now air conditioned.

In it's early years, riders on the *General Jackson* could pay $10 to $30, depending on the time of day, and travel between the four decks enjoying food, dancing, sightseeing and country or Broadway-style music performances. As popularity grew, the showboat became a favorite for private parties, and even weddings. Today, visitors can enjoy many different types of shows and events, including the popular holiday shows. However, tickets cost just a little bit more than they did in the late 80s.

While this majestic paddle wheel boat looks like an antique from the 1800s, it is a modern engineering marvel offering passengers lazy afternoon cruises under the southern sky, as well as evening cruises complete with entertainment, dining, and dancing under the stars. Featuring a spacious Victorian theatre, indoor and outdoor bars, observation decks that offer spectacular views of the Nashville skyline, banquet dining and dance floors, the *General Jackson* has become Music City's favorite floating landmark.

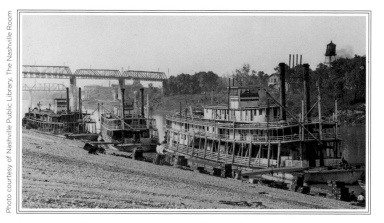

There was a time when steamboats like these came and went from Nashville every day.

< GENERAL JACKSON SHOWBOAT 18" x 24" Limited Edition Print created in 2005 by Abe Goolsby

"I did not have the luxury of time to hand draw this design like I had done on the Union Station or the State Capitol prints. So I started with a photo of the General Jackson and attempted to simulate a digital pen and ink effect on the computer. I still had to do a lot of illustration, but this time it was all done with a computer mouse instead of a pen. Come to think of it, I'm not sure that it really saved me any time when all was said and done — but it was fun to experiment with a different medium!"

VANDERBILT

NASHVILLE, TENNESSEE

VANDERBILT UNIVERSITY

ON THE SURFACE it would appear that noted journalist David Brinkley, champion basketball player Will Perdue, late actress Bettie Page, and former U.S. Vice President Al Gore would have nothing in common.

Original Main Building before it was destroyed in a fire.

But at one time or another, all four of these people were students at Vanderbilt University. Although they all went on to pursue very different careers, it gives an idea of the mass of diverse talent, and the level of success that's reached by the graduates of the university on 21st Avenue South.

Ironically, it was a successful man with little education that made Vanderbilt possible. Cornelius Vanderbilt gave one million dollars to start one of the finest Southern universities.

Vanderbilt traditionally did not entertain requests for money, but his wife helped her cousin, Methodist Bishop Holland N. McTyeire of Nashville, convince him to donate to the cause in 1873.

McTyeire chose the site for the new school, and supervised the construction. One building was erected to serve as an observatory and homes for professors. Landon C. Garland, the school's first chancellor, helped McTyeire set curriculum and policies. In 1873, the school's charter was amended, naming the school "The Vanderbilt University."

The main building burned in 1905, but was rebuilt and later named after the school's longest-serving chancellor, James Kirkland.

From day one, the school offered both undergraduate and graduate degrees in both the liberal arts and the sciences. For 40 years, the school was under the supervision of the Methodist Episcopal Church, but administrative differences would cause the two entities to split in 1914.

The school enrolled 307 students in the fall of 1875, and at least one woman would attend the school each year forward. Beginning in 1892, women worked for full legal equality and achieved it—except access to dormitories. By 1913, 78 women were Vanderbilt students; at this time they led the student body in grade point averages and university honors.

The school continued to grow, but still faced problems common to Southern universities at the time. In order to move the school forward, it fell to Chancellor Harvie Branscomb to push the school toward racial integration. The division of the campus after the dismissal of divinity student James Lawson in 1960, and changes in society at the time, would push the school to fully integrate in 1962. Other societal changes would influence university policy; in 1969, the quota that kept women to one-third of the enrollment in the College of Arts and Sciences was lifted.

Since the 60s, the campus has continued to grow and diversify. Today, Vanderbilt educates more than 10,000 students each year. It is also the largest private employer in Middle Tennessee, and still strives to reach Cornelius Vanderbilt's goal of contributing "to strengthening the ties which should exist between all sections of our common country."

Main Building was rebuilt and renamed Kirkland Hall.

< VANDERBILT UNIVERSITY 18" x 24" Limited Edition Print created in 2006 by Joel Anderson.

"Historic Kirkland Hall stands proudly as the centerpiece of the oldest part of the Vanderbilt University campus. To render this print, I had to visit the site repeatedly to get just the right angle of sunlight. By the way, 7:45 am in the month of September is the best time to see Kirkland Hall as it appears in this poster!"

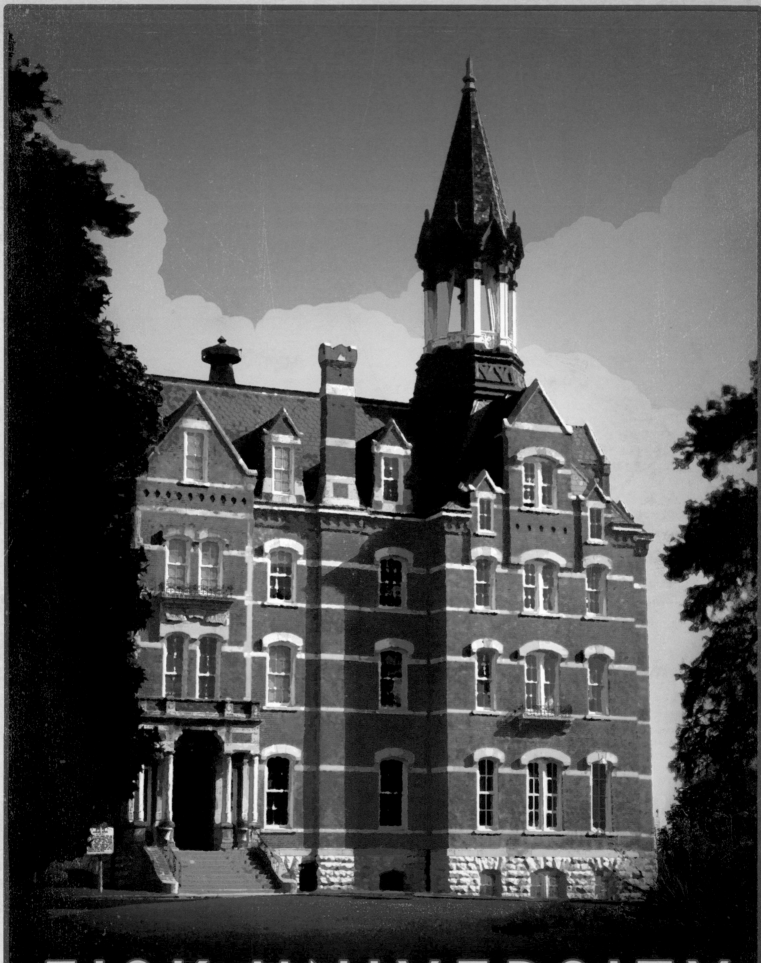

FISK UNIVERSITY

NASHVILLE, TENNESSEE

FISK UNIVERSITY

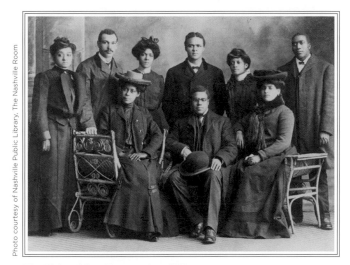

The Fisk Jubilee Singers circa 1872.

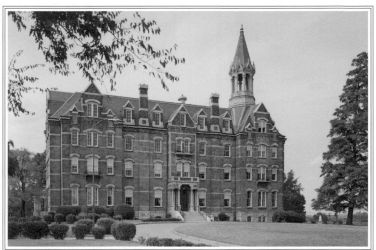

Fisk Jubilee Hall as it looked in the early 1900s.

MAJOR CONTRIBUTORS

to the Harlem Renaissance. Trailblazers in politics. Key leadership in the Civil Rights Movement.

If you look back through pertinent periods in American history, there's a good chance that a Fisk University alumnus or professor had a hand in shaping it. When you read about modern art or jazz or science, it's likely that a Fisk graduate was the first one to do it, make it, sing it, write it or play it.

In it's 141-year history, the school has earned and retained a reputation for academic and artistic excellence, despite financial hardships; those well-trained graduates, such as James Weldon Johnson, John Lewis and Constance Baker Motley, have gone on to contribute not just to African-American history, but American history.

The creation of Fisk is a historical event in itself. Just six months after the end of the Civil War, John Ogden, education superintendent for the Freedmen's Bureau, Reverend Erastus Milo Cravath and Reverend Edward Smith established a school for former slaves. Union Army General Clinton B. Fisk provided Union Army barracks, near the present site of

Union Station, to house the school, and the institution was named in his honor. The first classes at Fisk School were held January 9, 1866.

The next year, lawmakers passed legislation creating free public education in

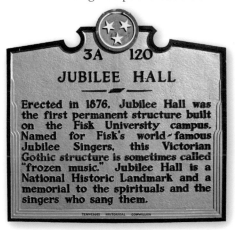

Tennessee, and to meet the new demand for qualified teachers, Fisk moved its focus from primary education to higher education. On August 22, 1867, Fisk Free Colored School was incorporated as Fisk University.

The years that followed brought a surge in enrollment, but the funding couldn't keep up with the demand for infrastructure updates. In order to raise money to keep the school's doors open, George L. White, professor of music,

created a nine-member choral ensemble of students and took it on tour. The group left campus on October 6, 1871, and used the contents of the school's treasury for travel expenses.

While on tour, the singers reached a point where they were physically and emotionally drained. To encourage them, White named them "The Jubilee Singers," a Biblical reference to the year of Jubilee in the Book of Leviticus. Incredible talent and dedicated work won over predominantly white audiences including Mark Twain, Ulysses S. Grant and Queen Victoria. Gradually they earned enough money to keep Fisk open and construct Jubilee Hall, which was designated as a National Historic Landmark in 1975.

Over the years, the addition of programs and resources has helped place Fisk as a renowned academic institution, producing such seminal figures in history as W.E.B. DuBois, Thurgood Marshall, John Hope Franklin and Nikki Giovanni. And after more than 100 years, the founders' dream of having a learning institution open to all, one that measures itself by "the highest standards, not of Negro education, but of American education at its best" is still a reality.

< FISK UNIVERSITY 18" x 24" Limited Edition Print created in 2007 by Joel Anderson

"The tower on the corner of the old Fisk building is one of my favorite steeples in Nashville. While shooting my reference photography, I felt as if I was on hallowed ground—I could sense the weighty historical and social importance of this great Nashville institution."

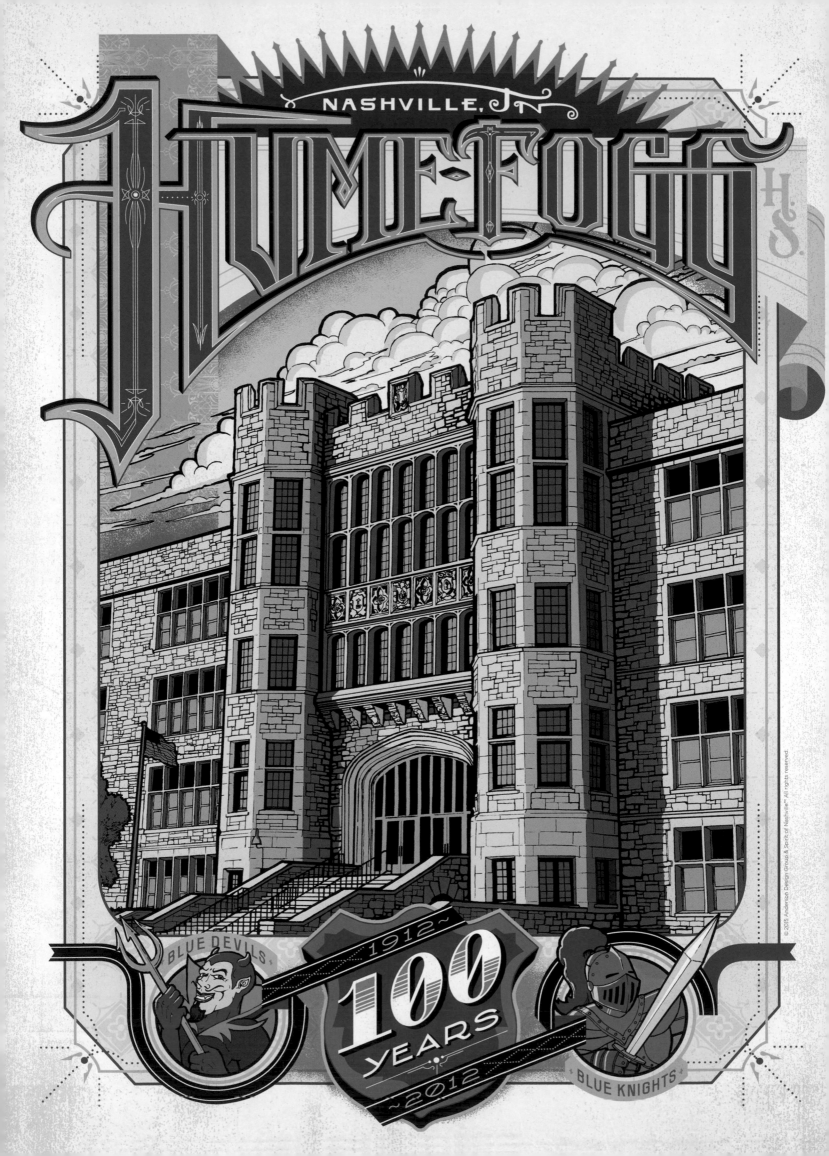

NASHVILLE, TN

HUME-FOGG

H.S.

BLUE DEVILS

1912

100 YEARS

2012

BLUE KNIGHTS

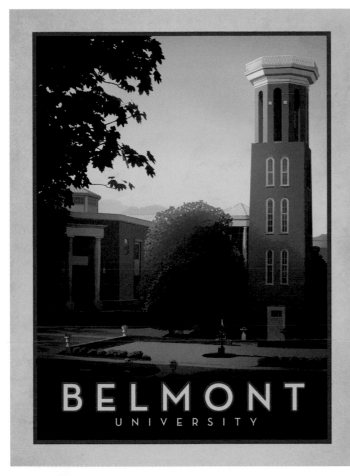

BELMONT
UNIVERSITY

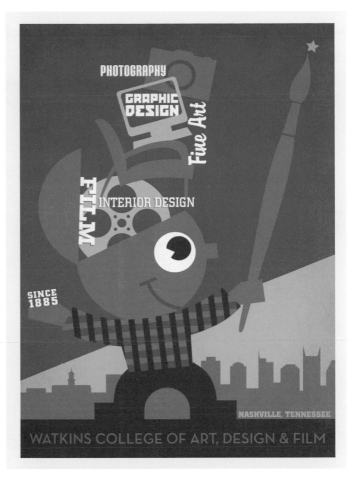

PHOTOGRAPHY

GRAPHIC DESIGN

Fine Art

FILM

INTERIOR DESIGN

SINCE 1885

NASHVILLE, TENNESSEE

WATKINS COLLEGE OF ART, DESIGN & FILM

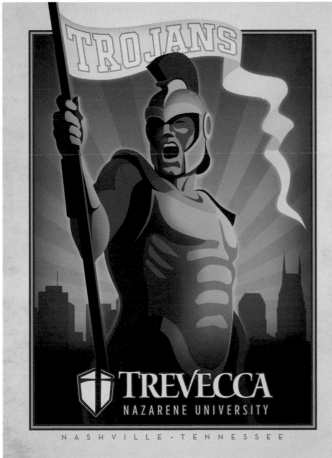

TROJANS

TREVECCA
NAZARENE UNIVERSITY

NASHVILLE · TENNESSEE

LIPSCOMB
UNIVERSITY

< HUME FOGG HIGH SCHOOL 18" x 24" Limited Edition Print created in 2011 by Andy Gregg
BELMONT UNIVERSITY 18" x 24" Limited Edition Print created in 2007 by Joel Anderson
WATKINS COLLEGE OF ART, DESIGN & FILM 18" x 24" Limited Edition Print created in 2010 by Joel Anderson
TREVECCA NAZARENE UNIVERSITY 18" x 24" Limited Edition Print created in 2008 by Joel Anderson
LIPSCOMB UNIVERSITY 18" x 24" Limited Edition Print created in 2007 by Joel Anderson

THE GREAT FLOOD OF 2010

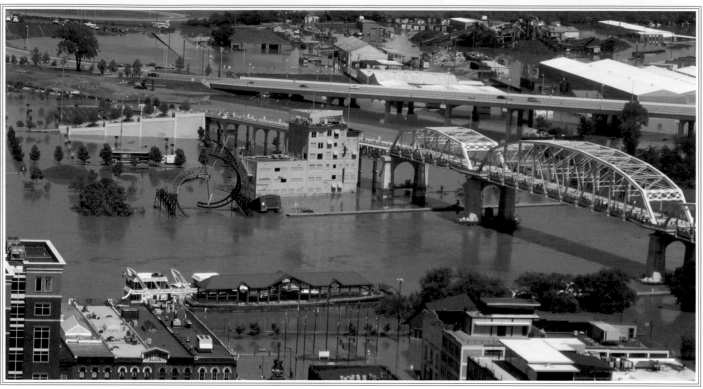

This photo: Courtesy of Metro Nashville Archives

Photo below: Flood 2010 Digital History Collection, Nashville Public Library

IN A 36-HOUR PERIOD on May 1st and 2nd, 2010, Nashville broke almost every historical rainfall record as an epic storm system dumped over 13 inches of rain. Some areas reported receiving over 20 inches in just a day and a half. Of the 20 gauges that monitor river levels in Middle Tennessee, 13 showed the highest levels ever. Others failed when waters rose higher than the guages could register, and others were simply swept away. On May 2, 2010, the Cumberland River crested at 51.86 feet in downtown Nashville—almost 12 feet above flood stage.

The flood is estimated to have caused more than 2 billion dollars in damage to homes, businesses and city infrastructure. Almost 11,000 properties were damaged or destroyed—and more than half of them were outside the 100-year flood plain. 10,000 people were displaced from their homes, and 24 people died across Tennes-

see—11 of them were in Davidson County. 2,773 businesses were forced to close temporarily or permanently, affecting over 14,000 employees and costing 3.6 billion dollars in lost revenue. Thousands of dollars worth of vintage musical instruments and sound equipment were lost in storage

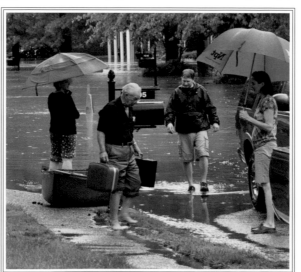

sites that were engulfed. It was the biggest disaster to ever hit the city of Nashville.

Almost immediately, volunteers mobi-

lized all over the city to rescue stranded people, bring food and water to those who needed it, remove water-logged drywall, furniture, and debris, and comfort neighbors who had lost everything. The outpouring of generosity and care was simply astounding. Over 25,000 volunteers signed up for clean-up and repair efforts, freely giving over 332,000 hours of their time to help their fellow citizens. *The Community Foundation of Middle Tennessee* received over 14 million dollars in donations from individuals and organizations. Country singer Garth Brooks raised almost 5 million dollars through a series of benefit concerts.

The day after the flood, several of us helped remove debris from people's homes. After hundreds of volunteers poured into devastated neighborhoods to continue the reconstruction efforts, we returned to our design studio to put our skills to

PLAY ON FLOOD RELIEF POSTER 18" x 24" Limited Edition Print created in 2010 by Matt Lehman & Joel Anderson

"This was the second design we created to raise money for flood victims. Combined with the first print, we raised over $30,000."

work creating art that we could sell to raise funds for flood victims. We initially created two posters with powerful symbolism—the first design featured two helping hands lifting a guitar out of the rising water. The second design was a quick re-tooling of an older Music City print featuring a female singer at a microphone. We illustrated water up to her knees and added the words PLAY ON to the bottom of the poster. That phrase became a rallying cry for all of Music City. It's what we do here in Nashville. The show must continue. Everyone we knew rolled up their sleeves and played on. No whining. No blaming. We just helped each other out, gave of our time, resources and energy, and did what needed to be done. Ten-

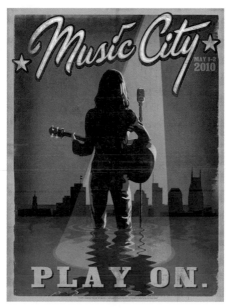

nessee is the Volunteer State, after all!

A year later, we created a new print to commemorate the 1-year anniversary of the flood. This third design showed

a mandolin drying out—only a drip and a small puddle remained. Flowers had bloomed from the broken strings. A bright golden sky symbolized the dawning of a new day. Nashville was different as a result of the adversity. While the flood was a terrible experience, it brought everyone together like nothing else could.

The tragic event activated our community and brought about a new sense of civic pride and volunteerism. *Hands On Nashville*, an organization that coordinated volunteers in the aftermath of the flood, and enlisted thousands of volunteers during the following months. To this day, they continue to connect over 120,000 volunteers each year with various community projects. We are truly stronger, better and brighter as a result.

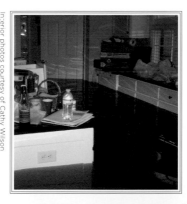

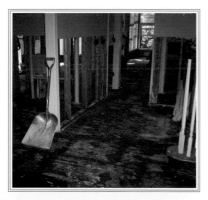

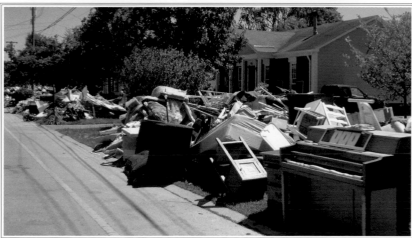

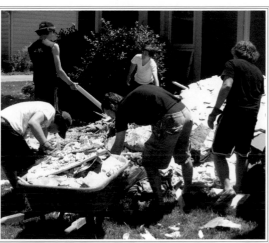

The Harpeth River rose to record levels and swallowed up entire neighborhoods. These photos were taken in Bellevue a few days after the flood.

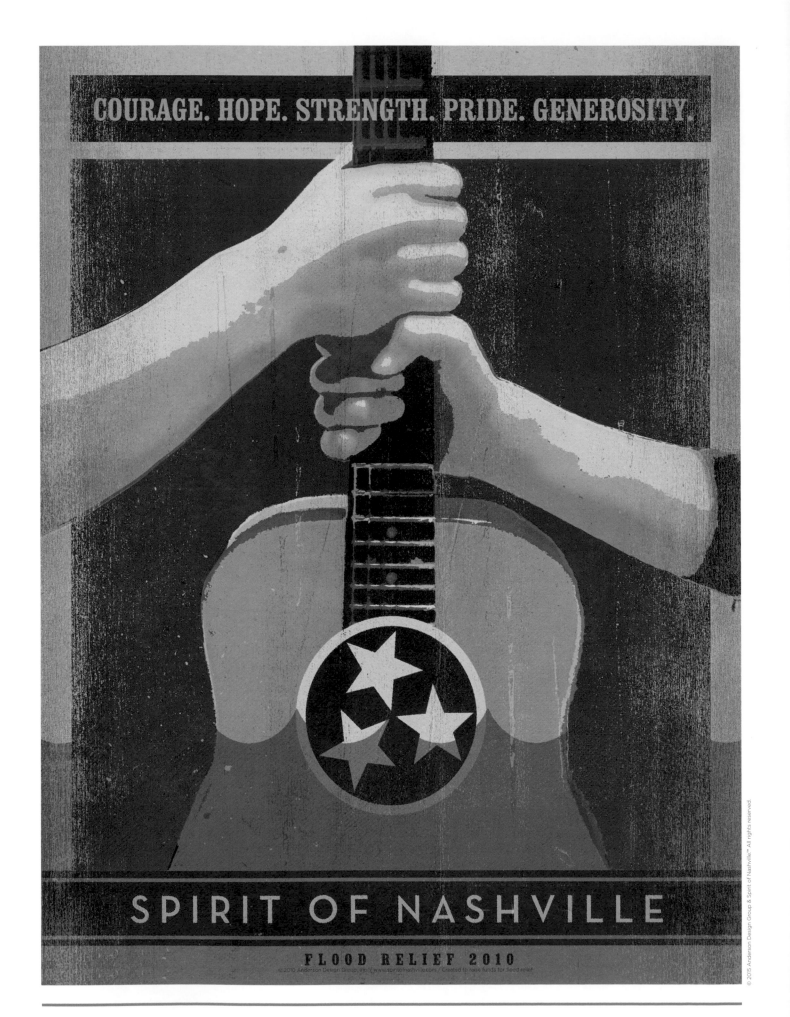

COURAGE. HOPE. STRENGTH. PRIDE. GENEROSITY.

SPIRIT OF NASHVILLE

FLOOD RELIEF 2010

HELPING HANDS FLOOD RELIEF POSTER 18" x 24" Limited Edition Print created in 2010 by Joel Anderson

"This was the first design we created to raise money for flood victims. We printed 500 of them and sold out in 3 weeks. Many people bought our commemorative prints to help friends or neighbors redecorate their homes after losing everything in the flood."

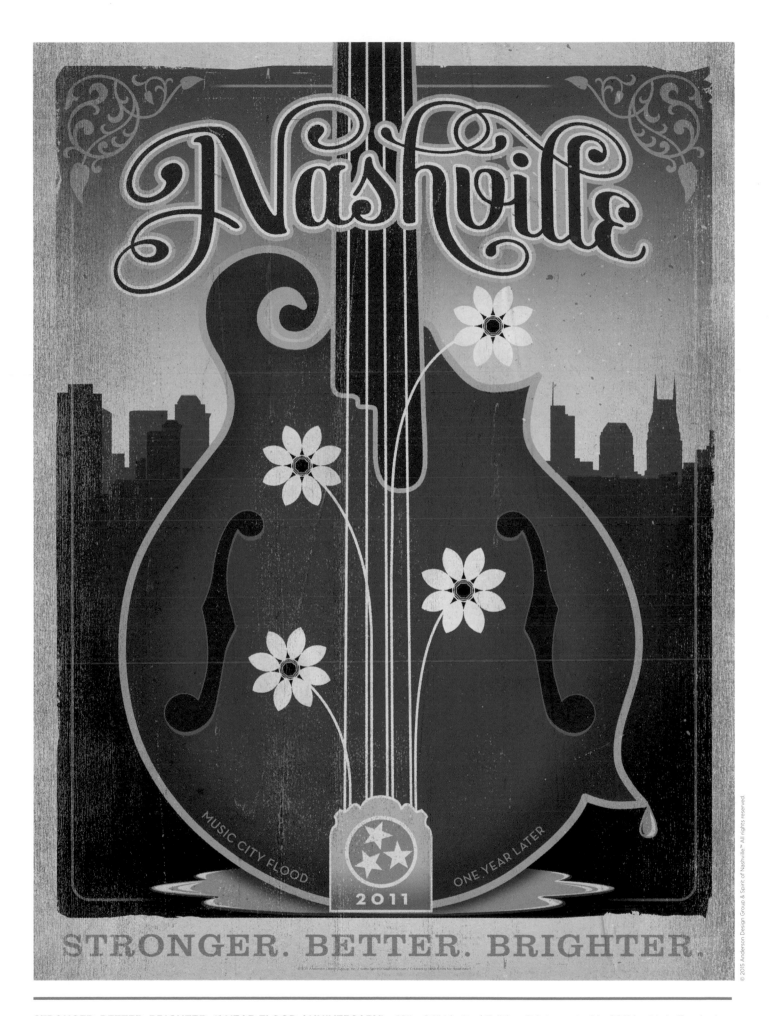

STRONGER. BETTER. BRIGHTER. (1-YEAR FLOOD ANNIVERSARY) 18" x 24" Limited Edition Print created in 2011 by Ligia Teodosiu

"Even one year after the flood, there were still people who were struggling to rebuild their homes and businesses. We wanted to continue to help them and to raise awareness that many of our fellow citizens still needed support to rebuild their homes or businesses."

Music & Melody

MUSIC CITY USA

NASHVILLE
TENNESSEE

SINCE 1806

WHERE MUSIC
lives and breathes

MUSIC CITY USA

NASHVILLE HAS LONG been home to the country recording industry and the famous Grand Ole Opry. It's the place that popularized country music giants such as Johnny Cash, Patsy Cline, Hank Williams, Minnie Pearl, Roy Acuff, Dolly Parton and Loretta Lynn. Nashville was first called "Music City" by WSM announcer David Cobb during a radio broadcast in 1950, and is now known around the world as "Music City, U.S.A." City promoters have recently abbreviated Nashville's nickname as "Music City" in hopes of making the name even more catchy and easy to remember.

Over the years, Nashville's reputation as a mecca for music business, songwriting, recording, and performing has expanded to more than just country music. Today, Music City proudly boasts musical excellence in nearly every genre—from the grandeur of the Nashville Symphony to the mellow sounds of smooth club jazz; from the familiar twang of little honky-tonk country bands to stadium-filling Top 40 acts. Nashville is also home to several gospel music record label headquarters.

Nashville's music scene began to pick up momentum in the 1920s and 30s with the formation of the symphony orchestra and the Grand Ole Opry. The mid 1940s and early 1950s brought Country Music into full swing when the Opry moved to the Ryman, dubbing the old tabernacle "The Mother Church of Country Music."

Music Row began to take shape with the birth of new recording studios and record labels. Castle Studio, Nashville's first recording studio, opened for business. Capitol Records became the first major record label to station a director of country music in Nashville. Soon RCA Studio B opened it doors on Music Row and became famous under the management of Chet Atkins, who was instrumental in crafting the Nashville Sound.

Performers such as Elvis, the Everly Brothers and Dolly Parton recorded their chart-topping hits in Nashville. The Country Music Association was founded and The Country Music Hall of Fame and Museum was built on Music Row.

Over the years, Nashville's music scene has evolved into a diverse and vibrant industry, attracting new indie rock groups, alternative bands, and music production ventures for television and movies.

Today, aspiring songwriters and performers continue to flock to Music City to make a name for themselves, proving that no place sounds as good as Nashville, Tennessee.

Loretta Lynn, Johnny and June Carter Cash, and Chet Atkins are just a few of the many famous voices that helped turn Nashville into Music City.

> " *I love Nashville. I love that on any given day you might walk past the guy who wrote "Midnight Train To Georgia,"*
> *"He Stopped Lovin' Her Today" or "Because He Lives." I love that the wide-eyed girl refilling your coffee cup, who*
> *just flew into town on a dream and a prayer, might be "the next big thing" but no one knows it yet. Nashville's been*
> *good to people who love music, it's been good to songwriters like me. It's the one town where the song still matters*
> *the most. That's what makes me get up every morning and try again. That's why I call it home.* "
> **— Connie Harrington, songwriter**

< MUSIC CITY (RED GUITAR) 18" x 24" Limited Edition Print created in 2007 by Taaron Parsons

"This print was based on a design I did as a student. I finished it at the last minute, and it was added to the 2007 Spirit of Nashville calendar and poster collection almost as an afterthought. It has turned out to be one of the more popular prints in the series."

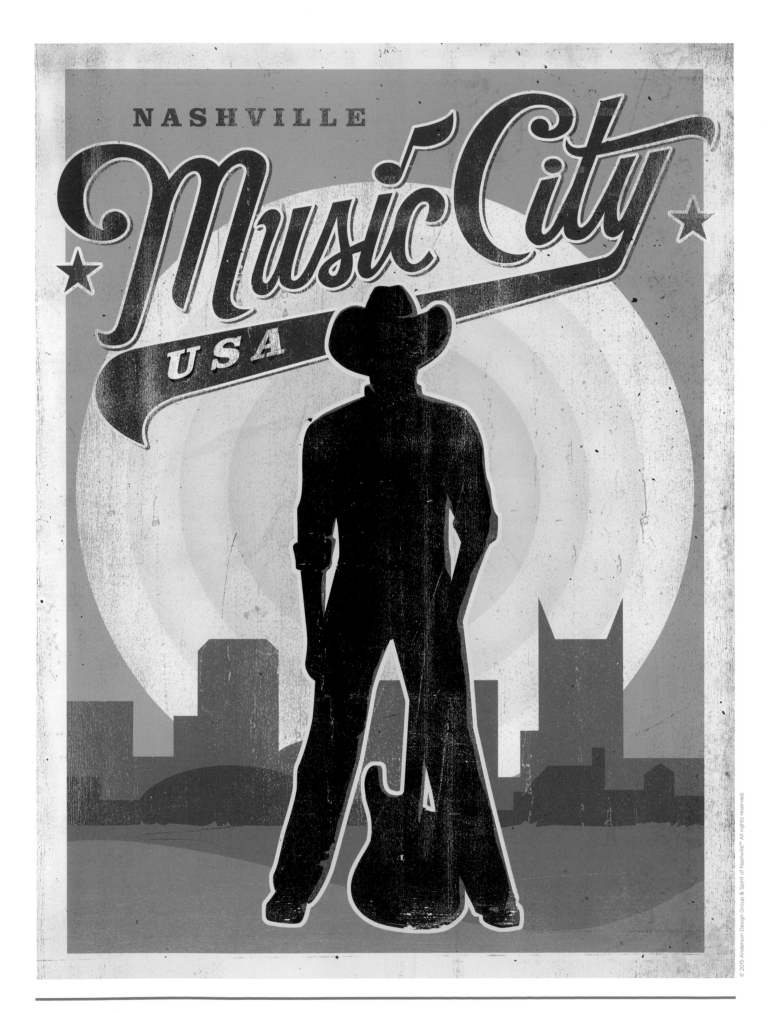

MUSIC CITY (MAN) 18" x 24" Limited Edition Print created in 2003 by Matt Lehman

"This was the first Music City theme in the collection. Due to its popularity with locals and tourists, we have done a new one each year."

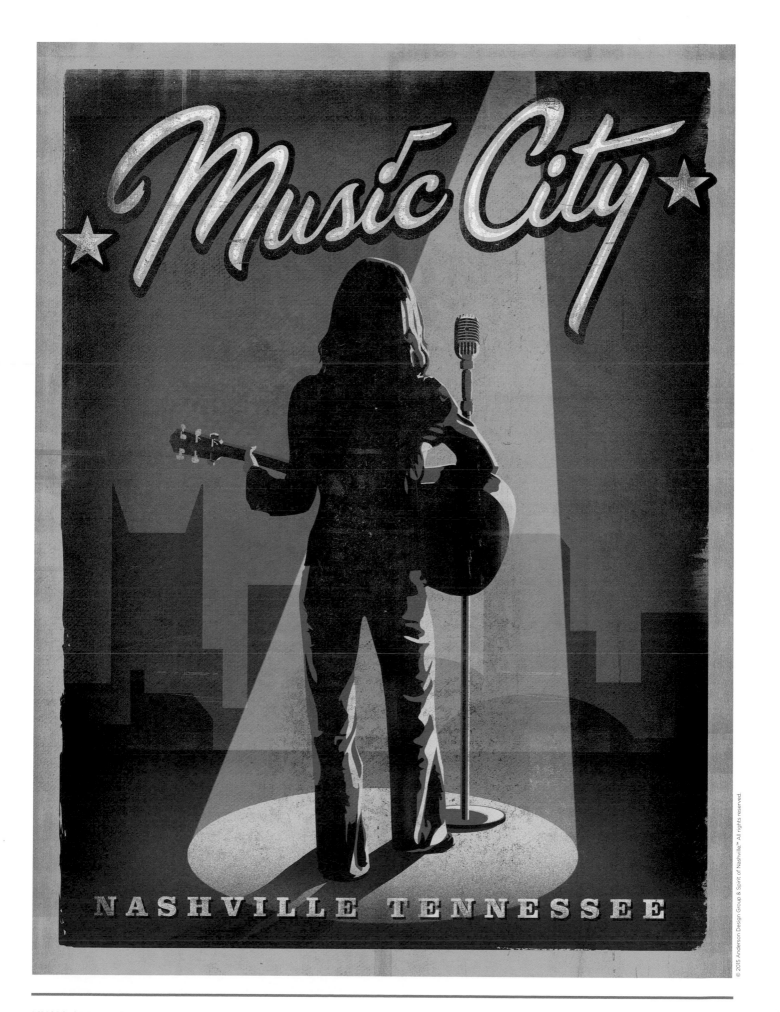

MUSIC CITY (WOMAN) 18" x 24" Limited Edition Print created in 2005 by Matt Lehman

"No, she is not someone famous... I needed a model in a hurry for this design, so I called my wife, Amber, and had her come to the studio and pose."

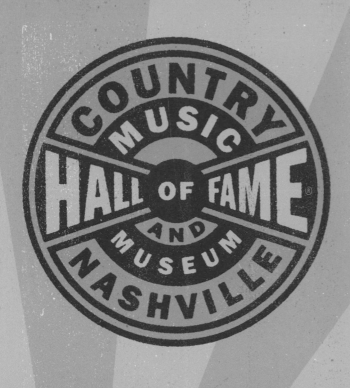

HONOR THY MUSIC

COUNTRY MUSIC HALL OF FAME® AND MUSEUM

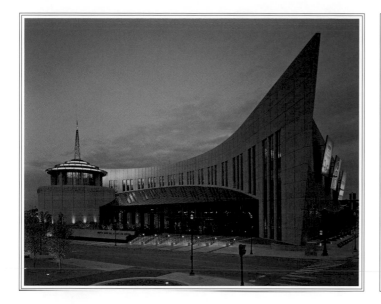

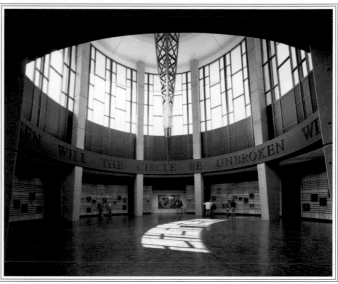

IN 2007, the Country Music Hall of Fame® and Museum celebrated its fortieth anniversary as a not-for-profit educational institution, while also marking the sixth anniversary of its landmark new building at Fifth Avenue South and Demonbreun Street, the heart of downtown Nashville's sports and entertainment district.

Curving behind the glass of the building's Curb Conservatory and the indigenous stone of the facade are two block-long floors of gallery spaces where visitors discover the Museum's core exhibition, *Sing Me Back Home: A Journey Through Country Music.* This epic story traces country music history from its nineteenth century origins to its present-day cultural value. The Museum's vigorous changing exhibition schedule includes a major 5,000-square-foot installation that rotates every two years and a biographical cameo exhibit that generally honors a member of the Country Music Hall of Fame and opens each year in late summer. Throughout the Museum, visitors will find smaller exhibits of shorter duration spotlighting special country music anniversaries or new items in the collection. All changing exhibits amplify and expand the *Sing Me Back Home* story.

The building's rotunda, topped by a replica of the iconic 650 WSM diamond-shaped radio tower, houses the Museum's intimate Ford Theater on the ground floor. Above the theater, wreathed in clerestory windows and pierced by the bottom half of the radio tower, is the Country Music Hall of Fame exhibit, a circle of bronze plaques commemorating the lives and careers of those who have received country music's highest honor.

From major exhibitions to school programs, and from books and records to special events in the Ford Theater, research and scholarship in- form the many offerings that have made the Museum a playground and learning lab for millions of visitors.

Over four decades, the Museum has amassed a country music collection generally considered the finest and most complete in the world. Accredited by the American Association of Museums since 1987, the institution's collection and the experts who care for it, interpret it, and make it publicly accessible are an eternal flame that validates and memorializes the lives of untold numbers of known and unknown musicians forever connected through the power of country music. So that we may be instructed and inspired by them, the Country Music Hall of Fame and Museum saves our songs of home, our common wealth, for the betterment of all mankind.

In 2014, a new 210,000 square-foot expansion was opened to showcase more of the museum's 2 million artifacts.

< COUNTRY MUSIC HALL OF FAME® AND MUSEUM 18" x 24" Limited Edition Print created in 2006 by Joel Anderson

*"As simple as this poster looks, it was actually quite difficult to create. There are so many famous instruments, costumes, photos and artifacts in the Country Music Hall of Fame and Museum, but because of complicated permissions and copyrights, and the fact that hundreds of people are represented in the museum, we could not depict a famous person's face or single out any one performer's instrument to feature on the poster. So we settled on showing off the striking building along with the logo and now famous tag line, Honor Thy Music.*TM*"*

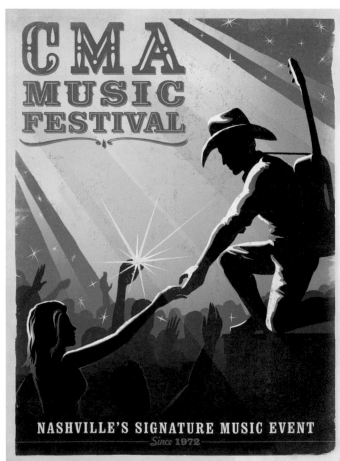

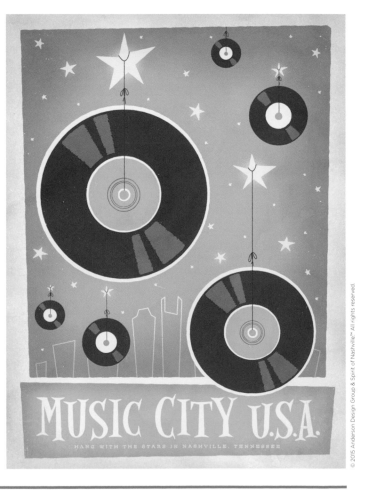

NASHVEGAS 18" x 24" Limited Edition Print created in 2006 by Darren Welch
MUSIC CITY PATTERN PRINT 18" x 24" Limited Edition Print created in 2010 by Joel Anderson
CMA MUSIC FESTIVAL 18" x 24" Limited Edition Print created in 2010 by Andy Gregg
MUSIC CITY (RECORDS) 18" x 24" Limited Edition Print created in 2007 by Darren Welch

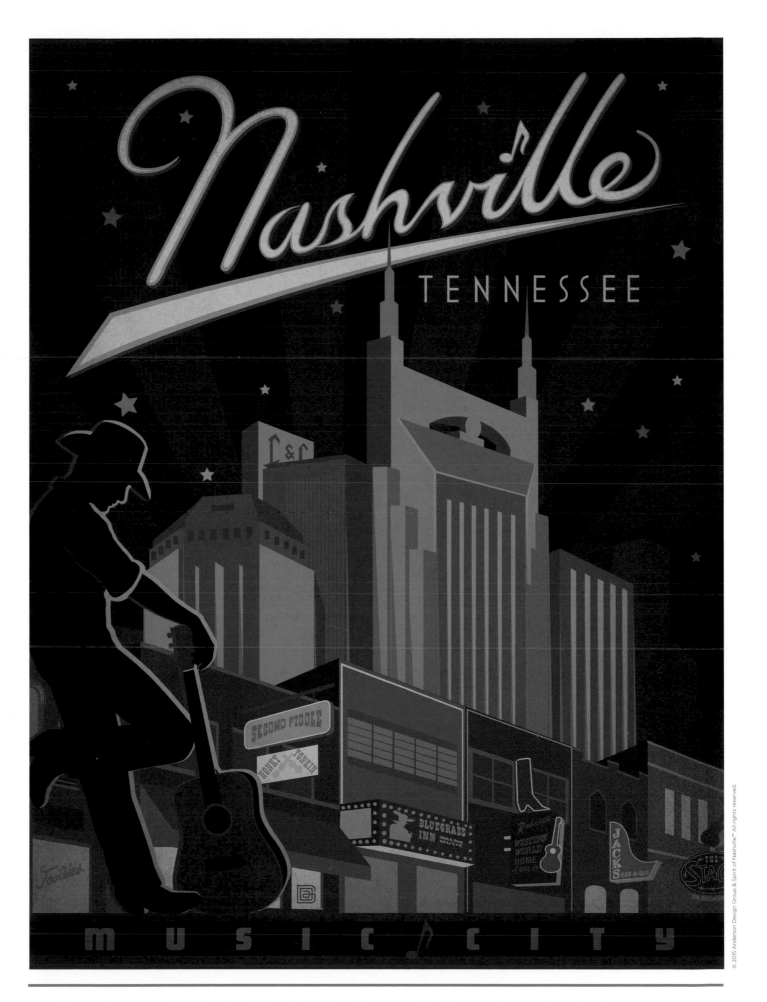

LOWER BROADWAY, MUSIC CITY 18" x 24" Limited Edition Print created in 2012 by Andy Gregg & Joel Anderson

"This design was actually created as part of the Art & Soul of America series which celebrates great American Cities and travel destinations. Everyone liked the design so much that we decided to include it in the Spirit of Nashville Collection, too!"

★ NASHVILLE'S LEGENDARY ★
SINGER/SONGWRITER SHOWROOM

The Bluebird Cafe

NASHVILLE ★ TENNESSEE

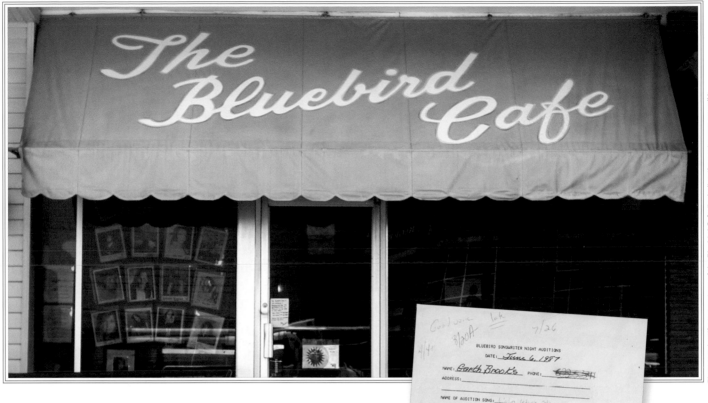

<div style="writing-mode: vertical;">Photos and artifacts courtesy of the Bluebird Cafe (including the next pages as well.)</div>

YOU WOULD NEVER GUESS that this ordinary awning-covered storefront entrance is actually a doorway to fame. When you turn off of Hillsboro Pike into the Bluebird Cafe parking lot, it looks like nothing more than a neighborhood bar—with a line of people waiting to get in. When you go in, it's a small, eclectic place, with a stage, tables and chairs, and walls papered with autographed headshots of performers.

But unless you'd heard of the place before, you wouldn't know that the little place is nicknamed the "Ellis Island of Nashville" — it's the stage that every musical newcomer to Music City must cross.

Upon its opening in June of 1982, it was just a casual restaurant that featured live music at night. Three years later, Sunday Songwriters Night was added to help show-

case new talent. By 1987, the focus had moved from food to music, hosting live music every night of the week.

"I decided to focus on singer-songwriters," said owner Amy Kurland. "I was interested in helping up-and-coming artists and songwriters get noticed."

Several famous stars such as Kathy Mattea, Faith Hill and Trisha Yearwood once performed on the Bluebird stage.

Garth Brooks also played at the Bluebird before he was discovered.

"When Garth Brooks first moved to town, he'd become friends with Tony Arata, who's a songwriter," Kurland said. "And one time Tony played a song

in the early show, and Garth was really struck by it. Garth said that when he got a record deal, he was going to record that song. That song was "The Dance", and it became one of his most well-known songs."

Because of its reputation, "listening room" would be a better description of

This is the original songwriter night audition form filled out for Garth Brooks. He autographed it for Amy Kurland, owner of the Bluebird.

< BLUEBIRD CAFE 18" x 24" Limited Edition Print created in 2006 by Darren Welch

"The Bluebird print was one of my favorite posters to work on. We tried several options including a guy sitting on a stool playing the guitar. It was a cool look but it didn't seem to represent all the different artists—both men and women—that perform at the Bluebird. So I came up with an original bluebird character that would represent all artists and give the design a fun and unique look. The fork and knife that we added to the composition communicates that the Bluebird is also a place to eat while you listen to music."

BLUEBIRD CAFE

" *Throughout all the years, this industry has changed a million times, and in a world of changing waters, we all look for a rock to stand upon. In my opinion, the songwriter is the foundation of music and the Bluebird is the rock on which that foundation sits. The Bluebird has my gratitude, and Amy Kurland has my respect and my love.* " **— Garth Brooks**

" *The Bluebird's the nest that's hatched many a gifted songwriter. If I sound like a fan, it's because I am. I've stood in line. I've played the stage, In the Round, sat in the crowd, and been the last one to leave. It will always hold a very special place in my memory.* " **— Keith Urban**

" *For performers, New York City has Carnegie Hall. Los Angeles has the Hollywood Bowl. London has the Royal Albert Hall. Nashville has the Ryman Auditorium. For the past twenty years, thank God, songwriters have had the Bluebird Cafe...It is truly the Mecca for all songwriters. Thanks, Amy, for giving all these songs a home.* " **— Vince Gill**

the Bluebird than a "bar" or "restaurant". Performers don't play cover songs, and there is no house band. More often than not, if you come to the Bluebird, you're hearing musical talent in its most pure form—a piano or guitar, and a voice. Because of that, the place's slogan is "Shhh!", because quiet is requested at all times during a performance.

Kurland said that while the Bluebird is a place of encouragement for the up-and-coming, the audience provides a mix of "love and honest feedback". While some have received standing ovations and never made it big, others got polite applause at the Bluebird and went on to write hit songs. What matters, Kurland said, is that an artist is driven to keep going, no matter the level of response.

And there are plenty of driven people at the Bluebird every week. Twenty-five years later, there are two shows a night, seven nights a week; 75 songwriters a week cross that stage.

"You know how the Ryman is the Mother Church of Country Music?" Kurland said. "Well, we're the 'little chapel in the woods.' We like to think we're the open door, and you'll get your chance here."

In 2008, Amy sold the Bluebird to the Nashville Songwriters Association International. On October 10, 2012, the club became an important fixture on the ABC TV hit drama *Nashville*.

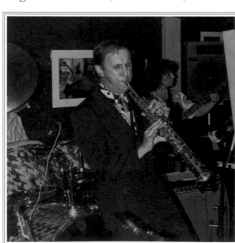

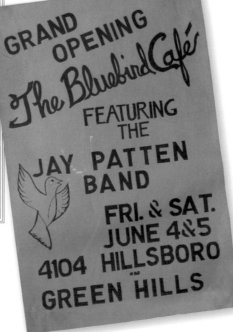

This home-made poster appeared on a hundred telephone poles around town, announcing the Bluebird's grand opening. The Jay Patten Band, was the club's opening night act in 1982

A partial list of people who have performed on the Bluebird stage:

Mose Allison
Susan Ashton
Margaret Becker
Dierks Bentley
Karla Bonoff
Paul Brady
Lenny Breau
Garth Brooks
Brooks & Dunn
Mary Chapin Carpenter
Carlene Carter
Gary Chapman
Kenny Chesney
Guy Clark
Rita Coolidge
David Crosby
Steve Earle
Melissa Etheridge
Crystal Gayle
Patty Griffin
Emmylou Harris
Faith Hill
Indigo Girls
Alan Jackson
Carole King
Michael McDonald
Juice Newton
Maura O'Connell
Brad Paisley
John Prine
Kim Richey
Ray Stevens
Donna Summer
Bonnie Raitt
Rascal Flatts
Trisha Yearwood

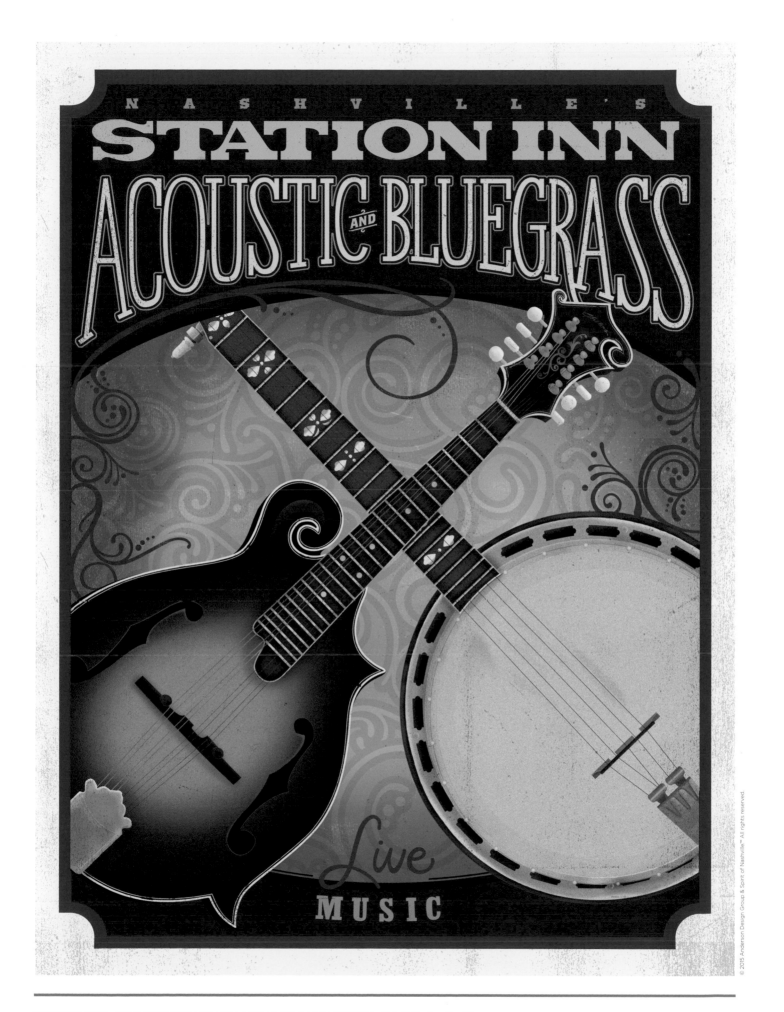

STATION INN 18" x 24" Limited Edition Print created in 2006 by Kristi Carter Smith

"As legendary as it is, the Station Inn's exterior is not much to look at, so I took inspiration from the signage for the lettering, and chose to keep the focus on the banjo and mandolin. The detail in the instruments had to be right because any mistake would be immediately obvious to a musician."

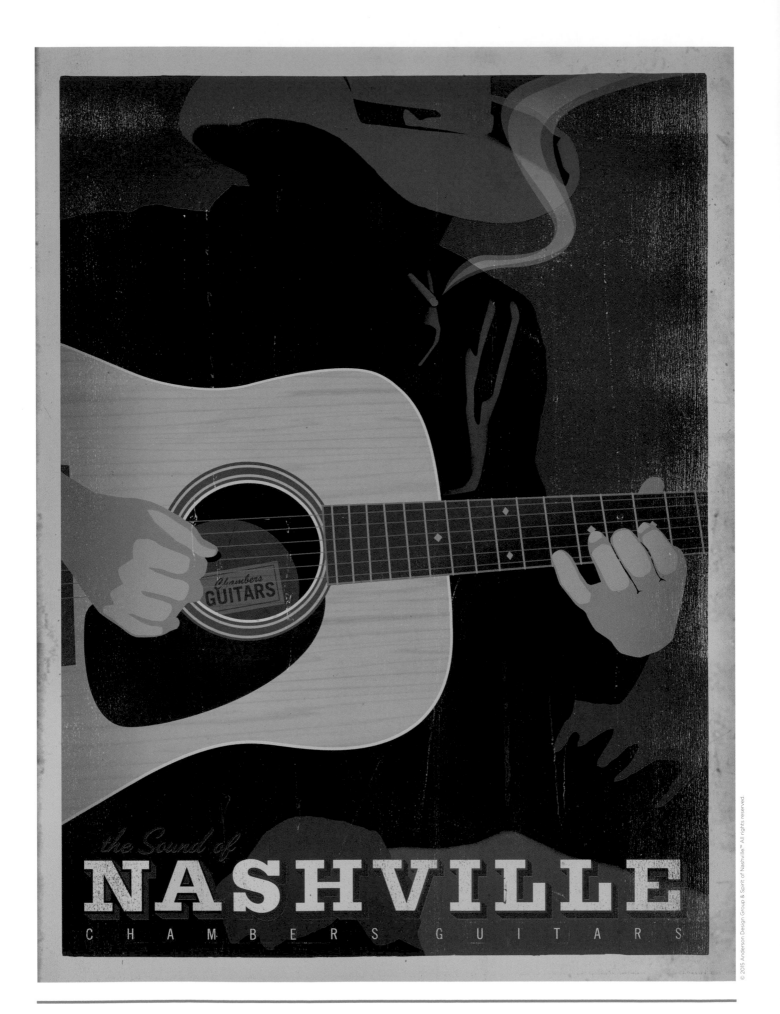

CHAMBERS GUITARS 18" x 24" Limited Edition Print created in 2005 by Darren Welch

"This iconic poster has become one of the flagship designs in the Spirit of Nashville Collection. Originally created to celebrate Chambers Guitars, a shop just a few blocks from our design studio, this image has become a favorite icon for Music City souvenirs such as t-shirts and coffee mugs."

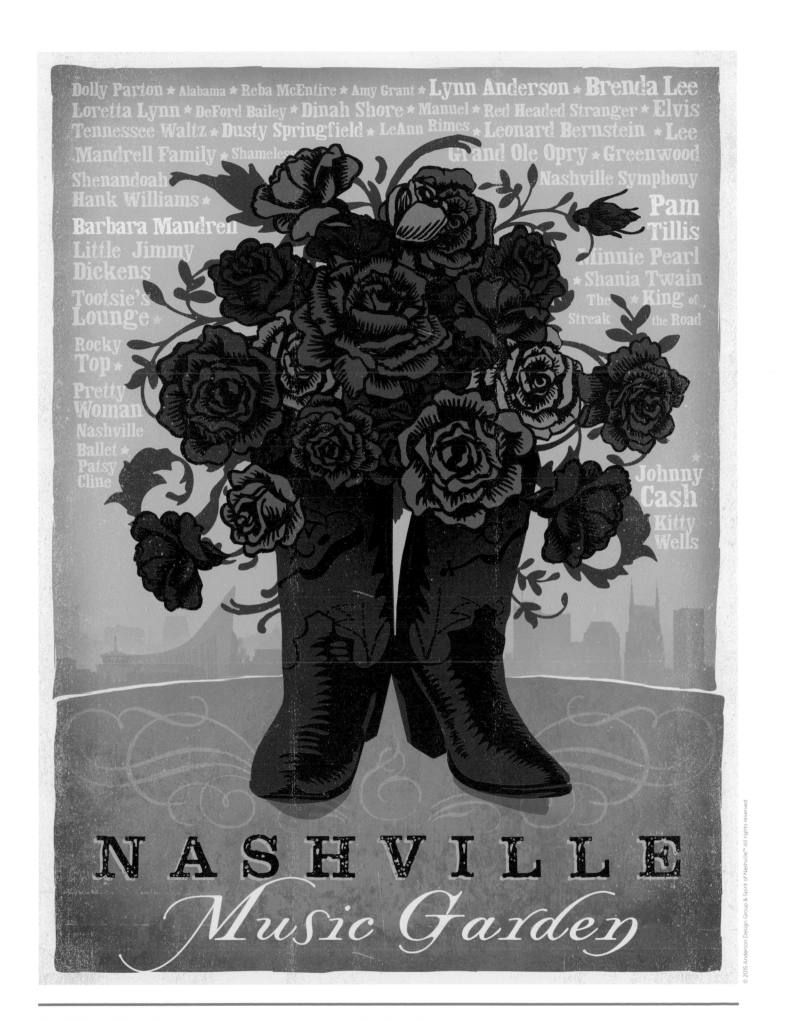

MUSIC IN BLOOM 18" x 24" Limited Edition Print created in 2011 by Ligia Teodosiu

"There is a lovely rose garden across from the Music City Center and the Country Music Hall of Fame. Upon closer inspection, you'll notice that all of the flowers are specially cultivated varieties named after famous Country Music singers like Dolly Parton, Barbara Mandrell, Pam Tillis and more."

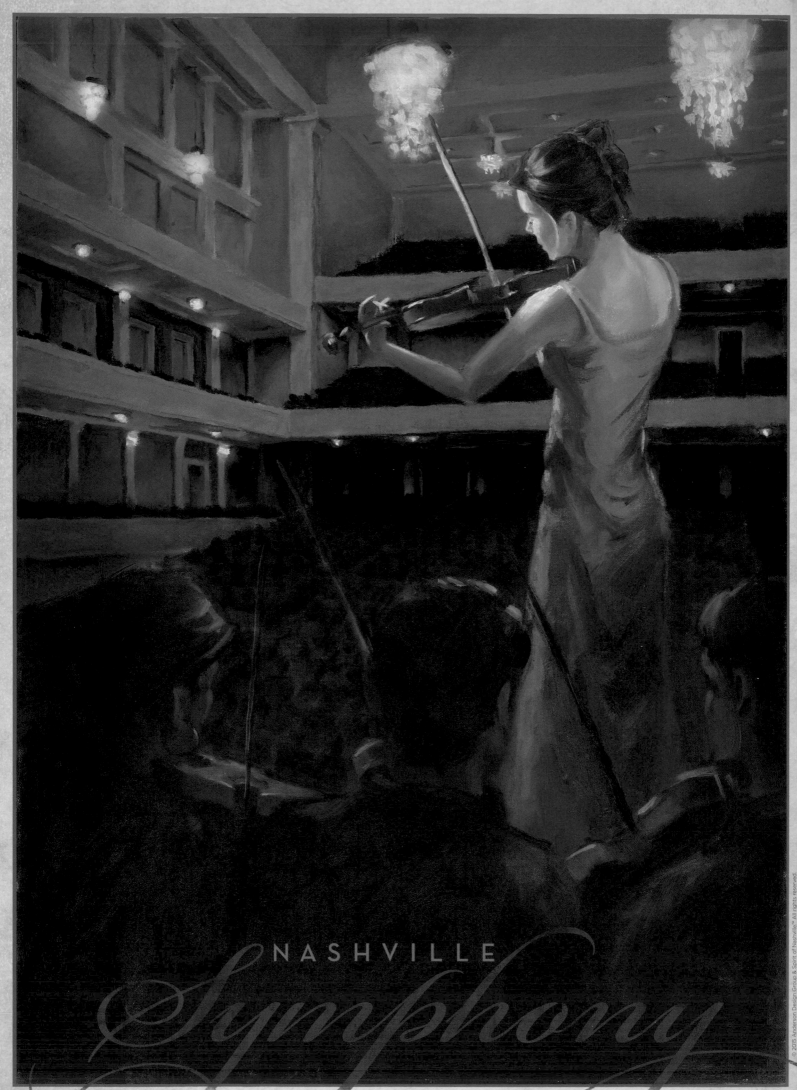

NASHVILLE
Symphony

SCHERMERHORN SYMPHONY CENTER

NASHVILLE SYMPHONY

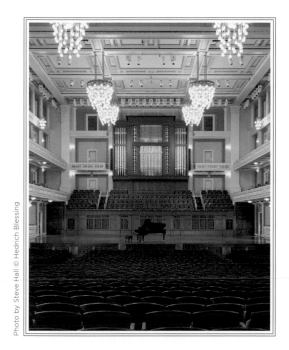

Photo by Steve Hall © Hedrich Blessing

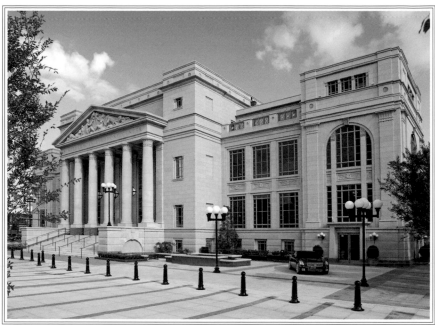

Photo by Tom Gatlin

A STUNNING architectural icon spans an entire block in the heart of Nashville's entertainment district. The Schermerhorn Symphony Center, a beautiful, elaborate building that houses the Nashville Symphony, is a world-class performance hall, the envy of symphonies across the USA. Inside, ornate hallways lead you to a concert hall with an intimate atmosphere and a quality of sound like no other.

While the Symphony now flourishes, it definitely had a rocky start. The Symphony actually started in the 1920s when a group of amateur and professional musicians formed the Symphony Society, but the group would succumb to the hardships of the Great Depression.

But a young Nashvillian and music enthusiast would revive the idea of a symphony, literally campaigning for the money to restart it. Walter Sharp and his wife, Cheekwood heir Huldah Cheek Sharp, dreamed of creating a symphony

in Nashville. While serving in the Army, Sharp met William Strickland, a fellow officer who'd done wonders with the Army band, and was convinced he was the man to lead Nashville's new orchestra. Strickland visited in 1946, upon his discharge from the service, and reactions from city leaders were encouraging. Sharp knew the true obstacle would be finances. But by the end of the summer of 1946, Sharp had more than 300 donors and $35,000 in start-up capital. Strickland was appointed as conductor in September 1946.

Strickland held auditions, and people from all walks of life tried out to be a member of the new symphony. When tickets went on sale for the first performance, people waited in line for two hours to buy them. The night of the performance, concertgoers were floored by the quality of the pieces; Strickland received four curtain calls.

Strickland left after the 1950-51 season; Guy Taylor (1951-1959), Willis Page

(1959-1967), Thor Johnson (1967-1975) and Michael Charry (1976-1982) would succeed him. The Symphony moved from the War Memorial Auditorium to the Tennessee Performing Arts Center during Charry's tenure. In 1982, the Symphony created its following season with a series of guest conductors that would use their concerts as auditions for the top job. Kenneth Schermerhorn was a favorite and accepted the job in 1983. For 22 years, he led the Symphony through hardship and resurgence. Construction on the Schermerhorn Symphony Center began in 2003, but the respected conductor passed away in 2005, never seeing the full grandeur when it opened in September 2006.

Today, the Nashville Symphony gives more than 200 performances annually and is one of America's most productive recording orchestras. By 2014, the Nashville Symphony had already released 19 recordings, received a total of 14 GRAMMY nominations and won 7 GRAMMY awards.

< NASHVILLE SYMPHONY 18" x 24" Limited Edition Print created in 2006 by Taaron Parsons

"This poster was created just before the completion of the new Schermerhorn Symphony Center. The Symphony wanted us to feature the grand interior of the concert hall, but we needed to create the art before the grand opening. So I went to the hall during a closed performance to take reference photos. My wife posed in the studio as the violinist, and I had to create the crowd without the benefit of reference photos of a full house. I created the original illustration as an oil painting that we scanned so we could add typography and make some minor edits on the computer."

HOW THE ART WAS CREATED

Nashville Symphony 18" x 24" oil painting by Taaron Parsons

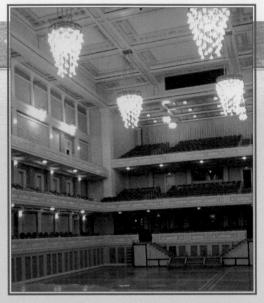

1 The first step in creating a poster design is to do some research and collect reference. As Anderson Design Group met with officials from the symphony, it became clear that the symphony needed to showcase the interior of the new performance hall, rather than the exterior of the building. Artist Taaron Parsons went to the empty hall before it was officially open to the public and took some reference photos. He was also invited to stand backstage during a special performance to observe the musicians from the angle he wished to paint. His concept was to create a view of the entire hall from behind the performers. Taaron's wife, Niki, posed for the violin soloist reference photo.

2 The next step was to sketch up possible poster concepts. Taaron began drawing a full orchestra, using his photographs for reference. After a few variations, he narrowed down the composition to just a few musicians surrounding a violin soloist. He planned to render his poster as an oil painting, so the composition needed to be figured out first in sketch form, and then redrawn onto a blank canvas before he could begin painting.

3 After finalizing the composition sketches and drawing on the canvas, Taaron began to paint. His focus was on capturing the grandeur of the performance hall while bringing the viewer up close and intimate with the musicians. His attention to detail, balanced with a loose, painterly style made the painting elegant, emotive and fluid.

4 The final step was to digitize the oil painting, so it could be retouched and combined with typography on the computer. Because of the quick deadline for this poster design, Taaron had to carefully transport the wet oil painting to a photo studio where it was placed on a copy stand and photographed with a high-resolution digital camera. The photo of the painting was burned onto a CD, brought back to the Anderson Design Group studio, and loaded onto Taaron's work station, which at that time was an Apple G4 computer. He began retouching and color correcting the painting in Adobe Photoshop, darkening the background to draw more attention to the soloist. He then added typography, and a border. The final print-ready poster art was burned onto a CD and sent to McQuiddy Printing, where a limited edition run of 500 prints was produced.

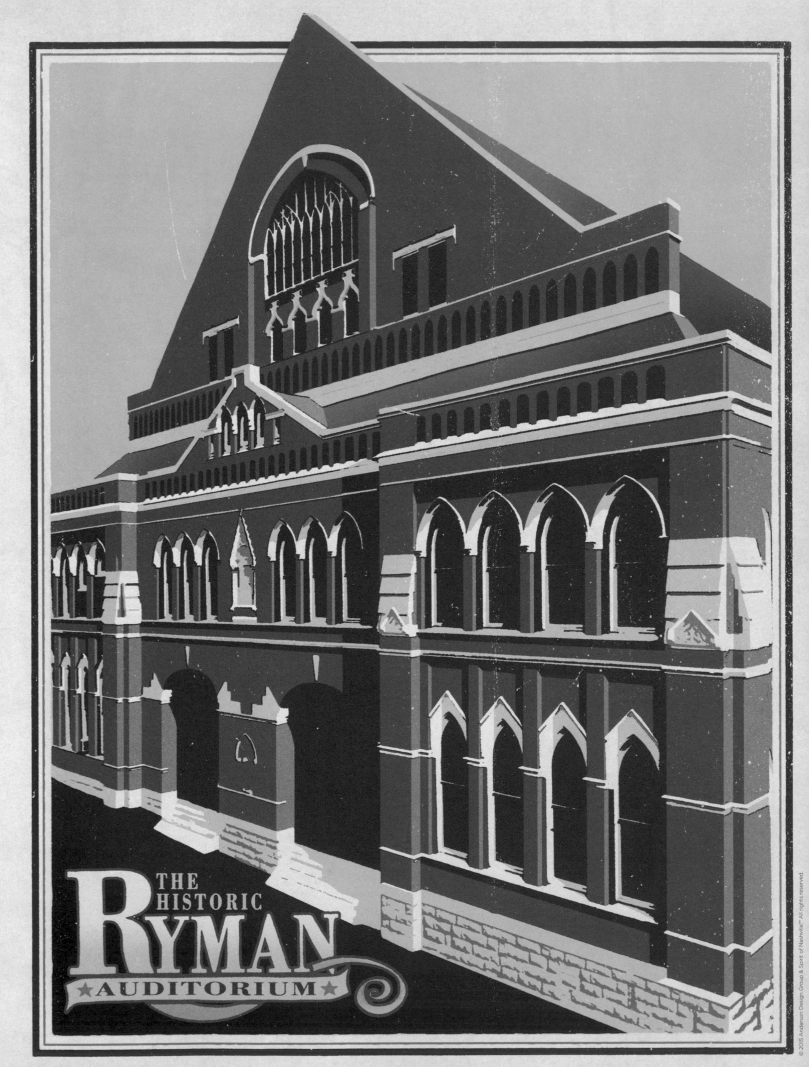

THE ★ MOTHER ★ CHURCH ★ OF ★ COUNTRY ★ MUSIC

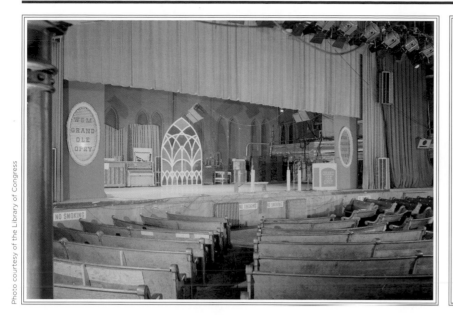

HAD REV. SAMUEL JONES never preached the gospel to a riverboat captain, there may never have been a Ryman Auditorium.

The popular evangelist converted Thomas G. Ryman to Christianity, and the former captain decided to build a venue to host the city's revivals. Ryman donated funds and Jones solicited additional monies to build the $100,000 Union Gospel Tabernacle. Nashville architect Hugh C. Thompson designed the Victorian Gothic building, and the first revival was held in May 1890, but the building wasn't completed until 1892. The pews, which are still used in the building, seated 3,755 attendees.

In order to have their conference there, the Confederate Veterans Association donated funds in 1897 to build an additional balcony. Known as the Confederate Gallery, the venue could now seat 6,000.

Ryman died in 1904, and Jones proposed the building should be renamed the Ryman Auditorium; the change was made official in 1944. For the next 40 years, the Ryman was the host of a number of concerts, plays, lectures, etc. President Theodore Roosevelt, John Philip Sousa, Isadora Duncan and countless others stood on the stage.

The Ryman gained national attention when the Grand Ole Opry began broadcasting from the venue in 1943. In 1963, National Life purchased the building and changed the name to the Grand Ole Opry House. Music greats such as Hank Williams, Sr., Elvis Presley, Johnny Cash, and Loretta Lynn all performed on the famous stage, until 1974, when the Opry moved to its current home at Opryland.

After the Opry left the Ryman, the venue went unused, except for the occasional concert. Although it was named to the National Register of Historic Places in 1971, the building almost faced demolition. It was saved, but greatly deteriorated from little use.

In the early 90s, Gaylord Entertainment commissioned architectural firm Hart Freeland Roberts to restore the Ryman. In June of 1994, after an $8.5 million renovation, the Ryman opened once again as a performance hall. Since then, the venue has hosted an increasingly diverse lineup, with musicians and performers from all genres taking the stage.

But no matter who's on stage, the Ryman will always be known as "The Mother Church of Country Music." Coun-

Show prints promoting events at the Ryman.

try legend Merle Haggard said: "You know, when you're standing there, you're on the sacred ground where all the grand old masters of country music have played."

< RYMAN AUDITORIUM 18" x 24" Limited Edition Print created in 2006 by Wayne Brezinka and Joel Anderson

"We started on this poster design using an old photo of the Ryman that was shot in the 1950s. At that time, there were some ugly additions to the building's grand doorways, which we had to paint out when we created the poster illustration. We chose a simplified color palette to make the poster more old fashioned and iconic, reminiscent of the days when the Grand Ole Opry called this magnificent old building home."

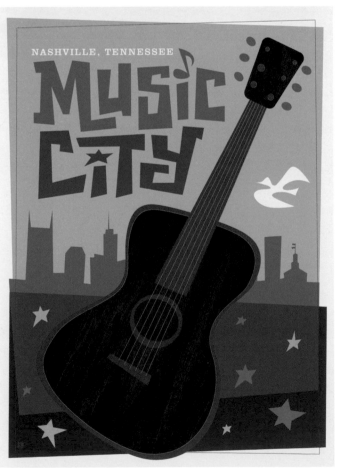

MUSIC CITY (GUITAR & MANDOLIN) 18" x 24" Limited Edition Print created in 2009 by Joel Anderson
MUSIC CITY (HORSE) 18" x 24" Limited Edition Print created in 2006 by Matt Lehman
MUSIC CITY DREAMING (LEANING COWBOY) 18" x 24" Limited Edition Print created in 2009 by Joel Anderson
MUSIC CITY (MOD) 18" x 24" Limited Edition Print created in 2014 by Joel Anderson

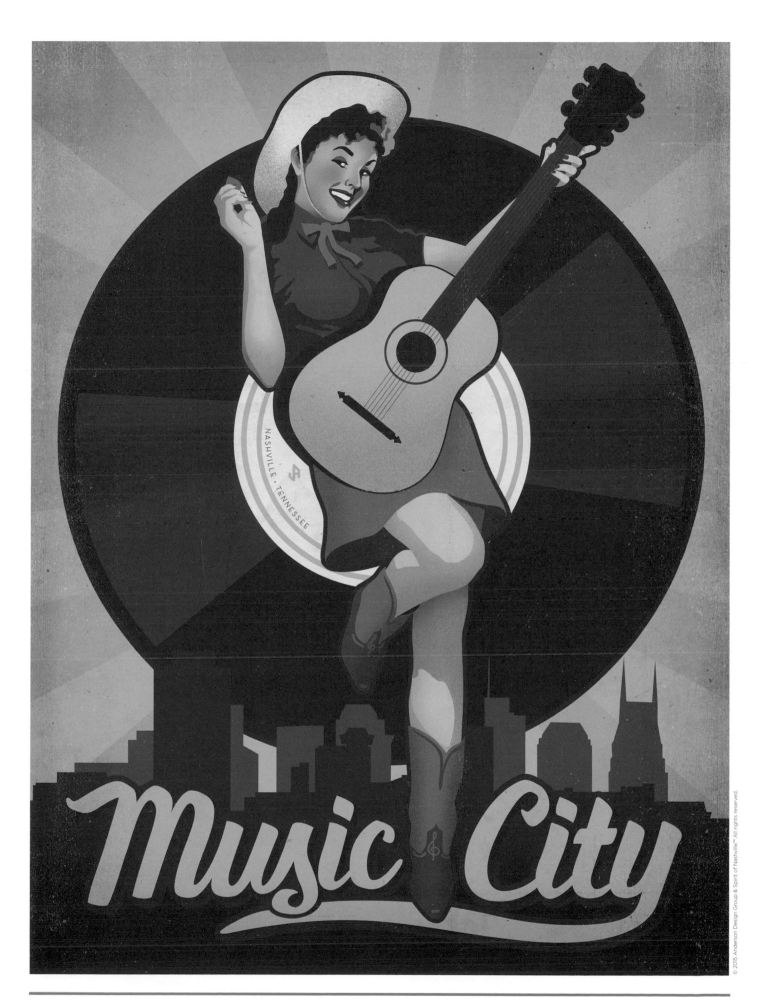

MUSIC CITY (PINUP GIRL) 18" x 24" Limited Edition Print created in 2008 by Joel Anderson

"This print pays homage to the sweetly evocative aircraft art that kept American airmen fighting for our country and longing for home."

Arts & Leisure

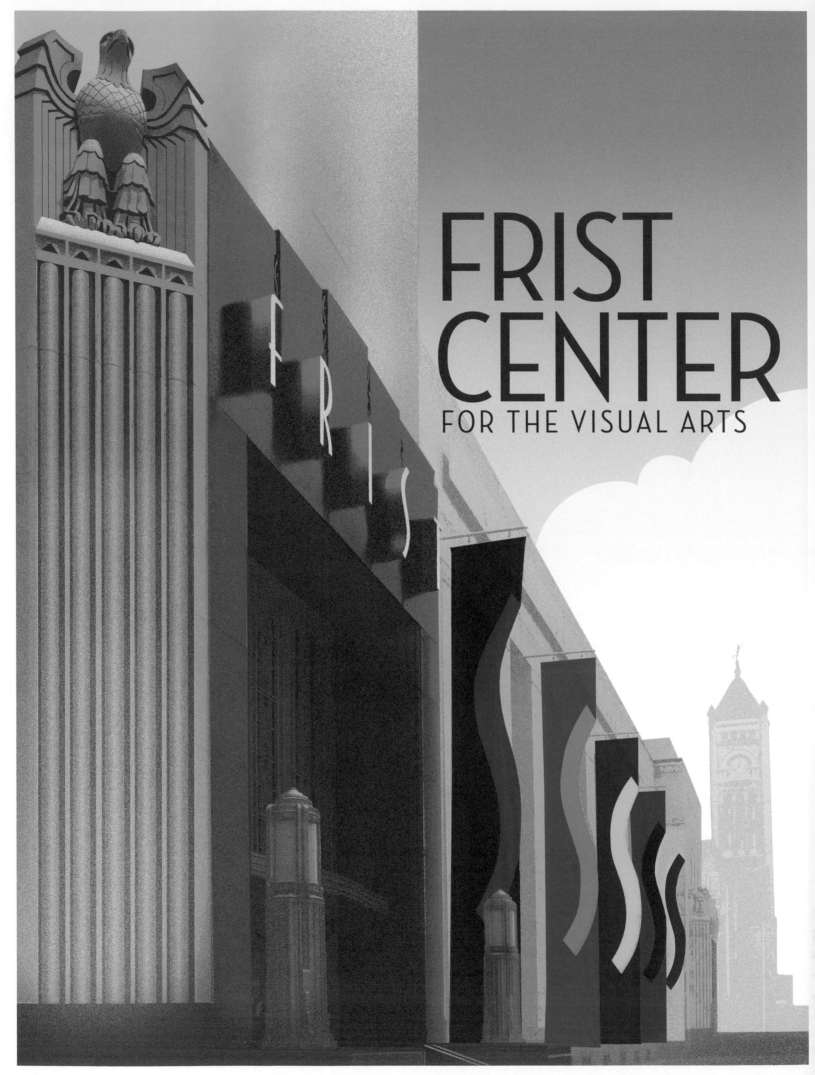

FRIST CENTER

FOR THE VISUAL ARTS

NASHVILLE TENNESSEE

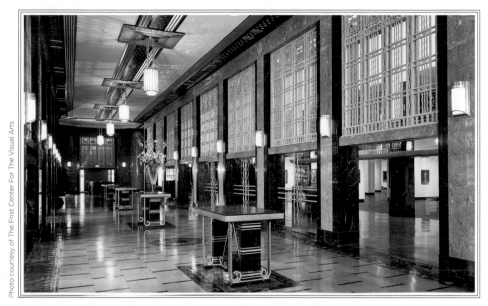

The interior lobby area looks very much as it did when it was built as a post office.

IT WAS THE GENEROSITY of a well-known Tennessee family that made it all possible. Having taken their children to museums during their travels, Dr. and Mrs. Thomas F. Frist, Jr. recognized the importance of art and cultural education for children and families. So in the early 1990s, they decided to focus efforts toward the creation of an art center that would not only entertain, but also educate.

Residents and officials had thrown about the idea of an art facility for almost 25 years, but it was the results of a 1993 citizen effort entitled Nashville's Agenda that would move the idea for a center toward reality. In polling Nashvillians on how to make the city better, several cited the need for a downtown fine art facility. In 1994, Nashville's Agenda formed a steering committee to research the issue. Upon seeing the committee's report, Dr. Frist and Ken Roberts decided to take the lead in the attempt to create a major visual arts institution for the city, and the discussions began.

With education and community outreach as core emphases, it became clear that the location of the new institution should be located in the downtown area, on a major thoroughfare, and readily accessible. Since 1986, when the city's main post office relocated to an area near the airport, the U.S. Postal Service had only been utilizing a part of the first floor of their building on Broadway. The Frist Foundation contracted a Toronto-based firm to see if the building would suit their needs, and they reported that the building's structure would be ideal for a center. The Frist Foundation then entered into a partnership with the U.S. Postal Service, the city of Nashville, and the Metropolitan Development and Housing Agency to purchase the building that would become the Frist Center for the Visual Arts. MDHA leases the building to the Frist Center for one dollar a year for 99 years.

Financed through funds from the Hoover administration, the building was erected in 1933 and 1934 under the supervision of architectural firm Marr and Holman. The building's exterior, outfitted in white Georgia marble, exemplifies the classical style popular during the period, but the colored marble and aluminum grillwork in the interior represents the art deco style of the day. During renovations, it was paramount that the building's original character be maintained. Both the Frist family and the foundation pledged at least $25 million to bring the building to the highest museum standards.

Today, the 125,000 square-foot building not only exhibits visual art from local, state, regional, U.S. and international sources, but also offers a variety of programs and activities, including educational programs for children and adults, lectures, concerts and music.

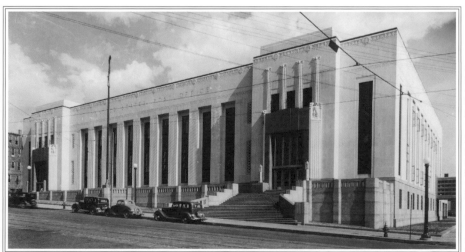

Exterior of the former main post office, constructed in 1933–34.

< FRIST CENTER FOR THE VISUAL ARTS 18" x 24" Limited Edition Print created in 2004 by Joel Anderson

"This building is a work of art. Covered inside and out with stylized relief sculptures and beautiful metal work, there is no way to capture it all in a poster. Another challenge was trying to fit the horizontal building into our vertical poster format. We settled on a perspective of the Broadway face of the building which leads the eye to Union Station's tower. I rendered the poster in an Art Deco style to match the building."

CHEEKWOOD BOTANICAL GARDEN & MUSEUM OF ART

The Wisteria Arbor.

A view of the Japanese garden; a mere fragment of the vast gardens and galleries at Cheekwood.

WITH LUSH GARDENS and a stately mansion spread across 55 acres, the Cheekwood Botanical Garden is just as breathtaking as when it was first built more than 70 years ago.

Each year, visitors make their way through this Nashville landmark, taking in the sea of tulips or a lovely stretch of wildflowers. Inside the mansion, people can marvel at pieces from the Permanent Collection, including a sculpture by Nashville sculptor William Edmondson.

And to think coffee started it all.

Leslie Cheek moved to Nashville in 1890 with his family to join his father's grocery business in Cummins Station. By 1892, the Cheeks were focusing on coffee; Leslie's cousin, Joel, had developed a blend of coffee, and members of the family invested to help support the new venture. In 1904, the Cheeks partnered with James Neal, and expanded the coffee line to other parts of the country. Joel was able to sell the best hotel in town, the Maxwell House, on their coffee, and they agreed to serve it exclusively. The coffee would now become known as Maxwell House coffee. Joel sold the coffee brand to Postum (now known as

General Foods) in 1928, and profited $40 million. Leslie's investment in the once-fledgling business had now paid off.

Leslie would take the more than $1 million he gained from the sale, and build a home for his wife, Mabel Wood, whom he'd married in 1896. The Cheeks hired Bryant Fleming, a sought-after residential and landscape architect from New York, to build it. Fleming's philosophy was that the architecture, design, décor and landscaping should work together to make a unified statement. Fleming and the Cheeks traveled to Great Britain to find furnishings for the home; it took four railroad cars to bring back all they'd

A group of curious ladies awaits the opening of the Cheekwood Fine Art Center in 1960.

purchased. The 30,000 square-foot Georgian-style mansion was completed in 1932; the construction of Cheekwood was one of the largest employers during the Great Depression.

Leslie only lived in the home two years, and died in 1935. Mabel lived in the home another nine years, and then deeded the home to her daughter, Huldah, and her husband, Walter Sharp. In 1957, the Sharps offered the mansion and 55 acres of land to create a botanical garden and fine arts center. After renovations, Cheekwood opened May 22, 1960. The dedication was given by Senator Albert Gore, Sr.

Major renovations were made in the late 1990s to elevate the museum's standards. Special attention was paid to restore the original architecture and landscaping of the mansion. Today, Cheekwood continues to strive to fulfill its mission, to "inspire and educate by making art, horticulture, and nature accessible to a diverse community. Attracting over 300,000 visitors each year, Cheekwood is considered to be one of the top 10 public gardens in North America.

< CHEEKWOOD BOTANICAL GARDEN AND MUSEUM OF ART 18" x 24" Limited Edition Print created in 2003 by Joel Anderson

"Since Cheekwood's mansion, sprawling botanical gardens, art galleries, vistas, trails, green houses and sculpture gardens could make up an entire series of prints, we had to try to capture the essence of Cheekwood. This composition features a lady in the period attire of when the Cheek family called this beautiful estate home. The view is from the boxwood maze looking out over the hills of West Nashville."

NASHVILLE

ballet

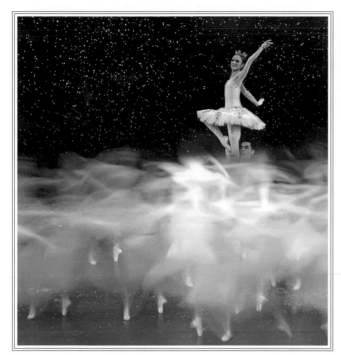

Rachel Ellis as the Snow Queen in Nutcracker.

Sadie Harris in Ploughing The Dark *during* 2007 Bluebird Cafe at The Ballet 2.

EVERY CHRISTMAS SEASON, both novices and aficionados of ballet file into the Tennessee Performing Arts Center to see the annual holiday story they know well. But whether they've seen it once or a hundred times, ballet-goers are always amazed by the grace, technique and beauty of the Nashville Ballet's Nutcracker. As the Nashville Symphony sets their movements to music, viewers are drawn into the visual and aural experience that is the ballet.

Perhaps that's why Nashville Ballet is the second largest performance arts organization in Nashville.

And, it only took 25 years to get to that point. Started in 1981 as a small group of volunteers, the Nashville Ballet was originally called The Young Dancers Concert Group. They held their first spring concert in 1983 in the then-brand-new TPAC. Peggy Burks was hired as the artistic director, and in 1984, there was enough support to establish the group

as an independent civic organization. The name was changed to Nashville City Ballet, and they offered two shows a year. The group became a professional company in 1986.

Artistic director Dane LaFontsee took the ballet's productions and performances to the next level; by the late 80s, the ballet was staging larger, more well-known story ballets such as Cinderella and Nutcracker.

And the audiences responded. The ballet's popularity continued to grow, and Paul Vasterling's promotion as artistic director in 1998 really catapulted the company, putting them on the national scene.

Providing world-class classical and contemporary ballet productions, Nashville Ballet pays homage to its Music City roots by working with local performers. Bluebird Cafe at the Ballet has become a popular performance where dancers bring the songs of local songwriters and musicians to life. Vasterling also pairs with up-and-coming talent, working with

faculty at Vanderbilt's Blair School of Music on Emergence!, a presentation of original dance and music.

Today, the company employs 17 full-time dancers and five apprentices. Another 20 dancers are enrolled in the ballet's two-year, pre-professional program, and perform over 150 outreach and education programs for more than 30,000 children a year. The ballet's mission is to create, perform, promote and educate about dance.

"Nashville Ballet rounds out the cultural scene in Nashville," said Paul Vasterling, Artistic Director for the company. "Lots of people think of Nashville only as Music City. When people come to a performance, the majority of them are surprised and impressed with the high level of dance that Nashville Ballet delivers, illustrating that Nashville offers its wonderful music and so much more."

< NASHVILLE BALLET 18" x 24" Limited Edition Print created in 2005 by Kristi Carter Smith

"I chose to use a very loose and impressionistic illustration style for this poster in order to convey the energy of the ballerina. I rendered her in conté (a chalky artists' crayon), watercolor, and Photoshop."

NASHVILLE BASEBALL 18" x 24" Limited Edition Print created in 2003 by Darren Welch

Nashville's love for baseball goes all the way back to 1860 when Union soldiers first introduced the game to the local community. The most successful team to ever play here is the current team, the Nashville Sounds. Their new state-of-the-art ballpark is located in historic Sulphur Dell, which is the former site of Athletic Park, built in 1870. Baseball was played there for nearly 100 years, from 1870 to 1963.

McCABE GOLF COURSE 18" x 24" Limited Edition Print created in 2011 by Joel Anderson & Darren Welch

"McCabe is a public course that is built on what used to be an old airfield. Their logo includes an old airplane, so we added it to the sky in a nostalgic nod to the past. The golfer is wearing classic attire, even though the clubhouse in the distance is the current modern structure."

HATCH
SHOW
PRINT

OLE OPRY
NASHVILLE, TN

FINE AMERICAN LETTERPRESS SINCE 1879

HATCH SHOW PRINT

IT'S AN UNDERSTATEMENT
to say Hatch Show Print makes posters.

When you see one of their posters, it's like seeing a Nashville icon—you recognize the style, and you know exactly where it came from.

Since its founding in 1879, the printer has produced bold advertisements in bright colors for some of entertainment's most well-known acts. But early on, the posters surpassed their primary use as an information tool, becoming a symbol of both American and Southern culture.

In 1875, William Hatch moved his family from Wisconsin to Nashville. His two sons, Charles R. and Herbert H., had worked in their father's print shop, and intended to use their skills in letterpress printmaking to open a shop in Nashville. Four years after their arrival, the sons opened C.R. & H.H. Hatch; their first job was a handbill announcing a lecture by Rev. Henry Ward Beecher, brother of Harriet Beecher Stowe, for a dollar at the Grand Opera House.

The print shop's popularity grew, and it was not uncommon to see a sea of posters covering brick building walls and wooden light poles, announcing baseball games or concerts. Although some of their work was simple advertisements for

Floor to ceiling shelves hold thousands of vintage wood block letters and photo plates.

Manager Jim Sherraden pulls a classic Hatch poster reprint off the press.

Photos by Jcel Anderson

grocery stores and movie theatres, they nonetheless served as a distinguishing brand for those businesses. Ironically, it was one of their own advertisements, placed in the December 1920 edition of the entertainment trade magazine *The Billboard,* which would first show the term "Hatch Show Print" in bold letters.

The business really entered its heyday when Charles' son, Will, took over. Until his death in 1952, Will worked in the shop right behind the Ryman Auditorium and, by carving wood blocks, created some of the most recognizable images in entertainment, especially country music. Some of his biggest customers were Roy Acuff and Bill Monroe, who always wanted him to make a poster for their shows at the Grand Ole Opry. Will also did posters for some of the African-American stars of the era, such as Cab Calloway and Bessie Smith. Posters were printed for local events, such as Fisk Jubilee

Singers' performances, and Vanderbilt University games, and big-name acts, like Elvis Presley and Hank Williams.

After Will's death, ownership of Hatch Show Print would change hands several times. In 1992, Gaylord Entertainment donated Hatch to the Country Music Hall of Fame® and Museum. Much effort was made to keep the print shop true to form as they made the move from their long-time home on Fourth Avenue North to the Mayfair Furniture building on Broadway.

Today, guided by the motto "Preservation Through Production," Hatch Show Print is a working print shop, owned and operated by the Country Music Hall of Fame and Museum. The crowded shop still houses more than 10,000 wood blocks, drawers filled with wood and metal type, and 14 presses. They still crank out more than 600 jobs a year for a myriad of acts and events, leaving no doubt that a little print shop in Nashville, Tennessee, is still in big demand.

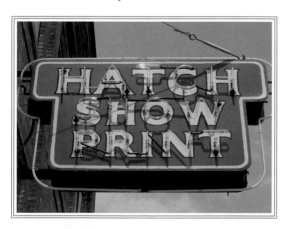

< HATCH SHOW PRINT 18" x 24" Limited Edition Print created in 2007 by Emily Keafer

"It was a surprise and an honor to be asked by Hatch Show Print if we would create a poster that featured their historic establishment. I have been a fan of this legendary print shop since college, when I attended a presentation by Hatch manager Jim Sherraden. It was a challenge to determine the subject matter for the print. I didn't want to mimic their distinct style, since that wouldn't pay homage as much as rip them off. So I decided to focus on the process of the art letterpress, depicting instead a printer hard at work over his press."

NASHVILLE ZOO

NASHVILLE ZOO

NASHVILLE ZOO

NASHVILLE ZOO

NASHVILLE ZOO

WILDLIFE IN NASHVILLE is abundant in the Nashville Zoo at Grassmere. It's a staple field trip spot for kids and adults alike, thanks to the friendly staff, outstanding playground, and wide variety of animals from around the world.

The Nashville Zoo opened in 1991 in Cheatham County and has experienced tremendous growth ever since. In 1996, Nashville Zoo took over management of the Grassmere property. Led by then-Mayor Phil Bredesen, the city offered Nashville Zoo the opportunity to relocate the Zoo from Joelton, TN and develop a "new" zoo for Nashville on the Grassmere property. In 1997, the Nashville Wildlife Park at Grassmere opened to the public under

Nashville Zoo management. It featured a 66,000 sq. ft. Jungle Gym—the largest community-built playground in the United States. In 1999, Entry Village was added, featuring a gift shop and restaurant. In 2000, Critter Encounters, the Zoo's first interactive exhibit, opened. In 2004, the Zoo received accreditation from the Association of Zoos and Aquariums (AZA). In 2005, the 3.2 acre African Elephant Savannah opened and won exhibit of the year. Lorikeet Landing, the Zoo's second interactive exhibit, and the Wild Animal Carousel also opened that year. In 2006, the Giraffe Savannah exhibit and the Alligator Cove exhibit opened. In 2010, the Flamingo Lagoon exhibit opened, and in

2011, the Wilderness Express Train was added. 2013 saw the Kangaroo Kickabout open, and a 10 million dollar donation kicked off a capital campaign in 2014 that promised to take the zoo to new heights.

Today, the 6,230+ featured animals, which include red pandas, clouded leopards, African elephants, giraffes, zebras, flamingos, and komodo dragons, have helped make the Nashville Zoo the #1 attraction in Middle Tennessee. Students and families from all walks of life are drawn to the Zoo every year—attendance in 2013 alone exceeded 775,000 people!

With the help of 2,600 volunteers, the Nashville Zoo continues to grow as one of Music City's favorite places to visit.

< NASHVILLE ZOO POSTER SERIES 18" x 24" Limited Edition Prints created in 2004-2007 by Kristi Carter Smith

"We created a new zoo print each year for 4 years in a row. People ask us how we decided which animals to feature in our art, since there are so many great species to choose from. In an effort to help the zoo promote new exhibits, we picked animals that were new to Nashville. We thought they probably wouldn't mind the extra attention since newcomers often need a little help when making new friends!"

Chaffin's BARN

DINNER THEATRE

Since 1967

THE "NASHVILLE WAY" TO ENJOY DINNER AND A PLAY!

CHAFFIN'S BARN DINNER THEATRE

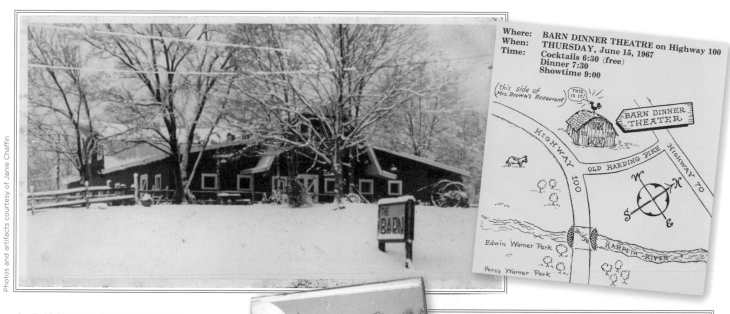

Where: BARN DINNER THEATRE on Highway 100
When: THURSDAY, June 15, 1967
Time: Cocktails 6:30 (free)
Dinner 7:30
Showtime 9:00

Photos, an invitation, and a matchbook from the Barn's first years in business.

A DINNER THEATRE in a barn? That's an unusual entertainment venue! Some may think that dinner theatres—barns, or no barns—are obsolete, but the steady popularity of Chaffin's Barn Dinner Theatre would prove them wrong.

For the past 40 years, eager crowds have come to the big red barn off Highway 100 for both the all-you-can-eat Southern-style buffet and the Broadway-style shows. As soon as they walk in the door, the aromas of home-cooked food and chocolate chip cookies greet them. Crisp white tablecloths and small lamps surround the buffet area which, after the hearty dinner, is cleared to make room for the stage which descends from the ceiling. For the rest of the evening, the audience is mesmerized by the professional play taking place only a few feet away from them.

In 1967, not many in the Nashville area had experienced the dinner theatre concept, but a New York promoter convinced John and Edna Lou (Puny) Chaffin that such a venue would do well. They built the barn, and it was an instant success. At the outset, all plays were produced in New York, and a traveling theatre troupe performed at dinner theatre venues across the country.

John P. Chaffin purchased the Barn from his parents in 1976 and changed the name to Chaffin's Barn Dinner Theatre. All productions are now directed at Chaffin's using a mix of local and national actors. Chaffin's is individually owned and operated by John and his wife, Janie, who produce nine or ten shows each season. They are very proud to own and operate Nashville's first professional theatre. Over the years, the Barn has not only offered great dinner theatre, but it has also hosted fund-raisers, fashion shows, high school and college proms.

Shows are performed on the descending "magic stage" or in the more traditional Backstage theatre, which provides a more intimate atmosphere. Because of the close proximity of the actors and audiences, patrons say there's a family atmosphere to the place. The waiters (actors not in a current production) serve the audience, often acknowledging birthdays or anniversaries.

It's that family feel that keeps people coming back year after year. Chaffin's becomes a tradition, as the birthdays of children and grandchildren, anniversaries, graduations and other memorable milestones are celebrated at the big red barn. While Chaffin's is definitely in the theatre business, its first priority is to provide a fun environment where memories are made every time.

CHAFFIN'S BARN 18" x 24" Limited Edition Print created in 2007 by Darren Welch

"When people think of Chaffin's Barn Dinner Theatre, they mention the bright red barn, the intimate setting for enjoying live theatre or the giant buffet. We chose to render this print in a style similar to the Bluebird Cafe poster, symbolically representing the venue with the barn, the theatre with the masks and the food with the fork and plate that doubles as the moon."

BELLE MEADE THEATRE 18" x 24" Limited Edition Print created in 2004 by Joel Anderson
MUSIC CITY TROLLEY HOP 18" x 24" Limited Edition Print created in 2014 by David Anderson
NASHVILLE ROLLERGIRLS 18" x 24" Limited Edition Print created in 2014 by Aaron Johnson
THE LOVELESS BARN 18" x 24" Limited Edition Print created in 2010 by Andy Gregg & Joel Anderson

BELCOURT THEATRE 18" x 24" Limited Edition Print created in 2005 by Emily Keafer

"I've attended many films and events at the Belcourt since moving to Nashville, so I was thrilled to have the opportunity to create a poster for the historic theatre. I took inspiration from the work of George Barbier, a French illustrator whose work was contemporary to the opening of the theatre in 1925. The abstract stage and the couple in period dress gave the poster its unique charm and sets the look apart from the rest of the collection."

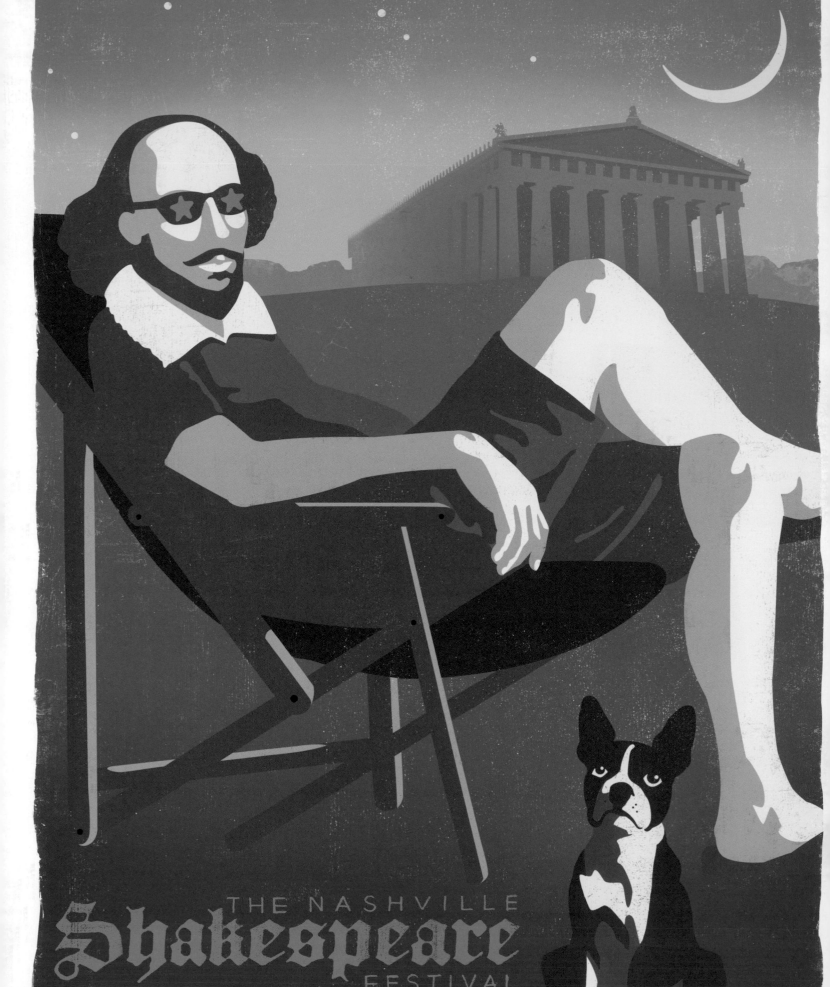

THE NASHVILLE
Shakespeare
FESTIVAL

SINCE 1988

NASHVILLE SHAKESPEARE FESTIVAL

Left photo by Brenda Sparks

Center and right photos by Roger Gibbs

Scenes from Shakespeare in the Park *productions featuring fresh new settings and costumes for classic Shakespearian plays.*

ON THE WEEKENDS of August and September, Centennial Park becomes a sea of beach blankets and lawn chairs, as people settle in to enjoy Shakespeare against a sunset-filled sky.

For 20 seasons, people from all different walks of life have congregated at the well-known park off of West End Avenue to enjoy the various works of The Bard, staged by The Nashville Shakespeare Festival. During the 2006 season, more than 12,000 people saw one of the Festival's inventive interpretations of the famed poet's works.

Photo courtesy of The Nashville Shakespeare Festival

Eclectic crowds spread out on blankets and lawn chairs to picnic and enjoy a play.

And while the Festival has enjoyed steady growth and success, the company's start was a grassroots effort. In 1988, a group of local actors who'd long dreamed of having a Shakespearean theatre com-

pany pooled their resources to start one. With $500 and no technical support, their first production of *As You Like It* drew 1,000 attendees over six performances. The founders were encouraged by the public's response, and since then, the company has focused on providing high-quality, full-scale productions of classics to people of all cultural and socioeconomic backgrounds at no cost. Some crowd favorites include *A Midsummer Night's Dream*, where the company set the play during the 1960s Summer

of Love; the audiences loved the way Shakespeare's themes of conservatism vs. teen rebelliousness worked into that era. Another favorite is a Maxfield Parrish-inspired *Twelfth Night*. The romance of the

1920s was enhanced by an opera singer with a choir of little girls dressed in white with flowers in their hair.

The imagination and creativity of the company translated well in another venue: the classroom. Responding to the Metro Schools' need for an arts-in-education program, in 1992 the company developed 50-minute versions of some of Shakespeare's best-known works and took them into the schools. Now more than 130,000 students, many of whom had never seen live theatre, have had the experience, thanks to The Nashville Shakespeare Festival. That collaboration has led to partnerships with the Nashville Institute for the Arts and the Tennessee Performing Arts Center's Humanities Outreach in Tennessee, bringing theatre to even more fresh audiences.

But the Centennial Park performances are still the company's main draw, providing a perfect opportunity for a casual date or a family outing. People come back year after year because it's affordable, accessible, and reliable entertainment, and most importantly, they know they'll have a great time.

< NASHVILLE SHAKESPEARE FESTIVAL 18" x 24" Limited Edition Print created in 2007 by Kristi Carter Smith

"In this poster design, we were asked to reference the Festival's logo which features William Shakespeare with stars in his eyes. The Shakespeare in the Park events bring all kinds of people together in Centennial Park, so illustrating William lounging in shorts with his dog in front of the Parthenon seemed to say it all."

FORT NEGLEY

METRO PARKS NASHVILLE

1862
150 YEARS

PRESERVING NASHVILLE'S CIVIL WAR HERITAGE

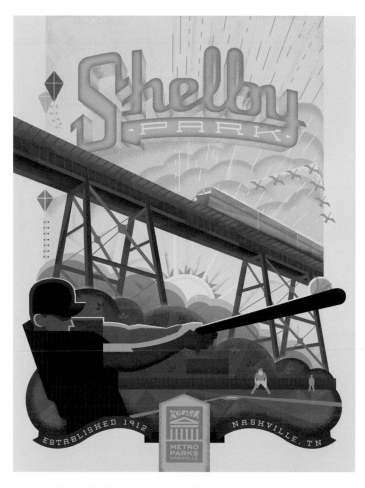

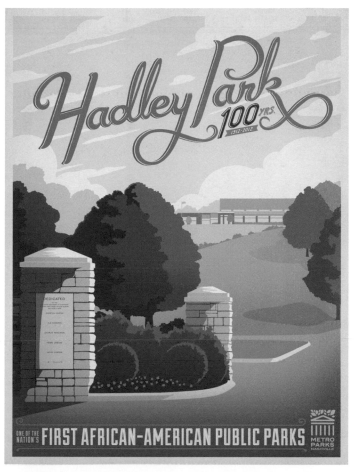

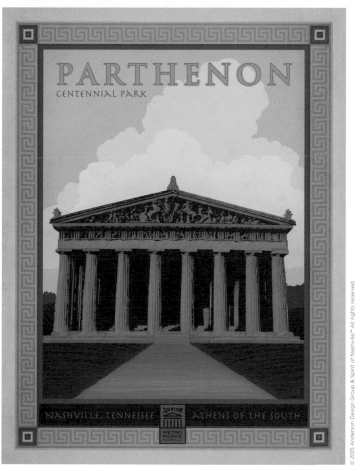

< **FORT NEGLEY** 18" x 24" Limited Edition Print created in 2011 by Andy Gregg
SHELBY PARK 18" x 24" Limited Edition Print created in 2011 by Andy Gregg
HADLEY PARK 18" x 24" Limited Edition Print created in 2011 by Edward Patton
NASHVILLE GREENWAYS 18" x 24" Limited Edition Print created in 2011 by Andy Gregg & Joel Anderson
PARTHENON 18" x 24" Limited Edition Print created in 2004 and updated in 2011 by Joel Anderson

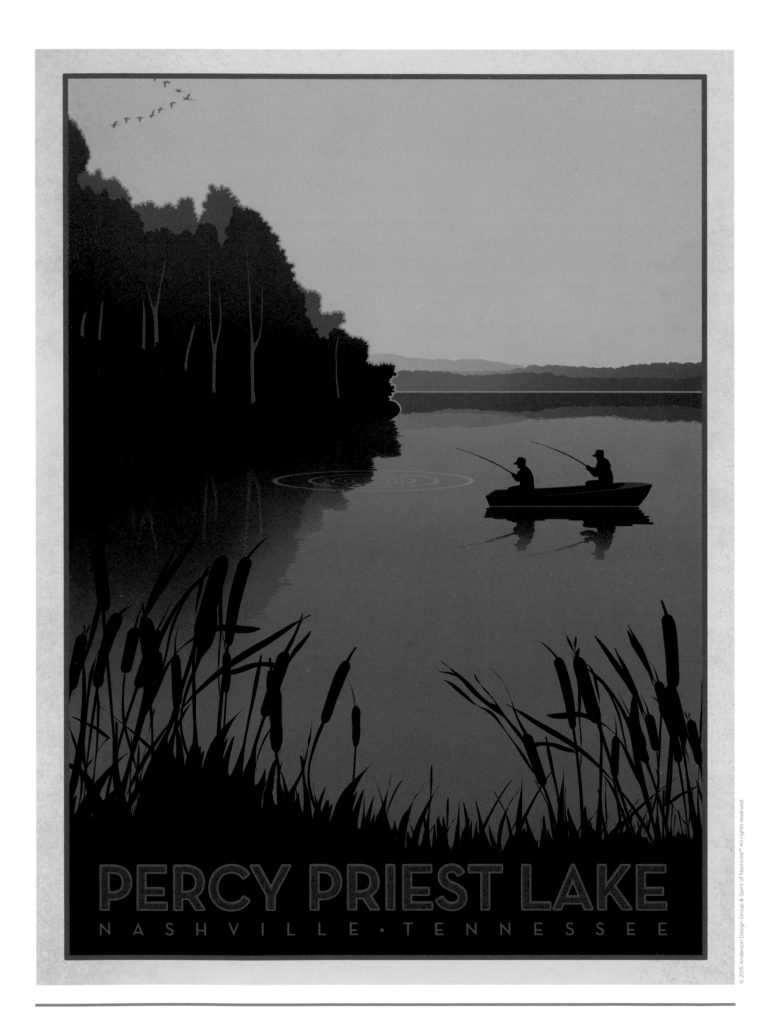

PERCY PRIEST LAKE 18" x 24" Limited Edition Print created in 2006 by Joel Anderson

"The Spirit of Nashville Collection needed a manly print to counter the Ballet, Symphony, and Chamber Orchestra prints. So I chose a peaceful fishing scene in masculine tones as a way of celebrating Percy Priest Lake, Nashville's biggest playground for big boys and their toys."

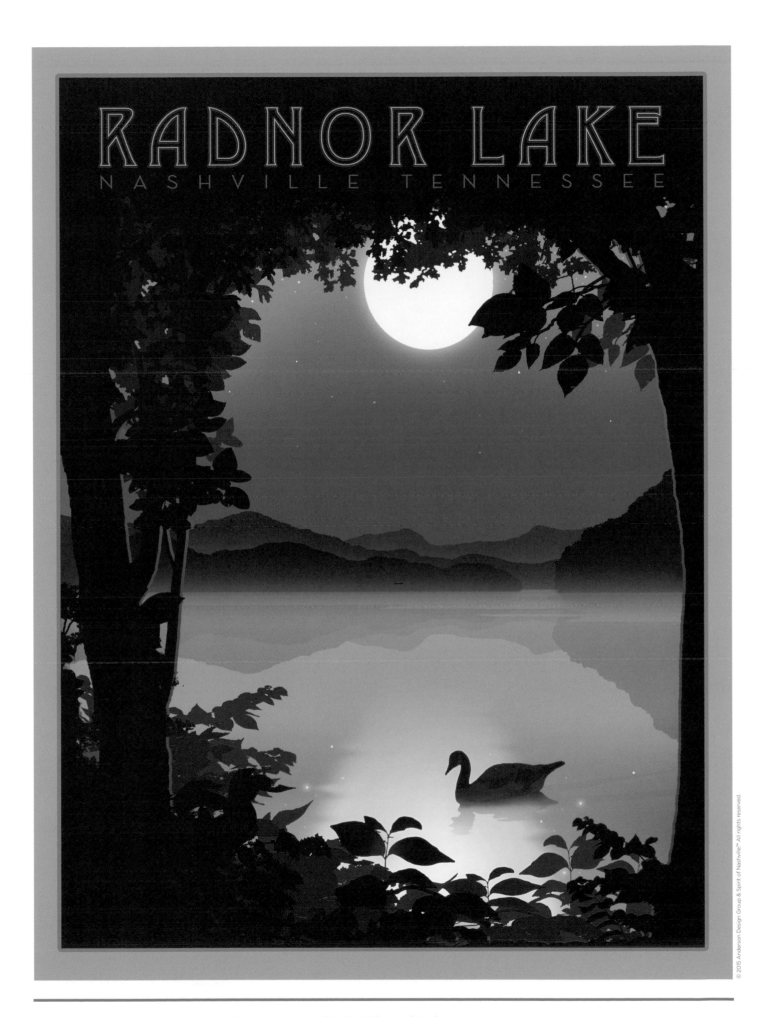

RADNOR LAKE 18" x 24" Limited Edition Print created in 2005 by Joel Anderson

"I went to Radnor many times to take reference photos as I planned the design of this poster. I explored colorful autumn leaves, bright, flowering springtime, and lush green summer foliage. Since I couldn't decide which season I liked best, I made the poster into a nighttime scene."

Percy Warner Park

NASHVILLE · TENNESSEE

PERCY WARNER PARK

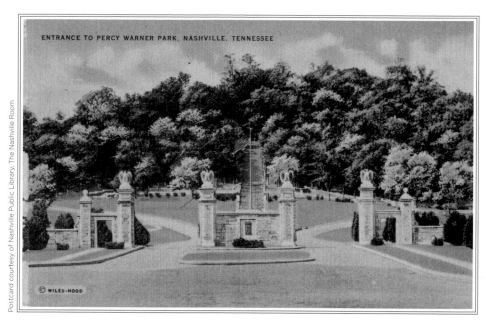

ENTRANCE TO PERCY WARNER PARK, NASHVILLE, TENNESSEE

© WILES-HOOD

A vintage postcard depicting the main entrance to Percy Warner Park.

PERCY WARNER PARK, along with Edwin Warner Park are collectively known as "The Warner Parks." These beautiful wooded parks are the largest municipally administered parks in Tennessee, containing 2,684 acres of forest and field, nine miles from downtown Nashville.

In 1927, Colonel Luke Lea and Mrs. Percie Warner Lea deeded the initial 868 acres of land to the city, and named the park after her father, Percy Warner. Today, the parks are composed of two different tracts of land—lush, wooded expanses of rolling hills and open fields separated by the thin corridor of Old Hickory Boulevard. A system of linked hiking trails was developed in the 1930s by the Works Progress Administration and enhanced in the 1970s by the Youth Conservation Corps and Nature Center staff.

Virtually unchanged since their establishment in 1927, the parks' thick, hardwood forests provide cool shade, open fields, and a habitat for wildlife.

Over 500,000 people visit the Parks annually to utilize picnic areas, scenic roadways and overlooks, 12 miles of hiking trails, an equestrian center and horse trails, cross-country running courses, golf courses, athletic fields, nature center, a model-airplane flying field, and 9 miles of mountain biking trails.

Since 1941, the Iroquois Steeplechase has been running continuously at Percy Warner Park on the beautiful race course inspired by Marcellus Frost and designed by William DuPont. The widely renowned event has created a festive sporting spectacle that has become a rite of spring for Nashvillians. The National Steeplechase Association sanctions 41 race meets throughout the Eastern U.S., with Nashville hosting one of the finest race courses. The Iroquois Steeplechase brings more than 25,000 people into Percy Warner Park each year to enjoy the all-day event while raising funds for charity.

< PERCY WARNER PARK 18" x 24" Limited Edition Print created in 2005 by Kristi Carter Smith

"I wanted to do a loose, impressionistic poster to add some texture to the Spirit of Nashville Collection. Middle Tennessee foliage can be spectacular, and I wanted to hint at the pleasure of the sights and smells of this beautiful park on a sunny autumn day."

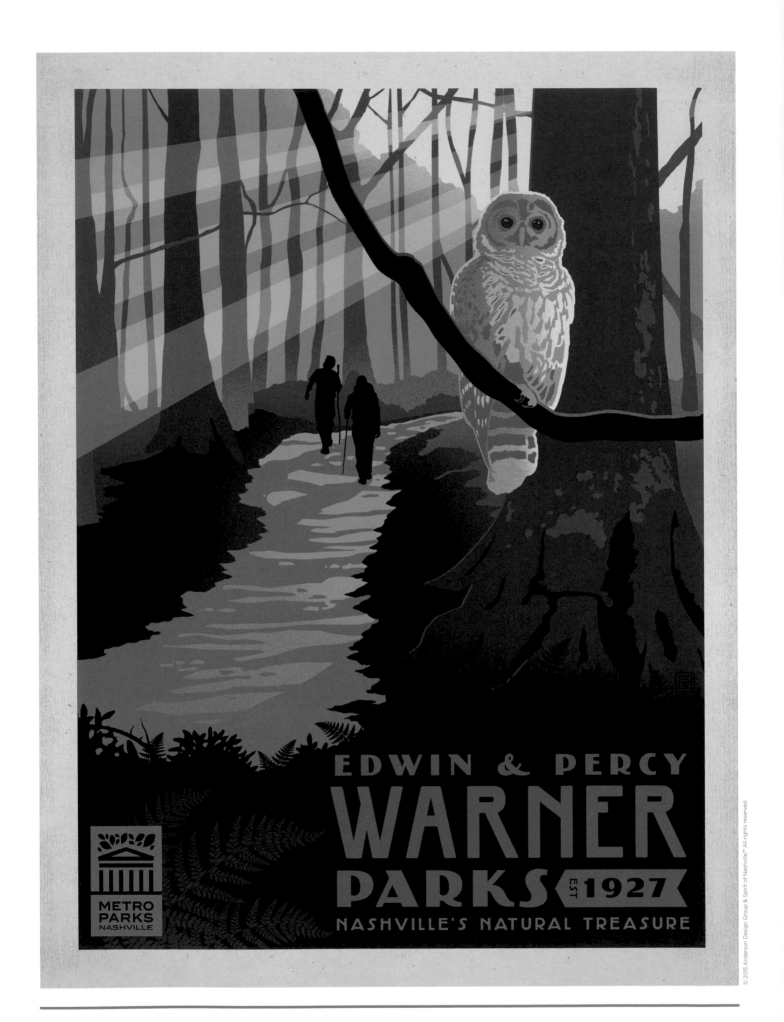

EDWIN & PERCY WARNER PARKS 18" x 24" Limited Edition Print created in 2012 by Michael Korfhage & Joel Anderson

"It is not uncommon for hikers to hear the hoot of an owl while exploring the shady wooded trails in Percy Warner Park."

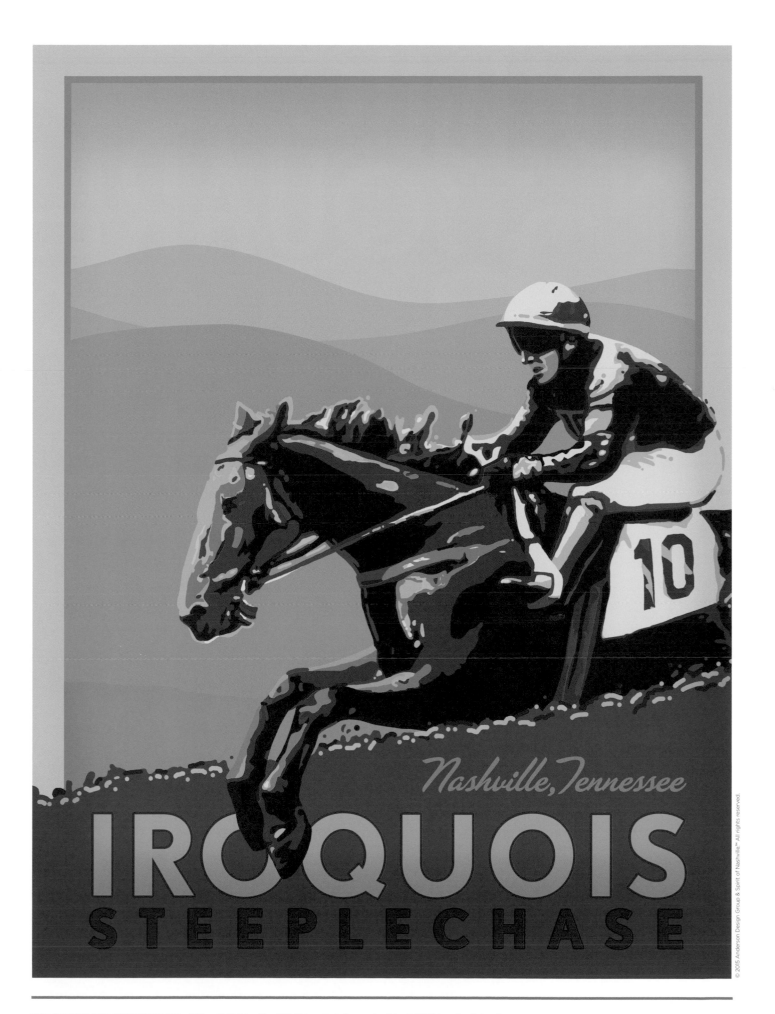

IROQUOIS STEEPLECHASE 18" x 24" Limited Edition Print created in 2003 by Joel Anderson

"The pomp and spectacle of this annual event would be hard to depict in a single poster design. So I opted to focus on the horse race rather than the social aspect of this high society gala. To capture the energy of the event, I created a bold image of a horse and rider bursting over a hedge."

PUBLIC SQUARE PARK

COURT HOUSE

METRO PARKS NASHVILLE

NASHVILLE'S CIVIC HEART SINCE 1784.

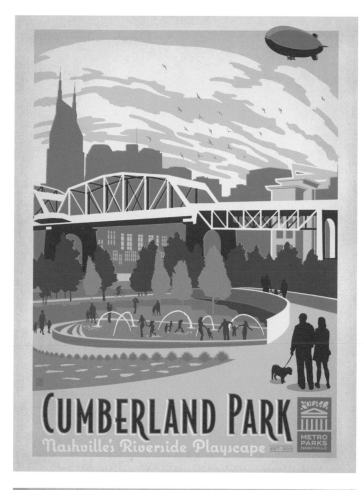

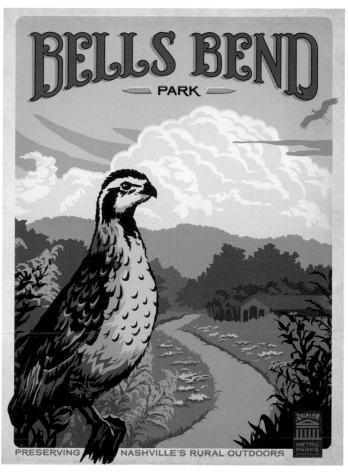

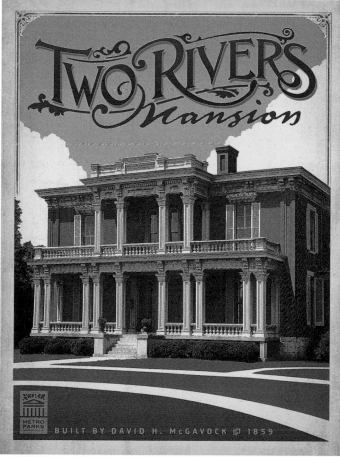

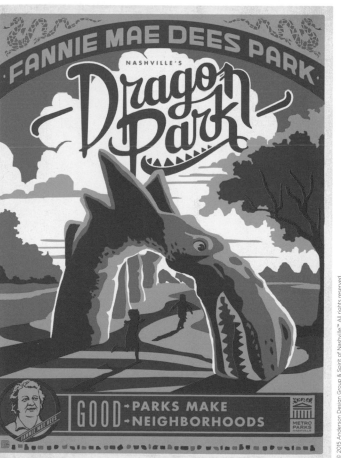

< PUBLIC SQUARE PARK 18" x 24" Limited Edition Print created in 2012 by Andy Gregg

CUMBERLAND PARK 18" x 24" Limited Edition Print created in 2012 by Michael Korfhage & Joel Anderson

BELLS BEND PARK 18" x 24" Limited Edition Print created in 2012 by Ligia Teodosiu

TWO RIVERS MANSION 18" x 24" Limited Edition Print created in 2011 by Joel Anderson

FANNIE MAE DEES PARK (DRAGON PARK) 18" x 24" Limited Edition Print created in 2012 by Andy Gregg

Food & Flavor

CAFE
HOT BISCUITS COUNTRY HAM
Loveless
MOTEL

AIR CONDITIONED
NO VACANCY

BUICK EIGHT
SUPER

8400 HIGHWAY 100 NASHVILLE, TENNESSEE

LOVELESS CAFE

Photos by David Thomas

Even after extensive renovations, the front of the Loveless Cafe looks almost exactly as it always did.

IF A NEWCOMER to Nashville asks where to get the best biscuits, the response is unanimous: the Loveless Cafe. Most locals know it's one of the best places for country ham, fresh preserves and their famous, made-from-scratch biscuits in a down-home atmosphere.

The roadhouse, with hardwood floors and red-and-white checkerboard cloths on the tables, isn't much different now than when Lon and Annie Loveless bought the property in 1951. At first, the Loveless Motel and Cafe was more of an outdoor venue, so to speak. The couple set up picnic tables outside and sold fried chicken and biscuits to hungry Natchez Trace travelers. As business grew, the Loveless' converted the rooms of the early 1900s home on the property into a dining room and kitchen. Lon smoked the hams, and Annie used her secret recipe to make perfect homemade biscuits, which she cut from the dough with a Campbell's Soup can.

Due to a decline in Lon's health, the Loveless' sold the motel and cafe to Cordell and Stella Maynard. The Maynards stayed true to the motel and cafe's original vibe; Annie even shared

the biscuit recipe so the restaurant could maintain its most authentic asset. After 14 years, the Maynards sold the business to Donna and Charles McCabe

in 1973. Their 12-year old son, George, helped do chores around the motel, and when he was old enough, became a partner in the business in 1982.

George expanded the business by offering the Hams & Jams mail order catalog, allowing customers to ship the country goodness anywhere in the world. The McCabes focused more on the new mail-order business, and shut down the motel portion of the business in 1985.

Part of the reason for the wait was the restaurant's ever-growing popularity. Personalities such as Willard Scott and George Jones have feasted on ham and grits. Superstar Paul McCartney had a bite to eat with Chet Atkins when he stopped by—and he even sang "Happy Birthday" to a fellow customer who was celebrating her 16th birthday.

The restaurant has received nods from *USA Today*, *Southern Living*, and even Martha Stewart herself. By 2003, the nearly century old-home could no longer keep up with the demands that the Loveless had created. Nashville caterer Tom Morales and investors bought the Loveless in 2003, and made expansions and renovations. It reopened in 2004, and on that first day, a diner told a reporter, "it's as good as it ever was."

In 2009, the Loveless Barn was built, providing a 4,800 square-foot live music and event venue. Today, the Loveless serves more than 450,000 guests per year.

< LOVELESS CAFE 18" x 24" Limited Edition Print created in 2003 by Joel Anderson

"When we began listing landmarks to feature in the first series of Spirit of Nashville prints, the Loveless Cafe was at the top of our list. Loveless is best known for its biscuits and for the big blue neon-lit sign out front. So to capture the feeling of stepping back in time, we chose to depict an old Buick in front of the famous sign. I couldn't figure out how to get biscuits into the picture, but then, just seeing the sign brings to mind the taste and aroma of hot, steamy biscuits and country cooking!"

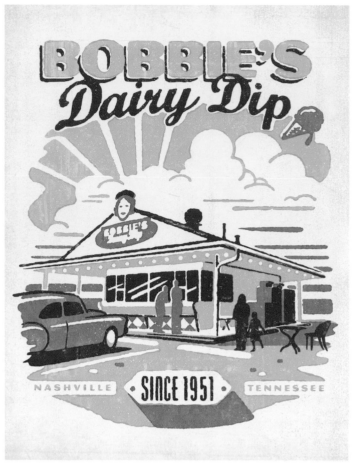

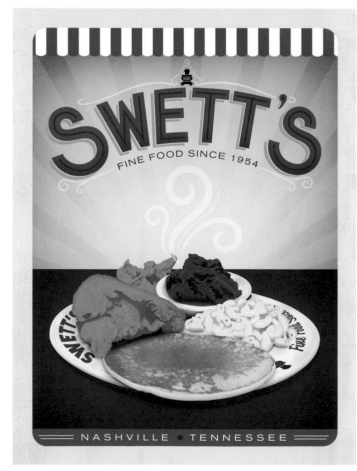

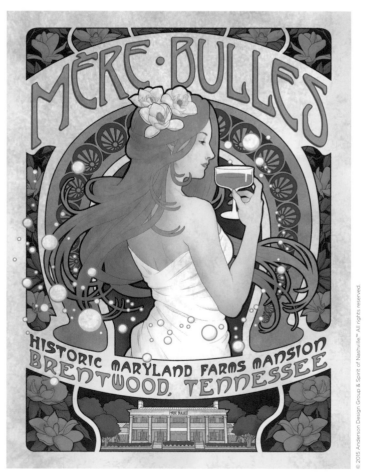

ARNOLD'S COUNTRY KITCHEN 18" x 24" Limited Edition Print created in 2012 by Joel Anderson

BOBBIE'S DAIRY DIP 18" x 24" Limited Edition Print created in 2012 by Andy Gregg

SWETT'S 18" x 24" Limited Edition Print created in 2012 by Edward Patton

MÈRE BULLES 18" x 24" Limited Edition Print created in 2013 by Aaron Johnson

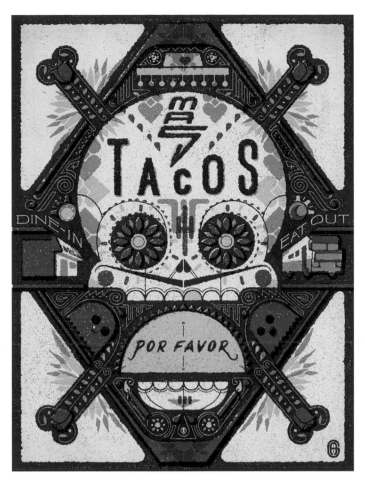

MAS TACOS POR FAVOR 18" x 24" Limited Edition Print created in 2012 by Andy Gregg

THE CUPCAKE COLLECTION 18" x 24" Limited Edition Print created in 2012 by Ligia Teodosiu

FIDO 18" x 24" Limited Edition Print created in 2012 by Ligia Teodosiu

THE PEANUT SHOP 18" x 24" Limited Edition Print created in 2012 by Joel Anderson

FARMERS' MARKET

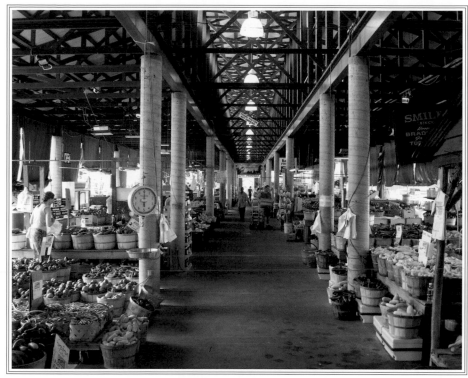

Scenes of fresh fruits and vegetables from inside the Nashville Farmers' Market, located on 8th Avenue near the State Capitol.

JUST AS THE DAY BEGINS

to heat up, people from all over Middle Tennessee begin to make their way down aisles lined with barrels of fresh greens, red onions and vine-ripened tomatoes.

Some know exactly what they're looking for, but others just come to the Nashville Farmers' Market to stroll from stall to stall, seeing if they can find some locally grown treasure such as pole beans, blackberries, or a flat of budding flowers.

But more than just a place to buy produce, the market has served as one of Nashville's gathering places for more than 50 years; people stop and chat with familiar faces, or come just to buy from that local grower they now consider a friend. Often the person who's selling to you is a

second or third-generation farmer, having spent a majority of their childhood helping out at the Farmers' Market.

People now visit the market on 8th Avenue North, but before it was built in the early 1950s, local farmers set up shop around the courthouse. Traffic became such a problem that the state legislature approved a bond issue in 1949 to build a permanent structure.

In 1993, the market received a face-lift; the building's extension from Jefferson Street back to Harrison Street would add five acres, providing space for additional, roomier stalls, groceries and restaurants. The new facility would be marketed as a part of the state's Bicentennial Mall project, scheduled for completion in 1996.

With the new space came even more diversity. Now alongside fresh vegetables, visitors could shop for ethnic meats, coffee, hot sauce, African and Jamaican products. Or they could try a gyro, homemade fudge or stir-fry at one of the many eateries.

In 2010, the Farmers' Market suffered severe damage during the May Flood. Thanks to the efforts of many kind folks, the market has been restored with expanded offerings such as classes, festivals and chef demonstrations. The important things still remain: it is a great place to find great food and a diverse community.

< FARMERS' MARKET 18" x 24" Limited Edition Print created in 2003 by Kristi Carter Smith

"We were going for a classic, earthy feel for this poster—one that might have been seen in an old feed store from the 1940s. The marketing team for the Nashville Farmers' Market liked our art so much they hired our studio to create a new logo, sign and web site with a similar feel to this print. The Farmers' Market is very eclectic place, so a basket of tomatoes doesn't quite tell the whole story. We may end up doing a series of posters to celebrate the wide variety of flowers, locally grown produce and international groceries this wonderful place has to offer."

"THANKS, PURITY LOVER!"

SERVING NASHVILLE SINCE 1925

PURITY DAIRIES

IN 1981, MILES EZELL, SR.

wrote these words to his children: "Share your earthly goods as well as your time and talent with the Lord and others who are in need of it…Work hard, make money and spend wisely. Don't try to keep up with the Joneses. Continue to have a humble spirit as you now have. Be truthful and honest."

It's these tenets and others that are at the heart of Purity Dairies, an 81-year-old, Nashville-born-and-raised business. Since the late 20s, the Ezell family has strived to produce the best dairy products, and use what they've been given to reach out to the community.

In 1926, Miles and Estelle Ezell were newlyweds, and they lived with his parents on a small dairy farm owned by Dr. C.N. Cowden. Dr. Cowden wanted to return to practicing medicine full time, and approached Miles about buying the dairy. Knowing he had no money, Dr. Cowden agreed to rent him 60 cows, an old delivery truck and equipment for $450 a month, and helped him secure a loan for the first month's expenses. With those items in place, Ezell's Dairy was born.

A year later, Ezell rented a 200-acre farm on Edmondson Pike and bought several new cows on credit, as Dr. Cowden had to sell his cows. He traded in his 1923 Ford Coupe for a delivery truck, and Ezell's Dairy was standing on its own. Although the dairy was at the bottom of the Nashville dairy totem pole, Miles worked tirelessly to gain business and produce a quality product. His strong reputation helped him grow through the Great Depression, and by 1945, the first section of the Murfreesboro Road operation was built. The following year, Ezell merged with Rosebank Dairies, and the coupling took on a new name: Purity.

Over the years, Purity would be at the forefront of the dairy industry, introducing refrigerated delivery trucks, non-wax milk cartons and a recognizable advertising campaign. The dairy also bought out some of its biggest competitors: Richmond Pure Milk Company, Swiss Dairy Farm, and Murfreesboro Pure Milk Company. Generations of Ezells have been involved with the family business; although Dean Foods bought Purity in 1998, it's still a family business—Miles' grandson, Mark Ezell, serves as CEO.

And while delivering superior dairy products has always been paramount, the moral responsibility of giving back what's so richly been given to them is equally important. The Golden Rule has always been at the heart of the Purity philosophy. As Miles once said, "I just tried to produce milk that I would've drunk myself. I tried not to sell anything I didn't want my family to use. That went along with treating people as I wanted to be treated."

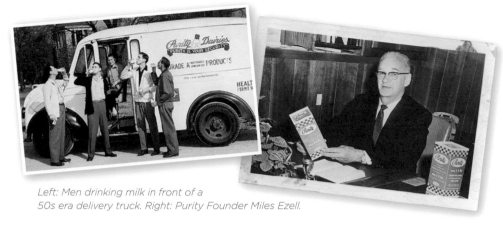

Left: Men drinking milk in front of a 50s era delivery truck. Right: Purity Founder Miles Ezell.

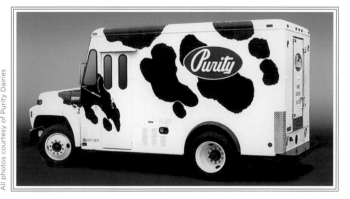

"What is black and white, has horns and gives great milk? A Purity home delivery truck!" The dairy's first milk truck (above) and a modern day truck (below).

All photos courtesy of Purity Dairies

< PURITY DAIRIES 18" x 24" Limited Edition Print created in 2003 by Joel Anderson

"This print was based on a photo taken by one of Nashville's top photographers, Dean Dixon. We worked with Dean to create imagery for a line of novelty ice cream products for Purity Dairies. After designing the packaging, the original photos sat unused for several years. When we decided to celebrate Purity Dairies as one of Nashville's great traditions, this Norman Rockwell-esque scene was the clear favorite for the poster image."

Vandyland

"NASHVILLE'S FINEST MILKSHAKE SINCE 1928"

VANDYLAND

Photo courtesy of Mitch Givens

Photo by Joel Anderson

Mack McGee, owner Mitch Givens, Councilman George Armistead, and Ellen Prisher celebrate Vandyland's 60th Anniversary.

It was a sad day when Vandyland closed its doors in May, 2006 and the familiar sign — a West End landmark — was removed from the storefront.

FOR MORE THAN SEVEN decades, Vandyland, and its predecessor, Candyland, was a Nashville landmark, especially for those with a sweet tooth. Kids hoped that a long afternoon downtown may be rewarded with a gourmet sweet treat from Candyland. And those who frequented the downtown location knew that they'd be greeted with a smile from Mack McGee and their "usual", made by one of the beloved staffers, before they could even sit down.

Over time, Vandyland became more than just a place to get a hot meal or a cool milkshake; it was a gathering place for young and old. So while the restaurant closed in 2006, many still hold fond memories of the restaurant on West End.

Vandyland's history actually starts with the opening of Candyland, at 817 Broadway, in the early 1900s. The shop later moved to its Church Street location and thrived there until its closing in 1986. Greek immigrant Billy Pappas, who was a cousin of one of the co-owners of the downtown location, opened the second Candyland location on West End in 1928; he became sole owner in 1945. Pappas died in 1985, and because of legalities, the new owner, Mitch Givens, had to change the name. The swap of one letter would reflect the culinary landmark's proximity to Vanderbilt University, thus calling it Vandyland.

Over the years, a who's who of Nashville (and beyond) strolled through Vandyland's doors. Former Tennessean publisher John Seigenthaler once worked there as a soda jerk. State Speaker of the House Jimmy Naifeh conducted business over chicken salad, and George W. Bush's campaign trail led there, maybe at the same time country star George Jones was sitting down for a bite to eat.

But no matter who you were, everyone was given the same special treatment. Longtime patron Glenda Higgins wrote: Vandyland was a "way of life" for many people—from regulars to those who moved and visited Vandyland upon each return to Nashville. The restaurant was a rendezvous for people from all walks of life. Myriads of special relationships evolved from the Candyland-Vandyland experience."

"As soon as we heard Vandyland was closing for good, my husband and I decided to take our whole family to enjoy one last meal at our favorite hangout. That meal was magical. At one point, not a word was being spoken—the entire family was focused on slurping the last drops from the last Vandyland milkshakes we would ever have. Happy slurping kids with eyes closed in ecstasy, the way our puppy looks when she is intently chewing on a bone—that is how I'll always remember Vandyland." **— Joel Anderson**

< VANDYLAND 18" x 24" Limited Edition Print created in 2003 by Darren Welch

"The chocolate shakes made with Purity ice cream were always a Vandyland favorite. Most of the sandwiches on the menu were ordinary delights that you could make at home, but the milkshakes and hand-dipped candies made a trip to Vandyland special. For this print, we decided on a bold and simple milkshake, playing up the lettering style from the sign."

Delicious Donuts, Bagels & Muffins

FRESH
Made Daily!

Fox's DONUT DEN

NASHVILLE, TENNESSEE

FOX'S DONUT DEN

THE 50s-STYLE SIGN stands out from the trendy new surroundings of the Green Hills shopping district. For more than 30 years, Donut Den has been a meeting place for businessmen, a study hall for area students, and a haven for any Nashvillian with a sweet tooth.

While getting his doctorate in biology at Vanderbilt, Norman Fox needed a way to make extra money. He'd come in contact with Oliver Harlow, the owner of a donut shop chain that was in its twilight years, and Fox became the beneficiary of Harlow's 50 years of business experience and a superior donut recipe. Fox found a spot on Granny White Pike, where Pizza Perfect now stands; Barbara, Fox's wife, said they should name their new donut shop Donut Den, since foxes live in dens.

Fox moved the business to Green Hills in 1977, and the sign from Harlow's Memphis store was moved to top the new location. The little man on the sign that had been a mascot for Harlow would now represent Donut Den.

Over the years, the shop has become a literal Green Hills landmark—people often give the Donut Den as a sign you've gone too far or haven't gone far enough down Hillsboro Pike. But it's also become somewhat of a tradition. Locals gather to talk about sports or current events, parents take their kids for a treat, and college students know they can get a job there. Most of Dr. Fox's longtime employees started when they were in school. Overnight cook Harold Graves started working there in 1973 when he was a freshman at Lipscomb. He still works there, and Dr. Fox says he's one of the best employees ever. Great donuts, long-term relationships and friendly service is what has made Fox's Donut Den a favorite Nashville tradition.

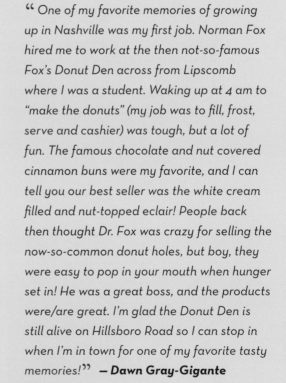

> " One of my favorite memories of growing up in Nashville was my first job. Norman Fox hired me to work at the then not-so-famous Fox's Donut Den across from Lipscomb where I was a student. Waking up at 4 am to "make the donuts" (my job was to fill, frost, serve and cashier) was tough, but a lot of fun. The famous chocolate and nut covered cinnamon buns were my favorite, and I can tell you our best seller was the white cream filled and nut-topped eclair! People back then thought Dr. Fox was crazy for selling the now-so-common donut holes, but boy, they were easy to pop in your mouth when hunger set in! He was a great boss, and the products were/are great. I'm glad the Donut Den is still alive on Hillsboro Road so I can stop in when I'm in town for one of my favorite tasty memories!" **— Dawn Gray-Gigante**

< FOX'S DONUT DEN 18" x 24" Limited Edition Print created in 2006 by Joel Anderson

"It was just a matter of time before we selected the Donut Den to be in the Spirit of Nashville Collection. It's always been a favorite stop for my kids on those rare days when we have extra time before school starts. I've always loved the faded neon sign that adorns the old den of dietary iniquity. So when I started on the poster, it practically designed itself... that happy little Dutch boy with four fingers on one hand and no fingers on the other was destined to be the poster child for Nashville's favorite fresh baked delights!"

PANCAKE PANTRY

Scenes from the early days at the Pancake Pantry shot in August 1961—not much has changed, besides the hair styles!

IT'S NOT UNCOMMON, especially on a Saturday morning, to drive down 21st Avenue South, and see a line of people curving around the sidewalk and into the Pancake Pantry.

College students stand next to investment bankers, area residents line up behind Vanderbilt professors—you may even see a few locally-based country music stars or the occasional Tennessee Titan patiently waiting to dig into some light, fluffy pancakes or omelet filled with sausage or ham.

But no matter who they are, they'll say the same thing: it's worth the wait.

Bob Baldwin opened the pancake eatery in 1961. A Cornell University graduate, Baldwin was a traveling Hotpoint-appliance salesman when he met Jim Gerding, owner of the Pancake Pantry in Gatlinburg, TN. When he saw the Gatlinburg restaurant, Baldwin

thought the concept would do well in Nashville. Baldwin opened the Hillsboro Village location, and it's been a local favorite since.

Two years after opening, Joyce Stubblefield was hired as a waitress. It wouldn't take long for her to become just as much of an institution as the restaurant itself. The customers know her, and she knows her customers. If you came there often, she may just bring you your

"usual." When she celebrated her 30th anniversary in 1993, country superstars Kathy Mattea and Pam Tillis sent flowers. She was like a mother to a lot of stars up and down Music Row.

But the real star here is the pancakes. Serving more than 20 kinds, owner David Baldwin (Bob Baldwin's son) makes sure the light, fluffy pancakes with the rich, warm syrups bring people through those doors just like they did in 1961. Those who frequent the restaurant say they love the sweet potato pancakes with cinnamon cream syrup, and the famous buttermilk pancakes with the maple syrup can't be beat.

But it's the combination of good service and great food that keeps people coming back to this Nashville landmark. As owner David Baldwin says, "We stopped selling pancakes years ago; now we're in the business of building relationships."

"Fan art" from some young pancake eaters. Favorite artwork is featured on the frequently updated children's menus.

<PANCAKE PANTRY 18" x 24" Limited Edition Print created in 2004 by Emily Keafer

"I LOVE eating at the Pancake Pantry. The sweet potato pancakes with cinnamon cream syrup are my absolute favorite, but I chose to go with the traditional (yet still tasty!) buttermilk pancakes for this design. Nothing says 'Good Morning!' like a tower of fluffy flap jacks drizzled with gooey syrup and held aloft in front of a sunny yellow sky."

ELLISTON PLACE SODA SHOP

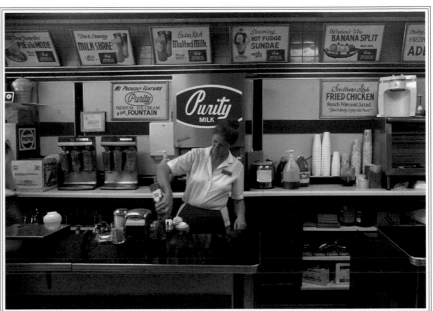

A JUKEBOX on every table—you don't see that anymore! Although Elliston Place has changed time and time again over the years, the Elliston Place Soda Shop remains. It may have changed ownership, but the tile floors, old-fashioned soda fountain, and good ole country meat-and-threes still remain.

The soda shop was actually the offspring of a pharmacy, which was in that location on Elliston Place when the street was largely residential. Dan Sanders owned the Elliston Place Pharmacy at 2113 Church Street, and by the late 1920s, he also owned the retail space next door. It's said that Doc Sanders was known for his storytelling abilities, and customers loved that he had fountain service, curb service and home delivery, which was usually made by bicycle.

In 1939, Lynn Chandler, 23, was offered the pharmacy's luncheonette business. (Chandler had practically grown up in a pharmacy, working at Noble's Pharmacy at age 9.) He used $234 of the $250 he'd saved to buy food and supplies. It was reported that, in those early days,

Chandler would stick around outside the business after it was closed, hoping someone would come by wanting to buy something. If they did he'd reopen just for them, and sit and chat with them.

"You have to make a friend before you can make a customer," Chandler once said in a newspaper article.

Over the years, people, both famous and not so famous, sat on the stools at the Elliston Place Soda Shop and ordered thick, creamy milkshakes or a hot plate full of fried chicken or turkey and dressing. In 1989, the restaurant turned 50. In 1996, Eleanor Clay bought the soda shop from the Chandlers, and would later buy their trio of Sylvan Park Restaurants. After a brief ownership by Charles Galbreath from 1998 to 2003, Clay bought Elliston Place Soda Shop back.

In 2011, Elliston Place Soda Shop nearly closed down when it was time for the lease to be renegotiated. Rough economic times, plus an increase in the rent made it look like the old Nashville icon would not continue to

survive. A public outpouring of support caused the landlord to restructure the lease so that Music City would not lose another cherished link to the past.

Today after more than 70 years, customers can still count on the same great food, sweet treats, and steady service that was there when Doc Sanders was still behind the pharmacy counter.

< ELLISTON PLACE SODA SHOP 18" x 24" Limited Edition Print created in 2005 by Aruna Rangarajan and Joel Anderson

"This print shows off the famous neon sign in front of the soda shop. We had to take some artistic license to get the Nashville skyline in the background, since the skyline is actually obstructed by the colossal buildings of the Baptist Hospital complex (now called St. Thomas Midtown.)"

NASHVILLE TENNESSEE

BONGO JAVA

ROASTING CO.

• THE HOME OF THE NUN BUN •

BONGO JAVA

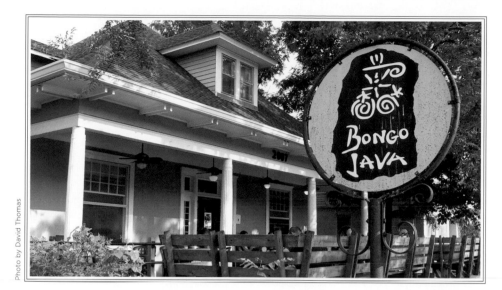

Photo by David Thomas

IT'S HIP, COOL, eclectic, and has always been way ahead of its time.

Before Starbucks was a household name in Nashville, there was Bongo Java, Nashville's oldest and most celebrated coffeehouse. The cafe opened March 28, 1993, and became world famous in December 1996 for the discovery of a cinnamon bun which many believe looks remarkably like Mother Teresa.

The bun was actually discovered on October 15, 1996 when store manager Ryan Finney was about to eat breakfast before the store opened. Something made Ryan look at the pastry he held in his hand before he ate it. He waited until the next employee came in, pushed the bun in front of his face and said, "What does this look like?" A barely awake and very surprised Todd Truly replied "Mother Teresa." The same test on the first few customers who came in that day confirmed the "miracle."

The NunBun™ was featured on the front page of *The Tennessean* the Saturday before Christmas. As a result, the story of the bun went world wide almost instantly, eventually reaching Calcutta, India.

Bongo Java received a letter from Mother Teresa saying she didn't mind the bun itself but she didn't want them making money off of her name or image. The letter served to further the NunBun™'s fame. It was featured by media outlets around the world including *The Washington Post*, CNN, BBC, Paul Harvey's Radio Show, and *The Late Show With David Letterman*, making Bongo Java one of the most famous coffeehouses on the globe.

The story went quiet until 2005, when thieves broke into Bongo Java on Christmas Day and stole the famous Immaculate Confection. But even without the famous bun, Bongo Java continues to be a gathering place for all of Nashville, attracting musicians, students, artists and even some "employed" people as well!

Photo by Bob Bernstein

> **"** From the gray wooden planks that line its front porch, to the whir of espresso machines and colorful baristas manning the counter, no place sets a mood of cool faster than Bongo Java. So for a permy-headed, department-store-clothes-wearing, fresh-faced freshman, no place could have been more intimidating. I admired Bongo Java from afar for several months before I ventured inside its walls. It wasn't until a national media frenzy erupted over the discovery of [the NunBun™] that my curiosity overcame me. I had to see [it]. I wasn't the only one, of course. Reporters, curious locals and college students waded past the patient "regulars"... to see the bun. As I stood in line wondering what on earth I'd order off the menu..., I spotted her. There she was—displayed under Plexiglas,... glorious in all her confectionary goodness. I had seen her, and my curiosity had been satisfied. More importantly, I had made it inside the über-hip Bongo Java. I knew I [now] had a place to come when I needed a break, some study time or space to reflect. Bongo Java was hip, but it was also warm and welcoming. I looked around and saw businessmen drinking their java next to bohemian types, college students polishing up papers next to politicians strategizing their next move. Under the watchful eye of the NunBun™, I realized that all walks of life were welcomed at Bongo. And I imagined that's just the way Mother Teresa would have it. **"** — *Cara Davis*

< BONGO JAVA 18" x 24" Limited Edition Print created in 2003 by Matt Lehman

"Most people think that designers just sit around wearing black turtlenecks drinking coffee while slouching in front of a Mac laptop. So what's wrong with that? You can't create a poster like this drinking iced tea, wearing a seersucker suit!"

HOG HEAVEN

NASHVILLE is a great place for eating high on the hog. And if you are lucky enough to make it to Hog Heaven, you'll never want to come back down to earth! Even though the tiny shack is tucked away on a little side street next to a giant city park, this BBQ joint is a bona fide Nashville landmark. With outdoor seating for 3,000 (the front porch faces the sprawling lawns of Centennial Park), Hog Heaven features some of the best BBQ in town—and all within view of the Parthenon.

Located at 115 27th Ave North, this little slice of Heaven serves up what many swear is the best hand-pulled pork, chicken, beef and breast of turkey BBQ not only in Nashville, but on the planet. Owners Andy and Katy Garner bought the restaurant in 1989, after it had already been in business

for 3 years. "We've always worked in the restaurant business and we wanted to run our own place. When we sampled the turkey sandwich and white sauce, we were in Hog Heaven—and we knew

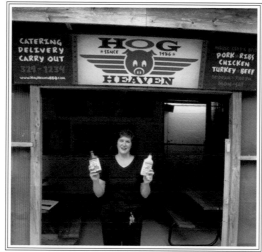
Co-owner Katy Garner stands in the gates of heaven.

without a doubt that this was a concept to build on" says Katy. Since they bought the

place, they've added beef brisket, chicken, and improved on a few of the recipes.

Hog Heaven has been featured on Food Network, Turner Network's *Blue Ribbon* show, Yahoo's *In Search of Real Food*, and voted Best BBQ by Nashville City Search several times over the years.

It may not be much to look at, but Hog Heaven is the real deal. But don't take our word for it; here is what some satisfied Hog Heaven fans have to say:

"I can definitely see why they call this Hog Heaven rather than Hog Purgatory."

—Wendy Williams

"The White Sauce isn't just a sauce, it's a way of life." —Cate Nance

"The building is small, the sandwiches are big, and Andy and Katy are about 5'9."

—Dayna Shaw

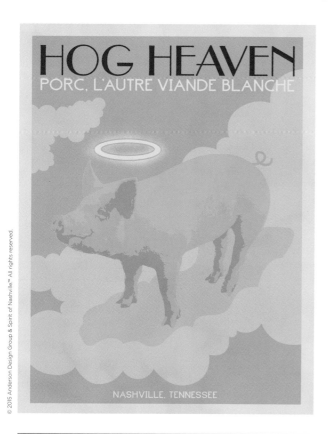

Food Network discovered the locally-famous BBQ Fight Club sauces and came to do a feature on Hog Heaven. Then the sauces started selling nationwide. We designed the Hog Heaven logo, sign, menu and label art in trade for 3 years worth of free BBQ. It was a great ride!

< This is the first Hog Heaven poster we created in 2003 as a part of the initial Spirit of Nashville print series. The art was created by Darren Welch.

< HOG HEAVEN BBQ FIGHT CLUB (PUNCHIN' PIG) 18" x 24" Limited Edition Print created in 2012 by Andy Gregg

"The food is amazing even if the restaurant looks like a summer campground cafeteria. As much as we love this dive, we just could not make a nice piece of art that featured a picture of the actual restaurant. So we ended up doing a poster to promote their amazing BBQ Fight Club sauces."

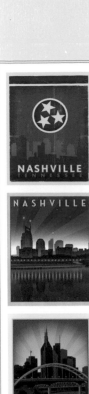

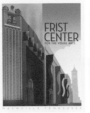

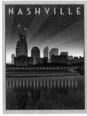
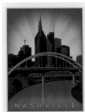

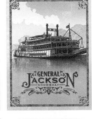

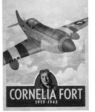

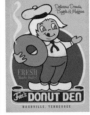
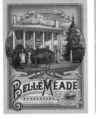
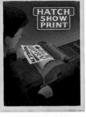

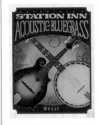
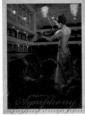
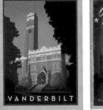
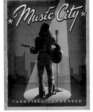
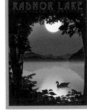
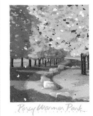

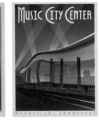

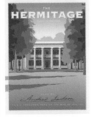

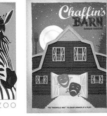

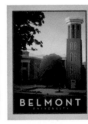

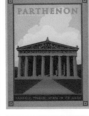

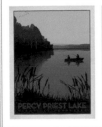

THE SPIRIT OF NASHVILLE

print collection came together as I was thinking of a way to showcase Nashville to my out-of-town clients and friends. At first, it was a publicity stunt to convince clients from New York or L.A. that Nashville was a hip place with a lot to offer. (Back then, folks didn't realize how cool it is to be Southern!) As founder of Anderson Design Group, I was looking for a way to show off our firm's illustration and design skills while shining a spotlight on Music City's most interesting, delicious and unique features.

I joined forces with McQuiddy Printing, formerly one of Nashville's oldest printers, to create a giant 18" x 30" limited edition calendar that would feature 14 illustrated prints of my favorite Nashville landmarks, restaurants, and cultural icons. I asked my creative team to join me in the massive challenge of rendering all of these designs in the tradition of the Golden Age of Poster Art, a glorious period of hand-illustrated and hand-lettered poster art which spanned from the late 1800s to the mid-1900s. After hundreds of hours of research, reference photography, drawing, painting, and designing, we finished the calendar and produced 1,500 copies. The rest is history. We ran out of calendars

in just a few weeks. People were calling from as far away as Canada asking where they could buy the prints they had seen. We soon realized we had stumbled onto something big. People were cutting up our calendars and framing the art!

The prints from the 2004 calendar won numerous design and illustration awards, and the requests for prints began to increase to the point that we started thinking about ways to make the art available to the public.

In 2005, the Spirit of Nashville Collection was officially born when we decided to create another set of designs that would not only be bound into a promotional wall calendar, but would also be produced as a limited edition run of ready-to-frame prints. The Metro Arts commission selected the entire print series for exhibition

in the Nashville International Airport. Soon, the Spirit of Nashville Collection was doing more than promoting our design firm—it also was proving to be a great promotional tool for the city and the establishments depicted in the art. We began looking for nonprofit organizations who could benefit from some extra exposure, and we created posters for notable establishments such as the Nashville Zoo, Andrew Jackson's Hermitage, The Frist Center for the Visual Arts, and the Nashville Ballet. We were on a roll, and we kept adding new designs to the collection each year. Today, the Spirit of Nashville series includes over 150 different prints, celebrating our city's rich and diverse history, culture and enduring charm.

New lines of poster art sprang from the success of the Spirit of Nashville Collection. Poster art fans and collectors from other cities began to ask for designs featuring their home towns. I have always loved vintage travel posters. So I began creating new designs depicting contemporary landmarks, but rendered in a classic style similar to our Spirit of Nashville designs. The Art & Soul of America Collection was born as a new poster series celebrating

our nation's favorite destinations. After creating more than 150 different prints of U.S. cities and national parks, I began creating new series like World Travel prints, the Coastal Collection, Coffee themes, Mid-Century Modern design, Music Festivals, Southern Expressions, Vintage Americana Advertising art, and a Man Cave collection. By 2014, Anderson Design Group had produced over 500 different poster designs. Our art has been exhibited on every continent on the globe (except for Antarctica.) Our prints have been purchased for display

all over Europe, Australia, South Africa, Canada, and South America. They have been featured on movie and network TV sets, given as gifts to diplomats, hung in embassies and consulates, published in design journals, and displayed in homes and offices by poster art lovers everywhere. What started in Nashville as a way to celebrate Music City and promote our little Nashville-based design firm has grown to become one of the largest bodies of decorative poster art ever assembled by one team of artists. While we have slowed down on Nashville art, we

are still creating new art for other cities.

As we proceed, we continue to abide by the belief that good poster art is all about strong, simple, beautiful composition. Poster art says hello to your brain, and then strikes up a long-term relationship with your heart. Effective poster design is meant to catch your eye from a distance, and then speak to your soul upon closer inspection. It is created to be affordable and accessible—simple enough to be enjoyed by anyone, yet profound enough to move everyone.

Every artist on my team, including my-

Shown above are prints from the Art & Soul of America series, the Coastal Collection, the World Travel series, and Southern Delights.

self, never stops learning and developing, honing skills, and being inspired by great artists of the early 20th Century. Even after creating poster art for over 30 years, I am still amazed at the beautiful things yesterday's artists cranked out in an era before photography was widely used in advertising art. They would paint and draw, creating temporary art that was produced to be pasted onto a wall to catch someone's attention as they hurried past. Their every-day advertising art had to be bold, iconic, emotive, and easily read in a split second. And it was done by very talented artists who never dreamed that their work would be collected and prized by future generations like ours.

We use the computer as a finishing tool, but I still insist that my artists draw and sketch to create art that is as authentic and iconic as the classic 20th Century works that inspire us. There is no quick or simple way to do this kind of art. Just like in the old days, each poster starts with a clever idea, and takes 30 to 60 hours to render. Years ago, poster art was disposable, (that is why the few surviving vintage posters are so rare and valuable today). And that is why we are creating a new generation of poster art which hopefully will not suffer the same fate of being pasted up on a wall, only to fade in the sun, peel in the wind, and disintegrate in the rain!

As you've seen in this book, everything we do is a labor of love, rooted in our appreciation of classic American advertising art. Check out more of our design work and poster art in the Anderson Design Group Studio Store located at 116 29th Ave. North, Nashville, TN, or online at www.ADGstore.com. — *Joel Anderson*

Shown above are more prints from the Art & Soul of America series, the Mod Collection, the Man Cave series, and the Coffee Collection.

INFORMATION SOURCES

These stories were written by Angela Patterson. Her research sources are listed below:

Belle Meade Plantation Sources:
www.bellemeadeplantation.com
www.bonps.org

Belmont University Sources:
Belmont Mansion Web site (www.belmontmansion.com/home.htm)
Belmont University Web site (www.belmont.edu/umac/belmont_history/250_word_history.html)
Davis, L. (1948, December 5). Woman-Run Belmont. The Nashville Tennessean Magazine.
Davis, L. (1986, October 26). Two faces of Belmont look on campus, city. The Tennessean.
Kreyling, C., Paine, W., Warterfield, C.W., and Wiltshire, S.F. (Eds.) (1996). Classical Nashville: Athens of the South. Nashville: Vanderbilt University Press.
The Tennessee Encyclopedia for History and Culture Web site (tennesseeencyclopedia.net/--entries for Adelicia Acklen, Belmont College, Ward-Belmont and Belmont University)

Bicentennial Mall Source:
Hinton, K. G., (1997). A Long Path: The Search for a Tennessee Bicentennial Landmark. Hillsboro Press: Franklin, TN.

Bluebird Cafe Sources:
A. Kurland, personal communication, May 16, 2007.
Bluebird Cafe Web site (www.bluebirdcafe.com/about/history.htm)

Chaffin's Barn Sources:
Adkins, Tim. (2002, May). Dinner with a show. The Tennessean.
Chaffin's Barn Dinner Theatre Web site (www.dinnertheatre.com/welcome.html)
Personal correspondence, Janie Chaffin, June 2007.

Cheekwood Sources:
Tennessee Encyclopedia of History and Culture Web site (tennesseeencyclopedia.net/)
Written history provided by Cheekwood Museum of Art

Donut Den Sources:
Blackwood, Suzanne Normand. (2004, March 25). Donut Den: A delectable treat for many. The Tennessean.
Fox, N. Personal Communication, May 30, 2007.

Elliston Place Soda Shop Sources:
Beasley, K. (1991, March 20). Soda Shop Shakes for 52 Years. Nashville Banner.
Carey, B. (1996, May 22). Soda Shop Sold, but Historic Charm to Remain. Nashville Banner.
Chappell, S. (1989, September 16). Soda Shop a Landmark on Elliston. Nashville Banner.
Deville, N. (2003, August 19). Former Owner Back at Helm of Elliston Place Soda Shop. The Tennessean.

Fisk University Sources:
The Fisk University Web site (www.fisk.edu/page.asp?id=115)
The Fisk Jubilee Singers Web site (www.fiskjubileesingers.org/our_history.html)
The Tennessee Encyclopedia of History and Culture Web site (tennesseeencyclopedia.net/imagegallery.php?EntryID=F020)

Frist Center for the Visual Arts Sources:
Traditional Fine Arts Organization Web site (www.tfaoi.com/aa/4aa/4aa410.htm)
Frist Center for the Visual Arts Web site (www.fristcenter.org/site/about/)

General Jackson Showboat Sources:
Battle, Bob. (1983, December 20). Opryland's showboat plan steaming full speed ahead. Nashville Banner.

Battle, Bob. (1984, October 10). Showboat to offer four trips daily. Nashville Banner.
Battle, Bob. (1985, March 27.) Opryland showboat taking to water. Nashville Banner.
Canfield, Clarke. (1985, June 24). The showboat's finally come to town! Nashville Banner.
Gaylord Opryland Web site (www.gaylordhotels.com/gaylordopryland/meetings/gjack/)

Hatch Show Print Sources:
Hance, M. (1991, December 10). History packs up, moves to Broadway. Nashville Banner.
Hatch Show Print pages on the Country Music Hall of Fame Web site (www.countrymusichalloffame.com/site/experience-hatch-history.aspx)
Sherraden, J., Horvath, E. and Kingsbury, P. (2001). Hatch Show Print: The History of a Great American Poster Shop. San Francisco: Chronicle Books.
York, M. (1982, October 31). Old-Time Print Shop Values Early Style. The Tennessean.

The Hermitage and The War of 1812 Source:
www.thehermitage.com

Lipscomb University Sources:
David Lipscomb Campus School Web Site (dlcs.lipscomb.edu/page.asp?SID=85&Page=2561)
Lipscomb University Web site (www.lipscomb.edu/content.asp?SID=4&CID=2117)
Hooper, Robert. (1977). David Lipscomb: More Than an Editor. Retrieved from (www.gospeladvocate.com/lipscomb.htm).
Tennessee Encyclopedia of History and Culture Web Site (tennesseeencyclopedia.net)

Loveless Cafe Sources:
19 Things You Didn't Know About....The Loveless Cafe. (2002, May 5). The Tennessean.
Ghianni, T. (1992, August 13). Long live beloved Loveless. Nashville Banner.
Lawson, R. (2003, November 27). Renovations to brighten future of Loveless. The Tennessean.
Loveless Cafe Web site (www.lovelesscafe.com/lovelesshistory.html)
Naujeck, J. A. (2006, June 29). Resurrected Loveless Cafe 'just as good as it ever was'. The Tennessean.

Montgomery Bell Academy Source:
Montgomery Bell Academy Web site

Nashville Ballet Source:
Davis, L. Personal Communication, May 10, 2007.

Nashville Farmers' Market Sources:
Duke, M. and Gerlock, K. (1993, April 19). Design would add 5 acres to market. Nashville Banner.
Goad, K. (1993, August 12). Farmers' Market planners site 21st century. Nashville Banner.
Kerr, G. (1995, July 24). Market Promises an Ethnic Extravaganza. The Tennessean.
Nashville Farmers' Market Web site (www.nashvillefarmersmarket.org/history.html)
Williams, J. B. (1986, May). "Farmers' Market: Pick of the Crop." Nashville Magazine.

Nashville Shakespeare Festival Source:
Personal correspondence

Nashville Symphony Sources:
Nashville Symphony Web site (www.nashvillesymphony.org/main.taf?p=2,11)
Hinton, A. (2006, May 11). A true work in progress. The City Paper.
Simbeck, R. (1996). The Nashville Symphony Celebrates 50 Seasons. Nashville: Nashville Symphony.
Natchez Trace Bridge Sources:

Nova page—PBS Web site (www.pbs.org/wgbh/nova/bridge/meetarch.html)
PCL Civil Constructors Web site (www.pcl.com/projects/Archived/5500600/index.aspx)
The Tennessee Encyclopedia for History and Culture (tennesseeencyclopedia.net)

Pancake Pantry Sources:
Arnold, Bernie. (1989, May 31). Pancakes make breakfast flat-out best. Nashville Banner.
Ippolito, Mark. (1993, May 15). Stars stop by to congratulate 'Momma'. The Tennessean.
Keel, Pinckney. (1979, November 29). Second Home at the Pantry. The Tennessean.

The Parthenon Sources:
Kreyling, C., Paine, W., Warterfield, C.W., and Wiltshire, S.F. (Eds.) (1996). Classical Nashville: Athens of the South. Nashville: Vanderbilt University Press.
Nashville Parks and Recreation Web site (www.nashville.gov/Parthenon/History.htm)

Purity Dairies Sources:
Promotional materials courtesy of Purity Dairies
Dudlicek, James. "Nashville Stars." Dairy Field. April 2007. Pgs. 18-22.

Ryman Auditorium Sources:
Nashville Public Television Web Site (www.wnpt.net/ryman/timeline/index.html)
Ryman Auditorium Web Site (www.ryman.com/)
Van West, C. (1998). Ryman Auditorium. In the Tennessee Encyclopedia of History and Culture. Pp. 820-821. Nashville: Rutledge Hill Press.
Zimmerman, P C. (1998). Tennessee Music: Its People and Places. San Francisco: Miller Freeman Books.

Tennessee State Capitol Sources:
Dekle, C. B. (1966). Tennessee State Capitol. Tennessee Historical Quarterly. Vol. 25, No.3. Pgs. 3-28.
Gadski, Mary Ellen. (1988). The Tennessee State Capitol: An Architectural History. Tennessee Historical Quarterly. Vol. 47, No. 2. Pgs. 67- 91.

Union Station Sources:
The Tennessee Encyclopedia of History and Culture
The Wyndham Union Station Hotel Web site
Cooney, Deborah, ed. "Speaking of Union Station: An Oral History of a Nashville Landmark." Williams Printing Co., 1977.
Sherman, Joe. "A Thousand Voices: The Story of Nashville's Union Station." Nashville: Rutledge Hill Press. 1987.

Vanderbilt University Sources:
Doll, G. (1994 Summer). Tales of the Commodore: Cornelius Vanderbilt at 200. Vanderbilt Magazine.
www.vanderbilt.edu
Vanderbilt University Special Collections and University Archives Virtual Reading Room

Vandyland Sources:
Blackwood, S. N. (2006, March 15). Customers say farewell to Vandyland. The Tennessean.
Courtney, R. (2006, April 7). Vandyland may not be dead yet; a plan is afoot. The City Paper.
Higgins, G. (2007, May 11). Reflections on West End's Candyland-Vandyland. The Tennessean.
Lawson, R. and Wood, T.E. (2006, February 24). Vandyland, R.I.P. Nashville Post.
Zepp, George. (2003, October 29). Candyland stirs sweet memories for many. The Tennessean.

Zoo Sources:
Nashville Zoo Website (http://www.nashvillezoo.org/about & http://www.nashvillezoo.org/our-blog/posts/city-invests-in-nashville-zoo)

THE CARIBBEAN

CENTRAL & SOUTH AMERICAN COOKBOOK

THE CARIBBEAN
CENTRAL & SOUTH AMERICAN COOKBOOK

TROPICAL CUISINES STEEPED IN HISTORY: ALL THE INGREDIENTS
AND TECHNIQUES AND 150 SENSATIONAL STEP-BY-STEP RECIPES

JENNI FLEETWOOD AND MARINA FILIPPELLI

HERMES
HOUSE

This edition is published by Hermes House

Hermes House is an imprint of Anness Publishing Ltd
Hermes House, 88–89 Blackfriars Road, London SE1 8HA
tel. 020 7401 2077; fax 020 7633 9499
www.lorenzbooks.com; info@anness.com

A CIP catalogue record for this book is available from the British Library.

Publisher: Joanna Lorenz
Editorial Director: Judith Simons
Editor: Clare Gooden
Photographers: Nicki Dowey, Will Heap and Patrick McLeavey
Home Economists: Fergal Connolly, Joanne Craig, Tonia George and Lucy McKelvie
Stylist: Helen Trent
Designer: Nigel Partridge
Jacket Design: Chloe Steers
Additional recipes: Rosamund Grant, Elisabeth Lambert Ortiz, Maggie Mayhew, Kate Whiteman

1 3 5 7 9 10 8 6 4 2

NOTES

Bracketed terms are intended for American readers.

For all recipes, quantities are given in both metric and imperial measures and, where appropriate, measures are also given in standard cups and spoons. Follow one set; they are not interchangeable.

Standard spoon and cup measures are level. 1 tsp = 5ml, 1 tbsp = 15ml, 1 cup = 250ml/8fl oz

Australian standard tablespoons are 20ml. Australian readers should use 3 tsp in place of 1 tbsp for measuring small quantities of gelatine, flour, salt, etc.

Medium (US large) eggs are used unless otherwise stated.

ACKNOWLEDGEMENTS

Jenni Fleetwood would like to pay tribute to Elisabeth Lambert Ortiz, Elisabeth Luard and Judy Bastyra, experts on the food and drink of Latin America and the Caribbean, whose books have been an inspiration for many years. In addition, she would like to thank Jane Raphaely for sending her to South America in the first place, and the 107ers for decades of support.

Marina Filippelli would like to thank her friends and family who were always present with suggestions, advice and a healthy appetite. This book would still be in the making were it not for Lizzie's help and Nick's infinite patience and encouragement. Special mention also goes to her parents who instilled in her a love for the food and culture of Brazil.

Additional picture material provided by South American Pictures: pages 7–25.

CONTENTS

A BRIEF HISTORY

The Caribbean and Latin America is a vast area comprising a large number of individual countries, each with diverse ways of preparing and serving food. The only thing they have in common is that they have all been subject to a Spanish or Portuguese influence, even if only, as is the case with some Caribbean islands, by way of exposure to their neighbours.

The events that led to the domination of the continent by two European powers began when Christopher Columbus petitioned for support for a voyage of discovery across the Atlantic in search of a sea route to India. At first he was turned down, but King Ferdinand and Queen Isabella of Spain eventually agreed to his request, largely out of a desire to find a new source for the spices the people of southern Spain had learned to love when under the control of the recently expelled Moors.

Columbus set sail on 3 August 1492, and in October of that year he reached Watling Island in the Caribbean. Convinced he had reached the Indies, he continued to Cuba and Hispaniola (now Haiti and the Dominican Republic). In 1500 the Portuguese explorer Pedro Cabral landed on the coast of Brazil,

and two years later Columbus reached the South American mainland. The early explorers were not interested in conquest, but individuals such as Hernán Cortés and Francisco Pizarro were dedicated to it. During the 16th century they invaded Mexico and Peru respectively, while other parts of Latin America fell to other conquistadors. In the process, great civilizations were overthrown and the stage was set for the total take-over of the continent by Spain and Portugal.

It was Napoleon III, the 19th century French emperor, who coined the term "Latin America" and applied it to those countries on the American continent where Spanish and Portuguese were spoken, including the Spanish-speaking Caribbean islands and Mexico. The term is now used to include all the islands.

The term "Latin America" suggests that nothing of value existed before the conquest, and it does not acknowledge the indigenous peoples nor the great civilizations – Maya, Aztec and Inca – they spawned. However, the term has value, if only as shorthand, in giving some indication as to the major cultural and culinary influences in this part of the world in the post-Columbian era.

NEW SETTLERS

When the first conquistadors landed in Latin America, they found many foreign ingredients. The most important of these was corn, which the indigenous peoples called *maïs*. Like wheat, corn could be used to make bread, but it was more versatile. The husks could be used as wrappers; the stalks for training beans; and the silks as ties. The cobs could be eaten fresh or stored for the winter.

Where corn and beans grew, so did squash. This remarkable food also kept well and yielded delicious seeds. Tomatoes were another important find, as were chillies. When Columbus first tasted a dish made using these fiery red and green pods, he assumed its heat came from black pepper and named the pods peppers.

The ships that brought the invaders sailed back to Spain laden with produce, then returned with settlers who brought their own bounty – cattle, pigs, sheep, wheat, sugar cane and nuts.

Below: The Caribbean islands and Central America have a vast coastline and fish and shellfish play an enormous part in their cuisines.

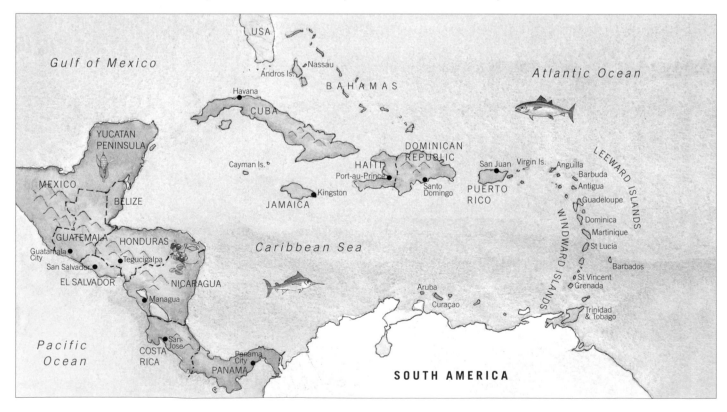

Priests came to Latin America too. Their aim was to convert the native population, but they also had valuable horticultural skills to pass on. The South American wine-making industries were started by priests who needed a ready supply of communion wine.

Lands were settled and crops were planted, but such activities required labour. At first the native population gave their assistance, but soon rebelled. The situation grew worse with the *encomienda* system, which gave Spanish individuals land rights. The indigenous peoples were forced to work for no payment other than Spanish lessons and religious instruction. They were shockingly exploited and the work was hard, especially for those already weakened by disease. They died in their thousands.

SLAVES AND SETTLERS

The colonists responded by importing African slaves to work the burgeoning sugar plantations. The Africans made a huge contribution to the regional cuisines, especially in Brazil. The climate was similar to their homeland, so the many vegetables and fruits they brought with them flourished.

Below: Native South American ingredients are sold daily at a busy traditional vegetable market in Peru.

The Spanish and Portuguese settlers intermarried freely with indigenous and African women and, as a result, the *mestizo* ("mixed") population grew.

The food became *mestizo* too. Many of the cooks were either indigenous or African women, and they prepared a mixture of their own recipes plus the dishes their employers wanted. Spanish ingredients – such as onions, garlic and rice – were incorporated, and Spanish dishes were adapted to include chillies, tomatoes and even cocoa. This two-way trade led to a vibrant Latino cuisine,

Other nations made a valuable contribution too. Indentured labourers from India, South-east Asia and the Far East have all contributed their own styles of cooking, and some Caribbean islands are, in culinary terms, forever England, France, Denmark or Holland, depending on their settlers.

Above: Although the cuisines of Latin America differ from country to country, there are some common ingredients.

Latin America is a turbulent part of the globe where the only certain thing is change; this is as true of the cuisine as anything else. Immigrants continue to introduce new dishes, and tourists take away memories of delicious meals they hope to recreate at home. This time the trade is between Latin America and the world. While pizza becomes commonplace in Brazil, ceviche is enjoyed in Canada, and Californian chefs hanker for *huitlacoche* (corn truffles).

Latin America still has secrets to divulge. In the jungles and hidden Andean valleys there are undoubtedly new ingredients waiting to be discovered. These will add another layer to a cuisine that is as exciting as it is extraordinary.

THE CARIBBEAN

A culinary cruise around the Caribbean is richly rewarding. Having feasted your eyes on beautiful turquoise sparkling seas, palm-fringed beaches, green velvet mountains and exquisite gardens, you can dine on dishes that are as diverse as the islands themselves. These islands offer some of the best seafood in the world, plus fragrant stews, spicy side dishes, unusual salads and sweet treats such as coconut ice cream and luxurious Caribbean fruit and rum cake.

EARLY HISTORY

The earliest inhabitants of the Caribbean islands were the Ciboney, hunter-gatherers who had themselves migrated from northern South America. They were supplanted by the Taino, Arawak-speaking fishermen and farmers, who in turn were harried by the warlike

Below: The Caribbean islands are a beautiful, lush and fertile place.

Caribs in a pattern that would be repeated again and again down the centuries as nation after nation fought for control of the islands.

The Taino were peace-loving people who lived in small communities and grew cassava, corn, squash, (bell) peppers, beans, sweet potatoes and yams – crops that remain the mainstay of the Latin American diet. Those who lived on the coast caught fish, which they often ate raw, and their diet was supplemented with ducks, turtles, snakes and small rodents.

The arrival of Christopher Columbus in 1492 spelled the beginning of the end for the Taino. Many of them succumbed to diseases, such as measles and smallpox, never before seen on the islands. Others died in the service of Spanish settlers who worked them cruelly on the land and digging for gold. The Caribs fared a little better. Most of them were now confined to the more eastern islands, and their fierce

reputation and remote location acted as a deterrent to would-be settlers. However, by the end of the 16th century, only a handful of the former inhabitants of the islands remained.

In their place came Spanish, English, French and Dutch settlers, the latter occupying the islands that Christopher Columbus had overlooked: Aruba, Curaçao and Bonaire. These islands, which would eventually become part of the Dutch Antilles, were "discovered" in 1499 by Alonso de Ojeda, one of Amerigo Vespucci's henchmen, and settled first by the Spanish and then by Dutch traders in the first half of the 17th century. The British and French, meanwhile, were becoming solidly entrenched in the Caribbean. Having already taken St Christopher (St Kitts) in 1623, the British quickly set up colonies on the islands of Nevis, Barbados, Antigua and Montserrat, while the French settled in Guadeloupe, Martinique and St Lucia.

Above: A local woman inspects the produce at a Caribbean street market.

SPANISH POSSESSIONS

The Spanish continued to dominate the most strategically important islands of Cuba, Jamaica, Puerto Rico and Hispaniola (modern day Haiti and the Dominican Republic).

During the next 200 years, the islands of the Caribbean became pawns in the hands of the European powers. They sometimes changed hands so frequently that would-be settlers set sail from home in the belief that they would be ruled by their compatriots,

only to discover on reaching their destination that it was now under the control of someone else. The island of St Martin, for instance, was tossed between Holland, Great Britain and France more than a dozen times, the shortest period of occupation being just 10 days. The island is still half Dutch and half French, which explains why it is today known by two separate names: Sint Maarten and Saint Martin.

Today, most of the islands have achieved autonomy from their European conquerors and have banded together to form Caricom, the Caribbean Community and Common Market.

FOOD AND DRINK

The turmoil of the early years meant that recipes tended to do the rounds. The Spanish dish, *pescado en escabeche* became known as eschovished fish, caveached fish or *escovitch*. *Callaloo*, a soup made from the leaves of a plant similar to spinach, is another successful migrant, being known variously as *le calalou, callilu, callau* and *calaloo*.

The French brought *bouillabaisse* to the islands, even though the fish used in the Caribbean version is very different from that found off the coast of Brittany. On Dominica and Montserrat they found frogs so large that their local name – mountain chicken – does not seem inappropriate. These French settlers wasted no time in teaching local cooks how to prepare frog's legs.

The Danes contributed recipes such as herring gundy, a dish of salt herring with potatoes, peppers and onion, and *croustadas*, which resemble savoury waffles. From the Dutch came *erwensoep* – a hearty pea soup – and the utterly delicious stew cooked within a whole cheese, *keshy yena*.

Made from fermented sugar cane, some of the world's best rums are still produced in the Caribbean, and rum cocktails are always a popular choice.

Below: Hard-working Caribbean fishermen bring the daily catch ashore, ready to be sold at market.

Creole cooking

This term is used to describe many traditional Caribbean recipes. It generally refers to dishes that have their roots in both Europe and Africa, and is also used in Louisiana and some other southern states of the USA. There, Creole cooking has French, Spanish and African influences, whereas in the Caribbean, the Spanish and African influences are dominant. The expression *cocina criolla* is loosely applied throughout Latin America as a catch-all term for the native cuisine.

Above: Sugar cane is a major export for the region; the annual harvest in Cuba is exhausting but rewarding work.

NEW CROPS

It is widely believed that Columbus planted the first sugar cane on the Caribbean islands. By the start of the 17th century, the crop's huge potential was being fully appreciated, and large sugar cane plantations had been established, together with plantations of other crops new to the islands, such as bananas, plantains, coffee, coconuts and oranges.

Growing all of these new crops required a large amount of labour, and since the indigenous population had been largely wiped out, this led to the importation of slaves on a massive scale. They arrived in their thousands, enduring dreadful journeys by sea and harsh lives after reaching their destination. The slaves often had to subsist on dried fish or meat alone, since they were forbidden from raising cattle and denied the opportunity to catch fresh fish. The many traditional Caribbean dishes based on salt cod, such as Jamaican salt fish and ackee, originated during this period. The

slaves, who came mainly from West Africa, introduced ingredients such as yams and okra, which were quickly incorporated into the Caribbean cuisine. They improved their bland diet even further by the imaginative use of spices, laying the foundation for the hot pepper sauces that would become synonymous with the islands in years to come.

When slavery was eventually abolished in the 1830s, indentured labourers from the Middle East, India and the Far East were brought to the islands; these labourers introduced yet more ingredients to the melange that is Caribbean cooking. Spicy curries and dishes such as lamb pelau entered the repertoire, along with *roti* and *dhal puri*, large flat breads filled with curried meat, fish or potatoes.

Today it is mainly tourism that drives the economy of the Caribbean islands. Although this has had some negative effects on the local cuisine, mainly due to the introduction of the "international menu" that some travellers demand, it has also stimulated interest in regional specialities. The more dynamic Caribbean chefs are revelling in the wonderful ingredients that are at their disposal, especially the superb seafood on offer all year round. New and exciting dishes continue to emerge alongside old favourites.

STREET FOOD AND SNACKS

Snacking is a popular pastime on the Caribbean islands, which goes some way towards explaining the abundance of food available from roadside stalls and bars, or beach vendors. In fact, street food accounts for 20–30 per cent of urban household expenditure on the islands, Whatever the time of day, wherever you are, tasty morsels can be found to satisfy your hunger pangs.

Among the items traditionally offered by street vendors are deliciously light fritters, made from conch, salt cod or perhaps split peas, with spring onions (scallions) or chillies for extra flavour. Barbecued jerk chicken is another favourite, and for easy eating and instant gratification you cannot beat a bowl of crispy plantain and sweet potato chips or lightly cooked coconut king prawns, served with a glass of ice cold beer or one of the rum cocktails for which the islands are famous.

The quintessential Caribbean fast food, enjoyed by locals and tourists alike, is *roti*, a large flat bread with a tasty curried filling such as conch, goat or a selection of vegetables. Plantain dumplings are also a popular choice.

Below: In Havana, Cuba, a street vendor prepares sausages, delicious stuffed pastries and fried potatoes.

Above: The "Day of Kings" festival, which celebrates African gods, is a time for partying on the streets of Cuba.

FEASTS AND FESTIVALS

Carnival is the highlight of the year on the Caribbean islands. The build-up begins with the calypso season, which starts in January, then as Ash Wednesday approaches, signalling a period of sobriety and self-control, the streets ring to the sound of steel bands. In Aruba and Trinidad and Tobago, Carnival is a particularly extravagant affair. Local festivals are also held throughout the year. Puerto Rico commemorates the island's African-American heritage every June, and Jamaica has a popular reggae festival in July. Saints' days are always a good excuse for a celebration too, and they inevitably offer the opportunity to sample local food.

Special occasions are often marked by the roasting of a suckling pig. Slow roasting and regular basting ensures

that the meat is beautifully tender, but the best part for many diners is the stuffing. This varies from island to island and from cook to cook, often being made to a recipe that is a closely guarded secret. It may be hot and spicy, fresh and fruity or made from offal, with the heart, liver and kidneys of the pig mixed with sausage, onions and herbs. Rum or brandy is often added to give an extra kick.

No festival would be complete without food, and traditional Caribbean festival fare, available from street vendors, includes fish cakes, Jamaican saltfish fritters ("stamp and go") and rice and peas. More adventurous regional delicacies include *griot* (hot Haitian fried pork), jerked chicken and curried goat. Street-side food vendors can often be seen serving up more exotic foods, including fresh catfish and red snapper, Thai noodles or Mexican empanadas. In addition, hot dogs, sweets (candy), fresh fruit smoothies, soft drinks, ice-cold beer and rum cocktails are always popular.

The rum tradition

Not much goes on in the Caribbean that doesn't involve rum. It was developed in the 16th century by colonists who distilled molasses to trade for slaves in Africa. From here it was sent north to European markets, where a Spanish wine merchant, Facundo Bacardi, developed a process of charcoal filtering, to make rum taste better. Bacardi is now the leading brand of white rum and the best-selling spirit worldwide. Aged rum is darker, taking on the colour of the barrel in which it ages. It has a mellower taste that makes it perfect for sipping. Not all dark rums are aged, however – some have colour and flavour additives. There are dozens of rum cocktails available throughout the Caribbean. Three favourites are the daiquiri, the mojito and the pina colada.

BRAZIL

Whether it is because it is the largest country in South America or has such rich cultural and racial diversity, Brazil is a place that celebrates excess. The Brazilian people love to eat, love to drink and love to dance. A trip to this, the only Portuguese-speaking country in South America, is a glorious assault on all of the senses, and never more so than during Carnival, when the streets throb with the sounds of samba music and the vibrant colours of the costumes fizz like the fireworks that explode overhead. The food is just as exciting, Sample delicious seafood in Rio de Janeiro, unusual pork dishes in Minas Gerais, tender beef in Rio Grande or the

Below: The Amazon river and rainforest cover much of Brazil and are home to many unusual species and crops.

spicy specialities of Bahia, where Africa meets South America in an explosion of unusual and fiery spices.

EARLY HISTORY

Some 50,000 years ago primitive peoples crossed from Asia to America by way of the Bering Strait land bridge and began the long trek south. Nobody knows for certain quite when they reached South America, but hunter-gatherers were certainly enjoying the fruits of the Amazon basin by 8000BC. Fish, manatees, turtles, game animals and birds were plentiful, and they supplemented their diet with cassava (*manioc*), nuts and fruits that grew in the area. Some migrated to the coast, and survived mainly on shellfish, as is evident from the huge shell mounds that they left behind.

Above: Coffee berries are picked by hand when ripe, then exported around the globe in huge quantities.

Brazil did not have the great civilizations that evolved in Central America and the west of the continent. Instead, as the indigenous people abandoned their nomadic lifestyle for farming, settled communities or chiefdoms were established. As well as cassava, corn, sweet potatoes and squash were grown, often on the shell mounds left by their predecessors. The existence of these early settlers was not as peaceful as it sounds, however. At least one of the tribes, the Tupinambá, were cannibals who not only ate their enemies, but fattened them up first.

PEDRO CABRAL

In 1500, the Portuguese explorer, Pedro Cabral, claimed Brazil for Portugal, but he only stayed long enough to erect a cross, say a few prayers and take on board his ship some unusual wood that yielded a red dye – *pao Brasil*. His compatriots at home were not very excited about this new territory, but Portuguese merchants considered that the wood might be worth exploiting, and a few expeditions were mounted to cut down the trees. Trading stations were gradually set up along the coast to the north and south of Salvador de Bahia, and the country came to be known by the same name as the wood, Brazil.

In the beginning, these Portuguese settlers and the indigenous peoples co-existed amicably enough, but when what had been a minor timber operation began to escalate into a mass export operation, the natives began to withdraw their labour. They were even less enthusiastic about working on the many sugar plantations that had been established from the middle of the 16th century onwards. The Portuguese settlers tried to force the native South Americans by enslaving them, but so many died from exhaustion or disease that the plantation owners began to import African slaves instead.

SUGAR AND THE SLAVE TRADE

By the time slavery was finally abolished in Brazil towards the end of the 19th century, around four million African slaves had made the terrible journey from their native land to Brazil. Many did not even survive the long crossing, and many others died shortly after their arrival on the plantations (*engenhos*) where sugar was grown and processed.

A few successfully escaped to form their own secret communities, known as *quilombos*, while others survived their bondage by focusing on keeping alive their music, culture and religion, and cooking food similar to that which they enjoyed at home. It was the Africans who originally introduced ingredients such as black-eyed beans (peas), okra and yams to Latin America, and these

thrived in a climate that was quite similar to that of West Africa. Food was used for purposes of ritual as well as sustenance, and some of the recipes cooked throughout Brazil today evolved from the foods prepared by African priestesses to offer to their gods.

GOLD RUSH

In the late 17th century, Brazilian explorers, known as *bandeirantes*, began to find gold in the mountain streams to the north of Rio de Janeiro. The ensuing gold rush led to a boom time in Brazil. Despite the relative inaccessibility of the main goldfields, new towns quickly began to spring up in the area that would later come to be known as Minas Gerais (which translates as "general mines").

Prospectors travelled to this area from all over Europe, hoping to make their fortune. Many of the country's sugar-cane planters also joined the gold rush, taking their slaves with them.

Above: In more cosmopolitan cities such as Rio, every imaginable cuisine from around the world is available.

Several years later, around 1720, diamonds were also discovered in the region, and for about a century, Brazil became the world's major supplier of both gold and diamonds. To this day, Minas Gerais remains one of the richest areas in the country.

THE ROYAL COURT

In 1808, after the occupation of Portugal by the French, the Portuguese royal court decamped to Rio de Janeiro, making the city the new capital of their empire. When King Dom João VI finally returned to Spain in 1821, he left his son Dom Pedro I behind to rule Brazil. Dom Pedro I was subsequently recalled to Portugal, but he defied his father and the Portuguese government and declared Brazil's independence in 1822, with himself as Emperor.

Dendê oil

African slaves transported to Brazil initially missed one of their favourite ingredients, dendê oil, which comes from the fruit of the African oil palm and is valued for its rich orange-red colour. Fortunately, they soon discovered that a similar colour could be obtained by adding crushed annatto (achiote) seeds to ordinary oil. Dendê oil is now widely used in Brazilian cooking, especially in Bahia, where the African influence is strongest.

GERMAN FARMERS

Dom Pedro's wife, Empress Dona Leopoldina, conceived the idea of peopling the vast area of southern Brazil with European farmers to work the land. Thousands of German colonists arrived and settled in the state of Rio Grande do Sul. In places such as Novo Hamburgo and Blumenau, their culinary contribution is evident and remains today, with sauerkraut, sausages, spätzle and delicious sweet pastries.

COFFEE – THE NEW CROP

In the century following independence, coffee replaced sugar as Brazil's premier export product. Further foreign immigration was encouraged for the purpose of having enough labour to work on the coffee plantations. Immigrants, especially Italians, quickly followed by Japanese, Spanish and Portuguese, flocked to cities such as Sao Paulo. Coffee was the major source of income for Brazil in the 1870s and the 1880s, and in 1889 the powerful coffee producers helped to bring about a military coup after which Brazil became a republic.

Below: Large freshwater catfish are displayed for sale at the busy Ver o Peso *market in the Amazon.*

FOOD AND DRINK

There is a wide variety of food on offer throughout Brazil. In the coastal belt, where the majority of the population lives, cosmopolitan cities such as Rio de Janeiro, Salvador and Sao Paulo have every type of restaurant imaginable to choose from, including those that specialize in regional cuisine.

Among the specialities is *feijoada completa*, not so much a dish as a lavish feast. A huge platter of fresh and smoked meats, including pig's tongue, is flanked by black beans, rice, spring greens, farofa (flavoured toasted cassava flour), orange slices and several sauces, all washed down with *caipirinha*, which is a mixture of *cachaça*, sugar and lime. Although they have a burgeoning wine industry in the temperate south, Brazilians prefer to drink iced beer or *cachaça*, which is often mixed with fruit juice or milk.

Rice is grown in Brazil and is the most widely used accompaniment, along with the ubiquitous farofa. In coastal areas, fine seafood is on offer.

REGIONAL CUISINES

There are four main regional cuisines in Brazil, plus the cooking of the Amazon region, where roasted game, exotic freshwater fish and unusual fruits can be encountered.

Above: The traditional Brazilian Saturday lunch is feijoada completa, *a meal of meats, rice, beans, greens and farofa.*

Comida Mineira is the cuisine of Minas Gerais. For over a century Minas Gerais was the wealthiest part of Brazil, and it is still rich in minerals. Farming is also important there. Crops include corn, beans, coffee and fruit, and there are large herds of beef and dairy cattle. Pork is the favourite meat, especially *lombo*, pork fillet or tenderloin. Bean dishes are also typical of the region, a favourite being *tutu*, which consists of black beans cooked with cubes of bacon and cassava flour and served with meat. Minas Gerais is also well known for its cheeses.

The well-travelled chilli
When African slaves introduced the malagueta chilli to Brazil, few people realized it was a returning immigrant. It originated in Central America, was taken to the northern hemisphere by the Spanish and eventually found its way to West Africa, finally returning to the continent of its birth in the baggage of slaves bound for Brazil.

Comida Baiana is perhaps the best known style of cooking in Brazil, celebrating that province's connection with Africa. Popular ingredients here include okra, dendê oil, dried shrimp, coriander (cilantro), coconut milk and lots of fresh seafood. A popular snack is *acarajés*, tasty bean patties or fritters, split and filled with various sauces. *Moqueca* is an aromatic dish of seafood, tomatoes, (bell) peppers, fresh coriander (cilantro) and dendê oil, invariably served with farofa to soak up the delicious coconut sauce. Brazilians like to finish a meal with fresh fruit. Desserts tend to be very sweet and are often based on custards in the Portuguese style. Avocado is often served as a mousse or ice cream.

Comida do Sertão is the cuisine of the vast plateau in the north-east of Brazil and can be sampled in the country's capital, the purpose-built city of Brasília. Dried salted meat – *carne seca* – comes from this region and beans are used in hearty meat dishes. Pumpkins, peppers and corn also feature, along with exotic fruits such as guavas, mangoes and carambolas. Favourite sweetmeats of the region include candied orange peel and candied figs.

Below: A Bahiana street vendor prepares local delicacies for passers-by, including acarajés, *delicious fried bean fritters.*

Comida Gaúcha means meat and plenty of it. This describes the cooking style of the vast Brazilian cattle country down south. A big feature of this area are the popular *churrascarias* – restaurants where you can sample almost every cut of meat imaginable, including all types of offal and a wide variety of delicious sausages.

Above: Brazil is renowned for its spectacular Mardi Gras carnival, when everyone takes to the streets to party.

STREET FOOD AND SNACKS

Brazilians like to be able to eat wherever and whenever the whim takes them, so street food is always on offer. This ranges from simple hot dogs, hamburgers and toasted cheese sandwiches to the filled bean or cheese patties known as *acarajés*. Pastries on offer include *pastels, esfihas* and *empadinhas*, which are baby empanadas stuffed with a variety of delectable fillings, such as fresh palm hearts in a tasty savoury sauce.

FEASTS AND FESTIVALS

The main celebration of the year throughout Brazil is *Carnaval*. Rio de Janeiro is the city usually associated with this extravaganza, but Brazilians often prefer to celebrate by taking part in the less touristy but equally electric spectacles in cities such as Salvador, Recife and Olinda. The build-up to *Carnaval* begins soon after Christmas and reaches its peak as Lent begins.

ARGENTINA, URUGUAY AND PARAGUAY

The cuisines of these three countries have one major ingredient in common – beef. Argentines eat a great deal of it and Uruguayans eat even more. It is less popular in Paraguay, but even there you will often find barbecues piled high with tender steaks, ribs and parts of animals that you never knew existed. Few ethnic dishes survive in these countries, except in Paraguay, where the indigenous Guaraní once lived. Their traditional crops – cassava, corn and sweet potatoes – are still staples.

EARLY HISTORY

Although this part of South America was claimed by Spain in the early part of the 16th century, there was no rush to colonize the territory. The first of the explorers to come ashore, Juan Días de Solís, was attacked by hostile natives and – according to some records – eaten. This was a powerful deterrent, although it did not prevent one of the survivors of the expedition from pressing on to Paraguay and then Bolivia. Here he acquired some silver, which was discovered after his death on

Below: Gauchos on an Argentine cattle ranch demonstrate their riding skills for Dia de la Tradicion.

the return journey. This sparked a rumour that Spain's recent acquisition might hold riches. The country was christened Argentina, meaning "place of silver", but when reality failed to match rumour the Spanish lost interest. In any event, by 1531 they were preoccupied with Peru, where gold and silver was being "liberated" from the Inca Empire by Francisco Pizarro.

The first permanent settlements in Argentina were in the Andean valleys close to the border. Santiago del Estero, Tucumán and Córdoba were established in 1535. A year later, Pedro de Mendoza set up camp close to the Rio de la Plata, on a site that would one day become Buenos Aires. His hopes of founding a city were dashed, however, when natives attacked and he was forced to decamp to Uruguay.

Until the arrival of the Spanish, this part of South America was peopled by various tribes of hunter-gatherers turned farmers, growing crops such as corn, cassava, sweet potatoes, beans and peppers. Coastal peoples supplemented their diet with food from the sea – fish, shellfish and even seals. There were no great civilizations in this area, like those that existed in Peru or Central America. Pottery, stone carvings

Above: The different varieties of corn display many striking colours – here they have been left to dry in the sun.

and rock paintings survive, but few of the inhabitants themselves withstood the arrival of the Europeans. War and disease quickly decimated their numbers, and by the end of the 19th century, very few of the early people remained.

THE PAMPAS

In 1581 the Spanish made a second attempt to establish a settlement on the banks of the Rio de la Plata in Argentina, and this time they succeeded. The extensive plains, or pampas, surrounding the place they called Buenos Aires proved to be incredibly fertile, and agriculture was rapidly established.

Cattle and horses that had escaped the original settlement had bred freely, and vast herds of animals now roamed across the pampas. This unexpected bounty was exploited by gauchos, or cowboys, who broke the horses and corralled the cattle. At first the animals were mainly killed for their hides, but when large salting plants were established in the early 19th century, the beef industry burgeoned. The pampas were fenced off and huge estates, *estancias*, were quickly established. Only the very rich could afford to buy these estates and soon the landed class became the most powerful people in Argentina.

In 1816 the country, for the first time, became independent. During the second half of the 19th century, demand for cheap food in Europe led to further expansion of the beef industry and immigrants poured in. Meat processing factories, including the famous Fray Bentos plant just across the river in Uruguay, were built. At the same time sheep farming was becoming established in Patagonia and by the early part of the 20th century, Argentina was a major exporter of beef and lamb, wheat and wool. These remain important today, although now much of the pampas is given over to grain and oil seed farming.

AN ARGENTINE ASADO

The traditional way of cooking meat in Argentina is *al asador* – on the spit. The meat is impaled on metal rods, which are stuck into the ground at an angle to prevent the meat juices from dripping on to the fire. Whole carcasses or sections of carcasses are cooked this way, and the meat is sliced off and served after guests have enjoyed the traditional appetizers – kidneys, morcilla and chorizo sausages, livers and *chinchulin* (loops of stuffed intestine).

Below: The herbal tea drink, yerba maté, *is drunk throughout Argentina, and is often served in a dried, decorated gourd.*

FOOD AND DRINK

With so much good quality beef at their disposal, it is not surprising that meals revolve mainly around meat, which is usually served with a piquant sauce, *chimichurri*. Fish is not as popular as meat, despite being in plentiful supply, and vegetables are not much in evidence either. Meat consumption is lower in Paraguay, which, along with northern Argentina, is the only area where ethnic cuisine is still widely served. Corn meal is used to make delicious spoonbreads and puddings. Cassava, which Paraguayans call *mandioca*, is baked with cheese and eggs or transformed into flat breads that resemble tortillas. The influence of indigenous cooks is also evident in Argentine dishes such as *carbonada criolla*, a stew served in a pumpkin; and *humitas*, a puréed corn mixture which is often steamed in corn husks.

Immigrants have exerted considerable influence on the food of Argentina and Uruguay. The pasta and pizzas in Buenos Aires and Montevideo are said to be as good as any in Italy, and the Italians also inspired an Argentine dish in which pork is baked in milk. The Spanish influence remains strong, but Middle Eastern, Chinese, Japanese and Korean settlers have also made their

Above: In Buenos Aires, Argentina, a chef prepares large pieces of meat to be grilled at a traditional asado.

mark. In the beautiful Lake District, where the Andes provide a towering backdrop to towns that look more European than South American, visitors can sample delicious fondues, sweet pastries or the local chocolate.

Yerba maté, a type of herbal tea, is the drink of choice in Argentina, Uruguay and Paraguay, along with wine, beer and *caña*, a cane spirit.

STREET FOOD AND SNACKS

Empanadas with various fillings are popular, as are tiny cheese and ham sandwiches. Pastries are often very sweet, especially the ones that incorporate *dulce de leche* (caramelized milk). Churros, the Spanish answer to doughnuts, are enjoyed with hot drinks.

FEASTS AND FESTIVALS

The most interesting festivals in this area are those that focus on the gaucho tradition. These include demonstrations of riding skills and the opportunity to sample a traditional *asado*. In Montevideo, the summer *Carnaval* is famous for the African drumming that accompanies *candombe* dance troupes.

PERU, BOLIVIA AND ECUADOR

Many of the world's most popular foods come from the arable Andean highlands of Peru, Bolivia and Ecuador. Potatoes originated in this region, as did tomatoes, squashes, pine nuts, quinoa, tamarillos, sweet potatoes and several types of bean. All of these foods were cultivated by some of the most fascinating civilizations the world has ever seen.

EARLY HISTORY

Unlike Brazil and Argentina, where no major civilizations were based, this part of South America has been home to a succession of highly developed cultures. Among these were the Nasca of Southern Peru, who etched the soil with elaborate geoglyphs so large that their shapes – patterns, birds and animals – can only be fully appreciated from the air. In the north of the country, the Mochica people built impressive pyramids, while the Tiahuanuco established an empire that ruled Peru, Bolivia, Chile and Argentina for over 1,000 years. Shortly after their collapse towards the end of

Below: Corn grows in abundance on the Incan agricultural terraces in the Peruvian highlands.

the 12th century, a Quechua tribe, one of many in the mountains, began to establish a power base in the area around Cuzco. Their leader, known as the Inca, was Manco Capac. Within 300 years the Inca empire stretched from Colombia to northern Chile and ruled over more than 15 million subjects. Aside from their military might, skilled governance and prodigious building skills, the Incas also improved farming by introducing terracing and irrigation, cultivating new crops such as cassava and peanuts, and elevating the already high status of corn by declaring that only the Supreme Inca himself could plant the first seed of the new season.

The Inca civilization endured until 1533, when Cuzco fell to the Spanish conquistador, Francisco Pizarro. Along with Ecuador and Bolivia, Peru (which at that time included the northern part of present-day Chile) became part of the Viceroyalty of Peru, administered first from Lima and then from Quito. A period of Spanish colonial rule followed, coming to an end when Peru declared its independence in 1821. Ecuador did the same thing a year later, and Bolivia followed in 1825.

FOOD AND DRINK

Their shared history, first as part of the great Inca empire and later under Spain, means that the countries of Peru, Ecuador and Bolivia share similar cuisines, though each country has its own specialities. The Spanish influence is most noticeable on the coast, while in the high Andes, Quechua people fought to preserve their customs, eschewing Spanish ingredients and cooking methods. Away from the big cities it is still possible to come across dishes that have changed little for centuries.

Potatoes are eaten extensively throughout this region. Cooks are fortunate in having a wide variety of potatoes to choose from, and they take great care in selecting the right type for the dish. The yellow Papa Amarilla, for instance, tastes great in *causa*, a Peruvian speciality, which has an infinite number of variations. One way of preparing it is to layer cooked potatoes with flaked fish, chopped tomatoes and avocado; another variation tops the potato with an onion sauce before garnishing it with hard-boiled eggs, lettuce, peppers and olives. Equally delicious is *ocopa arequipena*, in which cooked potatoes are covered in a spicy cheese and walnut sauce.

A typical Peruvian dish is *carapulcra*. Dried potatoes, a throwback to Inca days when potatoes were freeze-dried on top of the high mountains, then squeezed dry and placed in the sun until hard, are traditionally used for this dish, although fresh potatoes can be substituted if the dried variety are unavailable. Potato and cheese rissoles are extremely popular in Ecuador, while in Bolivia potatoes are often simply mashed with a little oil and lemon juice, then served with chopped cassava, locally known as *yuca*, and corn, both of which are staple foods.

One of the most fascinating Peruvian ingredients is quinoa, known as the "mother grain" by the Incas. The tiny grains have a mild, slightly bitter taste and firm texture, and should be cooked in the same way as rice. Quinoa is an excellent source of protein and can be added to stews, bakes or salads.

Above: At an Ecuadorian market in Otavalo, women in traditional costume buy fresh fruit and vegetables.

FISH AND MEAT

Bolivia is one of only two landlocked countries in Latin America. As a result, the inhabitants do not eat as much sea fish as their neighbours, but fresh fish in the form of trout from Lake Titicaca is very popular. Peruvians enjoy a wide variety of fish and are especially fond of corvina or striped bass. They also have access to excellent seafood. The Pacific seaboard is noted for its delicious ceviche, the dish famous for "cooking" the fish by marinating it in fresh citrus juices. Lime juice is usually used in ceviche but in Ecuador the juice of bitter oranges is preferred.

Although Peruvians produce beef and pork and enjoy both, they are particularly partial to duck and chicken and also like to eat *cuyes* (guinea pigs). These vegetarian animals are raised in much the same way as rabbits or hens, and smallholders will often let them range freely around their homes. *Cuyes* are also raised commercially, on farms. Popular ways of cooking *cuyes* include stewing in a rich sauce and grilling over an open fire. Other exotic meats can be sampled in the jungles of Ecuador, where animals such as wild boar and monkey are often eaten.

Because mountain-bred animals are often tough, their meat is usually chopped into very small pieces, then stewed with corn and the rocoto or mirasol chillies that are widely used in this part of Latin America. This helps to tenderize the meat.

Many fruits are grown in this region, including pineapples, cherimoyas, mangoes, guavas and passion fruit. Bananas and plantains are also widely cultivated, especially in Ecuador. Other important ingredients are walnuts, pine nuts and peanuts, which are often ground to make rich sauces.

A favourite drink is *pisco*, a grape brandy that is common to Peru and Chile. *Chicha*, a type of beer made from fermented corn, is also drunk.

STREET FOOD AND SNACKS

A popular snack is *anticuchos* (ox heart kebabs). The meat is trimmed, marinated in spiced vinegar and speared on lengths of sugar cane before being grilled with a spicy basting sauce. Other street foods include empanadas or *pastelos* (pastries stuffed with a variety of tasty fillings) and *humitas* (fresh corn dough with a savoury or sweet filling, steamed in a corn husk parcel). Crisp plantain chips are an Ecuadorian speciality, while Bolivians like to snack on caramel-coated popcorn called *pasacaya*.

FEASTS AND FESTIVALS

Easter is celebrated in style in all three countries. The best-known Quechua festival is Inti Raymi (the festival of the sun), which celebrates the winter solstice on 24 June each year. This huge celebration often continues for days. In Ecuador, the self-proclaimed banana capital of the world, there is a banana festival every September.

Below: In La Paz, Bolivia, a market trader displays just some of the many varieties of potato grown in the region.

CHILE

A slender ribbon of a country, Chile is dominated by the Andes mountain range and measures some 4,830km/ 3,000 miles from north to south, but is never much more than 160km/100 miles wide. In the north is the strangely beautiful Atacama Desert; in the south, beyond the Continental ice field, lies a rugged land of glaciers and fjords. Between these extremes is a temperate, fertile zone where fruits and vegetables grow abundantly. The waters off the coast of Chile provide superb seafood.

EARLY HISTORY

The north of Chile was once ruled by the Incas, but before they came to prominence in the early 13th century, the land played host to a succession of tribal groups. The first of these is believed to have settled in the south of the country as early as 14,000 years ago. More recent inhabitants were the

Below: Chile's ice fields, such as Torres del Paine, Patagonia, lie to the south of a more temperate, fertile area.

Aymara, who cultivated corn and potatoes in the far north, trading these foods for guano, a rich fertilizer gathered by coastal tribes. Also occupying the northern region were the Atacameño, whose descendants still uphold some of their tribal traditions. Another important group, the Mapuche, were fierce warriors who successfully kept the Inca and Spanish invaders at bay for centuries.

The Spanish finally gained a foothold in Chile in 1541, when Pedro de Valdivia founded Santiago. The town was almost lost six months later when natives attacked, but the community survived and less than 20 years later the Spanish were firmly entrenched.

The colonists quickly began to establish large estates or haciendas over much of the country. These were initially worked by native South Americans who were little more than slaves, but when the spread of European diseases virtually annihilated the native population, tenant farmers of mixed blood (*mestizos*) took their place.

Until the 18th century, Chile remained a largely agrarian country. As the Audiencia de Chile, linked for administrative purposes to the Vice-royalty of Peru, it was ruled from Lima, and was only permitted to trade with the mother country. All goods destined for Spain therefore had to go via Lima.

Chile was ripe for change when Napoleon's invasion of Spain in the early 19th century signalled the beginning of the end of that country's dominance in Latin America. When Napoleon placed his brother on the Spanish throne, the citizens of Santiago who were loyal to the deposed King Ferdinand VII refused to acknowledge the usurper, and declared on 18 September 1810 that they would rule Chile themselves until the French were ousted from Spain. This independence was short-lived, however, as troops from Peru soon re-established control. Independence would only be formally declared in 1818, after José de San Martín's liberation army had crossed from Argentina into Chile.

Above: Garlands of dried shellfish hang from market stalls in Puerto Montt, Chile, a town known for its seafood.

After initial turmoil, the country became relatively stable. Agriculture and mining prospered, and were bolstered by the arrival of settlers from Ireland, England, Germany, France, Italy, Croatia and the Middle East. All of these immigrants had an influence on the Chilean cuisine, but the national diet still has strong links with its origins, and traditional ingredients such as corn, squash, beans and potatoes are widely used.

FOOD AND DRINK

Any discussion about food in Chile inevitably centres on the extent, excellence and variety of seafood available. The plankton-rich Humboldt current is responsible for the largesse, which includes crabs, clams, mussels, abalone, razor clams, sea urchins, squid, octopus, scallops and lobsters. Some or all of these types of seafood, plus less identifiable specialities such as *picorocco* (giant barnacles), are likely to be among the treats on offer at that most Chilean of feasts, the *curanto*, a massive cookout that involves a carefully constructed pit, hot rocks and leaves to seal in the steam.

Fish is equally abundant. Popular varieties include congrio, a slender fish that resembles an eel; corvina, a type of bass; swordfish and the Patagonian toothfish. Chile is also one of the world's biggest exporters of salmon.

Corn features widely in many recipes, from soups and breads to the delicious *pastel de choclo*, which is a traditional stew topped with a corn crust. Meat is not as central to the diet as it is in neighbouring Argentina, but Chile produces some fine beef, pork and lamb nevertheless.

Chilean desserts are similar to those served elsewhere on the continent, mainly taking their inspiration from Spain and making great use of the thick, sweet caramelized milk called *dulce de leche*. The central valleys produce excellent fresh fruit throughout the year, and deliciously sweet cakes and pastries are also available, courtesy of German settlers.

Chileans enjoy a good bottle of wine and are extremely proud of their vineyards, which are rapidly gaining worldwide recognition. Also popular is draft beer, known locally as *schop*, and the delicious grape brandy, *pisco*.

A curanto on Chiloé
The beautiful archipelago of Chiloé, situated off Puerto Montt, is famous for its fine seafood, wooden churches and laid-back atmosphere. This is a great place to sample the *curanto* – a full-scale Chilean seafood feast.

STREET FOOD AND SNACKS

For munching on the move, Chileans tuck into meat, seafood, empanadas, *humitas* and sandwiches, from steak with all the trimmings to *ave-palta* (chicken and avocado).

FEASTS AND FESTIVALS

Independence Day on 18 September is celebrated with music, dancing, eating and drinking, and marks the start of summer. The rodeo season also starts in September, with the major event, the National Rodeo, taking place in March. Ngillatun is an ancient Mapuche festival celebrating harvest and fertility.

Below: An impressive array of fresh fruit and vegetables are on offer at a market in Valdivia in Chile's Lake District.

COLOMBIA AND VENEZUELA

At the upper end of South America lie two countries that are as mysterious as they are magnificent. Colombia and Venezuela have some of the most rugged terrain on the continent. From the tropical rainforest of the coast, the land rises to range after range of high mountains, the cordilleras of the Andes. Ravines, mighty rivers and dense vegetation make exploration difficult, and communities have historically been isolated. Until the first settlers arrived there was, therefore, no universal style of eating, and the Spanish were able to establish theirs as the core cuisine in both countries.

EARLY HISTORY

Columbus discovered the mouth of the Orinoco River in 1498. The first Spanish settlement in Venezuela was established in 1521 and in Colombia four years later. In the early 19th century both countries united with Ecuador and Panama to form the union of Gran Colombia, after their independence was won by Simon Bolivar. Venezuela left the union to become a separate state in 1830, as did Ecuador, and Panama eventually left the union in 1903.

FOOD AND DRINK

Both Colombia and Venezuela have lowland plains, temperate zones above 900m/3,000ft and highlands leading to alpine-style meadows. At sea level, sugar, cacao, coconuts, bananas and rice are cultivated. Higher up are the coffee plantations and corn fields, and above these cereal crops, potatoes and temperate fruits are all grown. This huge diversity of landscape means that both countries have a wide range of foods available to them, from the traditional ingredients such as cassava, squash, beans and corn to a dazzling array of fruits.

Favourite Venezuelan dishes include delicacies such as *mondongo* (tripe with vegetables, corn and potatoes), *sancocho* (fish stew) and *parrillado* (barbecued meats), while Colombian specialities include rabbit in coconut milk, chicken hotpot with three different types of potato, and a delicious

pineapple custard. Colombia has the benefit of a coastline on both the Caribbean Sea and the Pacific Ocean, so it has a wonderful selection of fish and seafood readily available. *Arepas* (flat corn breads) are a very popular snack. Both countries produce lots of coffee and it is one of their major exports; Colombian coffee is reckoned to be among the finest in the world.

Above: Roadside vendors are a common sight in Colombia, selling fruits such as bananas, melons and pineapples.

A seasonal speciality and a great delicacy in the lowland regions are flying ants, which are toasted and served like peanuts. In Venezuela a delicious spicy sauce, *katara*, is made from the heads of leaf-cutter ants.

The lure of El Dorado

The rumour of a land where gold was so plentiful that people powdered themselves with gold dust lured many 16th-century adventurers to the countries now known as Guyana, Surinam and French Guiana. The glut of gold never materialized but the Spanish, Dutch, English and French all thought that the land was worth fighting for.

The English eventually triumphed in Guyana, but only after many years of Dutch settlement. Surinam went to the Dutch and French Guiana became first a French penal colony and then an overseas department of France. Still heavily subsidized by France, French Guiana has a distinctly Gallic atmosphere, with

pavement cafes and food with a distinctly French flavour. In Guyana and Surinam, where African slaves and indentured labourers from India, China and the East Indies were imported to work the sugar plantations, the cooking is more eclectic. Javanese noodle dishes and Chinese stir-fries are sold alongside native South American Indian dishes like pepperpot – a stew with meat tenderized by cassareep (cassava extract). Seafood is popular, especially prawns (shrimp), and plantains, bananas, cassava, beans, peanuts and squash are also widely used. The area is famous for its superb fruit, and for unusual vegetables like *pom*, a large yellow root that closely resembles cassava.

CENTRAL AMERICA

The land that connects Mexico with the rest of South America consists of seven countries, Guatemala, Belize, El Salvador, Honduras, Nicaragua, Costa Rica and Panama. Beans and rice are the staple foods in all these countries, but there is also fine fish to be had, thanks to the proximity of the Pacific Ocean and the Caribbean Sea.

EARLY HISTORY

The empire of the Maya extended to Honduras. When they disappeared from Central America around AD900 they not only left behind ruined cities like Tikal in Guatemala, but also new foods and sophisticated farming techniques, some of which were adopted by natives.

Columbus reached the shores of Honduras and then Costa Rica in 1502, but the area was not settled until some 20 years later, after troops led by Pedro de Alvarado came south from Mexico. Alvarado took Guatemala, Honduras and El Salvador. By 1530 there were Spanish colonists in most of Central America. Government was a haphazard affair, but in 1535 Guatemala, Honduras, El Salvador, Nicaragua and Costa Rica were incorporated into the Viceroyalty of New Spain, headquartered in Mexico City.

Below: Corn fields flourish alongside impressive mountains at the south-east tip of Lake Atitlan in Guatemala.

In 1821, the quintet opted out and two years later formed a federal republic, known as the United Provinces of Central America. The states were all autonomous, however. Belize became British, largely by default. Although the area was technically Spanish, British buccaneers established bases there and were later joined by British soldiers from Jamaica. In 1798 the British connection was formalized, and the link was only broken in 1981 when Belize became independent. Panama, meanwhile, looked to the south and was part of the Union of Gran Colombia until 1903. The building of the Panama Canal brought affluence to the area, and Panama is still one of the wealthier countries in Central America.

FOOD AND DRINK

The food of Central America is not as exciting as the surroundings, but competing against orchid-clad forests, volcanoes, waterfalls, barrier reefs and beautiful beaches would be a tall order. Dishes based on rice and beans are everywhere, but there are plenty of alternatives. Fish is universally popular. Varieties include tuna, mackerel, snapper, pompano, swordfish and mahi-mahi. The fish is often cooked simply and served whole, but there are also plenty of rich fish soups and stews. Lobsters, clams, prawns (shrimp) and

Above: In Costa Rica, a worker spreads out coffee beans to dry in the sun.

other types of seafood are also widely available. Chicken is always on the menu, alongside specialities such as *mondongo* (tripe stew) and *cecina* (beef marinated in citrus juices). There is a strong Mexican influence in Guatemala and Belize; Panama takes inspiration from Colombia; and Creole dishes are found on the Caribbean coast. Coffee is grown in Costa Rica, El Salvador and Guatemala and is enjoyed by everyone, from the very young to the very old.

Fabulous fruits

Central America is blessed with bountiful fruit. Markets throughout the region are filled with bananas, cherimoyas, mangoes, papayas, pineapples and guavas, plus many more varieties that are local to each country. Delicious fruit drinks are a popular choice. *Refrescos* or *frescos* are milk- or water-based, while *batidas* sometimes contain rum or a similar spirit. Also refreshing are *pipas*, large green coconuts that stallholders cut open on request so that thirsty purchasers can sip the cool liquid inside.

MEXICO

Most people tend to see typical Mexican cuisine as tortillas, tamales and tequila, but that is not strictly true. Mexico is a vast country, with an enormous range of unusual and delicious regional recipes, only some of which are represented in that synthesis of styles commonly known as Tex-Mex cooking. Many of the essential ingredients are only gradually becoming known outside the country, and the careful blending of flavours that is the mark of authentic Mexican cooking often comes as a delightful surprise to the uninitiated.

EARLY HISTORY

In ancient times, many different tribal groups occupied the area now known as Mexico. Most of these existed in isolation, hemmed in by lofty mountains or separated from each other by natural barriers such as deserts, jungles and canyons. On the central plateau and in Yucatan, two indigenous civilizations emerged that would have a considerable impact on the future of the country. The first was the Maya, whose empire stretched from Guatemala and Honduras to Yucatan, Chiapas and Campeche. The Maya had a complex society. They

Below: Workers sort through piles of newly picked avocados, a popular fruit used in many Mexican dishes.

used their knowledge of astronomy and mathematics to chart the heavens and built impressive stepped pyramids to their gods. They were also farmers, cultivating corn, beans, squash and chillies, including the bitingly hot habañero, which they used to make a sauce called *ixni-pec* (pronounced schneepeck) which is still popular today. A favourite flavouring was annatto (achiote) and they loved to drink chocolate. The Maya reached their zenith between AD600 and AD800, and by AD900 many of their ceremonial sites had been abandoned.

Not long after this, a tribe called the Mexica – better known as the Aztecs – began to emerge. By the beginning of the 14th century they had built a vast empire, with its capital at Tenochtitlán, where Mexico City is now. The city was magnificent, with gardens irrigated by water brought by an aqueduct from springs some distance away. Here successive emperors dined in splendour while their armies waged war on the surrounding tribes. Believing that the sun would only rise if regularly appeased with offerings of human hearts, the Aztecs sacrificed thousands of captives and earned a reputation for extreme cruelty. Their belief in the gods was to be their downfall, however, for when the Spaniard Hernán Cortes

Above: Cocoa beans were used to make chocolate, which was a popular drink among the ancient Aztecs.

reached their shores in 1519, they believed him to be the god Quetzalcoatl. When Cortes and his party reached Tenochtitlán, the Emperor Montezuma welcomed them, discovering too late that this was not a social visit. Within two years, the Spanish had totally subjugated the Aztecs.

For the next 300 years, Spain ruled Mexico, losing control only after Napoleon Bonaparte overran Spain in 1808. Mexico became an independent country in 1821, and a republic was set up in 1824, but this did not spell stability. In 1836 the state of Texas, which had been part of Mexico, declared itself an independent republic. When Texas joined the USA nine years later, the Mexican Civil War began, as a result of which Mexico ceded to the USA all territories south of the Rio Grande. The country has remained a republic ever since, apart from a brief period of French occupation between 1864 and 1867.

FOOD AND DRINK

The Spanish who invaded Mexico found a country filled with foods they had never seen before. Aside from corn, squash and unfamiliar beans, there were tomatoes, chillies, cactus paddles, tomatillos, avocados, jicamas, guavas

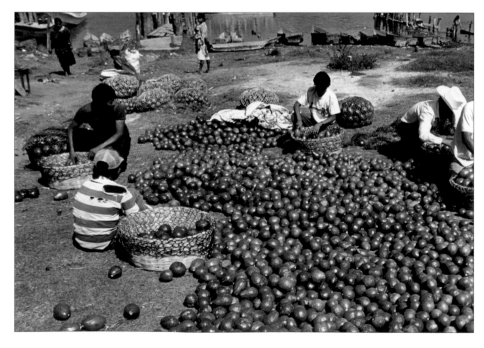

and pineapples. Turkeys, ducks and small hairless dogs were raised for the table, and runners brought fresh fish from the Gulf of Mexico every day, for Montezuma to feast upon. Corn was cooked in dozens of different ways. The common people consumed it as *atole*, which resembled porridge, or as tortillas, while the ruling class feasted on tamales. At the court of Montezuma, the emperor took his pick of hundreds of different dishes served at elaborate feasts. Although *pulque*, made from the fermented sap of the maguey cactus, was readily available, chocolate was the drink of choice for the Aztec elite.

The livestock that the Spanish brought with them revolutionized Mexican cooking. Cattle, goats, pigs and sheep were introduced. Milk, cheese, butter and eggs entered the diet, although they would never achieve the same importance in Mexico as they had in Europe. Pigs were used for lard, and lard made frying possible, which was a major step. Wheat, barley, citrus, olives, walnuts and grapes were planted, and other fruits and vegetables were introduced. Gradually, an entirely new style of cooking emerged.

Below: Small sugar skulls go on sale in early November to mark The Day of the Dead, a traditional Mexican festival.

The French occupation of Mexico left a legacy in the shape of delicious breads, crêpes, cakes and pastries. German settlers introduced brewing and expanded the local cheese-making, while recent immigrants from Asia and the Middle East have also had an impact on Mexican cuisine.

TYPICAL DISHES

Corn dishes are still hugely important in all but the north of the country, where wheat is more dominant. Tortillas form the basis of many *antojitos* (snack meals), but Mexican food has much more to offer. One example is *sopa seca*, the aptly named "dry soup" in which some of the moisture is soaked up by rice, vermicelli or strips of dry tortilla. On Pacific and Gulf shores, the seafood is outstanding, with sea bass, mackerel, swordfish and large prawns (shrimp) among the delights on offer.

Bean dishes have been popular in Mexico for millennia and *frijoles de olla*, pinto beans cooked slowly with water and a little lard, is not to be missed, especially if served with guacamole. Among the many meat and poultry dishes, *albondigas* (spicy meatballs) should be sampled, as should *chile verde*, pork in a green sauce with cactus paddles. Chillies are a central ingredient in the cuisine, and fresh and dried chillies are frequently blended to create dishes of great complexity.

Above: A typical Mexican street vendor sells fresh tortillas filled with beans, chillies, cheese and a variety of meats.

Custards and rice puddings, which are often very sweet, are the classic desserts. In contrast, fresh fruits are often served with salt, a sprinkling of chilli powder and fresh lime juice. Alcoholic drinks include locally produced wine and beer, tequila and mescal, and there is a wide selection of fruit drinks.

STREET FOOD AND SNACKS

Mexico has a handle on finger food. Neatly packaged burritos, tacos, tamales and *tortas* are all available from street vendors, as are *carnitas* – succulent pieces of pork cooked in orange-flavoured lard with garlic until the outside turns crisp.

FEASTS AND FESTIVALS

Most Mexican festivals have special foods associated with them. Epiphany, on 6 January, is celebrated with Kings' Day Bread, while The Day of the Dead at the start of November, when Mexicans honour their deceased relations, is marked by the eating of tamales, followed by a sweet pumpkin dessert and little sugar skulls. The traditional Christmas centrepiece is *mole poblano*, a rich turkey dish that brings together chilli and chocolate.

THE LATIN AMERICAN KITCHEN

Latin American cuisine is founded on simple ingredients of excellent quality. Fresh fish and shellfish, quality cuts of meat and locally grown exotic fruits and vegetables are abundant. Inevitably, each country has developed its own specialities, but there are common flavourings and techniques that are used throughout Latin America, creating a wonderfully varied cuisine.

EQUIPMENT

Latin American cooks are endlessly inventive, not only in the way they cook, but also in their approach to kitchen equipment. While the items featured here could give your cooking a more authentic touch, few are essential. If you intend making your own tortillas, a press and *comal* will be extremely useful, but for most purposes, it is perfectly possible to improvise.

METATE

Made from a sloping piece of volcanic rock and looking rather like a three-legged stone stool, this grinding stone is used to make *masa* dough from skinned, cooked corn kernels. It can also be used to grind cocoa and *piloncillo* (unrefined cane sugar). The grinding is done with the aid of a stone roller, a *muller*, which is made from the same stone as the *metate*. Before a new *metate* can be used, it must be tempered. A mixture of dry rice and salt is placed on the grinding surface, and the *muller* is rocked back and forth to press the mixture into the surface and remove any loose pieces of sand or grit. These are fairly difficult to obtain outside South America, but they are available by mail order.

Below: A metate *is a traditional grinding stone made from volcanic rock. The design has not changed for many centuries.*

MOLCAJETE AND TEJOLOTE

The Mexican mortar, the *molcajete*, is traditionally made from volcanic rock and must be tempered in the same way as the *metate*. The short, stubby pestle used to grind ingredients is called a *tejolote*. The best *molcajetes* are heavy and not too porous. Before purchasing, grind the *molcajete* briefly with the *tejolote*. If the stone seems soft and a lot of dust is formed, it is probably too porous. Similar to the Thai equivalent, which it closely resembles, it is ideal for grinding herbs, garlic, chillies and other spices such as achiote (annatto), as well as nuts and seeds for making *mole poblano*, for example. Fresh salsas, such as guacamole, are often made with a *molcajete* and *tejolote*. The flavours of the ingredients are crushed out, which gives a rustic texture and flavour. However, grinding spices or pounding chillies with a *molcajete* and *tejolote* is hard work so many Mexican cooks use a food processor or a blender instead.

Above: A mortar and pestle, or molcajete e tejolote, *is an essential tool for grinding spices and chillies.*

TORTILLA PRESS

In Mexico and other parts of Latin America where tortillas and similar griddle cakes are made, the *masa* dough was traditionally shaped by hand. Skilled women were able to make an astonishing number of perfectly shaped tortillas in a very short time, but this is something of a dying art. Today, most people use tortilla presses, and in tortilla bakeries or *tortillerias* the whole process is mechanized. The most effective tortilla presses are made from cast iron, but because these must be seasoned (oiled) before use, and carefully maintained, many people prefer steel presses. Tortilla presses consist of two round metal plates, hinged together. They come in various sizes and are heavy, in order to limit the leverage needed to work them. The dough is placed between the plates, which are then squeezed together with the aid of a lever. Placing thin sheets of plastic on the plates or covering them with plastic bags before making the tortillas will ensure that they are easy to remove once they are pressed. Tortilla presses are sold in good speciality kitchen shops and are also widely available by mail order.

Left: Perfect tortillas can be easily pressed with a heavy steel or cast-iron tortilla press.

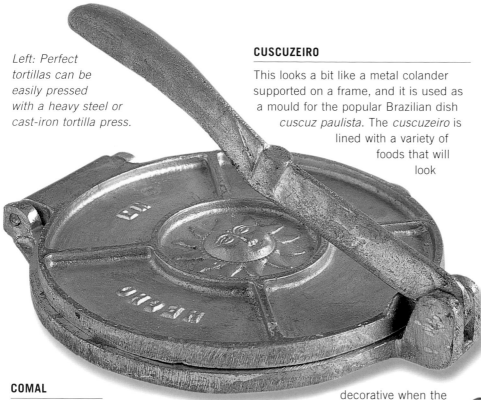

CUSCUZEIRO

This looks a bit like a metal colander supported on a frame, and it is used as a mould for the popular Brazilian dish *cuscuz paulista*. The *cuscuzeiro* is lined with a variety of foods that will look decorative when the dish is turned out, for example, slices of tomato, hard-boiled eggs or slices of pepper, with perhaps a few fresh prawns (shrimp). A moist corn meal mixture is then packed on top of these ingredients. More layers are added until the container is full, and it is then covered and steamed. When turned out the layers of the *cuscuz* look pretty and it tastes delicious. The name suggests that *cuscuz* evolved from couscous, and the method of preparation certainly calls to mind the North African dish.

EARTHENWARE DISHES

The Spanish influence on the region's cuisine is clearly visible in the clay pots (*ollas*) that are traditionally used for cooking stews and sauces throughout Latin America. Often beautifully hand-painted and decorated, they give food a unique earthy flavour, but are seldom found outside the region, as their fragility means that they do not travel well and are rarely exported. Sadly, modern materials and designs have made them relatively rare in Latin America itself. Flat earthenware dishes decorated around the edge are more easily found, and these are often used as serving dishes. Traditional Spanish *cazuelas* (shallow terracotta dishes) and casseroles also make excellent alternatives.

COMAL

This is a thin circular griddle, traditionally used over an open fire to cook tortillas. They were placed among the hot coals and pulled out with long sticks. Clay *comals* take longer to heat up, but they do not require oiling before use, unlike metal ones. If you cannot find a *comal*, a cast-iron griddle or large frying pan will do the job equally well.

FARINHERRA

This is a traditional shaker used mainly in Brazil for sprinkling *farinha de mandioca* (cassava flour) over meat or fish dishes, such as *feijoada*, to mop up the sauce and juices.

Above: For slow-cooking rich stews and sauces, Latin American cooks often use ollas, *traditional hand-decorated Spanish clay pots, which give an authentic flavour.*

Left: Available as metal or clay varieties, a comal is the traditional griddle pan used for cooking tortillas.

CORN

The Aztecs called it "first mother and father, the source of life". Corn was equally highly revered in Peru, first by the indigenous South Americans, who worshipped the corn goddess, and then by the Incas, who decreed that corn could only be planted after the Supreme Inca had turned the first sod with a golden plough reserved for this purpose.

Corn was a sacred food, of huge significance. Not only was it a vital source of sustenance, but it also provided shelter, fencing and even clothing. Every part of the plant was used, even the silks surrounding the kernels, which became ties for tamales. When corn was cooked, whoever added it to the pot had first to breathe on it to rid it of its fear of dying and accustom it to the heat.

Some corn was eaten fresh, but most was dried and stored, then processed to make a type of porridge called *atole*. This was a lengthy chore, made easier by the discovery that the skins came off much more easily if the kernels were heated in a lime solution. When boiled in fresh water, the skinned kernels made a mash (*pozole*), versions of which were eaten by the indigenous peoples of Central and South America.

The cooked skinned kernels were also the basis for *masa*, a dough made by crushing the corn. The dough was then transformed into tortillas or similar flat breads, using techniques that are much the same today.

Corn is a valuable carbohydrate food but it is deficient in the amino acids lysine and tryptophan. If corn is the sole food source, as in some parts of Africa, diseases such as kwashiorkor and pellagra result. The problem has not arisen in South America or the Caribbean, however, because the basic diet also includes beans and squash, which compensate for the nutritional deficiencies of corn.

History

Corn evolved in Central America but its precise origin is not known. No wild forms have ever been found, and its ancestor may have been a type of grass with tiny kernels, each embedded in a cob no bigger than a haricot bean. How the grass evolved into the much larger plant with rows of kernels growing side by side on a substantial cob is not known, but the indigenous farmers were highly efficient plant breeders.

Corn was already widely grown throughout South America when Columbus first encountered it on the island of Cuba. The tall, leafy plant was called *maïs*, and

Above: White Andean corn is ground and used to make masa *dough.*

Below: South American corn comes in many colours, including vibrant red.

in many parts of the globe it is still known as maize. The alternative name arose because Columbus and his crew saw it as a staple food equivalent to the corn they grew back home, and dubbed it native corn.

Varieties

There are five main varieties of corn. Dent corn is the most widely grown globally, and is mainly used for animal feeds and oil. Other varieties are popcorn, flint corn, flour corn and sweet corn, which is the type used in cooking. Baby sweet corn cobs are often picked before they are mature, then cooked and eaten whole. Yellow corn kernels are the most common, but the corn grown in South America comes in other colours too, including red, blue, purple and the pale white that is typical of the Andean region. There are even variegated types available, which have sweet white, red

Above: Corn, known as mais, *is a native South American crop.*

and purple kernels on the same cob. For flavour, one of the most highly prized varieties is Peru's purple corn, *maiz morado*, which has a subtle citrus flavour and is used to make *mazamorra*, a delicious pudding, or the unusual drink, *chicha morrada*.

Buying and storing

If possible, corn should be cooked within 24 hours of being picked. This is because the sugar in the kernels starts to turn into starch as soon as the cobs are cut. Look for husks that are clean, shiny and well filled. If you are not sure whether the corn is ripe or not, take a look at the tassels, which should be golden brown. Unless you are planning to cook the corn the minute you get home, do not part the green husks to check out the contents; once the kernels have been exposed to the air, they will quickly begin to dry out.

Preparing corn

Corn can be cooked in many different ways, but when served as an accompaniment is usually simply boiled.

1 Strip off the green husks surrounding the cobs.

2 If only the kernels are required, lift the cob slightly and slice downwards using a sharp knife to remove a few rows at a time.

3 Whether using whole cobs, slices or just the kernels, plunge the corn into lightly salted boiling water for 4–5 minutes, until tender. Drain and serve with a knob of butter.

Huitlacoche

During times of drought, corn kernels are sometimes infected by a fungus, which turns them grey and causes them to swell to many times their original size. Far from being a disaster, this is seen as a boon, because the "corn truffles" as they are sometimes known, have a delicious, earthy flavour when cooked and are regarded as a delicacy around the world.

Cooking

Corn remains a staple ingredient in modern Latin America. Young, tender corn cobs are first stripped of their husks and then either steamed or cooked whole on a brazier or barbecue as a delicious fast-food snack. The puréed kernels also make an excellent soup. In Argentina, corn is often added to stews, such as the popular meat stew, *carbonada criolla*, while in Ecuador the kernels are mixed with salt cod and other vegetables to make the traditional dish, *fanesca*.

CORN MEAL

Also known as maize flour, corn meal remains slightly gritty when cooked, giving a characteristic texture to the flat breads for which it is most often used. The product known as cornflour in the UK and cornstarch in the US is a pure starch extracted from the grain. When mixed with regular wheat flour in a cake, it produces a lighter result. *Masa harina* is sometimes known as tortilla flour, which indicates its purpose. Although Latin cooks will often make *masa* (tortilla dough) from cooked corn kernels, the flour is an easier option. It comes in various grades, depending on what sort of corn it is made from. *Masarepa* is a similar product, used for making *arepas*, the flat griddle cakes that are popular in Venezuela and Colombia.

Right: Wet corn is ground to make masa harina, *which can then be used to make corn tortillas.*

Above: Dried corn husks should be soaked in cold water before use.

DRIED CORN HUSKS

These make handy wrappers for Mexican tamales and Peruvian *humitas*. They are fairly brittle, so should be soaked in water for about 30 minutes before being used to wrap ingredients. Dried corn husks are not always easy to obtain outside Latin America, so baking parchment can be used instead.

RICE

After its introduction to Latin America and the Caribbean by the Spanish in the 16th century, rice rapidly became a staple food crop. Large tracts of wetlands are given over to rice production, especially in Brazil, which grows as much rice as Japan. Rice is an important source of protein and carbohydrates for the poorest sector of the population, especially in urban areas where individuals spend 15 per cent of their income on white rice.

In Brazil, rice is an essential accompaniment to almost all main meals, particularly the national dish, *feijoada*, and is often layered in a mould with many other ingredients. Rice is also an extremely important ingredient in Caribbean cooking. In Peru, Colombia and Ecuador, where cooked rice is served quite dry, its granular texture earns it the name *arroz graneado*. Rice is also used to make drinks, such as the Mexican *horchata* and Ecuador's fermented rice drink, *arroz fermentado*.

Varieties

White long-grain rice is the variety grown throughout the region, although the influence of immigrants means that other varieties are imported. White rice has been fully milled to remove the outer husk from the inner kernel, leaving a white grain with a delicate fragrance and slightly nutty flavour.

Left: White long-grain rice is served as an accompaniment throughout Latin America and the Caribbean.

Buying and storing

Buy good quality rice in packets and store it in a cool, dry place. Rice keeps well, but once opened, it should be transferred to an airtight container. If cooked rice is cooled quickly, it can be stored for up to 24 hours in the refrigerator. Make sure it is piping hot before it is served next time. Don't reheat rice more than once, and never keep it warm for long periods because there is a risk of food poisoning.

Preparing rice

White long grain rice is fluffy and absorbent when cooked, and makes the perfect accompaniment to soups, stews and sauces. It may also be cooked with other ingredients to make a composite dish. If serving rice as an accompaniment:

1 Add 15ml/1 tbsp oil to a pan, heat gently, then add 1 clove of crushed garlic.

2 Add the rice to the pan and roast the grains for a few minutes until they begin to turn golden.

3 Transfer the rice to a pan full of lightly salted water. Bring to the boil, then add a tight-fitting lid and simmer gently until all of the liquid has been absorbed.

If the rice is to be mixed with other ingredients, for example in the Mexican dish, *sopa seca*, try the following method. It encourages the rice to absorb other flavours and reduces the final cooking time.

Quinoa

Indigenous to Peru, quinoa is a complete protein, possessing all eight essential amino acids. Low in saturated fat and high in fibre, it is a good source of calcium, potassium, zinc, iron, magnesium and B vitamins. Cooked like rice, the grain becomes soft and creamy, but the germ stays crunchy.

1 In a pan or heatproof bowl, soak the rice in freshly boiled water for 10 minutes.

2 Drain thoroughly before adding the other ingredients.

This fairly unusual method of cooking rice is very popular throughout the region, especially in Colombia, and is particularly delicious served with seafood.

1 Add 50ml/2fl oz/¼ cup coconut milk to a pan with a pinch of brown sugar.

2 Add the rice, bring to the boil and simmer gently for 10–15 minutes, or until tender.

POTATOES

The potato is native to South America and was discovered by pre-Inca peoples in the foothills of the Andes. Archaeological digs in Peru and Bolivia have uncovered evidence that it was used as a food as long ago as 400BC. In Peru, the potato had religious significance, and the potato goddess was depicted with a potato plant in either hand. Potato designs were found in Nazca and Chimu pottery. One of the ways the South American Indians had of measuring time was to gauge how long it took to cook potatoes to certain consistencies. The Incas perfected the art of freeze-drying potatoes 2,000 years ago by leaving them out on lofty mountain tops to produce the early convenience food, *chuno*. In an entirely natural process, the night air froze the potatoes and the sun completed the lengthy dehydration process.

When the Inca empire was invaded by Francisco Pizarro in the 16th century, potatoes were among the plunder that the Conquistadors took back to Spain with them. Cultivation quickly spread throughout Europe via explorers such as Sir Francis Drake. Today there are up to 4,000 varieties worldwide. The potato is the staple food for two-thirds of the world's population and our third most important food crop.

Under the skin

Most of the nutrients in potatoes are either in or just beneath the skin, so it is best to avoid peeling potatoes if at all possible.

If you need to peel them, use a potato peeler that removes only the very top surface.

Potatoes are one of the best all-round sources of nutrition known to man. A valuable carbohydrate food, they also contain fairly high levels of protein. They are a very good source of vitamin C, a fact that was of huge value to early seafarers, who discovered that feeding potatoes to their crews helped to prevent scurvy. Potatoes also contain potassium, iron and vitamin B.

Varieties

In the UK, only about 15 varieties of potato are on general sale, but in Peruvian markets it is claimed that you can buy up to 100 different types, ranging in size from tiny potatoes to large ovals. Worldwide there are thought to be around 4,000 varieties. The colours are equally diverse, including red, black, yellow, brown, purple and black. Most are known only by their local names, but some are beginning to reach markets in the northern hemisphere. Look out for the Purple Peruvian, with its earthy, slightly nutty-tasting lavender flesh. Also prized, particularly for mashing, is the buttery Papa Amarilla, or yellow potato. Among the varieties with dark skins and dazzling white flesh are the Yanaimilla and the Compis. Potatoes will grow anywhere from sea level to 4,300m/ 14,000ft, so it is not surprising that so many different varieties continue to be cultivated in their place of origin.

Buying and storing

When buying potatoes, it is important to choose a variety that will give you the right results for the cooking method you intend to use. Check the labels or ask for advice from the seller. Store potatoes in a dark, cool, dry place. Paper sacks are better than plastic bags, which create humid conditions and hasten deterioration.

Above: Grown in Uruguay and Venezuela, the Red Pontiac has dark red skin and white waxy flesh.

Preparing and cooking

In Latin America, potatoes are usually either boiled in the minimum of water, as in the Peruvian speciality, *ocopa arequipena*, or diced and fried, which is a popular method in Mexico. Chillies are frequently added. Purple Peruvian potatoes are excellent in salads and they require less cooking than white or yellow potatoes.

Below: With striking dark skin and white flesh, Compis potatoes are grown by farmers in the Andean highlands.

BEANS

Along with corn and rice, beans are an extremely important food throughout the Caribbean and Latin America. The inhabitants of Mexico and Central America eat around six times as many beans as are consumed in Britain every year, and in Chile, where meat can be relatively scarce, they are a vital source of protein. Beans are served, in one form or another, at most meals.

Several varieties of bean are indigenous to this part of the world. They were traditionally planted with corn and squash, the idea being that the corn stalks would support the growing beans, while the squash plants spread out to suffocate encroaching weeds. This ancient method of cultivation also ensured that the beans enriched the soil depleted by the corn. The beans were served fresh in season, but vast amounts were dried to furnish versatile and nutritious dishes all year round. In the Caribbean, beans are often referred to as "peas".

Beans are a good source of protein and carbohydrate and supply vitamins A, B$_1$ and B$_2$. They also contribute valuable amounts of minerals, such as potassium and iron, to the diet.

Below: Black beans are an essential ingredient in the extravagant Brazilian national dish, feijoada.

Varieties

Black beans These small, shiny, kidney-shaped beans, sometimes known as black turtle beans, are particularly popular in Mexico, the Caribbean and Brazil. They are highly valued for their creamy white flesh and delicate earthy flavour, reminiscent of mushrooms. Their skins remain bright and shiny after cooking, so they look dramatic when combined with rice or other ingredients. Black beans are often used in salsas and soups, and are eaten as an accompaniment to Brazil's national dish, *feijoada*. In Costa Rica they are often fried with white rice to make the traditional breakfast dish, *gallo pinto*.

White beans A type of haricot (navy) bean, these vary in size but are always the same plump oval shape. When cooked, they have an earthy, rather floury flavour, and a fairly soft texture, but they retain their shape well. White beans are an extremely versatile ingredient and can be substituted for most other varieties when a recipe calls for dried beans.

Right: Native to Latin America, pinto beans are traditionally used to make refritos, *the Mexican speciality.*

Above: Versatile white beans, a type of haricot (navy) bean, are plump and soft with a delicious floury texture.

Pinto beans A smaller, paler version of the borlotti bean, the pinto has an attractive orange-pink skin speckled with rust-coloured flecks. One of the many relatives of the kidney bean, pinto beans are native to Latin America. They feature extensively in Mexican cooking as well as the cuisines of most other Spanish-speaking countries. The skins soften on cooking, which makes them easy to mash, so they are the perfect ingredient for the popular Mexican dish, *frijoles refritos* (refried beans).

Red kidney beans The shiny, dark red skin of these beans hides a pale interior. They retain their shape and colour when cooked and have a soft, mealy texture. Red kidney beans are particularly popular in Brazil, Mexico and some parts of the Caribbean, where they are used to make a delicious red bean chilli and the Jamaican speciality, rice and peas. They can also be used instead of the traditional pinto beans to make a variation on refried beans.

Lima beans These beans originated in Peru and are named after that country's capital city. Cream-coloured and tender, with soft flesh, these hold their shape well when cooked. Lima beans have a delicate flavour, similar to that of walnuts. Fresh lima beans are delicious. One variety of lima bean is the large white butter bean, which is familiar throughout Europe. Be careful not to overcook lima beans as they become pulpy and mushy in texture.

Black-eyed beans/peas Small and white, with a distinctive black mark, these beans were introduced to the Caribbean from West Africa. They need not be soaked before use because they rapidly become tender when cooked. They taste slightly sweet and readily absorb other flavours, especially in stews and curries. Add black-eyed beans to soups and salads for extra flavour.

Gungo peas Also known as pigeon peas, these are approximately the size of a garden pea. They have a sweetish, slightly acrid flavour, and are used fresh, canned or dried.

Chickpeas Also known as garbanzo beans, robust and hearty chickpeas resemble shelled hazelnuts and have a delicious nutty flavour and creamy texture, although they require lengthy cooking. Spanish migrants first introduced chickpeas to Latin America, and although they have never been as important or popular as native beans, they are now naturalized throughout the region. When fresh, they can be eaten raw or cooked, but they are more commonly available dried. The skin on chickpeas can be tough and you may like to remove it. Do this once the chickpeas are fully cooked and cooled.

Above: Chickpeas were first introduced to Latin America by Spanish settlers, but quickly became a popular ingredient.

Buying and storing

When buying fresh beans, buy young ones with bright, firm skins because the pods of older beans are likely to be slightly tough. Be sure to use fresh beans as soon as possible after purchase because they do not store well. Most fresh beans need little preparation other than trimming the ends, but older beans may need stringing.

When buying dried beans, look for plump, shiny beans with smooth, unbroken skins. Beans toughen with age and will take longer to cook the older they are, so although they will keep for up to a year in a cool, dark place, it is best to buy them in small quantities from a store with a regular turnover of stock. Avoid beans that look dusty or dirty, and store them in an airtight container in a cool, dark, dry place.

Canned beans are a useful standby as they require no soaking or lengthy cooking. Choose canned beans that do not have any added sugar or salt, and be sure to drain and rinse well before use. Canned beans still contain a reasonable amount of nutrients.

Preparing dried beans

Dried beans must be soaked before cooking.

1 Tip the beans into a colander or sieve (strainer) and pick them over to remove any grit or damaged beans.

2 Rinse the beans under cold running water and then drain.

3 Soak in cold water overnight, changing the water once.

4 Drain the soaked beans, rinse them, then place in a large pan with plenty of cold water.

5 Bring to the boil and boil vigorously for 10 minutes to remove natural toxins (this is particularly important with lima beans or red kidney beans).

6 Reduce the heat and simmer until the beans are tender.

COOK'S TIP

If you don't have time to soak dried beans overnight, put them in a pan with water to cover, bring them to the boil, then remove from the heat and leave to soak for about 1 hour.

CHILLIES AND SWEET PEPPERS

Chillies and their mild-mannered cousins, the sweet (bell) peppers, are without doubt Latin America's greatest contribution to the global kitchen. Full of flavour, colourful, nutritious and versatile, they are now so widely used in many different cuisines that it is difficult to imagine a world without them.

FRESH CHILLIES

The first chillies were tiny wild berries that grew in the South American jungle thousands of years ago. The plants gradually spread northwards from central South America through Central America and the Caribbean to south-western North America, evolving over the centuries into the wide range of shapes and sizes we encounter today.

It was Christopher Columbus who introduced chillies to the rest of the world. When he tasted a highly spiced dish on San Salvador, he assumed that its heat came from black pepper. He named the plant pimiento (pepper), and this name endured long after he realized his mistake. Columbus took chilli plants back with him when he returned to Europe, and by the 16th century they were widely distributed. Today the chilli is the most extensively cultivated and most commonly used spice in the world.

There are as many as 200 different varieties of chilli, varying enormously in shape, size, colour, flavour and, most of all, in the amount of heat they deliver.

Below: Poblanas, popular in Mexico, are often roasted to intensify their flavour.

Above: Scotch bonnet chillies are popular throughout the Caribbean and are used to make hot pepper sauce.

The fiery sensation from chillies is caused by capsaicin, an alkaloid that not only causes a burning sensation in the mouth, but also triggers the brain to release endorphins, natural painkillers that promote a sense of wellbeing and stimulation; this is why eating chillies can become quite addictive. Capsaicin is concentrated in the seeds and membrane of the pods, so removing these parts before eating will reduce the fieriness of a chilli considerably. Chillies are an excellent source of vitamin C and also yield valuable

quantities of beta-carotene, folate, potassium and vitamin E. They stimulate the appetite, help improve circulation, and can also be used as a powerful decongestant.

Varieties

Of the vast range of chillies grown in Latin America and the Caribbean, the following are the most popular. They have been rated on a scale of one to ten for heat and are listed in order of potency, mildest first. Be careful: the heat can vary widely, even with chillies from the same plant, so use these ratings as a guide only.

Left: Jalapeños and the smaller serrano chillies are either bright green or red, depending on ripeness.

Poblano These mild to medium-hot chillies (heat scale 3) are very popular in Mexico. Big and beautiful, poblanos are about 7.5cm/3in long, with thick flesh and a rich, earthy flavour. They start off dark green with a purple-black tinge and ripen to dark red. Green poblanos are always used cooked, and roasting gives them a more intense flavour. They are perfect for stuffed dishes such as *chillies rellenos* and taste good in traditional mole sauces. Dried poblanos are called anchos.

Jalapeño Well known and widely used the world over, jalapeños are medium-hot (heat scale 4–7). Plump and glossy, they are used in stews, salsas, breads, sauces and dips. Green jalapeños have a fresh, grassy flavour; red ones are slightly sweeter. Smoke-dried jalapeños are known as chipotle chillies.

Fresno Plump and cylindrical, these chillies are usually sold when red. They have thick flesh and a hot, sweet flavour (heat scale 5). Fresnos are excellent in salsas, ceviche, stuffings, bread and pickles. Roasting brings out their delicious sweetness.

Serrano Thin-skinned and quite slender, serranos are the classic Mexican green chilli (*chiles verdes*) and are always used in guacamole. Although they are quite fiery (heat scale 7), they have a clean, biting heat, matched by a high acidity. Both red and green serranos are frequently added to cooked dishes. They can also be pickled.

Left: Sweet, juicy fresnos are perfect for fresh salsas or pickles.

Aji mirasol Extensively used in Peruvian cooking, these chillies are narrow and tapered, with a tropical fruit flavour, yet they are decidedly hot (heat scale 6–7). Fresh yellow ones are particularly prized for salsas and ceviche. They are also used in cooked dishes, such as soups or stews, and are sometimes made into a paste, which is mixed with oil to make a hot dipping sauce.

Brazilian malagueta These very hot chillies (heat scale 8) are believed to be a wild form of tabasco. Very small, only about 2cm/¾in long, they have thin flesh and a fresh yet fiery taste. Malaguetas are often added to marinades and vinegars.

Jamaican hot, Scotch bonnet and habañero These chillies are closely related and are all intensely fiery (heat scale 10). The Jamaican hot is bright red and has a sweet hot flavour. It goes well with tropical fruits and is also used in fresh salsas, Caribbean fish stews, curries and spicy chutneys. The Scotch bonnet is an essential ingredient in many Caribbean dishes, especially curries and jerk sauce, and is used to make Jamaican hot pepper sauce.

Below: Chilli powder is a good alternative when fresh chillies are not available.

Measuring the heat
The heat level of a chilli is often measured in Scoville units on a scale where 0 is the rating for a sweet (bell) pepper and 557,000 relates to the hottest chilli grown in Latin America, the habañero. The simpler system used in this book rates the chillies on a scale of one to ten, with one indicating the mildest and ten the hottest.

Preparing Fresh Chillies
Take great care when handling chillies, as the capsaicin they contain is an extremely powerful irritant. Wear rubber gloves while preparing chillies or wash your hands in soapy water afterwards. If you touch your skin by mistake, splash the affected area with cold water. Avoid scratching or rubbing inflamed skin because this could aggravate the problem.

1 Cut the chilli in half lengthways, cut off the stalk and carefully scrape out the seeds (unless you wish to leave them in for extra heat).

2 Remove the remaining core and any white membrane.

3 Finely slice or chop each piece, depending on use.

SWEET PEPPERS

Sometimes known as capsicums, sweet (bell) peppers are native to Mexico and Central America and were widely grown there in pre-Columbian times. Pepper seeds were carried to Spain in 1493 and from there spread rapidly throughout Europe. They also spread rapidly throughout South America and were a staple food of the Incas in Peru. They contribute colour and flavour to a huge variety of dishes, including salsas, stews and spicy meat fillings, as well as fish dishes, vegetable accompaniments and salads. Sweet peppers come in many unusual shapes and sizes, from chilli-size rounds to slender drops, bells and even hearts. Colours range from bright green, through yellow and orange to vibrant

Below: Delicious either cooked or raw, sweet peppers should look glossy, feel firm and have a crisp, juicy bite. Avoid those that are wrinkled.

red, and there is even a dark purple variety (but this does turn green when cooked). Mild and sweet in flavour, with crisp, juicy flesh when ripe, they can be eaten either raw in salads or cooked. A popular way of serving peppers is to stuff and bake them.

Buying and storing

Whether you are buying hot chillies or mild sweet peppers, look for firm, shiny specimens with unblemished skins. Avoid peppers that are limp, that wrinkle when touched or that have "blistered" areas on the skin. Green peppers should be purchased before they change colour, but should not be too dark as this indicates immaturity and lack of flavour. Avoid red peppers with dark patches on the skin, as this could be a sign that they have begun to rot inside. Store peppers in the vegetable crisper in the refrigerator. Sweet peppers will keep well for up to a week and chillies up to three weeks.

Preparing sweet peppers

Depending on use, the core and seeds should usually be removed before cooking sweet peppers.

1 Halve or quarter the peppers, then, using a small, sharp knife, carefully cut out the core, any white membrane and the seeds.

2 If the peppers are being used whole, for example to be stuffed, cut around the stem and pull out the seeds like a plug.

Roasting peppers and chillies

To really bring out the delicious, sweet flavour of fresh peppers and chillies, try roasting them.

1 Place them under a hot grill (broiler) and turn occasionally until the skins blister and char.

2 Alternatively, dry-fry them in a frying pan or griddle until the skins are scorched.

3 Place them in a strong plastic bag and tie the top tightly, or place them in a bowl and cover with cling film (plastic wrap).

4 After approximately 20 minutes, remove the skins, then slit each pepper or chilli. Remove the seeds and membrane, and tear or slice the flesh into pieces.

DRIED CHILLIES

Travel through Latin America and you will frequently see bunches of colourful chillies dangling from hooks on the walls of houses. In the bright sunshine they soon dehydrate and can be packed away until needed. When rehydrated, the chillies will not taste the same as before. In many cases they will have acquired a new intensity and richness of flavour, which is one of the reasons why Mexicans really value dried chillies and view them as distinct from the fresh, often giving them completely different names. Each variety has unique characteristics, and cooks will often blend several types to get exactly the results they require.

Varieties

The following are the most widely used varieties of dried chilli.

Ancho These dried red poblanos have a rich deep colour and mild fruity flavour (heat scale 3). Anchos can be stuffed and are often used in mole sauces.

Mulato Related to the ancho and with the same level of heat, mulatos taste smoky rather than fruity.

Guajillo These large dried chillies, orange-red in colour, have a slightly acidic flavour (heat scale 3–4).

Right: Habañeros are used for chilli sauces.

Below: Anchos are delicious stuffed or added to stews.

Left: Cascabels have a delicious, slightly nutty flavour.

Pasada Roasted, peeled and dried, these chillies have a toasty flavour (heat scale 3–4), with apple, liquorice and cherry notes.

Cascabel The name means "little rattle" and refers to the sound the seeds make when the chillies are shaken. Thick-skinned and smooth, cascabels have a rich, woody flavour (heat scale 4).

Pasilla Long, slender and very dark, the flavour of pasillas is rich with hints of berries and liquorice (heat scale 4).

Chipotle Smoke-dried jalapeños, these have wrinkled dark red skin and thick flesh. Chipotles need long, slow cooking to soften them and bring out their full, smoky taste (heat scale 6–10).

Aji mirasol The dried version of Peru's favourite chilli is deep yellowish red with a berry-like fruit flavour (heat scale 6–7).

Pequin These small chillies are pale orange-red in colour, with a light, sweet, smoky flavour suggestive of corn and nuts (heat scale 8–9). They are excellent in sauces, salsas and soups and can be crushed over food as a condiment.

Habañero Used in moderation, these have a wonderful tropical fruit flavour (heat scale 10). Like dried Scotch bonnets, they are often used to make classic hot pepper sauces, particularly in the Caribbean, and are also good when added to fish stews and salsas.

Above: Pasadas are often used in sauces for meat or fish, or in rich spicy stews.

Buying and storing

Dried chillies should be flexible. Avoid any that smell musty or have powdery skins, as this could indicate insect infestation. Store for up to 1 year in an airtight container in a cool, dry place.

Preparing dried chillies

To appreciate their full flavour, dried chillies should be soaked before use. Toasting dried chillies before soaking will give a lovely smoky flavour. If the chillies are to be used in a slow-cooked stew, soaking is not necessary.

1 Lightly dry-fry or toast the dried chillies in a frying pan or griddle for a couple of minutes.

2 Seed large chillies and tear into pieces, then soak in warm water until soft. Soak smaller chillies before cutting into pieces.

Caribbean hot sauces

Most islands have their own recipe for hot chilli sauce. Based on the fiery habañero or Scotch bonnet chilli pepper, they should be used sparingly by the uninitiated.

OTHER VEGETABLES

A visit to a market in any Latin American country is a real feast for the eyes. Fruit and vegetables are laid on mats or heaped high on tables, strings of chillies hang overhead and everywhere there are people bustling or bargaining. The colours are glorious, the aromas are unfamiliar and there will usually be several local specialities on sale.

CHAYOTES

Also known as christophenes or chokos these pale green gourds are particularly popular in the Caribbean, where they are used in soups, salads and stews. Raw chayote is crisp and clean-tasting, rather like water chestnut. The cooked vegetable has a rather bland flavour, so needs plenty of seasoning. Cholesterol-free and low in calories, chayotes are a good source of fibre and vitamin C.

Buying and storing

Choose smooth, unwrinkled chayotes and store in the refrigerator. They keep well but are best used as soon as possible after purchase.

SQUASH

Cultivated in Latin America long before Columbus sailed, squash is an important food. Many different types are eaten in Latin America, from courgettes (zucchini) to huge hard-skinned pumpkins. Squash are eaten in both

Below: Halved chayotes can be baked for a simple yet delicious side dish.

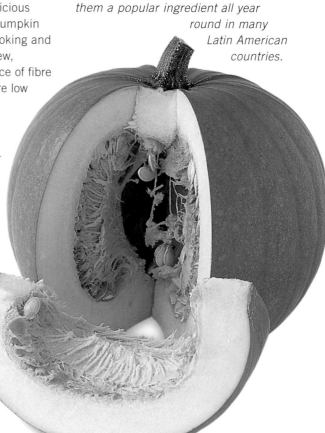

Preparing chayotes

Chayotes can be peeled, chopped and cooked in soups or stews, or cut in half and baked.

1 Preheat the oven to 190°C/375°F/Gas 5. Cut the chayotes in half, place them skin-side down on a shallow baking tray and brush with a little olive oil.

2 Bake for approximately 25 minutes or until tender.

savoury and sweet dishes, often with brown sugar. Pumpkin and prawns (shrimp) is an unusual but delicious combination. A hollowed-out pumpkin makes a good container for cooking and serving, as in the Argentine stew, *carbonada criolla*. A good source of fibre and carbohydrate, pumpkins are low in calories. Varieties with bright flesh are high in vitamin A.

Buying and storing

If buying courgettes or other summer squash, the general rule is that the smaller the specimen the better the flavour. Store courgettes in the refrigerator and use as soon as possible. Thanks to their hard skins, unbruised pumpkins and other winter squash keep well. Cut pumpkin should be wrapped in clear film (plastic wrap) and stored in the refrigerator.

Roasting squash

Instead of roasting, pieces of squash could be lightly boiled or steamed and added to stews.

1 Preheat the oven to 190°C/375°F/Gas 5. Cut the squash into wedges, remove the skin and seeds.

2 Place the wedges in a large roasting pan with a little olive oil and roast for approximately 45 minutes or until tender.

Below: Pumpkins can be easily stored over the long winter months, making them a popular ingredient all year round in many Latin American countries.

Above: Thin slices of sweet potato are fried to make chips, a popular street snack throughout Latin America.

SWEET POTATOES AND YAMS

These root vegetables are not related, although the American habit of calling red sweet potatoes yams can lead to confusion and the two are sometimes mixed up. Sweet potatoes have been grown in South America for centuries. In pre-Inca times, sun-dried sweet potato slices were a popular treat and Mayan cooks also used the vegetable to provide a sweet note in many savoury meat and fish dishes. Yams were brought to South America by African slaves and are widely used throughout the Caribbean and Brazil. Both of these vegetables provide some vitamin C, while orange-fleshed sweet potatoes also contain beta-carotene.

Varieties

There are hundreds of varieties of both sweet potatoes and yams. In Latin American cooking, the red-skinned sweet potato with white flesh is best known. The most commonly used yam is brown, with moist cream-coloured flesh that becomes dry when cooked.

Buying and storing

Buy vegetables that are firm and dry, with no soft areas. Store loose or in a brown paper bag in a cool, dry place, but do not put them in the refrigerator.

Preparing and cooking

Like regular potatoes, sweet potatoes can be scrubbed and baked in their skins, or peeled and sliced, then boiled or fried. They are delicious mashed or creamed, and make very good chips. Yams must be thickly peeled and should be washed well before and after slicing; this helps to remove any toxins that may be present in the raw tuber. Always cook yams very thoroughly.

CASSAVA

Also known as *manioc, mandioc* or *yuca* (in Peru), this starchy tuber looks like a long, fat sausage with dark, rough outer skin. Native to Brazil, it is also a popular ingredient in West Indian cooking. It is important to distinguish between sweet and bitter cassava: the root and leaves of the former can safely be eaten, but bitter cassava contains cyanide. Although bitter cassava is used for making beer, tapioca and cassava flour – *farinha de mandioca* – it must be detoxified first. Sweet cassava is a carbohydrate food with a high fibre

Below: Sweet cassava is a versatile tuber and can be cooked in many ways.

content, and the leaves are a valuable source of protein. *Cassareep* is a delicious syrup made from cassava and flavoured with cinnamon and cloves. It is an essential ingredient in the traditional Jamaican pepperpot stew. Cassava is fairly bland so it is best served with a sauce or dressing such as the traditional Cuban *mojo*, which is a mixture of oil, citrus juices and garlic.

Buying and storing

Most cassava that is exported around the world is first coated in a layer of wax to keep it fresh. When buying sweet cassava, look for roots that are fairly firm, dry and odour-free.

Preparing cassava

An extremely versatile vegetable, sweet cassava can be cooked in a number of ways.

1 Scrub the root, peel, then cut into fairly large pieces, removing the fibrous core.

2 Drop the pieces into a bowl of acidulated water to prevent discoloration.

3 Boil, steam, bake or fry the cassava pieces until tender.

PALM HEARTS

The terminal bud of the Acai or cabbage palm has long been considered a regional delicacy. Native to South America, this fast-growing palm is now widely cultivated in vast plantations, mainly in Brazil and Costa Rica. Fresh palm hearts make very good eating, but are rarely available outside the country of origin. Canned palm hearts have a slightly different texture to fresh, but are still delicious and make a good alternative. Low in saturated fat and cholesterol, palm hearts are a valuable source of vitamin C.

Buying and storing

Fresh palm hearts should be pale, moist and evenly coloured. To enjoy them at their best, use as soon as possible after purchase. Canned hearts are much more readily available.

Preparing and cooking

To prepare fresh palm hearts, simply strip off the outer layers. Eat them raw or roast or steam in the same way as asparagus. Canned palm hearts are delicious in soups, salads and pies.

Below: Canned palm hearts make a good alternative if fresh ones are unavailable.

Above: Look for okra pods that are firm, plump and smooth, but not too big.

OKRA

Also known as ladies' fingers, these pods ooze a sticky liquid when cut, which acts as a thickener in sauces. Okra was introduced to Latin America by African slaves and is an important ingredient in Brazilian and Caribbean cooking. A source of vitamin C, fibre-rich okra also contains folate, thiamin and calcium.

Buying and storing

Okra should be a fresh, pale green colour. Buy smaller pods and avoid any that are flabby, shrivelled or bruised. Store in the refrigerator and use as soon as possible after purchase.

Preparing and cooking

If cooking whole, trim the top of each pod. If destined for a composite dish, where the viscous liquid will act as a thickener, cut the pods into slices. Otherwise, leave whole. Okra can be steamed, boiled or fried. Try it Brazilian-style, with chicken and chillies. The Barbadian speciality, Cou-cou, combines okra with corn meal.

LEAFY GREEN VEGETABLES

A number of leafy green vegetables are on sale in Latin American markets, and many are available only in certain areas. The young tops of cassava and sweet potatoes are regularly eaten, as is amaranth, a chard-like vegetable esteemed by the Aztecs. *Callaloo* is the name given to the leaves of two related tubers that are used for a popular Caribbean soup. *Nopales* are the edible leaves of the prickly pear cactus, while bottled *nopales*, commonly known as *nopalitos*, can be found in specialist food stores.

Unusual tubers

Jicama is indigenous to Mexico but has achieved widespread popularity thanks to its crisp, juicy flesh. Also known as yam bean or Chinese turnip, it can be eaten raw with orange juice and chilli powder, or cooked, and is especially good in salsas.
Oca looks like a short, fat wrinkled carrot. There are several varieties available, including white, yellow, red and purple. Its sharp taste is moderated by sun-drying the tubers before cooking.
Yacón, related to the Jerusalem artichoke, is highly valued in Peru and Bolivia for its sweet, crunchy flesh. It can be eaten either raw or cooked.

Añu is a white or yellow tuber from a nasturtium-like plant with edible leaves and flowers. It is an important crop in Ecuador, Peru, Bolivia, Colombia and Venezuela.

Jicama has crisp, juicy flesh, similar to green apples or water chestnuts.

FRUIT VEGETABLES

Neither savoury nor sweet, these are popular throughout Latin America.

TOMATOES

Along with chillies and corn, tomatoes are one of Latin America's most important contributions to the global cooking pot. Although they originated in the lands to the west of the Andes, both the Mayas and the Aztecs grew the little cherry-sized fruit vegetables and the Spanish introduced them to Europe. Largely composed of water, tomatoes are a good source of vitamins A and C. Raw ones contain useful amounts of vitamin E. Tomatoes also contribute the powerful antioxidant, lycopene, which may help to lower the risk of cancer.

Varieties

There are hundreds of varieties ot tomato. Cherry tomatoes, the closest in size to their Peruvian ancestors, are delicious in salads, juicy plum tomatoes make excellent sauces and beefsteak tomatoes are great for stuffing. Tomatillos (literally translated as "little tomatoes") are covered in brown papery husks. The fruit itself is green, with a clean, slightly acidic flavour.

Buying and storing

For the best flavour, buy tomatoes straight from the grower and store them at room temperature. Chilling tomatoes dulls their taste. Fresh tomatillos are difficult to obtain outside Latin America, but canned ones make a perfectly acceptable substitute.

Below: Fresh tomatillos are a tasty addition to spicy Mexican salsas.

Above: Tomatoes were enjoyed by the Mayas and Aztecs in ancient times.

Preparing and cooking

When adding to salsas and sauces, tomatoes should ideally have the skin removed. To skin tomatoes, cut a cross on the base, put them in a heatproof bowl and pour over boiling water. Leave for 30–60 seconds, then remove the remaining skin with a sharp knife. In Mexico, tomatillos are used fresh and raw, mostly in salsas, but they also taste great cooked.

AVOCADOS

The most nutritious of all the fruit vegetables, the avocado is native to Mexico, where it is called *acuacate*. In Brazil it is known as *abacate*, and in the US, alligator pear.

Nutrition

Despite the hefty calorie content – half an avocado delivers around 143kcals – the fat they contain is mostly mono-unsaturated and is a valuable source of energy. Avocados are protein-rich and also contain vitamins E, C and B$_6$, plus copper and iron.

Varieties

Among the many varieties, some with soft, smooth skins, others encased in dark, wrinkled shells, the avocado with the best flavour is the hass, a dark avocado with buttery, golden yellow flesh.

Buying and storing

Obtaining the perfect avocado can be a tricky business. Some supermarkets package the fruits with a "ready to eat" label, which is helpful if the avocados are hard-skinned. To test if a soft-skinned avocado is ripe, press the top end gently – it should just give. Ripe avocados can be stored in the refrigerator; unripe ones should be put in a paper bag with a banana to soften.

Preparation and cooking

Avocados soon discolour when cut, but sprinkling the cut surface with lemon juice will help prevent this. To halve an avocado, run a knife lengthways around the fruit, cutting in to the stone (pit), then ease the halves apart. Remove the stone and peel the halves before chopping the flesh. The most common use for avocados is in guacamole, but they also taste wonderful in soups and mousses. Avocados are seldom cooked, but in Latin America slices are often added to soups or stews just before serving. In Brazil, avocado is served as a creamy dessert, *creme de abacate*.

Below: Although high in calories, avocados contain healthy fats and plenty of vitamins and minerals.

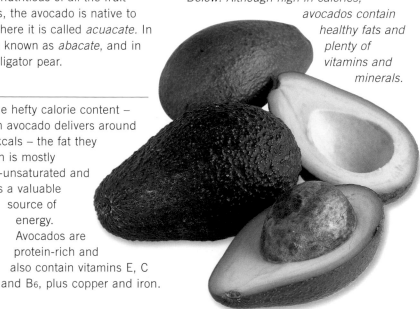

FRUIT

Some of the world's most colourful, exotic and intensely flavoured fruits are to be found throughout Latin America and the Caribbean.

PINEAPPLES

The taste of a freshly picked ripe pineapple is incomparable. Their aroma is so intense that a single pineapple can perfume the entire house, and the flesh is so sweet that it is unnecessary to add sugar or any other sweetener. Cultivated in Central America and the Caribbean long before the arrival of Columbus, this majestic fruit has become popular the world over. Costa Rica and the Dominican Republic are the major producers. Pineapples are used in both sweet and savoury dishes and make refreshing drinks. In Venezuela and Columbia, pineapple is a popular flavouring for sweet custard desserts. Rich in vitamin C and a valuable source of fibre, pineapples also contain bromelain, a protein-digesting enzyme that soothes digestive complaints.

Varieties

There are hundreds of varieties of pineapple, ranging in size from the small "baby pineapples" to specimens 30cm/12in long. Some turn a deep golden yellow as they ripen, while others remain a bronze-green colour. The latest varieties to be cultivated are deliciously sweet and juicy.

Below: Papaya is a popular addition to Latin American fruit salads.

Above: Look for okra pods that are firm, plump and smooth, but not too big.

Buying and storing

Choose firm, ripe fruit with no bruising. The leaves should be glossy and fresh, and there should be a distinctive pineapple aroma. One test of ripeness is to gently pull a leaf from the bottom of the plume; if it comes away easily, the pineapple is ripe. Store whole pineapples in a cool place, but not the refrigerator, and use them as quickly as possible. Slices or cubes of pineapple should be stored in an airtight container and chilled in the refrigerator, where they will keep for up to three days.

PAPAYAS

These Latin American natives were slow to gain popularity in Europe. Before careful packaging techniques and speedy air travel ensured that the fruit reached its destination in good condition, the papayas on sale throughout Europe were far from their best

Preparing pineapple

The fruit is usually served fresh and raw, but cooking brings out the sweet flavour still more and pineapple tastes particularly good in hot, spicy dishes. Avoid using fresh pineapple in gelatine-based desserts, as the bromelain will prevent it from setting.

1 To grill (broil) pineapple, cut the fruit into quarters, remove the core from each piece, then loosen the flesh by running a sharp knife between the flesh and the skin, as when preparing melon.

2 Douse liberally with rum, sprinkle with brown sugar and place under a hot grill (broiler) until caramelized.

3 To cube pineapples, quarter the fruit, then remove the core and skin from each quarter, taking care to cut out the peppery "eyes". Cube the wedges or cut them into sticks.

– hard and unappetizing or soft and squashy. Today, the situation has improved considerably and more and more people are now beginning to appreciate the sweet, scented flesh of this delicious fruit. Papayas are extremely easy to digest, thanks to an enzyme, called papain, which they contain. Papain is a natural tenderizer, a fact that was well known to the pre-Colombian Indians who often marinated their meat in papaya juice to improve the quality. Amply stocked with vitamins A and C, and calcium, papayas are also a valuable source of fibre.

Preparing mangoes

Ripe mangoes are juicy and can be messy to eat. For convenience, cut the fruit into cubes or strips.

1 Cut a broad slice from either side of the mango, removing the "cheeks" or plump sides.

2 For long pieces, peel the skin from each cheek, slice the flesh lengthways, then cut off any flesh still sticking to the stone (pit).

3 To dice mango, leave the flesh on the skin and use a sharp knife to mark it into neat squares.

4 Gently press the mango cheek back on itself so that the pieces stand proud. Either eat straight from the skin with a spoon or use a sharp knife to slice off the chunks.

Varieties

All papayas are pear-shaped, but the size varies considerably, with some weighing up to 5kg/11lb or more. The skin starts off green, before ripening to a bright yellow or red. The sweet, scented flesh can be either pink or yellow. A hybrid form of papaya is the *babaco* from Ecuador, a fruit that can be served fresh or cooked. Stewed *babaco* tastes particularly good with roast meats.

Buying and storing

Look for small, soft papayas with undamaged, yellow skins. Handle them gently and use them as soon as possible. Store ripe papayas in the refrigerator; unripe papayas will continue to ripen at room temperature.

Preparing and serving

Cut the fruit in half and scoop out the seeds. The flavour of papaya is often improved with a squirt of fresh lime juice. Papaya can be combined with coconut milk to make a soothing drink, while in the Caribbean, the unripe fruit is used in savoury dishes.

MANGOES

While many exotic native fruits have been transported from Latin America to European countries, mangoes made the journey in the opposite direction. These delectable fruits originated in Asia, but were enthusiastically embraced by Caribbean and Central American farmers as soon as they were introduced. The meltingly tender flesh, with its unique fragrance and flavour, makes mangoes a

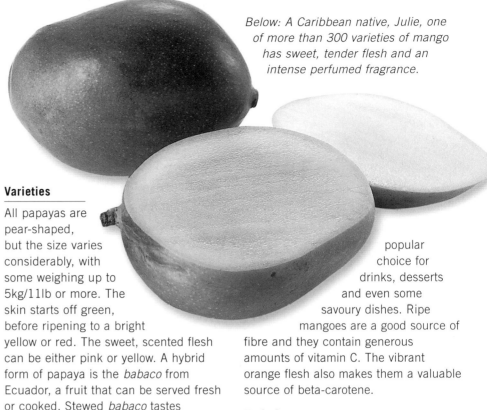

popular choice for drinks, desserts and even some savoury dishes. Ripe mangoes are a good source of fibre and they contain generous amounts of vitamin C. The vibrant orange flesh also makes them a valuable source of beta-carotene.

Varieties

Over 300 varieties of mango are commercially cultivated, with many more being grown in tropical gardens. One of the most popular varieties imported into Europe from the Caribbean is Julie. This medium-sized mango, slightly flattened on one side, comes mainly from the islands of Jamaica and Trinidad and Tobago. It contains only a small amount of fibre and is particularly noted for its fine flavour. Two other favourites are the kidney-shaped Madame Francis, which originated in Haiti, and the Brazilian Itamarica. Of the fibreless varieties, the Jamaican Bombay Green is highly regarded, as is Brazil's Mango de Ubá.

Buying and storing

Not all mangoes turn yellow or become rosy-cheeked when ripe, so colour is not necessarily a clear indication of ripeness. Avoid fruit with dark patches on the skin as this is a sign that the fruit is past its best. A perfect mango will have an intense sweet aroma and will yield when lightly pressed. Unripe mangoes will quickly ripen if placed in a paper bag with a banana.

*Above: Guavas
are used to make the
delicious sweetmeat* dulce de guayaba.

GUAVAS

Native to Central and Southern America, guavas were introduced to Europe by the Conquistadors. Brazil remains a major producer of these highly perfumed fruit, known as *guayabas* in Mexico. Guavas are usually used in desserts, but their flavour is such that they are equally good in savoury dishes, especially with fish. Guavas are an excellent source of vitamin C, better than most citrus fruits. They also contain vitamins A and B6.

Varieties

The fruits can be oval or round, with shiny skin that turns pale yellow when ripe. Some varieties have creamy white flesh, while others have pink or even

*Below:
Grapefruits
are native to
Latin America.*

purple flesh. Guava flesh has a clean, sweet, slightly acidic flavour, and a rather musky scent, but this disappears when the fruit is cooked.

Buying and storing

Look for firm, fairly small fruit that has ripened to a uniform yellow. Avoid any that are bruised or pockmarked. Wrap them well to avoid contaminating other foods with their musky odour, and store them in the refrigerator.

Preparing and serving

If the guavas are young there is no need to peel them. Just wash the fruit, then slice it, removing the larger seeds. Older fruit will need to be skinned and seeded. Guavas can be eaten raw with a little sugar to bring out their flavour, or cooked. In Latin America, sweetened guava pulp is used to make *dulce de guayaba*, which is similar to *membrillo*, the Spanish quince "cheese".

CITRUS FRUITS

The only citrus fruit that originated in Latin America was the grapefruit. A descendant of the Polynesian pomelo or shaddock, it is said to have been cultivated on Barbados. Grapefruit is thought to be useful in helping to lower cholesterol. Oranges came from China and India, and were introduced to the Caribbean by early traders. Seville oranges are particularly popular in the islands – although too bitter to eat raw, they are widely used in poultry and meat dishes. Limes were also an early import, hugely valued because they helped to prevent scurvy. Limes grow well in Latin America and their juice is widely used. Its most famous function is as a marinade for raw fish; the

Dulce de guayaba

This sweet guava paste, popular throughout Latin America, is delicious served with a hard cheese such as Manchego.

1 Peel 1kg/2¼lb guavas, then half each guava and scoop the seeds into a bowl. Add 200ml/7fl oz/ scant 1 cup water and set aside.

2 Chop the guavas and put them in a large, heavy pan. Pour over water to cover, bring to the boil, then cover and simmer, stirring frequently, for about 2 hours. Strain in the juice from the guava seeds and stir well.

3 Purée the mixture in a food processor, then press through a sieve into a bowl. Using a cup measure, scoop it into a heavy pan, noting the number of cups. Add an equal number of cups of sugar and stir in 30ml/2 tbsp lime juice.

4 Stir over a low heat until the mixture reddens and becomes very thick. Pour into a shallow pan and smooth the surface. Dry out in a barely warm oven and serve in small squares.

Above: Limes are a popular ingredient, especially in Mexican dishes.

action of the acid on the protein cooks the fish. Lemons are used in Latin American cooking, but are secondary to limes. All forms of citrus fruit are low in calories and are good sources of fibre and vitamin C.

Varieties

Grapefruit may be white, pink or ruby. There is also a green-skinned variety with sweet flesh. Oranges are either sweet or bitter. There are many varieties of sweet oranges, including Valencias, which are juicy and seedless. Of the bitter oranges, Sevilles are the best known. In addition to being used in cooking, bitter oranges are the basis for several Caribbean liqueurs, including curaçao. There are three main types of lime – Tahitian, Mexican and Key Limes. Mexican limes are fairly small but have a strong and aromatic flavour.

Buying and storing

The juiciest fruits are those that feel fairly heavy for their size. Choose those with firm skin, avoiding any that are damaged or wrinkled. This advice is especially

relevant to limes because they perish more quickly than other forms of citrus fruits. Choose bright green limes with shiny skins that are unmarked by brown patches. Grapefruit, lemons and limes should be stored in a cool place or the refrigerator for up to 1 week; oranges have a slightly longer shelf-life and will keep well for up to 2 weeks at cool room temperature.

BANANAS

Introduced to South America from Portugal in the 16th century, bananas rapidly became naturalized and are today a very important food crop in the region. In some areas, such as the Windward Islands in the Caribbean, they are practically the only crop. A large proportion of the world's organic bananas come from this area, as well as from the Dominican Republic and Mexico. Bananas are convenient, nutritious, tasty and so easy to digest that they can be eaten by everyone, old or young. With high levels of potassium, bananas also contribute vitamins C and B6. The carbohydrate they contain boosts flagging energy levels. Banana leaves are used as a wrapper for *pastelles*, the corn meal and meat parcels that are a speciality on Trinidad and Tobago, and similar wrapped dishes.

Varieties

There are hundreds of different varieties of banana, though few are identified by name. Most familiar in our stores are the common yellow curved bananas, but it is sometimes possible to buy the tiny Brazilian lady fingers or sugar bananas. Red bananas, which come from Ecuador, have orange flesh and taste particularly good when cooked.

Buying and storing

Bananas are harvested when they are still green. By the time they reach stores in the northern hemisphere they have begun to ripen, and most are at their peak after being allowed to ripen in a warm room for a day or two. The skin of the fruit will become progressively darker, and will acquire brown speckles, but even at this stage, the flesh will probably be perfectly good to eat. Do not throw away very soft bananas; they can be used to make banana bread.

Preparing and serving

There's nothing tricky about preparing a banana – simply peel back the skin and eat. If you want to eat half a banana, fold the skin back across the uneaten piece, wrap the fruit well and it will still be edible the next day. Bananas are delicious fresh but can also be cooked. A popular way of preparing them in the Caribbean is to bake them, or cook them on the barbecue, with plenty of brown sugar and a dash of rum to caramelize.

Above: Bananas are an important crop in Latin America and the Caribbean; much of the world's supply comes from plantations in these areas.

OTHER FRUITS

Latin America and the Caribbean are also home to some more unusual fruits, including the following.

Ackees The only part of this bright red fruit that is edible is the creamy-coloured aril, which looks a bit like scrambled egg. Ackee has an interesting texture and a subtle flavour and is one of the key ingredients of the Jamaican dish, salt fish and ackee. Canned ackees are available from Caribbean food stores.

Breadfruit This large green fruit has very starchy flesh. Although very ripe breadfruit can be eaten raw, they are more often roasted, as a Caribbean speciality, baked, boiled or fried. They are available fresh or canned.

Cherimoyas Indigenous to the region, cherimoyas have delicious creamy flesh that tastes like a cross between banana and pineapple, with a texture similar to papaya. The skin and seeds should not be eaten. Varieties include custard apples and soursops.

Prickly pears These are the fruit of a Central American cactus. Beneath the prickly skin, the flesh is sweet-scented, with a taste similar to melon. Prickly pear flesh can be eaten raw with a squeeze of lime juice and a sprinkling of chilli powder to bring out the flavour.

Right: Beneath the pink skin, the flesh of the prickly pear is vibrant red.

Above: Be sure to remove tamarillo skin before eating or cooking the tangy flesh.

Tamarillos Native to the west coast of South America, these shiny, bright red oval fruits are grown commercially in Argentina, Brazil, Colombia and Venezuela. The skin is very bitter and must be removed before the tangy flesh can be enjoyed. A tamarillo dip is the traditional accompaniment for *arepas*, the flat corn breads that are popular in Venezuela and Colombia.

Passion fruits These fragrant fruits come from Central and South America and the best-tasting variety is round and very dark-skinned. The greenish yellow pulp has an exquisite flavour and the seeds are edible, although some people prefer to remove them. Large yellow passion fruits that look rather like light bulbs are granadillas. These have greyish pulp and are neither as flavoursome nor as highly scented as passion fruits.

Above: Choose passion fruits with extra-dark skin as these are sweetest.

Plantains

These are a type of banana grown as a vegetable, but the name is also used for green sweet bananas. True plantains taste very bitter and must be cooked before being eaten. Treat them like potatoes – they are good when baked in their skins, or they can be boiled, mashed, baked or fried as chips. A popular snack on Spanish-speaking Caribbean islands is *tostones de plátano*, long slices of plantain that are partially fried, squashed flat and fried again until brown and crisp.

Below: Fresh plantains are prepared and cooked more like a vegetable than a fruit.

NUTS

Nutrient-rich nuts are a huge part of the Latin American diet, and they appear in various guises, most commonly as a thickening ingredient in both sweet and savoury sauces.

Coconuts The Latin American cuisine relies heavily on coconuts. The liquid they contain is used to flavour drinks and desserts, while the dense nutmeat is a valuable ingredient in almost everything, including soups, seafood and meat dishes and desserts. It is used fresh, dried or as coconut milk or cream, which can be bought canned.

Cashew nuts These are the fruit of an evergreen tree. Each nut grows out of the bottom of a fleshy bulge, which is called a cashew apple. Although not technically a fruit, it closely resembles one, rewarding the picker with crisp, juicy flesh. The nuts themselves are toxic and shelling is a tortuous business, but when released and detoxified, they make a tasty snack and are also used in drinks and sauces.

Pecan nuts These glossy red-skinned nuts are cultivated in northern Mexico, where they are often used in recipes, that hark back to the French occupation in the 19th century. Pecan nuts have a very high fat content so should be eaten sparingly.

Below: Many Latin American desserts are based on coconut or coconut milk.

Pine nuts The nuts of several native pine trees, including the Chilean araucaria and the Brazilian parana pine, are used in Latin American cooking. All are highly nutritious.

Almonds were introduced to Latin America by the Spanish, who cannily added the caveat that they might not be grown on a large scale, thus ensuring that the trade with their native country continued. They are still largely imported, so are fairly expensive and tend to be saved for more extravagant dishes or special occasions. Almonds are still used to make traditional Mexican chocolate, while almond paste is the basis of the luxurious sweetmeat, *turrón.*

Below: Cashew nuts are eaten as a snack with a cold beer or caipirinha.

Left: Almonds are mainly imported from Spain, while pecans and walnuts are native.

Below: Peanuts are a popular ingredient in savoury dishes, particularly with poultry.

Walnuts are grown in the highlands of central Mexico. Their bitter-sweet flavour makes them a popular ingredient in savoury dishes as well as desserts. They taste delicious when baked with potatoes and chillies.

Brazil nuts are the seeds of towering trees that grow wild in the Amazon rain forest. Inside the large husks are around twenty nuts, packed tightly together. Very high in oil, Brazil nuts go rancid quickly when shelled, so crack them at the last minute.

Peanuts These are actually pulses not nuts, and they grow just beneath the soil. They have been cultivated in Peru for centuries and are a valuable food crop, contributing protein and fat to the diet. Peanut brittle is a popular sweet treat, while savoury dishes include pork and potatoes in peanut sauce. Peanut oil and peanut butter are also used, the latter being the basis for a popular punch, which is often served in Trinidad with a shot of rum.

HERBS, SPICES AND FLAVOURINGS

Many of the herbs and spices used in Latin American cooking will be familiar to the foreign visitor. Bunches of thyme, basil, oregano, mint, parsley and coriander (cilantro) scent the air in city markets, and spices such as nutmeg, allspice and cinnamon add their warm aroma. Asian immigrants have introduced cumin, five-spice power and curry powder, but it is perhaps the local specialities that are of most interest to the food tourist: *epazote*, *palillo*, *guascas* and the fiery chilli sauces developed by Caribbean cooks.

THYME

Widely used, especially in Mexico, Colombia and the Caribbean, this robust herb lends its inimitable flavour to dishes such as rice and peas, okra fried rice, Colombian chicken hot-pot and thyme and lime chicken. The dried herb is included in the dry rub that is used to flavour *carnitas*.

Pebre

This hot coriander and chilli salsa from Chile is delicious with meats.

1 Whisk 15ml/1 tbsp red wine vinegar with 30ml/2 tbsp olive oil.

2 Add 2–3 aji mirasol chillies, seeded and very finely chopped, 1 finely chopped small onion, 2 crushed garlic cloves and 75ml/5 tbsp water.

3 Mix well, then stir in 90ml/ 6 tbsp chopped fresh coriander (cilantro). Cover and set aside for 2–3 hours at room temperature to allow the flavours to blend.

Below: Thyme is a popular flavouring in many Colombian dishes.

CORIANDER/CILANTRO

Native to Europe, coriander is grown in South America too, and is hugely popular, especially in Mexico and the Bahian cuisine of Brazil. Fresh coriander leaves go particularly well with fish. Chilli clam soup and Cuban seafood rice both owe their distinctive flavouring to this popular herb. It also goes well with avocado and is used in both guacamole and avocado soup. Mexican green tomato dishes inevitably include coriander.

Right: Use mint to make a refreshing mojito.

Below: Coriander is an essential ingredient in the Mexican salsa, guacamole.

MINT

South America cooks delight in using herbs in innovative ways. Mint and seafood is not an obvious combination, but their use of this familiar flavouring in chunky prawn chowder works extremely well. Mint is also used to flavour drinks and salads.

INDIGENOUS HERBS

Annatto/achiote The seeds of a tropical flowering tree, annatto has long been used as a flavouring and natural dye. The dried seeds have a mild flavour, with a hint of orange blossom. Annatto oil, pressed from the hard orange pulp that surrounds the seeds, is a popular flavouring and colouring for meat, fish and vegetable dishes. In the Yucatán peninsula and nearby Cuba, annatto seeds are often ground with cumin and oregano to make an aromatic rub for meats, such as spiced roast leg of lamb.

Epazote Also known as goose-foot, this herb is as commonplace in South America as oregano is on the islands of Greece. The dried leaves are crumbled and sold in jars. *Epazote* is widely used in central and southern Mexico, especially in bean dishes. The taste has been compared to anis.

Palillo This is an indigenous Peruvian herb. Dried and ground, it has little flavour and is mainly used to give food an attractive golden colour. Turmeric can be substituted, but use only half the amount suggested, as the flavour of turmeric can be overwhelming.

Guascas In Colombia, this herb is so common that it is sometimes viewed as a weed. The essential flavouring of the national dish, *ajiaco*, a delicious chicken soup, it is fairly difficult to obtain outside the country, except in dried and ground form. There is no real substitute as the flavour is unique, although it has been suggested that fennel comes close.

Huacatay comes from a plant that is closely related to the marigold. Pungent, with a rather unpleasant flavour, it is very much an acquired taste.

Caribbean spice mixes

These seasoning mixes are so frequently used in Caribbean recipes that it is perhaps worth making up a large amount and storing for future use.

Herb seasoning Chop 4 spring onions (scallions) and put them in a mortar. Add 1 chopped garlic clove and 15ml/1 tbsp each fresh coriander (cilantro), thyme and basil. Pound until smooth.

Spice seasoning Put 15ml/1 tbsp garlic granules in a bowl. Add 7.5ml/1½ tsp each of ground black pepper, paprika, celery salt and curry powder. Stir in 5ml/ 1 tsp caster (superfine) sugar. Mix well and store in a tightly sealed container in a dry, cool place.

Left: (From top) Warm spices, such as allspice, cinnamon sticks, ground cinnamon and achiote are popoular throughout Latin America.

SPICES

The most popular spices in Caribbean and Latin American cooking are those with warm flavours, such as cinnamon, cloves, cumin, nutmeg and paprika. Several of these flavours are combined in the aptly named allspice, which comes from a type of tree related to the myrtle. Allspice berries are dark brown. When dried they resemble peppercorns. Both the whole berries and the ground spice are used in Latin American cooking. Ground allspice is one of the main flavourings in the traditional Caribbean speciality, salt fish and ackee, and also appears in the marinade for the popular jerk chicken.

Vanilla is another warm spice. The pods or beans come from a climbing tree orchid, which grows in parts of Central America. Added whole to warm milk or chocolate, they impart a wonderfully sweet and fragrant flavour. If just the seeds are required, slit the bean lengthways and carefully scrape them out with a sharp knife.

SWEET AND SOUR

Ever since sugar was introduced to Latin America in the 16th century, sweetmeats (*dulces*) have been enormously popular. Elaborately shaped and decorated, they are an everyday indulgence, as are caramel desserts, such as the flan, which resembles a caramel custard, but sometimes contains pineapple or coconut. Many cooks use unrefined sugar to make treats like these, selecting either *piloncillo*, the dark-brown Mexican sugar, or *panela*, the Colombian version.

As a contrast to all this sweetness, bitter flavours are also highly valued. Angostura bitters, an infusion of gentian root and herbs on a rum base, is often used to add a tart note to fish and meat dishes as well as drinks.

Below: On the island of Barbados, fresh grapefruit is often served with a dash of herb-flavoured Angostura bitters.

DAIRY PRODUCTS AND EGGS

Dairy products came to Latin America relatively late, and although milk, cheese and eggs are important foodstuffs, they do not have as prominent a role as in Europe or North America.

CHEESE

Before the Spanish conquest in the 16th century, fresh milk was a rarity in Latin America. In Peru, indigenous llamas, vicuňas and alpacas that had been domesticated were occasionally milked, but cheesemaking was unknown until the arrival of Spanish missionaries. Nor did their presence spell instant conversion to cheesemaking, since finding a ready supply of milk would remain problematic for some time. The native animals were deemed unsuitable and goats failed to thrive in the humid lowlands. It was only when dairy cattle were established in more temperature zones that cheesemaking was attempted on anything but a minor scale, and the monks who travelled with the conquerors taught local people.

Cow's milk was used to make *queso blanco* (white cheese) – the simple soft cheese that is now a familiar sight in most Latin American countries. In the upland areas where goats were farmed, some cheese was made, but sheep's milk was not used until fairly recently, when farmers in Chile began producing a sheep's milk cheese similar to that produced in the Pyrenées.

There are plenty of cattle in Argentina and Brazil, but they are mainly beef animals. Most of the cheese eaten in Brazil is imported, as the high humidity makes cheese production difficult. A fresh cheese – Minas Frescal – is made in the Minas Gerais region, north of Rio de Janeiro, together with a stretched curd cheese called Minas Prensado.

The influx of immigrants proved to be a trigger for cheese production in many parts of South America. In 19th century Argentina, homesick Italians developed a cheese that closely resembled Parmesan, Treboligiano, as well as a mozzarella-type cheese called Moliterno. Cheese similar to Edam and Gouda satisfied the longing of Dutch settlers on Aruba for familiar flavours.

Below: Queso anejo *is a firm, dry cheese – use fresh Italian parmesan if unavailable.*

In Mexico, the demand for more European cheeses led to local production of cheeses such as Gruyère, Camembert and Port Salut, as well as a version of the Spanish cheese, Manchego. However, soft white cheeses remain the mainstay of the industry.

Queso blanco Made in most Latin American countries and eaten throughout the region, this white cow's milk cheese is traditionally produced from skimmed milk coagulated with lemon juice. Soft and crumbly, it is often used on enchiladas.

Queso fresco As the name, which means "fresh cheese" suggests, this is not a cheese for keeping. Young and unripened, it is usually eaten within a day or two of being made. It is mild and light, with a grainy, slightly crumbly texture. *Queso fresco* is actually the generic name for a number of cheeses, all of which share several common characteristics. It is often used for crumbling on top of finished dishes such as scrambled eggs, cooked *nopales* or other vegetables or bean dishes as a tasty garnish. *Queso fresco* has a fairly clean, sharp taste and is a good melting cheese so it is often used in tacos and on other tortilla-based snacks. If you can't find it in your local supermarket, substitute a good-quality mozzarella or ricotta.

Queso anejo Meaning "aged cheese", this is the dried version of a feta-like cheese. *Queso anejo* is a sharp, salty and fairly firm grating cheese similar to Parmesan, which makes a good substitute. It is often used for sprinkling on top of enchiladas

Queso Chihuahua Similar to *queso anejo*, but less salty, this originally comes from northern Mexico. It resembles Cheddar, and medium Cheddar can be used as a substitute. Alternatively, use the popular American cheese, Monterey Jack, which originated as *queso del pais* (country cheese) and was introduced to California by Spanish missionaries in the 18th century.

Asadero This slightly tart-tasting cheese is sometimes called *queso Oaxaca*, after the place in Mexico where it was originally made. The name *asadero* means "roasting cheese". It is a fairly stringy, supple cheese that is at its best when melted. It is ideal for stuffing fresh chillies, sweet (bell) peppers or other vegetables or meats, as it is unlikely to leak out during cooking. If *asadero* is unavailable, the closest equivalent is Italian mozzarella.

Above: Asadero *melts very well and is perfect for stuffing vegetables and meat.*

Above: When chickens were introduced to Latin America by the Spanish, hen's eggs quickly became popular and were added to many dishes.

MILK

As is the case in Spain, fresh milk is quite difficult to come by in this part of the world because of the heat and humidity. As a result, long-life, evaporated (unsweetened condensed) and condensed milks have become more popular. The use of these treated milks is simply a practical solution to the problem of keeping milk fresh in the heat, but several delicious dishes have evolved that make the most of these treated milks as ingredients. The most famous of these is *dulce de leche*, an incredibly sweet, caramel-flavoured concoction that is so thick and creamy it can be spread on bread like butter or jam. *Dulce de leche* is enomously popular among Latin American children. A rich bread and butter pudding from Barbados also makes the most of evaporated milk as one of its main ingredients.

Milk and cream are also used throughout the region in a similar way to in Europe – they are often combined with fruit to make refreshing drinks, added to rich desserts and used in many savoury sauces, stews and soups. Canned evaporated or condensed milk is nearly always used instead of fresh cream or milk in hot drinks, such as coffee and hot chocolate, adding a distinctive rich, thick sweetness.

EGGS

Until the Spanish arrived in Latin America, the only eggs eaten were those from game birds, ducks, wild geese, reptiles and insects. The Aztecs farmed wild turkeys, but although there is evidence of turkey eggs being used in religious festivals, the birds appeared to have been prized more for their plumage and meat. When chickens arrived on the scene, however, hen's eggs rapidly became a valued food, and today it would be hard to imagine Mexico without *huevos rancheros*, a complete egg-based breakfast, and *rompope*, a cinnamon eggnog; Brazil without *quindao*; or anywhere in Latin America without the traditional flan (caramel custard). Throughout the region, eggs are used in both sweet and savoury dishes. Hard-boiled eggs are often used as a garnish on top of stews or vegetable dishes.

Below: Milk and cream are often added to fresh fruit to make refreshing drinks.

Bajan bread and butter custard

This Caribbean variation of bread and butter pudding relies on evaporated milk for its rich flavour.

SERVES 4
3 thin slices buttered bread, crusts removed, plus extra butter
400g/14oz can evaporated milk
150ml/¼ pint/⅔ cup fresh milk
2.5ml/½ tsp mixed spice (pumpkin pie spice)
40g/1½oz/3 tbsp brown sugar
2 eggs
75g/3oz/½ cup sultanas (golden raisins)
30ml/2 tbsp rum
nutmeg

1 Lightly grease a baking dish with butter. Quarter each slice of bread and layer the pieces in the dish.

2 Whisk the milks, spice, sugar and eggs in a bowl. Pour over the bread and leave to stand for 30 minutes.

3 Meanwhile, soak the sultanas in the rum. Preheat the oven to 180°C/350°F/Gas 4.

4 Sprinkle the sultanas over the pudding, grate over a little nutmeg and bake for 30–45 minutes.

FISH AND SHELLFISH

When it comes to fish and shellfish, citizens of Latin America and the Caribbean are spoilt for choice. Every country except Bolivia and Paraguay has a coastline. You might expect the widest selection of fish to be available to the island dwellers of the Caribbean, but the finest seafood actually comes from the coastlines of Chile and Peru, where plankton brought up from the Antarctic by the icy Humboldt current provides a rich diet for the abundant sea life. The rivers and lakes teem with fresh fish, and both trout and salmon are farmed. The following list introduces just some of the fish available in Latin America, chosen either because they are particularly abundant or make a significant culinary contribution.

FRESH FISH

Snapper Two varieties of red snapper are to be found in the tropical waters of Central and South America. The American red snapper, which has lean white flesh with a very good flavour, is bright red all over, even including the eyes and fins. Its relative, the Caribbean red snapper, tends to be slightly smaller and is distinguished by its yellow eyes and paler belly. All snappers are very good to eat, whether baked, grilled (broiled), poached, steamed or pan-fried. The sweet, delicate flesh goes well with many types of fruit and fruit vegetables, such as mango or avocado. Caribbean snapper is often simply stuffed and baked, and sometimes wrapped in strips of bacon to keep the flesh juicy and tender.

Below: Found in the Caribbean seas, warm-water groupers have fairly firm flesh that can be cooked and served in many ways.

Mahi mahi/dolphinfish/dorade Of all the many names for this flavoursome fish, dolphinfish is perhaps the most unfortunate, since it leads people to imagine, quite wrongly, that it is related to the dolphin. The mahi mahi looks like no other fish. It has an unusual square head and a long, tapering body, which makes it look somewhat like a baseball bat. The firm white flesh of mahi mahi has a delicious sweet flavour.

Mackerel Several varieties of king mackerel are fished off the coast of Latin America, including the *cero*, which is fairly abundant in the Gulf of Mexico, and the *sierra*, which frequents Pacific waters. Mackerel are at their most delicious when eaten extremely fresh, and are a popular choice to be "cooked" with lime juice and eaten as *escabeche*. When cooking mackerel, team it with robust or sharp flavours, to offset the richness.

Above: A large Caribbean red snapper can be stuffed and simply baked or grilled for a delicious meal.

Sea bass These look rather like salmon, with elegant, slim bodies and silvery scales. Various species are found in the Caribbean Sea and the Pacific Ocean. Sea bass can be grilled (broiled), baked, braised, poached, fried or steamed, and they taste particularly good when combined with spicy flavours. In Peru, where the striped bass or corvina is preferred, the fish is cooked with chillies, while in Argentina it is often stuffed and baked.

Grouper These rather glum-looking fish, with their characteristic pouty lips, are members of the sea bass family. The warm-water groupers, such as those that are found in the Caribbean Sea, tend to have firmer flesh than delicate sea bass, and are good for poaching as well as frying, baking or cooking on the barbecue.

Patagonian toothfish This large fish is commonly known as the Chilean sea bass. It does come from Chilean waters, but the sea bass label is not accurate because it belongs to a separate species. Famed for its fine flavour, the Patagonian toothfish is popular in the US and Asia. There have been concerns about overfishing in recent years.

Buying fish

When buying fish, make sure that it is as fresh as possible. This is particularly important if you are intending to serve it as ceviche. Here's what to look for:
- There should be no apparent odour, other than a pleasant, faint smell of the sea.
- The eyes should be clear, bright and slightly bulging.
- The flesh should be firm and elastic; if you press it lightly with your finger it should spring back.
- The gills should gape, revealing a red or rosy interior.
- The scales should be firmly attached, not flaking off.

Swordfish are landed in the Gulf of Mexico and off the coast of Costa Rica from June to January and in Chile in late spring. The meaty flesh is low in fat and dries out quickly, so must be basted frequently if barbecued, or cooked in a sauce for the best results. Swordfish goes well with spicy flavours and Latin American cooks like to cook it with chillies and tomatoes. When buying swordfish, which is usually sold as steaks, check that the flesh is slightly translucent. It should be creamy white or pale pink, with the darker areas shading to a reddish-brown colour. Avoid steaks that look grey.

Pompano These are oily fish that taste similar to mackerel. They are available all year round, sometimes whole, but more often as fillets. There are several varieties in the warm seas off the coast of Central America, but the most common is the African

Left: Fresh trout are plentiful in Lake Titicaca, and are commonly eaten in the highlands of Peru and Bolivia.

pompano. This silvery, grey-finned fish has meaty flesh with a good, strong flavour. It is ideal for spicy dishes and goes well with chillies, coriander, red (bell) peppers and citrus fruit.

Congrio Found off the coasts of Chile and Peru, congrios resemble eels but are actually members of a distinctly separate species – *genypterus chilensis*. There are three types, all with firm, flavoursome flesh that flakes beautifully when cooked. This is one of the few fish to find its way into a poem. The Nobel prize-winning poet Pablo Neruda was so impressed with a bowl of congrio soup supped in his native Chile that he wrote an ode to the delicious fish.

Flying fish Also known as exocets, from which the name of the missile derives, these small fish really do look as if they are flying when you glimpse them leaping from the sea. Their propulsion comes from the tail and they stay in the air for several seconds, their large pectoral fins giving them lift. When freshly caught and pan-fried, flying fish taste delicious. Caribbean cooks like to rub them with a spicy mixture of garlic, herbs and hot pepper sauce before coating them in seasoned flour and frying them.

Above: Fresh swordfish steaks are delicious barbecued with a lime and chilli marinade.

Salt cod
Among the rations given to African slaves shipped over to work the sugar plantations was salt cod. They developed a taste for the rather unprepossessing looking food, and invented many recipes to make the most of its flavour. Some of these were based on those cooked by their Spanish or Portuguese masters, but they were often new. In Brazil, salt cod is served as a topping for baked eggs, while a Caribbean speciality is salt cod with scrambled eggs, spinach and bacon.

Below: Salt cod is used in many traditional Caribbean dishes.

Trout There are plenty of trout in the cooler regions of Latin America. Rainbow, brown and brook trout are found in the Patagonian lakes close to Bariloche, and the icy rivers that flow from the Andes to the sea in Peru are also a magnet for trout fishermen. Lake Titicaca, on the Andean highlands between Peru and Bolivia, also has a plentiful supply of trout. Trout has a fresh, clean flavour and, although it is often cooked very simply – either fried or grilled (broiled) – more inventive chefs delight in introducing unusual flavour combinations. One particularly tasty Caribbean dish combines spiced trout fillets with a rich wine and plantain sauce in a tasty Caribbean dish. The rosy flesh also looks lovely and tastes delicious when paired with fresh prawns (shrimp).

SHELLFISH

Latin America is a great place for shellfish. In the markets you'll not only come across familiar varieties, such as crabs and lobsters, but also rare and remarkable shellfish that look like algae-encrusted rocks, and sea urchins so large that their nickname – sea hedgehogs – seems entirely appropriate. In the Caribbean you can feast on conch, and in Brazil you can dine on some of the biggest prawns (shrimp) you are ever likely to encounter.

Crabs Both sea and land crabs are a delicacy in Latin America. There are many different varieties, from the soft-shelled blue crabs of the Atlantic and Gulf coasts to the mighty Patagonian king crabs. In Brazil, mangrove crabs are a great favourite, while Mexicans are partial to the California or Dungeness crab. Sweet and succulent, crab meat can be used in a wide variety of dishes. When carefully cooked, crab tastes good just as it is, but it also makes a great gumbo. Crab cakes are delicious. In Trinidad and Tobago, a favourite dish is a mixture of onion and crab meat in a rum sauce, served in crab shells.

Below: Crab meat is a Latin American delicacy, which can be added to soups or stews, alongside other seafood.

Above: Tender king prawns are often grilled with fresh coconut for a popular Brazilian street snack.

Prawns and shrimp Several different types of prawns and shrimp are found in the oceans surrounding the continent. The biggest and best are probably the Gulf shrimp, which are found in warm waters. Sometimes pinky grey in colour but more often brilliant scarlet, these are big and succulent. Prawns are always included on a cold mixed fish and shellfish platter but also feature in cooked dishes. They are often cooked with fresh coconut or coconut milk, an unusual combination but one that works extremely well.

Dried shrimp Tiny shrimp, tossed in dendê oil and dried in the sun until crunchy, are popular throughout Latin America, but particularly in Brazil's coastal Bahia region. They give flavour and texture to soups, stews and salads, and are an essential ingredient in the Brazilian dipping sauce, *vatapá*. To prepare dried shrimp, rinse them under cold running water, then soak in hot water for about 35 minutes. They are often ground before being used.

Mussels On the west coast of the continent, where the sea is often turbulent, mussels cling tenaciously to the rocks until prised off by chefs or diners. They inevitably form part of the pit-cooked seafood extravaganza, the Chilean *curanto*, and are also used in a variety of soups and stews. Their sweet, tender flesh is nutritious and they taste best when lightly steamed. Before cooking mussels, it is important to discard any that are not tightly closed, or which do not close when tapped. The opposite applies after cooking, when it is those mussels that have failed to open that must be discarded.

Clams Among the hundreds of different clams found in Latin America and the Caribbean, perhaps the most delicious are the *navajuelas* (razorshells) found off the coast of Chile and Peru. These clams have tubular brown shells. When packed in bundles, they look like bamboo sticks, with the soft creamy flesh of the animal protruding from one end. Razorshells are often served raw, but can be cooked. More familiar hard shell clams include quahogs and littlenecks, which are often used in *chupes* (chowders) and angelwing clams, which are harvested in Mexico, Cuba, Puerto Rico and Chile.

Below: Fresh mussels are abundant in Chile, where seafood is plentiful.

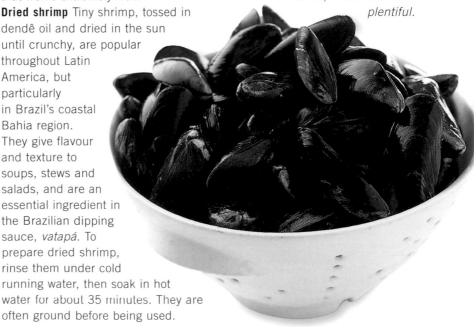

Above: Razorshell clams, also known as navajuelas, *can be cooked but are more often served raw.*

Scallops Easily identified by their fan-shaped shells, scallops are a source of two delectable treats: the sweet, tender white meat and the bright orange roe or "coral". In Latin America, scallops are widely enjoyed, especially on the western seaboard. Black scallops, which are found off the coast of Ecuador, are especially sought after. Scallops are often eaten raw, with just a squeeze of lime, but they can be cooked. Keep the cooking time short, however – a couple of minutes at most.

A Chilean extravaganza
The ultimate South American seafood experience has to be the Chilean *curanto*, a sort of clambake but with a much wider selection of fish and shellfish, including squid, mussels and scallops. A fire is made in a large stone-lined pit. When the stones are hot, the fish and shellfish are placed on top and covered with leaves. The pit is then sealed and only opened hours later when everything is cooked to perfection. One of the best places to sample a real *curanto* is on the island of Chiloe, otherwise, try the one-pot version called *curanto en olla*.

Right: Really fresh king scallops have the best flavour.

Conch Pronounced "konk", this is the animal that lives inside those big, beautiful pink-lined shells that many people display in their bathrooms. A large relative of the whelk, conches are found in the warm, shallow waters of the Caribbean. The pink flesh is tasty and chewy and good to eat, whether raw or cooked, but it must be beaten to tenderize it first. The meat is often used in chowders, but is also good delicately fried. In Barbados, fresh conch fritters are a great favourite, and are often served as a quick bar snack, alongside an ice-cold beer.

Abalone Like the conch, this is a gastropod, a sea creature with a single large foot for locomotion. Abalone feed exclusively on seaweed. They thrive in the cold waters off southern Chile, which are close to the world's largest kelp forests. Abalone are extremely difficult to prise from the rocks that they cling to, which helps to explain why they are fairly expensive. They are highly prized not only for their flesh, but also for their beautiful shells, which are lined with iridescent mother-of-pearl. Abalone has a delicious flavour but must be carefully prepared. Like conch, it needs to be tenderized carefully. Cynics sometimes suggest that the only way to do this successfully is to run it over with a truck, but beating with a wooden mallet usually does the trick.

Sea urchins There are over 800 species of sea urchin found all over the world, but only a few are edible. The ones found in Chile – called *erizos* – are unusually large, up to 10cm/4in across. Regarded as a gourmet delicacy, they are generally eaten raw. A tasty vinaigrette dressing may be offered, but lovers of sea urchins generally prefer them completely unadorned.

Squid
This is a very popular ingredient, especially in Mexico, Central America and the islands of the Caribbean. Squid has firm, lean, white flesh that can be tender and delicious when properly cooked. In Cuba, it forms part of a classic fish and shellfish rice dish, while in Chile it is combined with fresh chillies, potatoes and tomatoes to make a rich, warming stew. Small pan-fried squid can be found for sale along the coasts of South America as a delicious beach snack.

Below: Squid is a popular ingredient in Latin American cooking, with squid casserole a common dish in many areas.

MEAT

Visit Argentina, and you could easily imagine that South America was some kind of monument to meat, yet it was not always so. Before the 16th century, cattle, sheep and pigs were unknown on the continent and the only meat that was consumed came from wild boar, game birds, including the wild turkey, cameloids, small mammals, iguanas, snakes and some other reptiles.

BEEF

Fanning out from either side of the Rio de la Plata are the pampas, large grassy plains that are home to some of the finest beef cattle in the world. Stretching for thousands of miles, the pampas cover the temperate zones of Argentina and Uruguay.

It was the early colonists who introduced beef cattle to the region, along with the European grasses that soon supplanted native varieties. Those first cattle, with horses and other farm animals, were kept in compounds, but inevitably many escaped and, finding the pampas very much to their liking, multiplied to form the nucleus of what would eventually become vast wild herds. With both wild horses and cattle at large, it was only a matter of time before gauchos, the South American cowboys, tamed the one and set about capturing the other. Such private enterprise could not continue indefinitely, however. By the end of the 19th century, much of this cattle country was in

Below: Succulent thick rib joints are ideal for barbecuing.

the hands of private ranchers, and the gauchos had to work for them if they wanted to maintain their chosen way of life. Cattle farming became big business and today much of the world's supply of beef comes not only from Argentina but also from Brazil, Peru and Colombia. Large tracts of rainforest have been cleared to make way for new cattle stations; something that is of considerable and rising concern to environmentalists.

In Latin America, and especially in Argentina and Brazil, beef consumption is high. Argentines eat around one and a half times as much beef as Americans, with much of it cooked over coals, whether in restaurants or at outdoor *asados*. That the meat should be cooked to perfection is a matter of pride. Whole rib sections or flanks of beef are cooked vertically, speared on iron rods that are set at an angle to prevent the juices from dripping on to the fire. Smaller portions are laid out on barbecue grills, some of which are as big as table tennis tables.

A Brazilian speciality is the *churrasco* or mixed grill, which includes excellent beef steaks. Variations on this traditional dish are a feature of special restaurants called *churrascarias* that also specialize in spit-roasts. Pot roasts are a popular choice too, and there are scores of different recipes for rich beef stews, often incorporating chillies, chorizo or other sausages, fresh or dried fruit or even fish and shellfish. Vegetables that

Right: Beef topside is a lean, tender joint of meat, often used for braising or pot-roasting.

cook down to a purée, like potatoes and pumpkin, are often used for thickening sauces, or the delicious juices are mopped up with farofa, a form of toasted cassava flour. Beef is also used to make meatballs or as a tasty and often spicy filling for empanadas, *humitas* or tamales.

Dried meat

In the heat of Latin America, meat tends to go off fairly quickly, so before refrigeration was an option it was necessary to find ways of preserving it. Chief among these was drying, a method that remains popular to this day. To make *cecina*, beef or pork is salted and partially dried, then treated with fresh lemon juice before being briefly air-dried again. During the process the meat acquires a robust flavour, and when it is tenderized it makes extremely good eating. *Cecina* is used to add a rich flavour to stews or as fillings for tortillas and tamales. More thoroughly dehydrated meat is *charqui* or *jerky*, which is produced by air-drying strips of meat in the icy Andean winds. Also available is *carne seca*, the traditional sun-dried salt beef of Brazil, a version of which is also produced in Colombia.

Carnitas

These crisp morsels of marinated meat, usually pork, are a popular Mexican snack, especially in Bajio, to the north of Mexico City.

The meat is cooked in lard, with garlic and oranges, and has a delicious flavour. *Carnitas* are served with salsa as an appetizer or used as a delicious filling for tacos or burritos.

LAMB

The main sheep-farming areas of Latin America are Patagonia, in the south of Argentina, and Uruguay. Sheep are also to be found on the Paramos, the high plateaux between the tree line and the snow line in Chile and Peru. Although lamb and mutton have historically been

Below: Lamb is becoming more popular in South America and is often rubbed with a mixture of spices.

less popular than beef in Argentina, lamb is now gaining ground. Mutton and lamb are popular in Mexico and the islands of the Caribbean, featuring in dishes such as lamb pelau, lamb and lentil soup and "seasoned-up" lamb in spinach sauce. A favourite way of cooking lamb is to marinate it in a mixture of garlic and warm spices, including ground annatto (achiote) seeds, then roast it with sweet (bell) peppers and beans. The annatto gives the meat a rich red colour.

PORK

When Spanish and Portuguese colonists introduced pigs to Mexico and other parts of Latin America, there was jubilation, not just because the meat tasted so good, but also because the lard was such a valuable ingredient for frying and baking. Pork hasn't got the high profile that beef enjoys, but it is a popular meat, especially in Mexico, the Caribbean and Brazil, where pork ribs, smoked tongue and pork sausage feature in the national dish, *feijoada*. A favourite Caribbean treatment is to roast pork with rum, while in Argentina and Peru, meat is cooked in milk. Pork cooked this way is very tender.

KID

In the upland areas where goats thrive, they are highly valued for their milk, meat and hides. Kid – young goat – has a slighlty more gamey flavour than lamb, but the two types of meat are often used interchangeably. The famous Jamaican dish, curry goat, is frequently made using lamb

Above: The top end of a pork leg is excellent as a joint for roasting.

instead, although the title makes it obvious that this wasn't always the case. As well as a slightly stronger flavour, kid is a little tougher than lamb, and therefore needs a longer cooking time for the best results.

Offal

Latin American cooks don't just eat offal, they celebrate it. Intestines, hearts, kidneys, tripe, pigs' feet – in fact all the animal parts eschewed in many other places around the world – are elevated to gourmet status by careful cooking with herbs, spices and sauces. Sausages of all types are also widely eaten, with chorizo being a particular favourite.

Below: Spanish-style chorizo and other dried sausages are often eaten in Latin America.

POULTRY

Although turkeys are native to Latin America and were first domesticated by the Aztecs, along with ducks, chickens were unknown until they were introduced by the Spanish and Portuguese colonists.

CHICKEN

As in many other places throughout the world, chickens can be found absolutely everywhere in Latin America: scratching in backyards, on sale at busy markets and on the menu at home and in restaurants. In the Caribbean, where there is seldom enough land to raise large food animals, chickens are a practical source of protein. Chicken is often grilled (broiled); cut into strips and simmered in soups; roasted for traditional Sunday lunch; rubbed with jerk seasoning and cooked over the coals; or stewed in delicious hot-pots thickened with okra, squash, cassava or peanut-based sauces. All over Latin America, and especially in Peru, you can find simple spit-roasted chickens – *pollos a la brasa* – on sale.

Below: Every part of Latin America and the Caribbean has its own favourite chicken recipe.

Jointing a duck

When preparing a duck, it is important to remember that there is not a great deal of meat on these birds. The simplest and fairest way of serving it is in four equal-sized portions, so the duck must be jointed before cooking.

2 Continue cutting the bird in half, along either side of the backbone.

1 Place the whole bird, breast-up, on a chopping board. Remove the wing tips with poultry shears or a sharp knife and then cut the breast in half, working from the tail towards the neck.

3 Cut each piece of duck roughly in half, cutting diagonally.

DUCK

The wild ducks that wintered in Mexico were hunted for food long before the arrival of the Spanish, and muscovy duck was just one of the more than 300 dishes on the menu when the renowned Aztec emperor, Montezuma, sat down to dine. Duck is also extremely popular in Peru, where it is often cooked with fresh coriander (cilantro) leaves . For lovers of duck, Latin America provides some delicious and unusual recipes, such as duck roasted with sweet potatoes and red wine, or cooked with rum.

TURKEY

Two types of turkey are native to Latin America, one emerging in Yucatán and Guatemala and the other in Mexico. Turkeys were introduced to Europe by the Spanish and they soon became a popular choice in France, Italy and Britain. The wild birds were fast runners and strong fliers, and their bright feathers were highly prized for ceremonial head-dresses and jewellery, and to provide flights for arrows. The Aztecs were the first to domesticate wild turkeys, which they called *huexolotlin*. Aside from being a valuable food source, turkeys also had a strong religious significance, and two festivals were held every year in their honour. Probably the most famous Latin American dish involving turkey is the

Right: Duck is eaten throughout the region – a tasty Caribbean speciality is duck in rum.

Above: Quails are very small birds – for a main course, serve two per person.

Mexican *poblano mole*. There are many versions of this, all of which involve the bird being cooked in a thick, rich sauce, which contains numerous fresh or dried chillies and several pieces of rich, dark chocolate or cocoa powder. Turkey is often cooked with fresh fruit and tastes especially good with sweet, juicy mango in a traditional Caribbean dish.

GAME BIRDS

Wild birds were a vital part of the South American diet in the pre-Colombian era, and they are still hunted in many places today. Pheasant, partridge, quail and pigeon are all regularly eaten, along with several types of jungle bird, including some breeds of parrot. Pheasant is particularly good for roasting or stewing, young partridge is best simply roasted and served in their own cooking juices, while pigeon is delicious braised or cooked in a pigeon pie. The *curassow*, a large black bird with a distinctive crest of curved feathers, can be found from Mexico to Brazil. It is widely regarded as being the best game bird in Latin America, and is therefore in high demand, a fact that has led to over-hunting. Sadly, it has become an endangered species in some areas.

EXOTIC AND UNUSUAL MEATS

In Peru, guinea pigs (*cuyes*) have long been a favourite food. Domesticated in much the same way as chickens, roaming around backyards, they are cooked by similar methods. The vegetarian diet of *cuyes*, like rabbits, gives their meat a fairly light, delicate flavour. Roast *cuy* is sometimes on the menu at out-of-town restaurants and is readily available roasted at many Peruvian markets and on street stalls, but it is more often eaten at home.

Deer are hunted in forest regions, as are *moufflon*, a type of wild sheep, *peccaries*, which are similar to pigs, and wild goats. Llamas and other large cameloids were often cooked and eaten many centuries ago. In certain areas, they occasionally still are, but they tend to be more highly valued as pack animals. Subsistence hunters catch agoutis, tapirs, armadillos, capybara, monkeys, snakes, iguanas and even tortoises. Turtles are also considered a delicacy and are occasionally eaten, although some countries have made their capture and trade illegal.

Above: Turkeys are native to Latin America and were bred by the Aztecs centuries ago.

Pheasant in green pipian sauce

This delicious recipe from the Yucatán peninsula can be used for almost any game bird.

SERVES 4

INGREDIENTS
30ml/2 tbsp oil
2 oven-ready pheasants, halved lengthways
1 onion, finely chopped
2 garlic cloves, crushed
275g/10oz can tomatillos
175g/6oz/generous 1 cup pepitas (pumpkin seeds), ground
15ml/1 tbsp annatto (achiote) seeds, ground
475ml/16fl oz/2 cups chicken stock
salt and ground black pepper
fresh coriander (cilantro), to garnish

1 Heat the oil in a frying pan and sauté the pheasant halves until lightly browned. Place them in a large roasting pan.

2 Purée the onion, garlic and tomatillos, with their juice, in a food processor or blender. Scrape the purée into a pan and add the pepitas and annatto seeds.

3 Stir in the stock and cook gently for 10 minutes, taking care not to burn. Leave to cool.

4 Preheat the oven to 180°C/ 350°F/Gas 4. Pour the sauce over the pheasant and bake for about 40 minutes, basting occasionally. Garnish with fresh coriander (cilantro) and serve immediately.

DRINKS

There are some delightful ways of slaking your thirst in Latin America, from sipping cool coconut juice or a refreshing fruit drink to sampling local wines and spirits. If the latter makes you sleepy, there is always strong coffee to wake you up, or a cup of chocolate to help you relax.

ALCOHOL-FREE DRINKS

Fruit drinks These are something of a speciality in many parts of Latin America and the Caribbean. *Sugos* and *refrescos* or *frescas* are always worth sampling and are particularly popular with children. Made while you wait, from whatever local fruit is available, these fruit drinks tend to be on the sweet side. Ice helps to take the edge off, but they can be served without sugar if preferred. One unusual drink, which is very popular in Brazil, is *guaraná*. Made from the berries of a tree sacred to Amazonian tribes, the drink is sold in both still and carbonated forms and is credited with a vast range of health-giving properties. In the English-speaking islands of the Caribbean, ginger beer is a popular drink, especially around Christmas time, as is *agua de Jamaica*, a refreshing drink made from the bright red sepals of a tropical plant.

Below: Ginger beer is a popular drink in some parts of the Caribbean.

The perfect cup
In Latin America, any time is the right time for full-bodied coffee, and visitors are often staggered by the strength of the brew and the amount consumed. To make a perfect cup, follow these directions:
• Use fresh, cold water that has not been chemically softened.
• Use 60–75ml/4–5 tbsp per 600ml/1 pint/2½ cups.
• Boil the water, then let it cool slightly before pouring it on to the ground coffee.
• If you are using a jug or cafetière (plunge pot) let the coffee stand for 3–4 minutes before pouring or plunging.
• Do not reheat coffee or keep it warm for long periods.

Coffee Two-thirds of the world's supply of coffee comes from Latin America and the Caribbean. Brazil is the leading grower and exporter, with Colombia second. Other important producers are Mexico, El Salvador, Guatemala, Costa Rica, Ecuador and Peru. Coffee is not native to Latin America, however. It was introduced, so the story goes, by a young naval officer called Gabriel de Clieu, who carried a small sapling with him when he sailed to the Caribbean from Europe in 1723. On the voyage, the ship was becalmed, but De Clieu used part of his own water ration to keep the sapling alive until he could plant it on his estate in Martinique. It was clearly a robust specimen, however, because in fewer than 60 years there

Below: Coffee beans must first be roasted before they can be ground.

were 18 million coffee trees on Martinique and production had spread to Central and South America.

There are about 50 species of coffee, but the only ones that are commercially significant are *Coffea arabica* and *Coffea canephora (robusta)*. *Robusta* likes humid, tropical conditions and grows well below 600m/1,900ft, while *arabica* prefers the heights and is cultivated between 600 and 2000m/1,900 and 6,500ft. The young trees do best in well-drained volcanic soil. They need plenty of sun, but cannot tolerate excessively high temperatures, so shade trees are planted between the rows.

Coffee trees are beautiful. They bear jasmine-scented white flowers up to three times a year, and these are followed by the berry-like fruit. These start off green, but gradually ripen to red, when the cherries, as they are called, are harvested. After picking, which must be done by hand for coffee of the highest quality, the cherries go through lengthy processing to release the pair of beans hidden inside each. Before the beans can be ground to make coffee, they must be roasted. Coffee connoisseurs in Latin America like to roast and grind their own beans at home every day, but most of us buy our beans ready-roasted. In some countries, a light roast is preferred, while in others a dark roast is favoured.

Discriminating drinkers demand specific types of coffee, such as Colombian Medellin, but most of what is exported has been blended, either to appeal to the majority or to persuade us to buy coffee tailored to a time of day: light for breakfast and full-bodied for after dinner, for instance.

Above: Good-quality chocolate is still produced in Bariloche, Patagonia.

Chocolate The cacao tree is indigenous to Latin America. One fifth of the world's production now comes from Brazil, with Ecuador only 2 per cent behind. The Olmecs, who inhabited Central America around 1200bc, are credited with discovering that the cacao bean could be transformed into a delicious drink, but it was the Maya and later the Aztecs who perfected the art. For the emperor Montezuma, the perfect end to one of his legendary feasts was a gold cup full of the frothy beverage.

The Aztecs credited cocoa with medicinal powers, and used the drink to treat all sorts of ailments. In this they were ahead of their time, for cocoa has been proven to be high in antioxidants, the natural compounds that are widely believed to reduce cholesterol levels, fight cancer and heart disease and delay signs of ageing. The drink the Aztecs enjoyed was not sweetened, but the natural bitterness of the chocolate was often offset by adding chillies and other warm spices, such as vanilla.

The Spanish first introduced chocolate to the rest of the world and the beverage was soon being drunk in sophisticated resorts and cities all over

Above: Hot chocolate is the perfect end to a meal, according to Montezuma.

Europe. Although it is now as a form of confectionery that chocolate is best known and loved in Europe and the US, its main use in Latin America continues to be as a drink. Mexican chocolate is a delicate mixture of dark and bitter chocolate, sugar, ground almonds and cinnamon, and it tastes incredibly rich.

Swiss chocolate, Argentine-style
Although chocolate is more likely to be a drink than a sweet treat in Latin America, there is one place where bars of very good chocolate are regularly produced, and that is the beautiful Lake District of Patagonia. Descendants of Swiss, German and Northern Italian immigrants have established a thriving chocolate industry in Bariloche, with many locals hand-making their own chocolates. This Andean village is a visual delight, known for its mountains, its lakes and the European look of its streets. The thriving chocolate industry helps to reinforce the town's decidedly Swiss character.

Yerba maté
This herbal tea, made from the leaves of a plant that resembles holly, is popular in Argentina, Uruguay, Paraguay and Southern Brazil. It is traditionally sipped through a silver straw from a hollow gourd, the *maté*, from which it takes its name.

WINE

Much of South America is too hot for successful wine production. However, in Argentina and Chile, in the cool valleys on either side of the Andes, grapes flourish and wine is produced widely.

Argentina is the world's leading wine producer outside of Europe and the US, coming fifth in the global line-up. Until recently, Argentines drank most of the wine they produced themselves, but this is gradually changing. Despite producing less wine than Argentina, Chile has a bigger bite of the international market, and produces some highly regarded wines. Wine is also produced on a smaller scale in Uruguay, Brazil and Mexico.

Argentina

The first vines were planted in Argentina in the middle of the 16th century by Jesuit priests eager to ensure a steady supply of communion wine, Gradually the vineyards became established, and the industry gained a useful boost in the 18th and 19th

Below: Parts of South America, particularly Chile and Argentina, are well known for both their red and white wines.

centuries with the arrival of European viticulturists. They introduced many of the varieties that continue to dominate: Merlot, Cabernet Sauvignon, Chardonnay, Chenin and Pinot Noir.

Most of Argentina's wine comes from the western part of the country, in an area stretching from Rio Negro in the south to La Rioja and Salta in the north. By far the most productive region is Mendoza, which has well over a thousand wineries, despite having very low rainfall. This is because the whole area lies in the rain shadow of the Andes. Paradoxically, however, it is thanks to the Andes that the grapes flourish, as the vines are fed by irrigation from snow and ice-melt.

It is for red wines that Argentina is best known. These include Cabernet Sauvignon, Syrah, Merlot, Malbec, Bonarda, Pinot Noir, Tempranillo and Sangiovese. Malbec is of particular interest. This black grape originated in France, but never fully realized its potential until it was introduced to South America. A wine with an intense, vibrant colour, Malbec has been described as having distinctive berry flavours, with hints of damson, liquorice and even chocolate.

Among the white wines produced are Chenin Blanc, Sauvignon Blanc, Chardonnay and Semillon, From the northern provinces of Salta and La Rioja comes Torrontés, a varietal that is believed to have Spanish antecedents, but which is now strongly established in its adoptive country. Fresh, fruity and deliciously dry, it is extremely popular.

Chile

Roughly one-third of the length of this slender ribbon of a country is given over to the growing of grapes. Although the northern part of the country is desert and the southern tip is too cold for wine production, the central temperate valleys have ideal conditions. The main wine-producing area stretches for just under 900km/550 miles from north of Santiago to Concepción. This part of the country has a Mediterranean climate similar to that enjoyed in South Africa's Western Cape, and because the

Right: Red Stripe lager is one of Jamaica's most famous exports, and is popular throughout Europe and the USA.

moisture-laden clouds that roll in from the ocean drop their rain in winter on the Chilean side of the Andes, irrigation is not the problem it is on the other side of the mountains in Argentina.

Wine production began with the introduction of the rustic Pais grape to Chile in 1548, and owes its present character to the introduction of French vines in the middle of the 19th century. Established varieties like Cabernet Sauvignon, Cabernet Franc, Merlot, Malbec and Sauvignon Blanc soon flourished, and when European vineyards were devastated by a small insect – phylloxera – Chile was fortunately spared and made the most of this opportunity.

The Maipo Valley is the most famous wine-growing area of Chile and the site of some of the oldest established vineyards. It is well-known for producing excellent Cabernet Sauvignon. Also well known for reds are the Curicó and Colchagua Valleys, while some of the finest white wines come from the Aconcagua and Casablanca Valleys in the north. Mulchen, which is at the southern tip of the wine-producing region, is another white wine area, known especially for Sauvignon Blanc and Chardonnay wines.

Thanks to the huge north-south spread and a variety of microclimates, Chile has a wide range of both red and white wines, including several organic varieties. Aside from those varieties already mentioned, Merlot, Carmenère, Malbec, Syrah, Pinot Noir and Viognier are also successfully produced.

BEER

Best known for light, thin lager drunk straight from the bottle with a wedge of lime, Central and South American beer actually has a much richer tradition than is widely appreciated. The Mayans were brewing beer from fermented corn stalks long before Spanish conquistadors invaded, while, in northern Mexico, the Aztecs enjoyed a fermented drink made with sprouted maize. The Spanish settlers set up small breweries from the 16th century onwards, but beer came a poor second to distilled spirits, until German immigrants introduced lager to Mexico. Many of the brewing companies in existence today have German roots. Mexico remains the leading beer producer, followed by Brazil. Lager is the drink of choice and well known brands include Corona Extra, Cuzco, Dos Equis, Sol and Tecate. These lagers go well with spicy Latin American food. The Caribbean also has a strong beer culture and one of Jamaica's most famous exports is Red Stripe lager, now a familiar sight in the US and the UK.

SPIRITS

Latin America has given the world some fine spirits, including rum and tequila.
Rum Legend has it that rum was discovered after sugar-cane mash was left to ferment in the Caribbean sun

Above: The best rum in the world is still produced in the Caribbean.

soon after the first sugar plantations were established on the islands in the 16th century. In the early 18th century, it became standard practice for the British Navy to issue sailors with a daily ration of rum, largely because the spirit endured extremes of weather so much better than beer. At the same time, rum was becoming popular in Britain. Over the centuries, the spirit has been refined, and aged rums now have the same sort of prestige as that accorded to single malt whiskies. Rum is still largely produced in the Caribbean, and some of the world's finest rums come from Jamaica, Cuba, the Dominican Republic, Martinique, Barbados, Haiti and the British Virgin Islands. Rum is also produced in some parts of South America.
Cachaça Another cane spirit, *cachaça* is distilled from the first crush of the sugar cane. Also called *pinga* or *aguardente*, it is the national drink of Brazil and is often

mixed with freshly squeezed lime juice and sugar to make the delicious and popular *caipirinha* cocktail, which is often enjoyed with meals.
Pisco A grape brandy, the birthplace of *pisco* is in some doubt. It originated either in Peru or Chile, depending on which of those countries your informant favours. Its one-time reputation for rough fieriness does not apply to the top grades of *pisco*, which have a delicate, fruity flavour.
Mescal and tequila A distillate made from the juice of the agave cactus, *mescal* is that pale yellow spirit that traditionally comes with a worm in the bottle, and many Mexicans appreciate its fiery qualities. Tequila, of which there are many varieties, is produced by pulling the spirit through a second distillation process.

Below: Mexico's finest exports include mescal *(left) and* tequila blanco *(right).*

Liqueurs

Some of the world's most popular liqueurs originated in parts of Central America and the islands of the Caribbean. Curaçao, the bitter orange liqueur invented by Dutch settlers on the island of the same name, was the forerunner of Grand Marnier and Cointreau. All are still made using Caribbean oranges. Tia Maria is a popular coffee liqueur from Jamaica. It is slightly sweeter than its Mexican rival, Kahlúa, while Toussaint, a coffee liqueur from Haiti, has a delectable strong espresso flavour that makes it extremely good for cooking as well as drinking.

STREET FOOD AND SNACKS

Throughout the Caribbean and Latin America there is a tradition of street food. Market stalls, beach huts, bars and snack houses all offer sweet or savoury snacks, which make perfect accompaniments to fruit juice, cold beer or cocktails.

CASSAVA CHIPS

FOR A PERFECT SUNDOWNER, THERE'S NOTHING QUITE LIKE ENJOYING AN ICE-COLD BEER WITH SOME FRESHLY COOKED, GOLDEN CASSAVA CHIPS. DON'T WORRY ABOUT CUTTING PERFECT-SIZED CHIPS; THEY SHOULD BE CHUNKY AND IRREGULAR, AND EXTRA CRISP.

SERVES FOUR

INGREDIENTS
 800g/1¾lb cassava
 vegetable oil, for frying
 salt

1 Peel the cassava and cut it lengthways into 5cm/2in-wide pieces. Then cut these pieces into slices, about 2cm/¾in thick.

2 Place the slices in a large pan of salted water and bring to the boil. Lower the heat until the water simmers and cover the pan.

3 Cook the cassava for approximately 15 minutes, or until the slices are tender and just beginning to break up. Drain the cassava thoroughly and pat dry with kitchen paper.

4 Pour vegetable oil to a depth of 5cm/2in in a deep wide pan. Heat the oil, then add the cassava pieces. Fry for 3–4 minutes, turning occasionally, until the chips are golden and crisp all over. You may need to do this in batches.

5 Lift the chips from the pan with a slotted spoon and drain on kitchen paper. Season with salt and serve warm or at room temperature.

VARIATION
The chips are sometimes served with a sprinkling of grated Parmesan, in which case they will not need as much salt.

CHEESE TAMALES

CORN MEAL DUMPLINGS STEAMED IN CORN HUSKS ARE TO BE FOUND THROUGHOUT SOUTH AMERICA. THE RECIPE VARIES, WITH FRESH CORN KERNELS BEING USED INSTEAD OF CORN MEAL ON SOME OCCASIONS. THERE ARE MANY POSSIBLE FILLINGS; THIS RECIPE HAS ONE OF THE SIMPLEST.

MAKES TEN

INGREDIENTS
 10 large dried corn husks or
 greaseproof (waxed) paper
 75g/3oz/6 tbsp lard or white cooking
 fat, at room temperature
 225g/8oz/2 cups *masa harina*
 5ml/1 tsp salt
 5ml/1 tsp baking powder
 250–300ml/8–10fl oz/1–1¼ cups
 warm light vegetable stock
 200g/7oz fresh white cheese, such as
 feta, roughly chopped

1 Place the corn husks in a bowl and pour over boiling water to cover. Soak for 30 minutes, until the husks become soft and pliable. Remove from the water and pat dry with a clean dishtowel.

2 Meanwhile put the lard or white cooking fat in a mixing bowl and beat with an electric whisk until light and fluffy. Test by dropping a small amount of the whipped lard into a cup of water. If it floats, it is ready to use.

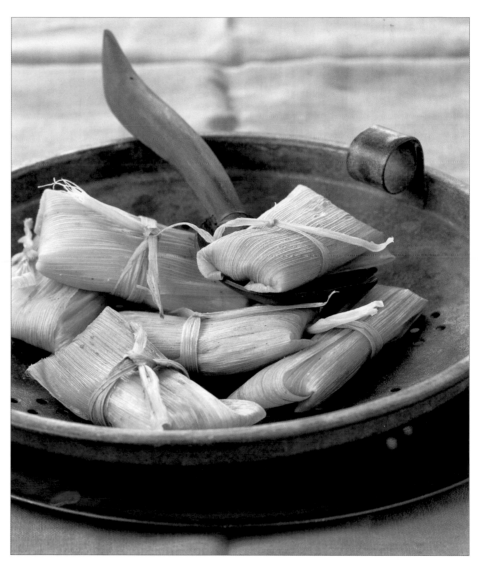

3 Combine the *masa harina*, salt and baking powder in a separate bowl. Gradually add to the lard, beating in 45ml/3 tbsp at a time. As the mixture begins to thicken, start adding the stock, alternating the dry mixture and the stock until both have been used and the mixture is light and spreadable. If it feels tough, or dry to the touch, beat in a little more warm water, but don't add more stock, as the dough will already be flavoursome enough.

4 To assemble, lay the prepared corn husks on a board and spread about one-tenth of the *masa* mixture in the centre of each, leaving a small border at either side, with a larger border at the top and bottom.

5 Place a piece of cheese in the centre of the *masa* mixture. Fold one of the longer lengths of husk over, so that it covers the filling, then repeat with the opposite end. Close the package by folding over the two remaining sides, to make a neat parcel. Secure the tamales by tying each one with a piece of string or strip of corn husk.

6 Pile the tamales in a steamer basket placed over simmering water. Cover and steam for 1 hour. Check the level of the water occasionally, topping up if necessary. The tamales are ready when the dough comes away from the corn husk cleanly. Allow to stand for 10 minutes, then serve.

COOK'S TIP
Masa harina is a flour made with finely ground dried white corn kernels. It is most famously used to make corn tortillas, to which it imparts a nutty flavour. *Masa harina* can be found in Latin food stores and markets.

PLANTAIN AND SWEET-POTATO CHIPS

SALTY YET SWEET, THESE CRISP CHIPS ARE A CARIBBEAN SPECIALITY AND MAKE A DELICIOUS SNACK.

SERVES FOUR

INGREDIENTS
 2 green plantains
 1 small sweet potato
 oil, for deep-frying
 salt

VARIATIONS
For maximum crispness, it is important to use green plantains. If these are not available, substitute green bananas. Yam can be used instead of sweet potatoes. The vegetables must be soaked in cold salted water to prevent discoloration.

1 Using a small sharp knife, trim the plantains and cut them in half widthways. Peel by slitting the skin with a knife, following the natural ridges, then lifting it off. Place the peeled plantains in a bowl of cold, salted water.

2 Peel the sweet potato under cold running water, and add it to the plantains in the bowl.

3 Heat the oil in a large pan or deep-fryer. Remove the vegetables from the salted water, pat dry on kitchen paper and slice into thin rounds.

4 Fry the plantains and sweet potatoes in batches for about 2 minutes until crisp, then remove with a slotted spoon and drain on kitchen paper. Sprinkle with salt and serve when cool.

COCONUT KING PRAWNS

POPULAR THROUGHOUT THE CARIBBEAN ISLANDS, THESE BUTTERFLIED PRAWNS LOOK VERY PRETTY AND THEY TASTE WONDERFUL WHEN PARTNERED WITH A CRISP COCONUT AND CHIVE COATING.

SERVES FOUR

INGREDIENTS
 12 raw king prawns (jumbo shrimp)
 2 garlic cloves, crushed
 15ml/1 tbsp lemon juice
 50g/2oz/4 tbsp fine desiccated (dry unsweetened shredded) coconut
 25g/1oz/⅔ cup chopped fresh chives
 150ml/¼ pint/⅔ cup milk
 2 eggs, beaten
 salt and ground black pepper
 oil, for deep-frying
 lime or lemon wedges and fresh flat leaf parsley, to garnish

COOK'S TIP
If raw king prawns (jumbo shrimp) are difficult to obtain, substitute cooked prawns. However, the raw prawns will absorb more flavour from the marinade, so they are the ideal choice.

1 Peel and de-vein the prawns, leaving the tails intact, then deepen the incision made when de-veining the prawns, cutting from the back almost to the belly so that they can be opened out. Rinse the prawns under cold water and pat dry.

2 Mix the garlic and lemon juice with a little seasoning in a shallow dish, then add the prawns. Toss to coat, cover and marinate for about 1 hour.

3 Mix the coconut and chives in a separate shallow dish, and put the milk and eggs in two small bowls. Dip each prawn into the milk, then into the beaten egg and finally into the coconut and chive mixture.

4 Heat the oil in a large pan or deep-fryer and fry the prawns for about 1 minute, until golden. Lift out and drain on kitchen paper. Serve hot, garnished with lime or lemon wedges and parsley.

TAMALES DE PICADILLO

IN ANCIENT TIMES THESE LITTLE PARCELS MADE FROM CORN HUSKS, POPULAR THROUGHOUT THE WHOLE OF MEXICO, WERE COOKED IN THE HOT ASHES OF A CAMP FIRE.

MAKES TWELVE

INGREDIENTS
 12 dried corn husks
 50g/2oz/¼ cup lard or white cooking fat
 150g/5oz/1 cup *masa harina*
 2.5ml/½ tsp salt
 5ml/1tsp baking powder
 175ml/6fl oz/¾ cup chicken stock
For the picadillo
 15ml/1 tbsp olive or corn oil
 450g/1lb minced (ground) beef
 ½ onion, finely chopped
 1 garlic clove, chopped
 1 eating apple
 225g/½lb tomatoes, peeled, seeded
 and chopped
 1 or 2 drained pickled jalapeño
 chillies, seeded and chopped
 25g/1oz raisins
 1.5ml/¼ tsp ground cinnamon
 1.5ml/¼ tsp ground cumin
 salt and ground black pepper

1 Soak the corn husks in warm water for about 30 minutes until pliable.

2 Meanwhile, make the picadillo. Heat the oil in a frying pan. Add the beef, chopped onion and garlic, and cook, stirring, until the beef is brown and the onion is tender.

2 Peel, core and chop the apple. Add the pieces to the pan with all of the remaining picadillo ingredients. Cook, uncovered, for about 20–25 minutes, stirring occasionally to prevent sticking.

4 In a bowl, cream the lard until it is light and fluffy. Mix the *masa harina* with the salt and baking powder, then gradually beat it into the lard, taking care not to add too much at once.

5 Warm the chicken stock slowly. It should not be hot or it will melt the lard.

6 Gradually beat enough of the chicken stock into the *masa* mixture to make a mushy dough. To see if the dough is ready, carefully place a small piece on top of a bowl of water. If it floats, the dough is ready; if it sinks, continue to beat the dough until the texture is light enough for it to float.

7 Drain a corn husk and lay it flat on a board. Spread about 30ml/2 tbsp of the dough down the centre part of the husk, leaving plenty of room all round for folding. Spoon 30ml/2 tbsp of the picadillo on to the centre of the dough.

8 Roll up the husk from one long side, so that the filling is completely enclosed, then fold the ends of the husks under. Make more tamales in the same way.

9 Prepare a steamer or use a metal colander and a deep pan into which the colander will fit with about 2.5cm/1in space all around.

10 Put the tamales in the steamer, folded ends under. Alternatively, place them in the colander and pour boiling water into the pan to within 2.5cm/1in of the bottom of the colander. Steam the tamales for about 1 hour, or until the dough comes away from the husk. Top up the water as required to prevent the tamales from drying.

11 Serve the tamales immediately, in the husk, leaving guests to open them at the table to reveal the delicious picadillo filling inside.

MIXED TOSTADAS

LIKE LITTLE EDIBLE PLATES, THESE TRADITIONAL MEXICAN FRIED TORTILLAS CAN SUPPORT ALMOST ANY INGREDIENTS YOU LIKE, SO LONG AS THEY ARE NOT TOO JUICY.

MAKES FOURTEEN

INGREDIENTS
 oil, for shallow frying
 14 freshly prepared unbaked
 corn tortillas
 225g/8oz/1 cup mashed red kidney
 or pinto beans
 1 iceberg lettuce, shredded
 olive oil and vinegar dressing
 (optional)
 2 cooked chicken breast portions,
 skinned and thinly sliced
 225g/8oz guacamole
 115g/4oz/1 cup coarsely grated
 mature (sharp) Cheddar cheese
 pickled jalapeño chillies, seeded and
 sliced, to taste

1 Heat the oil in a shallow frying pan and fry the corn tortillas one by one, until golden brown on both sides and crisp but not hard.

2 Spread each tortilla with a layer of mashed pinto or kidney beans. Put a layer of shredded lettuce (which can either be left plain or lightly tossed with a little dressing) over the beans.

3 Arrange chicken slices on top of the lettuce. Carefully spread over a layer of the guacamole and finally sprinkle over the grated cheese.

4 Arrange the mixed tostadas on a large platter and serve immediately, while still warm. Use your hands to eat tostadas as they are extremely messy.

VARIATIONS
• Instead of chicken, try using shredded pork, minced (ground) beef or turkey, or sliced chorizo.
• For a more authentic taste use *queso fresco* or feta cheese instead of Cheddar.

CHEESY EGGS

THESE DELICIOUS CARIBBEAN STUFFED EGGS ARE SIMPLE TO MAKE AND IDEAL FOR LAST-MINUTE PARTY SNACKS. SERVE THEM WITH A CRISP SALAD GARNISH AND DHAL PURI.

SERVES SIX

INGREDIENTS

6 eggs
15ml/1 tbsp mayonnaise
30ml/2 tbsp grated Cheddar cheese
2.5ml/½ tsp ground white pepper
10ml/2 tsp chopped fresh chives
2 radishes, thinly sliced, to garnish
lettuce leaves, to serve

VARIATION
A variety of fillings can be used instead of Cheddar cheese. Canned sardines or tuna mayonnaise make a tasty alternative.

1 Cook the eggs in boiling water for about 10 minutes until hard-boiled. Lift out the eggs and place them in cold water. When cool, remove the shells.

2 Put the mayonnaise, Cheddar cheese, pepper and chives into a small bowl. Cut the hard-boiled eggs in half lengthways and carefully scoop out the yolks without breaking the whites, Add the yolks to the bowl.

3 Mash all the ingredients with a fork until well blended.

4 Fill each egg white with the egg yolk and cheese mixture, and arrange on a plate. Garnish with thinly sliced radishes and serve with crisp green lettuce leaves.

CRAB CAKES

SERVED WITH A HOT AND SPICY TOMATO DIP, THESE CARIBBEAN CRAB CAKES ARE QUITE DELICIOUS. USE THE FRESHEST CRAB MEAT AVAILABLE AND SERVE AS A SNACK AT ANY TIME OF DAY.

MAKES ABOUT FIFTEEN

INGREDIENTS
 225g/8oz white crab meat
 115g/4oz cooked potatoes, mashed
 30ml/2 tbsp fresh herb seasoning
 2.5ml/½ tsp prepared mild mustard
 2.5ml/½ tsp ground black pepper
 ½ fresh hot chilli, seeded
 and chopped
 2.5ml/½ tsp dried oregano, crushed
 1 egg, beaten
 15ml/1 tbsp shrimp paste (optional)
 flour, for dusting
 oil, for frying
 lime wedges and fresh basil leaves,
 to garnish
For the tomato dip
 15ml/1 tbsp butter or margarine
 ½ onion, finely chopped
 2 canned plum tomatoes, drained
 and chopped
 1 garlic clove, crushed
 150ml/¼ pint/⅔ cup water
 5–10ml/1–2 tsp malt vinegar
 15ml/1 tbsp chopped fresh
 coriander (cilantro)
 ½ chilli, seeded and chopped

1 To make the crab cakes, combine the crab meat, mashed potato, herb seasoning, mustard, black pepper, chilli, oregano and egg in a large bowl. Add the shrimp paste, if using, and mix well. Cover and chill for 30 minutes.

VARIATION
If you cannot get hold of fresh crab meat, these taste just as good made with canned tuna.

2 Make the tomato dip. Melt the butter or margarine in a small pan. Add the onion, chopped tomato and garlic and sauté for about 5 minutes until the onion is soft.

3 Add the water, vinegar, coriander and chilli. Simmer for 10 minutes, then blend to a smooth purée in a food processor or blender. Pour into a bowl. Keep warm or chill, as required.

4 Using a spoon, shape the crab mixture into rounds and dust with flour. Heat a little oil in a large frying pan and fry the crab cakes, a few at a time, for 2–3 minutes on each side until golden brown. Remove with a fish slice, drain on kitchen paper and keep hot while cooking the remaining cakes. Serve with the tomato dip and garnish with lime wedges and basil leaves.

PAN-FRIED SQUID

VISIT A BEACH BAR ANYWHERE ALONG THE COAST OF SOUTH AMERICA AND THIS IS PRECISELY THE TYPE OF SNACK YOU ARE LIKELY TO FIND ON SALE.

SERVES FOUR

INGREDIENTS
 1kg/2¼lb fresh small squid
 30ml/2 tbsp olive oil
 2 garlic cloves, crushed
 1 fresh red chilli, seeded and
 finely chopped
 45ml/3 tbsp *cachaça*
 juice of 1 lime
 salt
 chunks of bread, to serve

1 Clean the squid under cold water. Pull the tentacles away from the body. The squid's entrails will come out easily. Remove the piece of cartilage from inside the body cavity and discard it.

VARIATION
If you cannot find *cachaça*, replace it with white rum or vodka.

2 Wash the body and peel away the membrane that covers it. Cut between the tentacles and head, discarding the head and entrails. Leave the tentacles whole, but discard the hard beak in the middle. Cut the body into small pieces.

3 Heat the oil over a high heat. Add the garlic, chilli and squid. Season with salt and cook for 2–3 minutes, until the squid is opaque and lightly charred.

4 Pour in the *cachaça* and continue cooking the squid until most of the liquid has evaporated. Remove the pan from the heat and then stir in the lime juice.

5 Tip the squid on to a plate and serve with chunks of bread to soak up the delicious cooking juices. Offer cocktail sticks (toothpicks) for picking up the pieces of squid.

FRIED WHITEBAIT WITH CAYENNE PEPPER

FOR THE PERFECT BEACH SNACK, TRY THESE CRISP, SPICY, BITESIZE FISH WITH A SQUEEZE OF LIME.

SERVES FOUR

INGREDIENTS
 50g/2oz/½ cup plain
 (all-purpose) flour
 1.5ml/¼ tsp cayenne pepper
 250g/9oz whitebait
 vegetable oil, for deep-frying
 salt and ground black pepper
 lime wedges, to serve

VARIATIONS
Small fresh anchovies are also delicious cooked whole in this way. Alternatively, make up a mixed platter using whitebait, squid and prawns (shrimp).

1 Sift the flour and cayenne pepper into a deep bowl or large shallow dish. Season with plenty of salt and ground black pepper.

2 Thoroughly coat the whitebait in the seasoned flour, then shake off any excess flour and make sure the whitebait are separate. Do this in batches, placing the coated fish on a plate ready for frying.

3 Pour oil to a depth of 5cm/2in into a deep wide pan. Heat the oil until very hot, then add a batch of whitebait and fry for 2–3 minutes until golden. Remove from the pan with a slotted spoon and drain on kitchen paper. Repeat with the remaining whitebait.

4 Pile the fried whitebait on a plate, season with salt and serve immediately with the lime wedges.

BLACK-EYED BEAN AND SHRIMP FRITTERS

THIS BRAZILIAN SNACK, LOCALLY KNOWN AS ACARAJÉ, IS FROM BAHIA, A REGION HIGHLY INFLUENCED BY ITS AFRICAN SLAVE HERITAGE. WOMEN FRY THESE PATTIES TO ORDER. THEY ARE THEN CUT OPEN AND FILLED WITH VARIOUS SAUCES, ALL DELECTABLE BUT VERY MESSY TO EAT.

MAKES TEN

INGREDIENTS
 250g/9oz/1¼ cups black-eyed
 beans (peas)
 40g/1½oz/¼ cup dried shrimp
 1 onion, roughly chopped
 palm oil and vegetable oil, for frying
 salt
 chilli oil, to serve
For the filling
 30ml/2 tbsp palm oil
 115g/4oz/⅔ cup dried shrimp
 1 large onion, thinly sliced
 2 fresh hot red chillies, seeded and
 finely chopped

1 Put the black-eyed beans in a large bowl and cover with plenty of water. Soak overnight to loosen the skins. Drain, then soak for a further 30 minutes in hot (but not boiling) water.

2 Drain the beans and tip them on to a board. Rub them between your hands to separate them from their skins. The patties will be very dry if the skins are not removed.

3 Transfer the beans to a bowl and pour over cold water to cover. The loose skins will begin to rise to the surface. Remove them with a slotted spoon and throw them away. Stir the beans to encourage more skins to float to the surface, continuing until all the skins have been removed. You'll be able to chart your progress easily, as the beans lose their distinctive "eye" when peeled. Drain.

4 Blend the dried shrimp and onion in a food processor until smooth. Add the beans and blend to a thick purée. Season with salt.

5 Mix equal quantities of palm oil and vegetable oil to a depth of about 5cm/2in in a deep pan. Form the *acarajé* mixture into 10 oval shapes. Heat the oil and fry half of the fritters for 5 minutes or until golden. Lift out with a slotted spoon and drain on kitchen paper. Between batches, skim the oil to remove any burnt bits.

6 Make the filling. Heat the oil in a frying pan. When hot, add the dried shrimp and sauté for 2–3 minutes until golden. Lift out with a slotted spoon and drain on kitchen paper. Lower the heat and stir in the onion slices. Cook for 5 minutes until soft, then add the chilli. Sauté for 1 minute and set aside.

7 Cut each fritter open lengthways and fill with the onion mixture. Add a couple of dried shrimp and drizzle with chilli oil.

BEEF EMPANADAS

YOU'LL FIND THESE PASTRY TURNOVERS THROUGHOUT LATIN AMERICA, WITH COLOMBIA'S BEING PERHAPS THE MOST FAMOUS. THEY COME WITH A VARIETY OF FILLINGS, INCLUDING BEEF, PORK, VEGETABLES AND CHEESE. WHAT BETTER WAY FOR USING UP LEFTOVERS?

MAKES TWENTY

INGREDIENTS
225g/8oz/2 cups plain
(all-purpose) flour
2.5ml/½ tsp salt
90g/3½oz/scant ½ cup cold butter,
cut into small chunks
juice of ½ lime
50ml/2fl oz/¼ cup lukewarm water
vegetable oil, for deep-frying
chilli salsa, to serve (optional)
For the filling
450g/1lb beef shin or leg (shank)
60ml/4 tbsp olive oil
1.5ml/¼ tsp ground cumin
1 garlic clove, crushed
10ml/2 tsp paprika
250ml/8fl oz/1 cup light beef stock
450g/1lb potatoes, peeled and cubed
2 tomatoes, finely chopped
3 spring onions (scallions),
finely chopped
salt and ground black pepper

1 Make the filling. Cut the beef into large chunks and chop in a food processor until finely diced, but not minced (ground). This will tenderize the meat, cutting the cooking time.

2 Heat 30ml/2 tbsp of the olive oil in a wide, heavy pan over a high heat. Add the beef chunks and sauté until golden brown. Push the beef to the side and add the cumin, crushed garlic and paprika to the pan. Reduce the heat and cook, stirring gently, for around 2 minutes, until the spices begin to release their delicious aroma.

3 Stir in the stock and bring to the boil. Cover and cook over a low heat for 30 minutes. Stir in the potatoes, tomatoes and spring onions. Cook for 15 minutes more, or until the beef and potatoes are tender. Season with salt and pepper to taste, then leave to cool.

4 Meanwhile, place the flour and salt in a food processor. Add the small chunks of butter and pulse until the mixture resembles fine breadcrumbs. Combine the lime juice and water and slowly pour into the food processor, with the motor still running. As soon as the pastry comes together, tip it on to a floured surface and gently knead to a soft dough. Shape into a ball, wrap in clear film (plastic wrap) and chill for at least 20 minutes.

5 On a floured surface roll out the pastry until it is very thin. Cut out 6cm/2½in circles, using a pastry (cookie) cutter.

6 Spoon about 7.5ml/1½ tsp of the filling into the centre of a pastry circle, then brush the edges with water. Fold the pastry over to form a half-moon, then press around the edges to seal. Repeat with the rest of the pastry.

7 Pour vegetable oil to a depth of 5cm/2in into a deep frying pan. Heat the oil, then add five or six empanadas. Fry for 5 minutes until golden brown, turning halfway through cooking. Remove from the pan with a slotted spoon and drain. Repeat with the remaining empanadas. Serve with a little chilli salsa, if using.

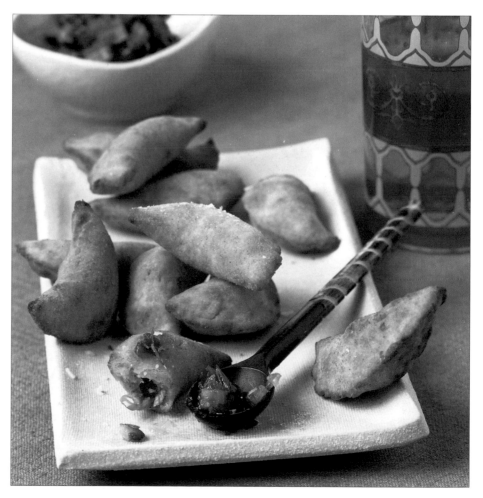

NUT BRITTLE

NUTS ARE VERY POPULAR IN SOUTH AMERICA AND VARIATIONS OF THIS SNACK ARE TO BE FOUND THROUGHOUT THE CONTINENT. IN BRAZIL IT'S CALLED PE-DE-MOLEQUE *(KID'S FEET).*

MAKES ABOUT TEN

INGREDIENTS
 vegetable oil, for greasing
 250g/9oz/2¼ cups unsalted peanuts
 250g/9oz/generous 1 cup
 granulated sugar

COOK'S TIP
Act quickly once the sugar has reached the ideal colour, otherwise the caramel could burn and become bitter. Don't worry if the pieces of brittle don't snap evenly when cooled – they'll be just as delicious if irregular.

1 Using vegetable oil, grease a shallow 30 x 20cm/12 x 8in baking tin (pan). Tip the sugar and peanuts into a heavy pan and place over a low heat.

2 As the sugar begins to melt, start stirring the nuts with a wooden spoon, bringing the sugar that is beginning to caramelize around the edges of the pan into the centre.

3 When all the mixture has caramelized and has taken on a deep brown colour, remove the pan from the heat and quickly pour the mixture into the prepared baking tin. Leave it to cool.

4 When the brittle has almost set, use a knife to mark it into regular squares or rectangles. This will make it easier to snap the cold brittle into pieces.

COCONUT SWEETS

THESE CHEWY SWEETS (CANDIES) ARE A FAVOURITE WITH CHILDREN. THEY CAN BE MADE PLAIN, BUT THE LIME JUICE AND CLOVES ADD AN INTERESTING TWIST THAT ADULTS CANNOT RESIST EITHER.

MAKES TWENTY-FIVE

INGREDIENTS
 50g/2oz/⅔ cup desiccated (dry
 unsweetened shredded) coconut
 105ml/7 tbsp water
 175g/6oz/¾ cup light muscovado
 (brown) sugar
 large pinch ground cloves
 juice of ½ lime

1 Line a baking tray with baking parchment. Place the coconut in a pan with the water and sugar. Heat gently until the sugar dissolves.

2 Stir in the ground cloves and lime juice and increase the heat. Cook, stirring with a wooden spoon, until the mixture has thickened and become dark golden brown.

3 Drop spoonfuls of the mixture on to the lined tray, pressing the mixture down with the back of the spoon to flatten it lightly into chunky, irregular pieces. Leave to cool before eating.

VARIATION
Equal quantities of grated fresh coconut and grated raw pumpkin can be used instead of the desiccated coconut.

SOUPS

The colonizers of Latin America and the Caribbean introduced soup to the region, transforming their original recipes by using local ingredients. Light soups, such as heart of palm soup, are ideal as an appetizer, while heartier soups, such as chilli clam broth, make excellent light meals.

VERMICELLI SOUP

THIS POPULAR MEXICAN SOUP, DELICIOUS AS AN APPETIZER, DRAWS INSPIRATION FROM TRADITIONAL ITALIAN CUISINE, USING INGREDIENTS SUCH AS VERMICELLI, GARLIC AND PARMESAN CHEESE.

SERVES FOUR

INGREDIENTS
30ml/2 tbsp olive or corn oil
50g/2oz/⅓ cup vermicelli
1 onion, roughly chopped
1 garlic clove, chopped
450g/1lb tomatoes, peeled, seeded
 and roughly chopped
1 litre/1¾ pints/4 cups
 chicken stock
1.5ml/¼ tsp sugar
15ml/1 tbsp finely chopped fresh
 coriander (cilantro)
salt and ground black pepper
chopped fresh coriander, to garnish
25g/1oz/¼ cup freshly grated
 Parmesan cheese, to serve

COOK'S TIP
Vermicelli burns easily, so move it about in the frying pan and remove from the heat as soon as it is brown.

1 Heat the olive or corn oil in a shallow frying pan and gently sauté the vermicelli over a moderate heat until golden brown. Take care not to let the strands burn. Remove the vermicelli with a slotted spoon and drain thoroughly on kitchen paper.

2 Purée the chopped onion, garlic and tomatoes in a food processor until smooth. Return the frying pan to the heat. When the oil is hot, add the purée.

3 Cook the tomato purée, stirring constantly, for about 5 minutes.

4 Transfer the purée to a pan. Add the vermicelli and pour in the stock. Season to taste. Stir in the coriander, bring to the boil, then lower the heat, cover the pan and simmer until the vermicelli is tender.

5 Serve sprinkled with chopped coriander, with the Parmesan on the side.

TOMATO SOUP

THE TASTE OF FRESH CORIANDER ADDS A MEXICAN FLAVOUR TO THIS CLASSIC TOMATO SOUP RECIPE. SPRINKLE GENEROUSLY WITH BLACK PEPPER AND SERVE WITH CRUSTY BREAD FOR A SATISFYING LUNCH.

SERVES FOUR

INGREDIENTS
15ml/1 tbsp corn or peanut oil
1 onion, finely chopped
900g/2lb tomatoes, peeled, seeded
 and chopped
475ml/16fl oz/2 cups chicken stock
2 large fresh coriander
 (cilantro) sprigs
salt and ground black pepper

1 Heat the oil in a pan and gently fry the finely chopped onion, stirring frequently, for about 5 minutes, or until it is soft and translucent but not brown.

2 Add the chopped tomatoes, chicken stock and coriander sprigs to the pan. Bring to the boil, then lower the heat, cover the pan and simmer gently for about 15 minutes.

3 Remove and discard the coriander. Press the soup through a sieve and return it to the clean pan. Season and heat through. Serve sprinkled with ground black pepper.

CREAMY HEART OF PALM SOUP

THIS DELICATE SOUP HAS A LUXURIOUS, CREAMY, ALMOST VELVETY TEXTURE. THE SUBTLE YET DISTINCTIVE FLAVOUR OF THE PALM HEARTS IS LIKE NO OTHER, ALTHOUGH IT IS MILDLY REMINISCENT OF ARTICHOKES AND ASPARAGUS. SERVE WITH FRESH BREAD FOR A SATISFYING LUNCH.

SERVES FOUR

INGREDIENTS
 25g/1oz/2 tbsp butter
 10ml/2 tsp olive oil
 1 onion, finely chopped
 1 large leek, finely sliced
 15ml/1 tbsp plain (all-purpose) flour
 1 litre/1¾ pints/4 cups
 well-flavoured chicken stock
 350g/12oz potatoes, peeled
 and cubed
 2 x 400g/14oz cans hearts of palm,
 drained and sliced
 250ml/8fl oz/1 cup double
 (heavy) cream
 salt and ground black pepper
 cayenne pepper and chopped fresh
 chives, to garnish

1 Heat the butter and oil in a large pan over a low heat. Add the onion and leek and stir well until coated in butter. Cover and cook for 5 minutes until softened and translucent.

2 Sprinkle over the flour. Cook, stirring, for 1 minute.

3 Pour in the stock and add the potatoes. Bring to the boil, then lower the heat and simmer for 10 minutes. Stir in the hearts of palm and the cream, and simmer gently for 10 minutes.

4 Process in a blender or food processor until smooth. Return the soup to the pan and heat gently, adding a little water if necessary. The consistency should be thick but not too heavy. Season with salt and ground black pepper.

5 Ladle the soup into heated bowls and garnish each with a pinch of cayenne pepper and a scattering of fresh chives. Serve immediately.

VARIATION
For a richer, buttery flavour, add the flesh of a ripe avocado when blending.

PEANUT AND POTATO SOUP WITH CORIANDER

PEANUT SOUP IS A FIRM FAVOURITE THROUGHOUT CENTRAL AND SOUTH AMERICA, AND IS PARTICULARLY POPULAR IN BOLIVIA AND ECUADOR. AS IN MANY LATIN AMERICAN RECIPES, THE GROUND NUTS ARE USED AS A THICKENING AGENT, WITH UNEXPECTEDLY DELICIOUS RESULTS.

SERVES SIX

INGREDIENTS
 60ml/4 tbsp peanut oil
 1 onion, finely chopped
 2 garlic cloves, crushed
 1 red (bell) pepper, seeded
 and chopped
 250g/9oz potatoes, peeled and diced
 2 fresh red chillies, seeded and
 chopped
 200g/7oz canned chopped tomatoes
 150g/5oz/1¼ cups unsalted peanuts
 1.5 litres/2½ pints/6¼ cups beef stock
 salt and ground black pepper
 30ml/2 tbsp chopped fresh coriander
 (cilantro), to garnish

1 Heat the oil in a large heavy pan over a low heat. Stir in the onion and cook for 5 minutes, until beginning to soften. Add the garlic, pepper, potatoes, chillies and tomatoes. Stir well to coat the vegetables evenly in the oil, cover and cook for 5 minutes, until softened.

2 Meanwhile, toast the peanuts by gently cooking them in a large dry frying pan over a medium heat. Keep a close eye on them, moving the peanuts around the pan until they are evenly golden. Take care not to burn them.

COOK'S TIP
Replace the unsalted peanuts with peanut butter if you like. Use equal quantities of chunky and smooth peanut butter for the ideal texture.

3 Set 30ml/2 tbsp of the peanuts aside, to use as garnish. Transfer the remaining peanuts to a food processor and process until finely ground. Add the vegetables and process again until smooth.

4 Return the mixture to the pan and stir in the beef stock. Bring to the boil, then lower the heat and simmer for 10 minutes.

5 Pour the soup into heated bowls. Garnish with a generous scattering of coriander and the remaining peanuts.

FISH <u>AND</u> SWEET POTATO SOUP

THE SUBTLE SWEETNESS OF THE POTATO COMBINES WITH THE STRONGER FLAVOURS OF FISH AND
OREGANO TO MAKE THIS AN APPETIZING SOUP, POPULAR THROUGHOUT THE CARIBBEAN.

SERVES FOUR

INGREDIENTS
175g/6oz white fish fillet, skinned
½ onion, chopped
1 sweet potato, about 175g/6oz,
 peeled and diced
1 small carrot, about 50g/2oz,
 chopped
5ml/1 tsp chopped fresh oregano or
 2.5ml/½ tsp dried oregano
2.5ml/½ tsp ground cinnamon
1.35 litres/2¼ pints/5½ cups
 fish stock
75ml/5 tbsp single (light) cream
chopped fresh parsley, to garnish

1 Remove any bones from the fish and put it in a pan. Add the onion, sweet potato, carrot, oregano, cinnamon and half of the stock. Bring to the boil, then simmer for 20 minutes or until the potatoes are cooked.

2 Leave to cool, then pour into a food processor and blend until smooth.

3 Return the soup to the pan, stir in the remaining fish stock and gently bring to the boil. Reduce the heat.

4 Stir the cream into the soup, then gently heat it through without boiling. If the soup boils the cream will curdle. Serve hot, garnished with the chopped parsley.

CARIBBEAN VEGETABLE SOUP

THIS HEARTY VEGETABLE SOUP IS FILLING ENOUGH TO BE SERVED ON ITS OWN FOR LUNCH, BUT STRIPS
OF COOKED MEAT, POULTRY OR FISH CAN ALSO BE ADDED.

SERVES FOUR

INGREDIENTS
25g/1oz/2 tbsp butter or margarine
1 onion, chopped
1 garlic clove, crushed
2 carrots, sliced
1.5 litres/2½ pints/6¼ cups
 vegetable stock
2 bay leaves
2 fresh thyme sprigs
1 celery stick, finely chopped
2 green bananas, peeled
 and quartered
175g/6oz white yam or eddoe,
 peeled and cubed
25g/1oz/2 tbsp red lentils
1 chayote (christophene), peeled
 and chopped
25g/1oz/2 tbsp macaroni (optional)
salt and ground black pepper
chopped spring onion (scallion),
 to garnish

1 Melt the butter or margarine in a pan and fry the onion, garlic and carrots for a few minutes, stirring occasionally. Add the stock, bay leaves and thyme, and bring to the boil.

2 Add the celery, green bananas, white yam or eddoe, lentils, chayote and macaroni, if using. Season with salt and ground black pepper and simmer for 25 minutes or until the vegetables are cooked through. Serve garnished with chopped spring onion.

VARIATION
Use other root vegetables, such as potatoes or sweet potatoes, if yam or eddoes are not available.

CRAB, COCONUT AND CORIANDER SOUP

QUICK AND EASY TO PREPARE, THIS SOUP HAS ALL THE FLAVOURS ASSOCIATED WITH THE BAHIA REGION OF BRAZIL: CREAMY COCONUT, PALM OIL, FRAGRANT CORIANDER AND, OF COURSE, CHILLI.

SERVES FOUR

INGREDIENTS
 30ml/2 tbsp olive oil
 1 onion, finely chopped
 1 celery stick, finely chopped
 2 garlic cloves, crushed
 1 fresh red chilli, seeded and
 chopped
 1 large tomato, peeled and chopped
 45ml/3 tbsp chopped fresh
 coriander (cilantro)
 1 litre/1¾ pints/4 cups fresh crab
 or fish stock
 500g/1¼lb crab meat
 250ml/8fl oz/1 cup coconut milk
 30ml/2 tbsp palm oil
 juice of 1 lime
 salt
 hot chilli oil and lime wedges,
 to serve

1 Heat the olive oil in a pan over a low heat. Stir in the onion and celery, and sauté gently for 5 minutes, until softened and translucent. Stir in the garlic and chilli and cook for a further 2 minutes.

2 Add the tomato and half the coriander and increase the heat. Cook, stirring, for 3 minutes, then add the stock. Bring to the boil, then simmer for 5 minutes.

3 Stir the crab, coconut milk and palm oil into the pan and simmer over a very low heat for a further 5 minutes. The consistency should be thick, but not stew-like, so add some water if needed.

4 Stir in the lime juice and remaining coriander, then season with salt to taste. Serve in heated bowls with the chilli oil and lime wedges on the side.

CHILLI CLAM BROTH

THIS SOUP OF SUCCULENT CLAMS IN A TASTY STOCK COULD NOT BE EASIER TO PREPARE. POPULAR IN COASTAL AREAS OF COLOMBIA, IT MAKES THE PERFECT LUNCH ON A HOT SUMMER'S DAY.

SERVES SIX

INGREDIENTS

30ml/2 tbsp olive oil
1 onion, finely chopped
3 garlic cloves, crushed
2 fresh red chillies, seeded and
 finely chopped
250ml/8fl oz/1 cup dry white wine
400ml/14fl oz can plum tomatoes,
 drained
1 large potato, about 250g/9oz,
 peeled and diced
400ml/14fl oz/1⅔ cups fish stock
1.3kg/3lb fresh clams
15ml/1 tbsp chopped fresh
 coriander (cilantro)
15ml/1 tbsp chopped fresh flat
 leaf parsley
salt
lime wedges, to garnish

1 Heat the oil in a pan. Add the onion and sauté for 5 minutes over a low heat. Stir in the garlic and chillies and cook for a further 2 minutes. Pour in the wine and bring to the boil, then simmer for 2 minutes.

2 Add the tomatoes, diced potato and stock. Bring to the boil, cover and lower the heat so that the soup simmers.

3 Season with salt and cook for 15 minutes, until the potatoes are beginning to break up and the tomatoes have made a rich sauce.

4 Meanwhile, wash the clams thoroughly under cold running water. Gently tap any that are open, and discard them if they do not close.

5 Add the clams to the soup, cover the pan and cook for about 3–4 minutes, or until the clams have opened, then stir in the chopped herbs. Season with salt to taste.

6 Check over the clams and throw away any that have failed to open. Ladle the soup into warmed bowls. Offer the lime wedges separately, to be squeezed over the soup just before eating.

CHUNKY PRAWN CHUPE

CHOWDERS, KNOWN AS CHUPES IN SOUTH AMERICA, ARE A MEAL IN THEMSELVES. POTATOES ARE ALWAYS INCLUDED, BUT THE OTHER INGREDIENTS VARY. THIS IS A SEAFOOD VERSION.

SERVES SIX

INGREDIENTS

500g/1¼lb raw king prawns
 (jumbo shrimp)
750ml/1¼ pints/3 cups fish stock
1 carrot, finely chopped
2 celery sticks, thinly sliced
45ml/3 tbsp annatto (achiote) oil
1 large onion, finely chopped
1 red (bell) pepper, seeded and diced
2 garlic cloves, crushed
2 fresh red chillies, seeded
 and chopped
5ml/1 tsp turmeric
1 large tomato, peeled and chopped
675g/1½lb potatoes, peeled and cut
 into 2.5cm/1in cubes
115g/4oz/1 cup fresh or frozen peas
15ml/1 tbsp chopped fresh mint
15ml/1 tbsp chopped fresh
 coriander (cilantro)
salt

1 Peel the prawns and set them aside. Place the shells in a large pan with the fish stock, carrot and celery. Bring to the boil, then simmer over a low heat for 20 minutes. Strain into a bowl or jug (pitcher) and set the stock aside.

VARIATION
Traditionally this soup would be made using *huacatay*, a pungent Peruvian herb that tastes like a cross between mint and coriander (cilantro).

2 Heat the oil in a large pan over a low heat. Stir in the onion and red pepper and sauté for 5 minutes. Stir in the garlic, chillies and turmeric and cook for a further 2 minutes.

3 Add the chopped tomato and potatoes to the pan, season to taste with salt and cook for about 10 minutes, allowing the tomato to break down slightly and the potatoes to absorb the flavours of the other ingredients.

4 Pour in the strained stock and bring to the boil. Lower the heat and simmer for 15 minutes, or until the potatoes are cooked through.

5 Stir the prawns and peas into the soup and simmer for 4–5 minutes, or until the prawns become opaque. Finally, stir in the mint and coriander, and serve in warmed bowls.

CORN SOUP

CORN SOUP TURNS UP ALL OVER LATIN AMERICA. TOMATOES ARE OFTEN COOKED WITH THE ONION, BUT HERE THEY ARE SPRINKLED OVER THE SOUP, LEAVING THE FLAVOURS FRESH AND DISTINCT.

SERVES FOUR

INGREDIENTS

40g/1½oz/3 tbsp butter
1 large onion, finely chopped
500g/1¼lb fresh or thawed frozen
 corn kernels
1 litre/1¾ pints/4 cups chicken stock
250ml/8fl oz/1 cup double
 (heavy) cream
salt and ground black pepper
1 tomato, peeled, seeded and
 chopped, to garnish

VARIATION
The corn kernels make this soup very sweet. If it is not to your taste, add 350g/12oz diced potato to the pan at the same time as the corn. Increase the chicken stock accordingly.

1 Melt the butter in a large heavy pan. Stir in the onion and cook over a low heat for 5 minutes or until softened and translucent.

2 Add the corn and the stock, increase the heat and bring to the boil. Lower the heat, cover and simmer for 10 minutes, until the corn is tender.

3 Pour the soup into a blender or food processor and process until smooth. Return to the pan and stir in the cream. Bring to the boil, then season with salt and pepper to taste.

4 Ladle the soup into heated bowls, garnish with the chopped tomato and serve immediately.

BEEF AND CASSAVA SOUP

THIS SIMPLE, TASTY SOUP IS ALMOST A STEW. SUCH SOUPS, MADE IN ONE POT, ARE EVERYDAY FARE IN LATIN AMERICA. THE ADDITION OF WINE IS NOT TRADITIONAL, BUT IT ENHANCES THE FLAVOUR.

SERVES FOUR

INGREDIENTS

450g/1lb stewing beef, cubed
1.2 litres/2 pints/5 cups beef stock
300ml/½ pint/1¼ cups white wine
15ml/1 tbsp soft brown sugar
1 onion, finely chopped
1 bay leaf
1 bouquet garni
1 fresh thyme sprig
15ml/1 tbsp tomato purée (paste)
1 large carrot, sliced
275g/10oz cassava or yam, peeled
 and cubed
50g/2oz fresh spinach, chopped
a little hot pepper sauce, to taste
salt and ground black pepper

1 Mix the cubed beef, stock, white wine, sugar, chopped onion, bay leaf, bouquet garni, thyme and tomato purée in a large pan. Bring to the boil, then cover and simmer very gently for about 1¼ hours. If you want very tender meat, allow about 2–2¼ hours.

2 Add the sliced carrot, cubed cassava or yam, spinach and a few drops of hot pepper sauce. Season with salt and ground black pepper to taste and simmer for a further 15 minutes until the meat and vegetables are both tender. Serve in heated bowls.

LAMB AND LENTIL SOUP

LENTILS ARE POPULAR ON CARIBBEAN ISLANDS, SUCH AS TRINIDAD, WHERE THEY WERE INTRODUCED BY SOUTH-EAST ASIAN INDENTURED LABOURERS RECRUITED TO WORK THE SUGAR CANE PLANTATIONS.

SERVES FOUR

INGREDIENTS

1.5–1.75 litres/2½–3 pints/
 6¼–7½ cups water or stock
900g/2lb neck of lamb, cut
 into chops
½ onion, chopped
1 garlic clove, crushed
1 bay leaf
1 clove
2 fresh thyme sprigs
225g/8oz potatoes
175g/6oz/¾ cup red lentils
600ml/1 pint/2½ cups water
salt and ground black pepper
chopped fresh parsley

1 Pour 1.5 litres/2½ pints/6¼ cups of the water or stock into a large pan and add the lamb, chopped onion, crushed garlic, bay leaf, clove and thyme sprigs. Bring to the boil, then lower the heat and simmer gently for about 1 hour, until the lamb is tender.

2 Peel the potatoes and cut them into rough 2.5cm/1in cubes. Add them to the soup in the pan and cook for a further 5 minutes.

3 Add the red lentils to the pan, stirring them gently into the stock, then season the soup to taste with a little salt and plenty of ground black pepper. Add approximately 300ml/½ pint/1¼ cups of warm water to completely cover the meat and vegetables.

4 Bring the soup back to the boil, then lower the heat, cover and simmer for 25 minutes or until the lentils are cooked, stirring occasionally. Add a little more water during cooking if the soup becomes too thick. Just before serving, stir in the chopped parsley.

FISH AND SHELLFISH

Fish and shellfish play an important part in Latin-American cuisine and the most popular recipes rely on the freshest fish cooked simply. In parts of Brazil and the Caribbean, where the local cuisine has been shaped by African slave influences, richly flavoured fish and shellfish stews are more popular.

BAKED SEA BASS WITH COCONUT

THIS ELEGANT COLOMBIAN DISH IS IDEAL FOR A DINNER PARTY. THE BAY LEAVES GIVE A DEPTH OF FLAVOUR TO THE CHILLI AND COCONUT SAUCE.

SERVES FOUR

INGREDIENTS
 1 whole large sea bass, about
 900g/2lb, cleaned
 2 fresh red chillies, seeded and
 finely chopped
 1 onion, finely sliced
 2 garlic cloves, crushed
 juice of 1 lime
 15ml/1 tbsp olive oil
 2 bay leaves
 200ml/7fl oz/scant 1 cup
 coconut milk
 salt

VARIATION
For a complete meal, cook some vegetables in the roasting pan with the sea bass. Sliced carrots, fennel or/and courgettes (zucchini) would all go well with the coconut sauce.

1 Preheat the oven to 180°C/350°F/ Gas 4. Thoroughly rinse the fish inside and out, then pat dry with kitchen paper. Place in a large roasting pan and season all over with salt.

2 Generously sprinkle the chopped chillies, onion, garlic, lime juice and olive oil over the fish. Add the bay leaves to the pan and bake the fish in the oven for about 15 minutes.

3 Pour the coconut milk over the fish and return it to the oven for a further 10 minutes, or until the flesh flakes easily when tested with the tip of a sharp knife.

4 Cut along the back of the fish. This will release the flesh from the bones, making it easy to divide into portions. Serve with the sauce. A rice dish would make a good accompaniment.

PAN-FRIED SEA BREAM WITH LIME AND TOMATO SALSA

THE MOST POPULAR WAY OF COOKING A FRESH PIECE OF FISH IS TO PAN FRY IT OR GRILL IT. IN THIS RECIPE A SIMPLE SALSA IS FLASHED IN THE PAN AT THE END OF COOKING, TO MAKE A LIGHT SAUCE.

SERVES FOUR

INGREDIENTS
 4 sea bream fillets
 juice of 2 limes
 30ml/2 tbsp chopped coriander
 (cilantro)
 1 fresh red chilli, seeded and
 finely chopped
 2 spring onions (scallions), sliced
 45ml/3 tbsp olive oil, plus extra
 to serve
 2 large tomatoes, diced
 salt
 cooked white rice, to serve

1 Place the fish fillets in a shallow china or glass dish large enough to hold them all in a single layer.

2 Mix the lime juice, coriander, chilli and spring onions in a jug (pitcher). Stir in half the oil, then pour this marinade over the fish. Cover and marinate for around 15–20 minutes. Do not be tempted to marinate the fish for longer than this or the acid in the marinade will start to "cook" it.

3 Heat the remaining oil in a large heavy frying pan over a high heat. Lift each piece of fish from the marinade and pat dry with kitchen paper.

4 Season the fish with salt and place in the hot pan, skin side down. Cook for 2 minutes, then turn and cook for a further 2 minutes, until the flesh is opaque all the way through.

5 Add the marinade and the chopped tomatoes to the pan. Bring the sauce to the boil and cook for about 1 minute, until the tomatoes are lightly cooked but still retain their shape. Drizzle a little olive oil over the fish and serve on individual warm plates, with white rice and the tomato salsa.

HALIBUT WITH PEPPERS AND COCONUT MILK

THIS AROMATIC DISH, KNOWN LOCALLY AS MOQUECA COMES FROM THE STATE OF BAHIA, ON THE EAST COAST OF BRAZIL. COOKED AND SERVED IN AN EARTHENWARE DISH, IT IS USUALLY ACCOMPANIED BY WHITE RICE AND FLAVOURED CASSAVA FLOUR TO SOAK UP THE DELICIOUS SAUCE.

SERVES SIX

INGREDIENTS
 6 halibut, cod, haddock or monkfish
 fillets, each about 115g/4oz
 juice of 2 limes
 8 fresh coriander (cilantro) sprigs
 2 fresh red chillies, seeded
 and chopped
 3 tomatoes, sliced into thin rounds
 1 red (bell) pepper, seeded and
 sliced into thin rounds
 1 green (bell) pepper, seeded and
 sliced into thin rounds
 1 small onion, sliced into thin rounds
 200ml/7fl oz/scant 1 cup
 coconut milk
 60ml/4 tbsp palm oil
 salt
 cooked white rice, to serve
For the flavoured cassava flour
 30ml/2 tbsp palm oil
 1 medium onion, thinly sliced
 250g/9oz/2¼ cups cassava flour

1 Place the fish fillets in a large, shallow dish and pour over water to cover. Pour in the lime juice and set aside for 30 minutes. Drain the fish thoroughly and pat dry with kitchen paper. Arrange the fish in a single layer in a heavy pan which has a tight-fitting lid.

2 Sprinkle the coriander and chillies over the fish, then top with a layer each of tomatoes, peppers and onion. Pour the coconut milk over, cover and leave to stand for 15 minutes before cooking.

3 Season with salt, then place the pan over a high heat and cook until the coconut milk comes to the boil. Lower the heat and simmer for 5 minutes. Remove the lid, pour in the palm oil, cover again and simmer for 10 minutes.

4 Meanwhile make the flavoured cassava flour. Heat the oil in a large frying pan over a very low heat. Stir in the onion slices and cook for 8–10 minutes until soft and golden. Stir in the cassava flour and cook, stirring constantly, for 1–2 minutes until lightly toasted and evenly coloured by the oil. Season with salt.

5 Serve the *moqueca* with the rice and flavoured *cassava* flour.

PRAWN AND POTATO OMELETTE

MORE LIKE A SPANISH TORTILLA THAN A FRENCH OMELETTE, THIS DISH MAKES A DELICIOUS LUNCH WHEN SERVED WITH A FRESH LEAFY GREEN SALAD. THE SWEET PRAWNS ARE COOKED GENTLY INSIDE THE OMELETTE, STAYING TENDER AND SUCCULENT.

SERVES SIX

INGREDIENTS

 200g/7oz potatoes, peeled and diced
 30ml/2 tbsp olive oil
 1 onion, finely sliced
 2.5ml/½ tsp paprika
 2 large tomatoes, peeled, seeded
 and chopped
 200g/7oz peeled raw prawns (shrimp)
 6 eggs
 2.5ml/½ tsp baking powder
 salt

1 Cook the potatoes in a pan of salted boiling water for about 10 minutes or until tender.

2 Meanwhile, pour the oil into a 23cm/9in frying pan which can safely be used under the grill (broiler). Place over a medium heat. Add the onion slices and stir well to coat evenly in the oil. Cook for 5 minutes until the onions begin to soften. Sprinkle over the paprika and cook for 1 minute more.

3 Stir in the tomatoes. Drain the cooked potatoes thoroughly and add them to the pan. Stir gently to mix. Increase the heat and cook for 10 minutes, or until the mixture has thickened and the potatoes have absorbed the flavour of the tomatoes. Remove from the heat and stir in the prawns.

4 Preheat the grill. Beat the eggs, stir in the baking powder and salt. Pour into the pan and mix thoroughly. Cover and cook for 8–10 minutes until the omelette has almost set, then finish under the grill.

SALMON IN MANGO AND GINGER SAUCE

MANGO AND SALMON MAY SEEM UNLIKELY PARTNERS, BUT THE FLAVOURS COMPLEMENT EACH OTHER VERY WELL, ESPECIALLY WHEN THE DISTINCT FLAVOUR OF TARRAGON IS ADDED TO THE EQUATION.

SERVES TWO

INGREDIENTS
 2 salmon steaks, each about
 275g/10oz
 a little lemon juice
 1–2 garlic cloves, crushed
 5ml/1 tsp dried tarragon, crushed
 2 shallots, roughly chopped
 1 tomato, roughly chopped
 1 large ripe mango, peeled, stoned
 (pitted) and chopped
 150ml/¼ pint/⅔ cup fish stock
 or water
 15ml/1 tbsp syrup from a jar of
 preserved ginger
 25g/1oz/2 tbsp butter
 salt and ground black pepper

1 Place the salmon steaks in a single layer in a shallow dish and sprinkle with the lemon juice, garlic, tarragon and salt and pepper. Cover and set aside in the refrigerator for at least 1 hour.

2 Meanwhile, place the shallots, tomato and mango in a blender or food processor and blend until smooth. Add the fish stock or water and the ginger syrup, blend again and set aside.

3 Melt the butter in a frying pan and cook the salmon steaks for about 3 minutes on each side.

4 Add the mango purée, cover and simmer for a further 5 minutes, until the salmon is cooked and flakes easily.

5 Transfer the salmon to plates. Heat the sauce, adjust the seasoning and pour over the salmon. Serve hot.

FRIED SNAPPER WITH AVOCADO

THE COMBINATION OF CRISP FRIED FISH AND SILKY SMOOTH AVOCADO WORKS EXTREMELY WELL IN THIS RECIPE. IN THE ISLANDS OF THE CARIBBEAN, WHERE THIS RECIPE ORIGINATED, THE FISH IS OFTEN SERVED WITH FRIED DUMPLINGS OR HARD-DOUGH BREAD.

SERVES FOUR

INGREDIENTS
 1 lemon
 4 red snappers, each about
 225g/8oz, prepared
 10ml/2 tsp spice seasoning
 flour, for dusting
 oil, for frying
 2 avocados and cooked corn, sliced
 widthways, to serve
 chopped fresh parsley and lime
 slices, to garnish

1 Squeeze the lemon juice both inside and outside the fish, and sprinkle with the spice seasoning. Place the fish in a shallow dish, cover and set aside in a cool place to marinate for a few hours.

2 Lift the marinated fish out of the dish and dust thoroughly with the flour, shaking off any excess.

3 Heat the oil in a large non-stick frying pan over a medium heat. Add the fish and fry gently for about 10 minutes on each side.

4 Meanwhile, cut the avocados in half, remove the stones (pits) and cut in half again. Peel away the skin and cut the flesh into thin strips.

5 When the fish are cooked through and the skin is crisp and brown, transfer them to warmed serving plates. Add the avocado and corn slices. Garnish with the chopped parsley and lime slices and serve immediately.

COOK'S TIP
Using two frying pans will allow you to cook all four fish simultaneously. Alternatively, cook two and keep them hot in a covered dish in a warm oven while cooking the remaining pair.

TROUT IN WINE SAUCE WITH PLANTAIN

EXOTIC FISH FROM THE WARM CARIBBEAN WATERS, SUCH AS MAHI MAHI OR GROUPER, WOULD ADD A DISTINCTIVE FLAVOUR TO THIS TASTY DISH, WHICH IS EATEN THROUGHOUT THE REGION. IF YOU CANNOT FIND EXOTIC FISH, HOWEVER, TROUT IS IDEAL, OR YOU CAN USE ANY FILLETED WHITE FISH.

SERVES FOUR

INGREDIENTS
 4 trout fillets
 spice seasoning, for dusting
 25g/1oz/2 tbsp butter or margarine
 1–2 garlic cloves
 150ml/¼ pint/⅔ cup white wine
 150ml/¼ pint/⅔ cup fish stock
 10ml/2 tsp clear honey
 15–30ml/1–2 tbsp chopped
 fresh parsley
 1 yellow plantain
 salt and ground black pepper
 oil, for frying
 green salad, to serve

1 Season the trout fillets by coating them in the spice seasoning. Place in a shallow dish, cover with cling film (plastic wrap) and marinate in a cool place for at least 1 hour.

2 Melt the butter or margarine in a large frying pan and heat gently for 1 minute. Add the fish fillets. Sauté for about 5 minutes, until cooked through, turning carefully once. Transfer to a plate and keep hot.

3 Add the garlic, white wine, fish stock and honey to the pan and bring to the boil, stirring. Lower the heat and simmer to reduce slightly. Return the fish to the pan and spoon over the sauce. Sprinkle with the parsley and simmer gently for 2–3 minutes.

4 Meanwhile, peel the plantain, and cut it into rounds. Heat a little oil in a small frying pan and fry the plantain slices for 2–3 minutes, until golden, turning once. Transfer the fish to warmed serving plates. Stir the sauce, season and pour over the fish. Serve with the fried plantain and a green salad.

COOK'S TIP
Plantains belong to the banana family and can be green, yellow or brown, depending on how ripe they are. Unlike bananas, they must be cooked.

ESCHOVISHED FISH

THIS PICKLED FISH DISH IS OF SPANISH ORIGIN AND IS VERY POPULAR THROUGHOUT THE CARIBBEAN ISLANDS. IT GOES BY VARIOUS NAMES, INCLUDING ESCOVITCH AND CAVEACHED FISH, BUT NO MATTER WHAT THE NAME, IT INEVITABLY TASTES DELICIOUS.

SERVES SIX

INGREDIENTS
 900g/2lb cod fillet
 ½ lemon
 15ml/1 tbsp spice seasoning
 flour, for dusting
 oil, for frying
 lemon wedges, to garnish
For the sauce
 30ml/2 tbsp vegetable oil
 1 onion, sliced
 ½ red (bell) pepper, sliced
 ½ chayote (christophene), peeled,
 seeded and cut into small pieces
 2 garlic cloves, crushed
 120ml/4fl oz/½ cup malt vinegar
 75ml/5 tbsp water
 2.5ml/½ tsp ground allspice
 1 bay leaf
 1 small fresh Scotch bonnet or
 Habañero chilli, chopped
 15ml/1 tbsp soft brown sugar
 salt and ground black pepper

1 Place the fish in a shallow dish, squeeze over the lemon juice, then sprinkle with the spice seasoning. Pat the seasoning into the fish using your hands, then cover and leave to marinate in a cool place for at least 1 hour.

VARIATION
Cod fillets are very expensive so, if they are available, try using whole red snapper or red mullet, which are often used for this dish in the Caribbean.

2 Cut the cod fillet across into 7.5cm/3in pieces. Dust the pieces of fish with a little flour, shaking off any excess.

3 Heat the oil in a heavy frying pan and fry the fish pieces for 2–3 minutes, turning occasionally, until they are golden brown and crisp. Using a fish slice or slotted spoon, lift the cooked fish pieces out of the pan and place in a serving dish. Keep hot.

4 Make the sauce. Heat the oil in a frying pan and fry the onion for 4–5 minutes. Add the pepper, chayote and garlic and stir-fry for 2 minutes.

5 Pour in the vinegar, then add the water, allspice, bay leaf, chilli and sugar. Simmer for 5 minutes, then season. Leave to stand for 10 minutes, then pour the sauce over the fish. Serve hot, garnished with the lemon wedges.

SEA BASS CEVICHE

THIS TASTY DISH, ALSO KNOWN AS SEVICHE, IS PARTICULARLY POPULAR IN PERU, WHERE IT IS MADE WITH A VARIETY OF FISH AND SHELLFISH. THE RAW FISH SIMPLY "COOKS" IN A FRESH CITRUS MARINADE, AND NEEDS NO HEATING, SO IT IS VITAL THAT THE FISH IS PERFECTLY FRESH.

SERVES FOUR

INGREDIENTS

 675g/1½lb sea bass fillets
 300ml/½ pint/1¼ cups lime juice
 200ml/7 oz orange juice
 2 fresh red chillies, seeded and
 finely sliced
 1 medium red onion, finely sliced
 30ml/2 tbsp fresh coriander
 (cilantro) leaves
 1 large tomato, seeded and chopped
 salt and ground black pepper
 green salad and crusty bread,
 to serve

1 Cut the sea bass fillets into 2.5cm/1in strips, removing any stray bones with tweezers. Place the fish in a bowl and season with salt and pepper.

2 Pour the lime juice and orange juice over the fish, then gently stir in the chillies and onion slices. The fish must be totally immersed in the marinade, so add a little more juice if necessary.

3 Cover with clear film (plastic wrap) and chill for at least 2 hours, until the fish becomes opaque.

4 Stir the coriander leaves and chopped tomato into the ceviche and serve with a green salad and crusty bread.

COOK'S TIP
The ceviche should be kept covered in the refrigerator right up until it is to be served. It must be eaten on the day it is made.

MACKEREL ESCABECHE

THIS TRADITIONAL WAY OF PRESERVING FISH IN VINEGAR, WAS BROUGHT TO LATIN AMERICA BY THE SPANISH AND PORTUGUESE. OILY FISH, SUCH AS MACKEREL AND SARDINES, LEND THEMSELVES PARTICULARLY WELL TO THIS TREATMENT. IT TAKES AT LEAST A DAY, SO ALLOW PLENTY OF TIME.

SERVES SIX

INGREDIENTS
12 small mackerel fillets
juice of 2 limes
90ml/6 tbsp olive oil
2 red onions, thinly sliced
2 garlic cloves, thinly sliced
2 bay leaves
6 black peppercorns
120ml/4fl oz/½ cup red wine vinegar
50g/2oz/½ cup plain
 (all-purpose) flour
salt and ground black pepper

1 Place the mackerel fillets side by side in a large, shallow glass or china dish. Pour over the lime juice. Season with salt and pepper and cover. Marinate in the refrigerator for 20–30 minutes, but no longer.

2 Meanwhile, heat half the oil in a frying pan. Add the onions and cook over a low heat for 10 minutes, until softened but not coloured. Stir in the garlic and cook for 2 minutes.

3 Add the bay leaves, peppercorns and vinegar to the pan and simmer over a very low heat for 5 minutes.

COOK'S TIP
If you are planning to keep the fish for more than one day, make sure it is completely immersed in the vinegar, then top with a thin layer of olive oil. Cover tightly. It will keep in the refrigerator for up to 1 month.

4 Pat the mackerel fillets dry and coat them in the flour. Heat the remaining oil in a large frying pan and fry the fish, in batches, for 2 minutes on each side.

5 Return the fish to the dish in which they were originally marinated. Pour the vinegar marinade over the fish. Leave to marinate for 24 hours before serving.

MARINATED RED MULLET

THIS POPULAR LATIN AMERICAN RECIPE IS BASED ON A SPANISH WAY OF COOKING FISH EN ESCABECHE BY FIRST FRYING IT, THEN MARINATING IT. IF YOU ARE UNABLE TO FIND FRESH MULLET, SNAPPER, SEA BREAM OR TILAPIA ARE ALL GOOD ALTERNATIVES.

SERVES SIX

INGREDIENTS

7.5ml/1½ tsp mild Spanish paprika,
 preferably Spanish smoked
 pimentón
45ml/3 tbsp plain (all-purpose) flour
120ml/4fl oz/½ cup olive oil
6 red mullet, each weighing about
 300g/11oz, filleted
2 aubergines (eggplants), sliced or
 cut into long wedges
2 red or yellow (bell) peppers, seeded
 and thickly sliced
1 large red onion, thinly sliced
2 garlic cloves, sliced
15ml/1 tbsp sherry vinegar
juice of 1 lemon
brown sugar, to taste
15ml/1 tbsp chopped fresh oregano
18–24 black olives
45ml/3 tbsp chopped fresh flat
 leaf parsley
salt and ground black pepper

1 Mix 5ml/1 tsp of the paprika with the flour and season well with salt and black pepper. Heat half the oil in a large frying pan. Dip the fish into the flour, turning to coat both sides, and fry for 4–5 minutes, until browned on each side. Place the fish in a glass or china dish suitable for marinating it.

2 Add 30ml/2 tbsp of the remaining oil to the pan and fry the aubergine wedges until softened and browned. Drain thoroughly on a piece of kitchen paper to remove excess oil, then add the aubergine to the fish.

3 Add another 30ml/2 tbsp oil to the pan and cook the peppers and onion gently for 6–8 minutes, until softened but not browned. Add the garlic and remaining paprika, then cook for a further 2 minutes. Stir in the sherry vinegar and lemon juice with 30ml/ 2 tbsp water and heat until simmering. Season to taste with a pinch of sugar.

4 Stir in the oregano and olives, then spoon over the fish. Set aside to cool, then cover and marinate in the fridge for several hours or overnight.

5 About 30 minutes before serving, bring the fish and vegetables back to room temperature. Stir in the parsley just before serving.

COD CARAMBA

This colourful Mexican dish, with its contrasting crunchy topping and tender fish filling, can be made with any economical white fish such as coley or haddock. Serve with a tasty green salad for a hearty midweek supper.

SERVES SIX

INGREDIENTS
 450g/1lb cod fillets
 225g/8oz smoked cod fillets
 300ml/½ pint/1¼ cups fish stock
 50g/2oz/¼ cup butter
 1 onion, sliced
 2 garlic cloves, crushed
 1 green and 1 red (bell) pepper,
 seeded and diced
 2 courgettes (zucchini), diced
 115g/4oz/⅔ cup drained canned or
 thawed frozen corn kernels
 2 tomatoes, peeled and chopped
 juice of 1 lime
 Tabasco sauce
 salt, ground black pepper and
 cayenne pepper
For the topping
 75g/3oz tortilla chips
 50g/2oz/½ cup grated Cheddar cheese
 coriander (cilantro) sprigs, to garnish
 lime wedges, to serve

1 Lay the fish in a shallow pan and pour over the fish stock. Bring to the boil, lower the heat, cover and poach for about 8 minutes, until the flesh flakes easily. Leave to cool slightly, then remove the skin and separate the flesh into large flakes. Keep hot.

2 Melt the butter in a pan, add the onion and garlic and cook gently over a low heat until soft and translucent. Add the peppers, stir and cook for about 2 minutes. Stir in the courgettes and cook for 3 minutes more, until all the vegetables are tender.

3 Stir in the corn and tomatoes, then add lime juice and Tabasco to taste. Season with salt, black pepper and cayenne. Cook for 2 minutes to heat the corn and tomatoes, then stir in the fish and transfer to a dish that can safely be used under the grill (broiler).

4 Preheat the grill. Make the topping by crushing the tortilla chips, then mixing in the grated cheese. Add cayenne pepper to taste and sprinkle over the fish. Place the dish under the grill until the topping is crisp and brown. Garnish with coriander sprigs and lime wedges.

PUMPKIN AND PRAWNS WITH DRIED SHRIMP

THIS CARIBBEAN RECIPE IS AN EXCELLENT WAY OF MAKING A SMALL AMOUNT OF SEAFOOD GO A LONG WAY. THE DRIED SHRIMPS AND COOKED PRAWNS ARE DELICIOUS WITH THE SPICED PUMPKIN.

SERVES FOUR

INGREDIENTS

50g/2oz/⅓ cup dried shrimps
30ml/2 tbsp vegetable oil
25g/1oz/2 tbsp butter or margarine
1 red onion, chopped
800g/1¾lb pumpkin, peeled
 and chopped
225g/8oz peeled cooked
 prawns (shrimp)
2.5ml/½ tsp ground cinnamon
2.5ml/½ tsp five-spice powder
2 garlic cloves, chopped
2 tomatoes, chopped
chopped fresh parsley and lime
 wedges, to garnish

1 Rinse the dried shrimps under cold water and put them in a bowl. Pour in enough hot water to cover, then leave them to soak for about 35 minutes.

2 Meanwhile, heat the oil and butter or margarine in a large frying pan. Add the onion and sauté over a medium heat for 5 minutes, until soft.

3 Add the pumpkin and cook for about 5–6 minutes, until it starts to soften. Tip in the peeled prawns and the dried shrimps with their soaking water. Stir in the cinnamon, five-spice powder and chopped garlic.

4 Add the tomatoes and cook over a gentle heat, stirring occasionally, until the pumpkin is soft.

5 Spoon on to a warmed serving plate and serve hot, garnished with the chopped parsley and lime wedges.

SALT FISH AND ACKEE

THIS IS A CLASSIC JAMAICAN DISH, THAT IS ALSO POPULAR THROUGHOUT THE CARIBBEAN. IT IS OFTEN SERVED WITH BOILED GREEN BANANAS AS WELL AS FRIED DUMPLINGS.

SERVES FOUR

INGREDIENTS
 450g/1lb salt cod
 25g/1oz/2 tbsp butter or margarine
 30ml/2 tbsp vegetable oil
 1 onion, chopped
 2 garlic cloves, crushed
 225g/8oz tomatoes, chopped
 ½ hot chilli, chopped (optional)
 2.5ml/½ tsp ground black pepper
 2.5ml/½ tsp dried thyme
 2.5ml/½ tsp ground allspice
 30ml/2 tbsp chopped spring
 onion (scallion)
 540g/1lb 6oz can ackees, drained
 fried dumplings, to serve

1 Place the salt cod in a bowl and pour in enough cold water to cover. Leave to soak for at least 24 hours, changing the water about five times. Drain and rinse in fresh cold water.

2 Put the salt cod in a large pan of cold water. Bring the water to the boil, then remove the fish and leave it to cool on a plate. Carefully remove and discard the skin and bones, then flake the fish and set it aside.

3 Heat the butter or margarine and oil in a large heavy frying pan over a medium heat. Add the onion and garlic and sauté for 5 minutes. Stir in the tomatoes, with the chilli, if using, and cook gently for a further 5 minutes.

4 Add the salt cod, black pepper, thyme, allspice and spring onion, stir to mix, then stir in the ackees, taking care not to crush them. If you prefer a more moist dish, add a little water or stock. Serve hot with fried dumplings.

JAMAICAN FISH CURRY

THIS RECIPE USES SOME OF THE MOST COMMON SPICES IN CARIBBEAN CUISINE, WHERE THE INFLUENCE OF INDIA IS CLEARLY VISIBLE. THE TASTE IS FOR STRONG, PUNGENT FLAVOURS RATHER THAN FIERY HEAT, AND THE RICE IS AN INTEGRAL PART OF THE DISH.

SERVES FOUR

INGREDIENTS
 2 halibut steaks, total weight about
 500–675g/1¼–1½lb
 30ml/2 tbsp groundnut oil
 2 cardamom pods
 1 cinnamon stick
 6 allspice berries
 4 cloves
 1 large onion, chopped
 3 garlic cloves, crushed
 10–15ml/2–3 tsp grated fresh
 root ginger
 10ml/2 tsp ground cumin
 5ml/1 tsp ground coriander
 2.5ml/½ tsp cayenne pepper,
 or to taste
 4 tomatoes, peeled, seeded
 and chopped
 1 sweet potato, about 225g/8oz,
 cut into 2cm/¾in cubes
 475ml/16fl oz/2 cups fish stock
 or water
 115g/4oz piece of creamed coconut
 1 bay leaf
 225g/8oz/generous 1 cup white
 long grain rice
 salt

1 Rub the halibut steaks well with salt and set aside.

2 Heat the oil in a flameproof casserole dish and stir-fry the cardamom pods, cinnamon stick, allspice berries and cloves for about 3 minutes to release the delicate aromas.

3 Add the chopped onion, crushed garlic and grated ginger. Continue cooking for about 4–5 minutes over a gentle heat, stirring frequently, until the onion is soft

4 Add the ground cumin, coriander and cayenne pepper and cook briefly, stirring all the time.

5 Stir in the tomatoes, sweet potato, fish stock or water, creamed coconut and bay leaf. Season well with salt. Bring to the boil, then lower the heat, cover and simmer for about 15–18 minutes, until the sweet potato is tender.

6 Cook the rice according to your preferred method. Meanwhile, add the halibut steaks to the pan of curry sauce and spoon the sauce over to cover them completely. Cover the pan with a tight-fitting lid and simmer gently for about 10 minutes until the fish is just tender and flakes easily.

7 Spoon the rice into a warmed serving dish, spoon over the curry sauce and arrange the halibut steaks on top. Garnish with chopped coriander (cilantro), if you like, and serve immediately.

COOK'S TIP
Sweet potato discolours very quickly when cut. If preparing ingredients in advance, put the cubes of potato into a bowl of cold water with 30–45ml/ 2–3 tbsp lemon juice until ready to use.

KING PRAWNS IN A COCONUT AND NUT CREAM

FOR THIS BRAZILIAN RECIPE, COCONUT MILK IS USED TO MAKE VATAPÁ, A LUXURIOUS SAUCE THICKENED WITH CASHEWS, PEANUTS AND BREADCRUMBS, THEN USED TO COOK PRAWNS.

4 Grind the peanuts and cashew nuts in a food processor until they become a fine powder. Stir into the pan and cook for about 1 minute more.

5 Stir in the breadcrumb purée and prawn stock and bring to the boil. Reduce the heat and continue to cook, stirring constantly, for 6–8 minutes, until thick and smooth.

SERVES SIX

INGREDIENTS
130g/4½oz/2¼ cups fresh white
 breadcrumbs
105ml/7 tbsp coconut milk
30 raw king prawns (jumbo shrimp),
 about 900g/2lb
400ml/14fl oz/1⅔ cups fish stock
2 large tomatoes, roughly chopped
1 onion, quartered
2 fresh red chillies, seeded and
 roughly chopped
130g/4½oz dried shrimps
45ml/3 tbsp palm oil
2 garlic cloves, crushed
25g/1oz fresh root ginger, grated
75g/3oz/¾ cup roasted peanuts
50g/2oz/½ cup cashew nuts
60ml/4 tbsp coconut cream
juice of 1 lime
salt and ground black pepper
chopped fresh coriander (cilantro)
 and hot chilli oil, to serve

1 Place the breadcrumbs in a bowl and stir in the coconut milk. Leave to soak for at least 30 minutes. Purée, in a blender or food processor, then scrape into a bowl and set aside.

2 Meanwhile, peel the fresh prawns and set them aside in a cool place. Place the shells in a pan and add the fish stock and tomatoes. Bring to the boil, then simmer over a low heat for 30 minutes. Strain into a bowl, pressing the prawn shells against the sides of the sieve with a wooden spoon to extract as much flavour as possible. Reserve the prawn stock but discard the shells.

3 Put the onion, chillies and dried shrimps in a blender or food processor and blend to a purée. Scrape into a large pan and stir in the palm oil. Cook over a very low heat for 5 minutes. Add the garlic and ginger and cook for a further 2 minutes.

6 Add the coconut cream, lime juice and prawns. Stir over the heat for 3 minutes until the prawns are cooked through and the *vatapá* resembles a thin porridge. If necessary, stir in a little water. Season with salt and black pepper.

7 Serve immediately, adding a scattering of chopped coriander and a couple of drops of chilli oil to each portion. Cooked white rice makes a good accompaniment.

VARIATIONS
• Instead of prawns, try using white fish.
• For chicken *vatapá*, replace the prawns with chicken pieces, seasoned and pan-fried in a little olive oil until tender. Use chicken stock rather than fish stock.

STUFFED CRAB

*SERVE THIS SIMPLE DISH AS AN APPETIZER FOR A DINNER PARTY. A TRADITIONAL BRAZILIAN RECIPE,
IT IS USUALLY SERVED EITHER IN CRAB SHELLS OR SMALL EARTHENWARE DISHES.*

SERVES SIX

INGREDIENTS
 400g/14oz crab meat
 juice of 1 lime
 50g/2oz/1 cup fresh breadcrumbs
 105ml/7 tbsp full-fat (whole) milk
 25g/1oz/2 tbsp butter
 1 onion, finely chopped
 2 garlic cloves, crushed
 2 tomatoes, finely chopped
 15ml/1 tbsp chopped fresh flat
 leaf parsley
 2 egg yolks, plus extra for glazing
 15ml/1 tbsp dried breadcrumbs
 15ml/1 tbsp grated Parmesan cheese
 salt
 lemon wedges, to serve

1 Place the crab meat in a large
glass bowl and squeeze over the lime
juice. Marinate for about 20 minutes.
Meanwhile, put the breadcrumbs in a
separate bowl with the milk and leave to
soak for 10 minutes.

2 Melt the butter in a pan over a low
heat. Add the chopped onion and cook
gently for 10 minutes until softened.
Stir in the crushed garlic and cook for
1 minute more. Drain the crab meat
and squeeze out all of the excess liquid
from the breadcrumbs.

COOK'S TIP
The crab mixture can be prepared in
advance. Spoon it into the individual
crab shells or bowls and cover. Keep
refrigerated until needed, then add the
topping and bake in a preheated oven at
200°C/400°F/Gas 6 for 10–15 minutes.

3 Add the crab meat, tomatoes and
breadcrumbs to the pan and stir well
to combine. Return to a medium heat
and cook, stirring, for 4–5 minutes.
Stir in the chopped parsley and season
to taste with salt and ground pepper –
the mixture should actually taste
over-seasoned at this stage.

4 Lower the heat and add the egg yolks,
stirring vigorously for 1 minute. Do not
allow the mixture to boil.

5 Preheat the grill (broiler). Transfer the
mixture to six empty crab shells, or
small ovenproof dishes and brush with
beaten egg yolk. Combine the dried
breadcrumbs and Parmesan and
sprinkle a thin coating over the crab
meat. Grill (broil) for 3–4 minutes, until
golden. Serve with the lemon wedges.

CRAB AND CORN GUMBO

A TYPICALLY CREOLE DISH, THIS IS THICKENED WITH A CLASSIC NUT-BROWN ROUX. IT IS POPULAR ON THE CARIBBEAN ISLANDS OF MARTINIQUE AND ST BARTS.

SERVES FOUR

INGREDIENTS

 25g/1oz/2 tbsp butter or margarine
 25g/1oz/¼ cup plain
 (all-purpose) flour
 15ml/1 tbsp vegetable oil
 1 onion, finely chopped
 115g/4oz okra, trimmed and chopped
 2 garlic cloves, crushed
 15ml/1 tbsp finely chopped celery
 600ml/1 pint/2½ cups fish stock
 150ml/¼ pint/⅔ cup sherry
 15ml/1 tbsp tomato ketchup
 2.5ml/½ tsp dried oregano
 1.5ml/¼ tsp ground mixed spice
 (pumpkin pie spice)
 10ml/2 tsp Worcestershire sauce
 dash of hot pepper sauce
 2 fresh corn cobs, sliced
 450g/1lb crab claws
 fresh coriander (cilantro), to garnish

1 Melt the butter or margarine in a large heavy pan over a low heat. Add the flour and stir together to make a roux.

2 Cook for about 10 minutes, stirring constantly to prevent the mixture from burning. The roux will turn golden brown and then darken. As soon as it becomes a rich nut brown, turn the roux on to a plate, scraping it all out of the pan, and set aside.

3 Heat the oil in the same pan over a medium heat, add the chopped onion, the okra, garlic and celery and stir well. Cook for about 2–3 minutes, then add the fish stock, sherry, tomato ketchup, dried oregano, mixed spice, Worcestershire sauce and a dash of hot pepper sauce.

4 Bring to the boil, then lower the heat and simmer gently for about 10 minutes or until all the vegetables are tender. Add the roux, stirring it thoroughly into the sauce, and cook for about 3–4 minutes, until thickened.

5 Add the corn cobs and crab claws and continue to simmer gently over a low heat for about 10 minutes. until both are cooked through.

6 Spoon on to warmed serving plates and garnish with a few sprigs of fresh coriander. Serve immediately.

COOK'S TIP
The roux must not be allowed to burn. Stir it constantly over a low heat. If dark specks appear in the roux, it must be discarded and a fresh roux made.

CREOLE FISH STEW

THIS IS A SIMPLE DISH THAT LOOKS AS GOOD AS IT TASTES. IT IS A GOOD CHOICE FOR A DINNER PARTY, BUT REMEMBER TO ALLOW TIME FOR MARINATING THE FISH.

SERVES SIX

INGREDIENTS

2 whole red bream or large snapper, prepared and cut into 2.5cm/ 1in pieces
30ml/2 tbsp spice seasoning
30ml/2 tbsp malt vinegar
flour, for dusting
oil, for frying

For the sauce

30ml/2 tbsp vegetable oil
15ml/1 tbsp butter or margarine
1 onion, finely chopped
275g/10oz fresh tomatoes, peeled and finely chopped
2 garlic cloves, crushed
2 fresh thyme sprigs
600ml/1 pint/2½ cups fish stock or water
2.5ml/½ tsp ground cinnamon
1 fresh hot chilli, chopped
1 red and 1 green (bell) pepper, seeded and finely chopped
salt
fresh oregano sprigs, to garnish

1 Toss the pieces of fish with the spice seasoning and vinegar in a bowl. Cover and set aside to marinate for at least 2 hours at cool room temperature or overnight in the refrigerator.

COOK'S TIP
Take care when preparing the chilli as the capsaicin it contains is a powerful irritant and will burn the skin. Wear gloves if possible and avoid touching your face until you have removed them. Leave the chilli seeds in, or remove them for a slightly milder result.

2 When ready to cook, place a little flour in a large shallow bowl and use to coat the fish pieces, shaking off any excess flour.

3 Heat a little oil in a large frying pan. Add the fish pieces and fry for about 5 minutes, turning the pieces carefully, until golden brown, then set aside. Do not worry if the fish is not quite cooked through; it will finish cooking in the sauce.

4 To make the sauce, heat the oil and butter or margarine in a frying pan and stir-fry the onion for 5 minutes. Add the tomatoes, garlic and thyme and simmer for a further 5 minutes. Stir in the stock or water, cinnamon and chilli.

5 Add the fish pieces and the chopped peppers. Simmer until the fish is cooked and the stock has reduced to a thick sauce. Season with salt. Serve hot, garnished with the oregano.

CUBAN SEAFOOD RICE

THIS IS THE PERFECT DISH FOR A LARGE GATHERING. THE MORE PEOPLE YOU MAKE IT FOR, THE MORE TYPES OF SEAFOOD YOU CAN ADD, AND THE TASTIER IT WILL BECOME.

SERVES EIGHT

INGREDIENTS
 450g/1lb raw prawns (shrimp)
 1 litre/1¾ pints/4 cups fish stock
 450g/1lb squid
 16 clams
 16 mussels
 60ml/4 tbsp olive oil
 1 onion, finely chopped
 1 fresh red chilli, seeded and
 finely chopped
 2 garlic cloves, crushed
 350g/12oz/1⅔ cups long grain rice
 45ml/3 tbsp chopped fresh
 coriander (cilantro)
 juice of 2 limes
 salt and ground black pepper

1 Peel the prawns and set them aside. Place the shells in a pan and add the fish stock. Bring to the boil, then simmer for 15 minutes. Strain into a bowl, discarding the shells.

2 Clean the squid under cold running water. Pull the tentacles away from the body. The squid's entrails will come out easily. Remove the clear piece of cartilage from inside the body cavity and discard it. Wash the body thoroughly.

3 Pull away the purplish-grey membrane that covers the body. Now cut between the tentacles and head, discarding the head and entrails. Leave the tentacles whole but discard the hard beak in the middle. Cut the body into thin rounds.

4 Scrub the clams and mussels under cold running water. Pull away the 'beard' from the mussels and discard any open shells that fail to close when tapped. Place the shellfish in a bowl, cover with a wet piece of kitchen paper and put in the refrigerator until needed.

COOK'S TIP
Live shellfish are best kept in a cool moist environment. Place them in a bowl covered with wet kitchen paper and store them in the refrigerator.

5 Pour half the olive oil into a pan with a tight fitting lid. Place over a high heat. When the oil is very hot, add the squid and season well. Stir-fry for 2–3 minutes, until the squid curls and begins to brown. Remove the pieces from the pan with a slotted spoon and set aside.

6 Add the prawns to the pan and cook for 2 minutes. The moment they turn pink, remove them from the heat.

7 Pour the remaining oil into the pan. Stir in the onion and sauté over a low heat for 5 minutes. Add the chilli and garlic and cook for 2 minutes. Tip in the rice, and cook, stirring, for 1 minute, until lightly toasted but not coloured.

8 Add the prawn stock and bring to the boil. Cover, lower the heat and simmer, for 15–18 minutes.

9 Add the clams and mussels and cover the pan. Cook for 3–4 minutes, until their shells open. Remove from the heat and discard any that have remained closed. Stir the cooked squid, prawns, coriander and lime juice into the rice. Season and serve immediately.

CHILEAN SQUID CASSEROLE

THIS HEARTY STEW IS IDEAL ON A COLD EVENING. THE POTATOES DISINTEGRATE TO THICKEN AND ENRICH THE SAUCE, MAKING A WARMING, COMFORTING MAIN COURSE.

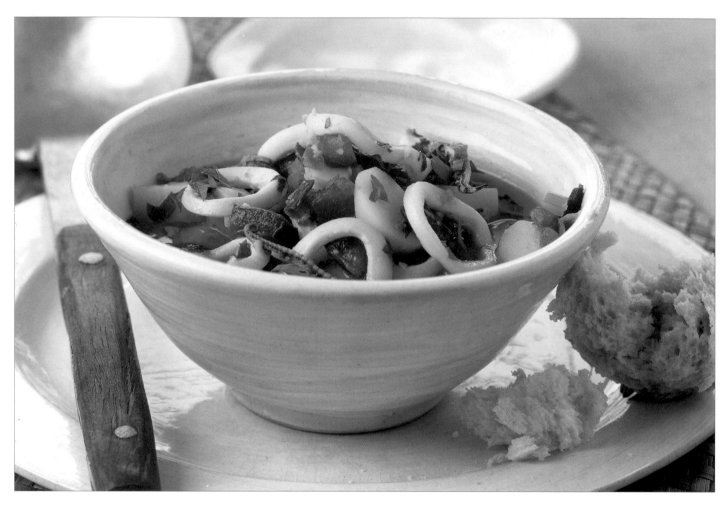

SERVES SIX

INGREDIENTS

800g/1¾ lb squid
45ml/3 tbsp olive oil
5 garlic cloves, crushed
4 fresh jalapeño chillies, seeded and
 finely chopped
2 celery sticks, diced
500g/1¼ lb small new potatoes or
 baby salad potatoes, scrubbed,
 scraped or peeled and quartered
400ml/14fl oz/1⅔ cups dry
 white wine
400ml/14fl oz/1⅔ cups fish stock
4 tomatoes, diced
30ml/2 tbsp chopped fresh flat
 leaf parsley
salt
white rice or *arepas* (corn breads),
 to serve

1 Clean the squid under cold water. Pull the tentacles away from the body. The squid's entrails will come out easily. Remove the cartilage from inside the body cavity and discard it. Wash the body thoroughly.

2 Pull away the membrane that covers the body. Cut between the tentacles and head, discarding the head and entrails. Leave the tentacles whole but discard the hard beak in the middle. Cut the body into thin rounds.

COOK'S TIP
Adding the tomatoes and parsley at the end gives a real freshness to the sauce. If you'd prefer an even heartier dish, add these ingredients to the pan with the potatoes. Replace the white wine with a Chilean cabernet sauvignon.

3 Heat the oil, add the garlic, chillies and celery and cook for 5 minutes. Stir in the potatoes, then add the wine and stock. Bring to the boil, then simmer, covered, for 25 minutes.

4 Remove from the heat and stir in the squid, tomatoes and parsley. Cover the pan and leave to stand until the squid is cooked. Serve immediately.

CHILEAN SEAFOOD PLATTER

FRESHNESS IS IMPORTANT FOR THIS RAW SEAFOOD APPETIZER, SO CHILEAN COOKS USE THE PRIME CATCH OF THE DAY, INCLUDING EXOTIC SHELLFISH. YOU CAN USE WHATEVER IS AVAILABLE LOCALLY.

SERVES SIX

INGREDIENTS
 450g/1lb raw king prawns
 (jumbo shrimp)
 12 clams
 12 mussels
 6 scallops
 6 oysters
 12 razor clams
 lime wedges, to serve
For the salsa
 60ml/4 tbsp chopped fresh
 coriander (cilantro)
 15ml/1 tbsp chopped fresh flat
 leaf parsley
 2 shallots, finely chopped
 1 fresh green chilli, seeded and
 finely chopped
 juice of 2 limes
 30ml/2 tbsp olive oil
 salt

3 Use an oyster knife to open the raw shellfish. Push the point of the knife into the hinge, then twist to loosen. Push the knife along the edge of the whole shell so it can be opened.

4 Use the knife to loosen the fish from their shells and carefully remove the black "string" that runs along the edge of the scallop.

5 Arrange the seafood, in the shells, on a platter and serve with the fresh coriander and chilli salsa, and lime wedges, if you like. Eat immediately.

1 Combine the salsa ingredients in a bowl and season to taste. Make the salsa a few hours in advance, if possible, so that the delicate flavours have time to develop.

2 Bring a pan of salted water to the boil. Plunge the prawns into the water and remove from the pan as soon as they turn pink. Refresh the prawns in a bowl of cold water, drain and set aside.

COOK'S TIP
If you prefer to cook the shellfish, it could be steamed quickly and then refreshed in cold water before being served. Do not overcook the shellfish, or it will become tough.

MEAT

The gaucho nations of Argentina, Paraguay and Uruguay are real meat-eaters, and large cuts of beef, lamb and pork are cooked whole at their famous barbecues. Richly flavoured stews and pot roasts are also popular, made with herbs, spices and fruits, or as a combination of mixed meats, as in the Brazilian national dish Feijoada.

THE GAUCHO BARBECUE

THERE IS NO BETTER WAY OF ENJOYING THE PRESTIGIOUS PAMPAS BEEF THAN WITH A TRADITIONAL BARBECUE. THE MEAT IS COOKED SIMPLY, WITH NO NEED FOR RUBS OR MARINADES, THEN ENJOYED WITH A DELICIOUS SELECTION OF SALADS AND SALSAS.

SERVES SIX

INGREDIENTS
 50g/2oz/¼ cup coarse sea salt
 200ml/7fl oz/ scant 1 cup
 warm water
 6 pork sausages
 1kg/2¼lb beef short ribs
 1kg/2¼lb rump (round) steak, in
 one piece
 salads, salsas and breads, to serve

COOK'S TIP
Regularly basting the meat in salted water keeps it moist and succulent.

1 Dissolve the sea salt in the warm water in a bowl. Leave to cool.

2 Prepare the barbecue. If you are using a charcoal grill, light the coals about 40 minutes before you want to start cooking. Wait until the coals are no longer red but are covered in white ash. Occasionally add coals to the barbecue to maintain this temperature.

3 Start by cooking the sausages, which should take 15–20 minutes depending on the size. Once cooked on all sides, slice the sausages thickly and arrange on a plate. Let guests help themselves while you cook the remaining meats.

4 The short ribs should be placed bony side down on the grill. Cook for 15 minutes, turn, brush the cooked side of each rib with brine and grill for a further 25–30 minutes. Slice and transfer to a plate for guests to help themselves.

5 Place the whole rump steak on the grill and cook for 5 minutes, then turn over and baste the browned side with brine. Continue turning and basting in this way for 20–25 minutes in total, until the meat is cooked to your liking. Allow the meat to rest for 5 minutes, then slice thinly and serve with salads, salsa and bread.

VARIATION
A selection of meat cuts can be used, from sirloin to flank steak or chuck steak. Sweetbreads, skewered chicken hearts and kidneys are popular additions to the Gaucho barbecue, as well as chicken, lamb and pork. The star of the show, however, will always be the beef.

BEEF STUFFED WITH EGGS AND SPINACH

THIS TRADITIONAL ARGENTINIAN DISH MAKES A GREAT LUNCH WHEN SERVED COLD WITH A SALAD, BUT CAN ALSO BE SERVED HOT FOR DINNER WITH SOME BOILED POTATOES. ITS NAME, MATAMBRE ("KILL HUNGER") IS SOMEWHAT UNFAIR; FOR ALTHOUGH FILLING, IT IS NOT A HEAVY DISH.

SERVES SIX

INGREDIENTS
 60ml/4 tbsp olive oil
 1 small carrot, finely chopped
 1 celery stick, finely chopped
 1 onion, finely chopped
 2 eggs
 675g/1½lb flank steak
 250g/9oz spinach, trimmed
 2.5ml/½ tsp cayenne pepper
 1.5 litres/2½ pints/6¼ cups beef stock
 salt and ground black pepper
 boiled potatoes or salad, to serve

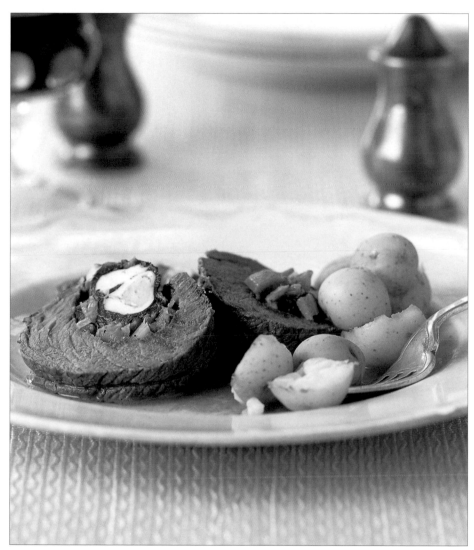

1 Heat half the olive oil in a frying pan over a medium heat. Add the carrot, celery and onion and sauté for 5 minutes, until soft and beginning to colour.

2 Meanwhile hard boil the eggs. Place them in a pan with cold water to cover. Bring to the boil, then lower the heat to a simmer. Cook for 10 minutes then lift out and cool in a bowl of cold water. Shell the eggs, then slice them thinly.

3 Season the steak generously with salt and ground black pepper. Spread the cooked onion mixture over the beef, leaving a 1cm/½in border round the edge. Arrange the spinach over the onion, then top with the egg. Season with extra salt and cayenne pepper.

COOK'S TIP
Flank steak is ideal for slow cooking, becoming so tender you can almost cut it with a fork. If you cannot get flank, skirt steak is very similar.

4 Roll the meat up tightly, being careful not to lose any of the stuffing. Tie with string four or five times along the length of the roll.

5 Heat the remaining oil in a pan. Add the beef roll to the pan and cook on all sides until golden brown. Pour in the stock, then bring to the boil. Lower the heat, cover and simmer gently for 1½–2 hours, until very tender.

6 Remove the beef from the stock and slice it as thinly as possible. Serve hot with boiled potatoes or as part of a buffet or picnic.

CARBONADA CRIOLLA

MEAT AND FRUIT ARE OFTEN COMBINED IN ARGENTINIAN COOKING, AND THIS COLOURFUL STEW IS A PRIME EXAMPLE. THE TENDER BEEF COOKED IN RED WINE BALANCES THE SWEETNESS OF THE PEACHES, POTATOES AND PUMPKIN. MAKE SURE THE PUMPKIN FITS IN YOUR OVEN.

SERVES EIGHT

INGREDIENTS

1 large pumpkin, about 5kg/11lb
60ml/4 tbsp olive oil
1kg/2¼lb braising steak, cut into
 2.5cm/1in cubes
1 large onion, finely chopped
3 fresh red chillies, seeded
 and chopped
2 garlic cloves, crushed
1 large tomato, roughly chopped
2 fresh bay leaves
600ml/1 pint/2½ cups beef stock
350ml/12fl oz/1½ cups red wine
500g/1¼lb potatoes, peeled and cut
 into 2cm/¾in cubes
500g/1¼lb sweet potatoes, peeled
 and cut into 2cm/¾in cubes
1 corn cob, cut widthways into
 6 slices
3 peaches, peeled, stoned (pitted)
 and cut into thick wedges
salt and ground black pepper

1 Wash the outside of the pumpkin. Using a sharp knife, carefully cut a slice off the top 6cm/2½in from the stem, to make a lid. Using a spoon, scoop out the seeds and stringy fibres and discard. Scoop out some of the flesh, leaving a shell about 2cm/¾in thick inside of the pumpkin. Cut the flesh you have removed into 1cm/½in pieces.

COOK'S TIP
Calabaza is a large West Indian pumpkin with a greenish orange skin that is often used for *carbonada criolla*. Look for it in Caribbean markets.

2 Brush the inside of the pumpkin and the flesh side of the lid with a little olive oil. Season with salt and ground black pepper. Place both pumpkin and lid on a baking sheet, flesh-side up. Set aside.

3 Preheat the oven to 200°C/400°F/ Gas 6. Heat half the remaining oil in a large heavy pan over a high heat. Add the beef, season and sauté for 8–10 minutes, until golden brown, then remove with a slotted spoon – you may need to do this in batches. Avoid adding too much beef to the pan or it will steam rather than brown.

4 Lower the heat and add the remaining oil to the pan. Stir in the onion and chillies, and sauté for 5 minutes. Scrape the base of the pan with a wooden spoon, to loosen any sediment. Add the garlic and tomato and cook for 2 minutes more.

5 Return the meat to the pan and add the bay leaves, stock and red wine. Bring to the boil, then lower the heat to a gentle simmer. Cook for 1 hour or until the meat is tender.

6 Place the baking sheet containing the pumpkin and its lid in the oven and bake for 30 minutes.

7 Add the potatoes, sweet potatoes, pieces of pumpkin and corn to the stew. Pour in more liquid if needed and bring to the boil. Reduce the heat to a simmer, cover and cook for 15 minutes.

8 Finally add the peach wedges and season with salt and black pepper to taste. Spoon the stew into the partially cooked pumpkin, cover with the pumpkin lid and bake for 15 minutes or until the pumpkin is tender.

9 Carefully lift the filled pumpkin on to a large, strong platter and take it to the table. Ladle the stew on to plates, then cut the empty pumpkin into six to eight wedges, depending on the number of people to be served.

PEPPERED STEAK IN SHERRY CREAM SAUCE

THE VAST SUBCONTINENT OF SOUTH AMERICA IS SUBJECT TO MANY CULINARY INFLUENCES, ALL OF WHICH HARMONIZE WITH THE NATIVE RECIPES OF EACH COUNTRY. VERSIONS OF THIS DISH ARE TO BE FOUND ALL OVER THE WORLD, BUT THE ADDITION OF PLANTAIN IS A CARIBBEAN ADAPTATION.

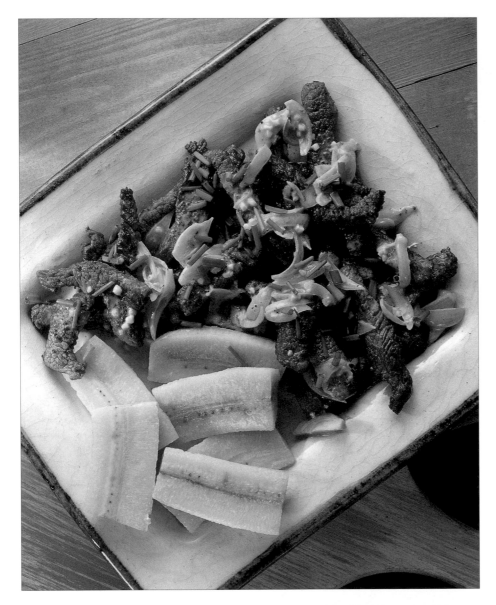

2 Season the meat with pepper and spice seasoning, place in a shallow dish and cover. Leave to marinate in a cool place for 30 minutes.

3 Melt the butter in a large frying pan and sauté the strips of steak for about 4–5 minutes, until browned on all sides. Using a slotted spoon, transfer to a warm plate and set aside.

4 Add the shallots and garlic, fry gently for 2–3 minutes, then stir in the sherry and water. Simmer for 5 minutes.

SERVES FOUR

INGREDIENTS
 675g/1½lb frying steak
 5ml/1 tsp spice seasoning
 25g/1oz/2 tbsp butter
 6–8 shallots, sliced
 2 garlic cloves, crushed
 120ml/4fl oz/½ cup sherry
 45ml/3 tbsp water
 75ml/5 tbsp single (light) cream
 salt and ground black pepper
 chopped fresh chives, to garnish
 cooked plantain, to serve

1 Cut the frying steak into thin strips, of even length and thickness, discarding any fat or gristle.

5 Stir in the cream and season. Return the meat to the pan and heat through. Serve with plantain and chopped chives.

OXTAIL AND BUTTER BEANS

THIS IS A TRADITIONAL CARIBBEAN STEW — OLD-FASHIONED, ECONOMICAL AND FULL OF GOODNESS. IT REQUIRES PATIENCE BECAUSE OF THE LONG COOKING TIME. THERE IS NOT MUCH MEAT ON THE OXTAIL, SO IT IS NECESSARY TO BUY A LARGE AMOUNT.

SERVES FOUR

INGREDIENTS
1.6kg/3½lb oxtail, chopped into pieces
1 onion, finely chopped
3 bay leaves
4 fresh thyme sprigs
3 whole cloves
1.75 litres/3 pints/7½ cups water
175g/6oz/scant 1 cup dried
 butter (lima) beans, soaked overnight
2 garlic cloves, crushed
15ml/1 tbsp tomato purée (paste)
400g/14oz can chopped tomatoes
5ml/1 tsp ground allspice
1 fresh hot chilli
salt and ground black pepper

1 Put the pieces of oxtail in a large heavy pan, add the chopped onion, bay leaves, thyme and cloves and cover with water. Bring to the boil.

2 Reduce the heat, cover the pan and simmer gently for at least 2½ hours or until the meat is very tender. If the meat looks like it might dry out, add a little extra water, being careful not to add too much at one time.

3 Meanwhile, drain the butter beans and tip them into a large pan. Pour in water to cover. Bring to the boil, lower the heat and simmer for about 1–1¼ hours or until just tender. Drain and set aside until ready to use.

COOK'S TIP
Unless you are confident using a meat cleaver to chop the oxtail into short lengths, ask your butcher to do it for you.

VARIATION
Haricot (navy) beans can be used in the same way as butter beans in the recipe.

4 When the oxtail is cooked, add the garlic, tomato purée, tomatoes, allspice, and chilli, and season. Add the beans, simmer for 20 minutes, then serve.

BLACK BEAN CHILLI <u>CON</u> CARNE

*FRESH GREEN AND DRIED RED CHILLIES ADD PLENTY OF FIRE TO THIS CLASSIC TEX-MEX DISH OF
TENDER BEEF COOKED IN A RICH AND SPICY TOMATO SAUCE.*

SERVES SIX

INGREDIENTS

225g/8oz/1¼ cups dried black beans
500g/1¼lb braising steak
30ml/2 tbsp vegetable oil
2 onions, chopped
1 garlic clove, crushed
1 fresh green chilli, seeded and
 finely chopped
15ml/1 tbsp paprika
10ml/2 tsp ground cumin
10ml/2 tsp ground coriander
400g/14oz can chopped tomatoes
300ml/½ pint/1¼ cups beef stock
1 dried red chilli, crumbled
5ml/1 tsp hot pepper sauce
1 fresh red (bell) pepper, seeded and
 chopped
salt
fresh coriander (cilantro), to garnish
boiled rice, to serve

1 Put the beans in a large pan. Cover with cold water, bring to the boil and boil vigorously for about 10 minutes. Drain, tip into a bowl, cover with cold water and leave to soak overnight.

2 Preheat the oven to 150°C/300°F/ Gas 2. Cut the steak into small dice. Heat the oil in a large, flameproof casserole. Add the onion, garlic and green chilli and cook gently for 5 minutes until soft. Transfer the mixture to a plate.

3 Increase the heat to high, add the meat to the casserole and brown on all sides, then stir in the paprika, ground cumin and ground coriander.

4 Add the tomatoes, beef stock, dried chilli and hot pepper sauce. Drain the beans and add them to the casserole, with enough water to cover. Bring to simmering point, cover and cook in the oven for about 2 hours. Stir occasionally and add extra water, if necessary, to prevent the casserole from drying.

5 Season the casserole with salt and add the chopped red pepper. Replace the lid, return the casserole to the oven and cook for about 30 minutes more, or until the meat and beans are tender. Sprinkle over the fresh coriander and serve with boiled rice.

VARIATION
Use minced (ground) beef in place of the braising steak.

COOK'S TIP
Red kidney beans are traditionally used in chilli con carne, but in this recipe black beans are used instead. They are the same shape and size as red kidney beans but have a shiny black skin.

MEXICAN SPICY BEEF TORTILLA

THIS DISH IS NOT UNLIKE A LASAGNE, EXCEPT THAT THE SPICY MEAT IS MIXED WITH RICE AND IS LAYERED BETWEEN MEXICAN TORTILLAS, WITH A HOT SALSA SAUCE FOR AN EXTRA KICK.

SERVES FOUR

INGREDIENTS
 1 onion, chopped
 2 garlic cloves, crushed
 1 fresh red chilli, seeded and
 thinly sliced
 350g/12oz rump (round) steak, cut
 into small cubes
 15ml/1 tbsp oil
 225g/8oz/2 cups cooked long
 grain rice
 beef stock, to moisten
 3 large wheat tortillas
For the salsa picante
 2 x 400g/14oz cans chopped
 tomatoes
 2 garlic cloves, halved
 1 onion, quartered
 1–2 fresh red chillies, seeded and
 roughly chopped
 5ml/1 tsp ground cumin
 2.5–5ml/½–1 tsp cayenne pepper
 5ml/1 tsp fresh oregano or 2.5ml/
 ½ tsp dried oregano
 tomato juice or water, if required
For the cheese sauce
 50g/2oz/4 tbsp butter
 50g/2oz/½ cup plain (all-purpose)
 flour
 600ml/1 pint/2½ cups milk
 115g/4oz/1 cup grated Cheddar
 cheese
 salt and ground black pepper

1 Preheat the oven to 180°C/350°F/ Gas 4. Make the salsa picante. Place the tomatoes, garlic, onion and chillies in a blender or food processor and process until smooth. Pour into a small pan, add the spices and oregano and season with salt.

2 Gradually bring the mixture to the boil, stirring occasionally. Boil for 1– 2 minutes, then lower the heat, cover with a lid and simmer gently for about 15 minutes. The sauce should be thick, but of a pouring consistency. If it is too thick, dilute it with a little fresh tomato juice or water.

3 Make the cheese sauce. Melt the butter in a pan and stir in the flour. Cook for 1 minute. Add the milk, stirring all the time until the sauce boils and thickens. Stir in all but 30ml/2 tbsp of cheese and season to taste. Cover the pan with a lid and set aside.

4 Mix the onion, garlic and chilli in a bowl. Add the steak cubes and mix well.

5 Heat the oil in a frying pan and stir-fry the meat mixture for about 10 minutes, until the meat cubes have browned and the onion is soft. Stir in the rice and enough beef stock to moisten. Season to taste with salt and freshly ground black pepper.

6 Pour about a quarter of the cheese sauce into the bottom of a round ovenproof dish. Add a tortilla and then spread over half the salsa followed by half the meat mixture.

7 Repeat these layers, then add half the remaining cheese sauce and the final tortilla. Pour over the remaining cheese sauce and sprinkle the reserved grated cheese on top. Bake in the preheated oven for about 15–20 minutes, or until golden on top.

FEIJOADA

THIS MIXED MEAT AND BLACK BEAN STEW IS INDISPUTABLY THE NATIONAL DISH OF BRAZIL AND IS TRADITIONALLY SERVED FOR SATURDAY LUNCH. IT'S IMPOSSIBLE TO MAKE A GOOD FEIJOADA FOR FEWER THAN TEN PEOPLE, SINCE THERE ARE SO MANY DIFFERENT TYPES OF MEAT INVOLVED. THE MEATS CAN VARY, BUT THE BEANS HAVE TO BE VERY SMALL AND BLACK.

SERVES TWELVE

INGREDIENTS
 1kg/2¼lb/5½ cups black
 turtle beans
 1 smoked pig's tongue, optional
 500g/1¼lb *carne seca* or beef jerky
 250g/9oz salted pork ribs
 350g/12oz smoked streaky (fatty)
 bacon, in one piece
 500g/1¼lb smoked pork ribs
 300g/11oz pork sausages
 300g/11oz smoked chorizo
 2 fresh bay leaves
 60ml/4 tbsp vegetable oil
 5 garlic cloves, crushed
 salt
 fresh orange slices, peeled, to serve
 cooked white rice
 toasted cassava flour
 stir-fried kale
 chilli oil

1 Wash the beans in running water, then place in a bowl with cold water to cover. Soak overnight. Rinse the tongue, *carne seca* or beef jerky, and salted pork ribs in cold running water and place in a separate bowl. Pour over water to cover and soak for 8 hours, or overnight, changing the soaking water three or four times.

2 Drain the beans and place them in a very large heavy pan. Pour in enough water to cover, and bring to the boil over a high heat. Skim the surface, then lower the heat. Cover the pan and simmer for 1 hour.

3 Meanwhile, drain the soaked meats, rinse them again under cold running water and transfer to a second large heavy pan. Add the streaky bacon and smoked pork ribs, then cover with water. Bring to the boil over a high heat, skim the surface, then cover the pan. Lower the heat and simmer for 1 hour.

4 Transfer the cooked meats, with their cooking liquid, to the pan with the beans. Add the pork sausages, chorizo and bay leaves. If necessary, add more water to cover. Bring to the boil, skim the surface, cover, and continue simmering for about 30 minutes.

5 Heat the oil in a large frying pan over a low heat. Add the crushed garlic cloves and cook, stirring, for about 2 minutes, being careful not to let it burn.

6 Ladle some beans from the large pan into the frying pan and fry, mashing the beans with a wooden spoon. Return the mashed beans to the meat mixture and lower the heat for 5 minutes. Taste the stew and add some salt if needed.

7 Lift the meats from the pan and cut them into even-size pieces. Arrange on a platter, keeping each type of meat separate. Spoon a ladleful of beans over the meats. Pour the remaining beans into a large serving bowl.

8 Take the beans and meats to the table with a platter of peeled, sliced oranges, cooked white rice, toasted cassava flour, stir-fried kale and chilli oil.

COOK'S TIPS
• *Carne seca*, a Brazilian beef jerky, can be bought in Brazilian or Portuguese food stores. You can make a *feijoada* without it, but it won't be as rich.
• Toasted cassava flour is sold in Latin American or Portuguese food stores. Here it is served from the packet, but it can be flavoured with palm oil or eggs.

SPICY MEATBALLS ᵂᴵᵀᴴ TOMATO SAUCE

Wherever you go in Latin America, you'll find a different interpretation of this hearty family dish. Spanish in origin, the meatballs are often made with pork or veal, or a mixture of meats, and known as albondigas.

SERVES FOUR

INGREDIENTS
 500g/1¼lb minced (ground) beef
 3 garlic cloves, crushed
 1 small onion, finely chopped
 50g/2oz/1 cup fresh breadcrumbs
 2.5ml/½ tsp ground cumin
 1 egg, beaten
 50g/2oz/½ cup plain
 (all-purpose) flour
 60ml/4 tbsp olive oil
 salt
 cooked white rice, to serve
For the sauce
 30ml/2 tbsp olive oil
 1 small onion, thinly sliced
 2 red (bell) peppers, seeded
 and diced
 2 fresh red chillies, seeded
 and chopped
 2 garlic cloves, crushed
 150ml/¼ pint/⅔ cup canned
 chopped tomatoes
 400ml/14fl oz/1⅔ cups light
 beef stock
 ground black pepper

COOK'S TIP
An electric frying pan is ideal for cooking the meatballs, as its large surface area will allow you to fry them in one or two batches, and there is plenty of room for reheating them in the sauce.

1 Place all the meatball ingredients, except the flour and oil, in a large bowl. Using your hands, mix until thoroughly combined. Season with salt and shape the mixture into even-size balls. Wet your hands to prevent the mixture from sticking. Dust lightly with flour.

2 Heat the oil in a large frying pan and cook the meatballs, in batches, for 6–8 minutes or until golden. When all the meatballs have been browned, wipe the pan clean with kitchen paper.

3 Pour the olive oil into the pan and cook the onion and peppers over a low heat for 10 minutes, until soft. Add the chillies and garlic, and cook for a further 2 minutes. Pour in the tomatoes and stock, and bring to the boil. Lower the heat, cover the pan and simmer for 15 minutes. Season to taste.

4 Add the meatballs to the pan and spoon the sauce over them. Bring back to the boil, then cover and simmer for 10 minutes. Serve with rice.

SCRAMBLED EGGS WITH CHORIZO

THIS POPULAR MEXICAN DISH IS OFTEN EATEN FOR BREAKFAST. DRIED, SPANISH-STYLE CHORIZO GIVES THE EGGS A RICH GOLDEN COLOUR AND DELICIOUS SMOKY FLAVOUR. BUY THE SAUSAGE IN ONE PIECE AND SLICE IT JUST BEFORE COOKING.

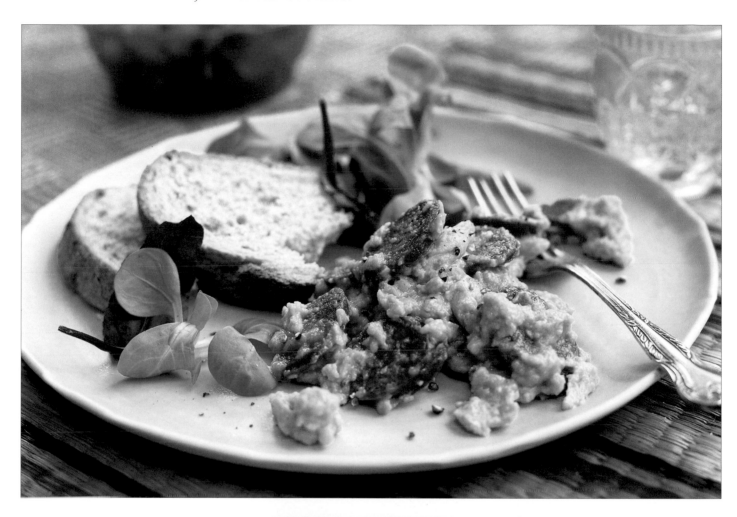

SERVES FOUR

INGREDIENTS
 15ml/1 tbsp olive oil
 150g/5oz dried chorizo, cut into
 1cm/½ in slices
 2.5ml/½ tsp paprika
 8 eggs, lightly beaten
 salt
 country bread and green salad,
 to serve

1 Heat the oil in a large frying pan over a medium heat and pan-fry the chorizo slices for 1–2 minutes, until golden brown.

COOK'S TIP
The chorizo will brown very quickly, so do not leave it to cook unattended, or it may burn.

2 Add the paprika, stir for 30 seconds, then pour in the beaten eggs. Season lightly with salt. As the eggs start to set, break them up with a fork.

3 Remove the pan from the heat when the mixture is still quite moist; it will continue cooking off the heat. Serve with the bread and a green salad.

HEARTY BEEF STEW

BROWN ALE ENRICHES THIS CARIBBEAN BEEF STEW AND GIVES IT A REAL KICK. VARY THE AMOUNT TO SUIT YOUR TASTE, BUT DON'T OVERDO IT OR YOU WILL OVERWHELM THE TASTE OF THE PAPRIKA.

2 Simmer the beans for 30 minutes or until tender, but still quite firm. Drain the beans, reserving the cooking liquid.

3 Melt the butter or margarine in a large pan and sauté the onion for a few minutes. Add the beef, paprika, garlic, cinnamon and sugar and fry for about 5 minutes, stirring frequently.

4 Pour in the beef stock and brown ale, cover and cook gently for 1½ hours, until the beef is almost cooked.

SERVES FOUR

INGREDIENTS
 50g/2oz/⅓ cup black-eyed beans (peas)
 25g/1oz/2 tbsp butter or margarine
 1 onion, chopped
 675g/1½lb stewing beef, cubed
 5ml/1 tsp paprika
 2 garlic cloves, crushed
 10ml/2 tsp ground cinnamon
 10ml/2 tsp sugar
 600ml/1 pint/2½ cups beef stock
 150ml/¼ pint/⅔ cup brown ale
 45ml/3 tbsp evaporated
 (unsweetened condensed) milk
 salt and ground black pepper
 steamed baby patty-pan squash

1 Put the black-eyed beans in a bowl and pour over water to cover. Leave to soak overnight, then drain, tip into a large pan, cover with water and bring to the boil. Boil rapidly for 3–4 minutes, then reduce the heat.

5 Add the evaporated milk and beans. Season with salt and pepper and continue cooking until the beans and beef are tender. Serve with steamed baby patty-pan squash.

CARIBBEAN LAMB CURRY

THIS JAMAICAN DISH IS POPULARLY KNOWN AS CURRIED GOAT OR CURRY GOAT, ALTHOUGH KID, LAMB OR MUTTON ARE EQUALLY LIKELY TO BE USED TO MAKE IT.

SERVES SIX

INGREDIENTS
900g/2lb boned leg of mutton
 or lamb
50g/2oz/4 tbsp curry powder
3 garlic cloves, crushed
1 large onion, chopped
leaves from 4 fresh thyme sprigs,
 or 5ml/1 tsp dried thyme
3 bay leaves
5ml/1 tsp ground allspice
30ml/2 tbsp vegetable oil
50g/2oz/¼ cup butter or margarine
900ml/1½ pints/3¾ cups lamb stock
 or water
1 fresh hot chilli, chopped
fresh coriander (cilantro) sprigs,
 to garnish
cooked rice, to serve

3 Melt the butter or margarine in a large heavy pan. Add the seasoned mutton or lamb and fry over a medium heat for about 10 minutes, turning the meat frequently.

4 Stir in the stock or water and chilli, and bring to the boil. Lower the heat, cover and simmer for 1½ hours or until the meat is tender. Garnish with coriander and serve with rice.

1 Cut the meat into 5cm/2in cubes, discarding excess fat and any gristle. Place it in a large bowl.

2 Add the curry powder, garlic, onion, thyme, bay leaves, allspice and oil. Mix well, then cover the bowl and place in the refrigerator. Marinate for at least 3 hours or overnight.

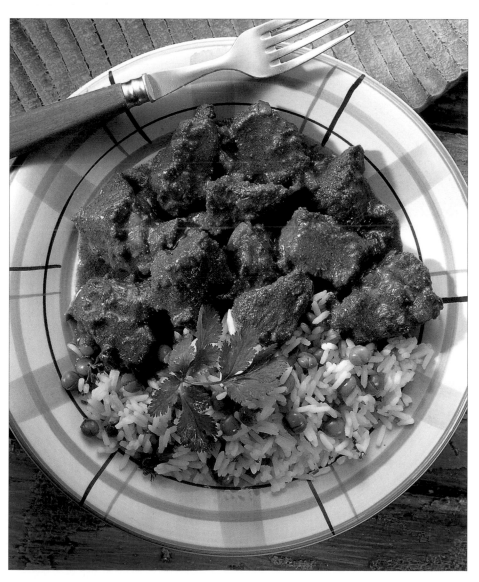

"SEASONED-UP" LAMB ᴵᴺ SPINACH SAUCE

IN THE CARIBBEAN, ESPECIALLY IN THE ENGLISH-SPEAKING ISLANDS, YOU WILL OFTEN HEAR DISHES DESCRIBED AS "SEASONED UP". THIS IMPLIES THE USE OF A SPICY RUB OR MARINADE, A TECHNIQUE THAT WORKS WELL WITH CHEAPER CUTS OF MEAT.

SERVES FOUR

INGREDIENTS

675g/1½lb boneless lamb, cubed
2.5ml/½ tsp ground ginger
2.5ml/½ tsp dried thyme
30ml/2 tbsp olive oil
1 onion, chopped
2 garlic cloves, crushed
15ml/1 tbsp tomato purée (paste)
½ fresh hot chilli, chopped (optional)
600ml/1 pint/2½ cups lamb stock
 or water
115g/4oz fresh spinach, finely
 chopped
salt and ground black pepper

1 Put the lamb cubes in a dish. Sprinkle over the ginger and thyme, season and mix well to coat. Cover and marinate for at least 2 hours or overnight in the refrigerator.

2 Heat the olive oil in a heavy pan, add the onion and garlic and fry gently for 5 minutes or until the onion is soft.

3 Add the lamb with the tomato purée and chilli, if using. Fry over a medium heat for about 5 minutes, stirring frequently, then add the lamb stock or water. Cover and simmer for about 30 minutes, until the lamb is tender.

4 Stir in the spinach and simmer for around 8 minutes. Serve hot.

LAMB PELAU

INDIAN IMMIGRANTS INTRODUCED THE PILAU TO THE CARIBBEAN. THE NAME HAS CHANGED SLIGHTLY, BUT RICE DISHES LIKE THIS ONE REMAIN TRUE TO THEIR ORIGINS.

SERVES FOUR

INGREDIENTS

450g/1lb stewing lamb
15ml/1 tbsp curry powder
1 onion, finely chopped
2 garlic cloves, crushed
2.5ml/½ tsp dried thyme
2.5ml/½ tsp dried oregano
1 fresh or dried chilli
25g/1oz/2 tbsp butter or margarine,
 plus extra for serving
600ml/1 pint/2½ cups beef or
 chicken stock or coconut milk
5ml/1 tsp ground black pepper
2 tomatoes, chopped
10ml/2 tsp sugar
30ml/2 tbsp chopped spring
 onion (scallion)
450g/1lb/2½ cups basmati rice
spring onion (scallion) strips,
 to garnish

1 Cut the lamb into cubes and place in a dish. Add the curry powder, onion, garlic, herbs and chilli and stir well. Cover with clear film (plastic wrap) and leave to marinate for 1 hour.

2 Melt the butter or margarine in a pan and fry the lamb for 5–10 minutes. Pour in the stock or coconut milk, bring to the boil, then lower the heat and simmer for 35 minutes or until tender.

3 Add the black pepper, tomatoes, sugar, chopped spring onion and rice. Stir well and reduce the heat. Make sure that the rice is covered by 2.5cm/1in of liquid; add a little water if necessary. Cover the pan; simmer the pelau for 25 minutes or until the rice has absorbed the liquid and is cooked. Spoon into a serving bowl and stir in a little extra butter or margarine. Garnish with spring onion strips and serve.

SPICED ROAST LEG OF LAMB

*PEPPERS AND BEANS ARE DELICIOUS COOKED WITH THIS SPICED LAMB — THE BEANS SOAK UP THE
MEAT JUICES AND COMBINE WITH SWEET RED PEPPERS TO MAKE A SUCCULENT ONE-POT MEAL.*

SERVES SIX

INGREDIENTS

 1 leg of lamb, about 1.8kg/4lb
 4 garlic cloves, crushed
 5ml/1 tsp ground cumin
 10ml/2 tsp ground annatto
 (achiote) seeds
 10ml/2 tbsp sweet paprika
 5ml/1 tsp dried oregano
 45ml/3 tbsp olive oil
 3 red (bell) peppers, cored, seeded
 and thickly sliced
 2 x 400g/14oz can black-eyed beans
 (peas), drained
 105ml/7 tbsp dry white wine
 salt and ground black pepper
 cooked white rice or polenta, to serve

COOK'S TIP
Look for ground annatto in South
American or Caribbean markets, or
replace with saffron or turmeric.

1 Weigh the lamb and calculate the
cooking time. For medium-cooked
lamb, allow 20 minutes per 450g/1lb,
plus 20 minutes. Allow either 5 minutes
more or less per 450/1lb for rare and
well-done meat.

2 Mix the garlic, cumin, annatto,
paprika and oregano in a bowl. Stir in
half the olive oil. Using a spoon, rub the
paste all over the lamb. Cover and
marinate in a cool place for 2–3 hours.

3 Preheat the oven to 180ºC/350ºF/
Gas 4. Place the lamb in a roasting pan
with the peppers and beans. Pour in the
wine and drizzle with the remaining oil.
Season, then roast for the calculated
time. Check occasionally, adding water
if the vegetables begin to dry out.

4 When the lamb is cooked, remove
from the oven and cover the meat
loosely with foil. Leave to rest for 15
minutes, then serve with rice or polenta.

RABBIT IN COCONUT MILK

*THIS UNUSUAL DISH COMES FROM COLOMBIA. THE RABBIT IS STEWED IN A LIGHTLY SPICED TOMATO
SAUCE, AND WHEN IT IS ALMOST READY, COCONUT MILK IS STIRRED IN TO ENRICH THE SAUCE.*

SERVES FOUR

INGREDIENTS

 1 rabbit, cut into 8 pieces (ask your
 butcher to do this for you)
 3 garlic cloves, crushed
 1.5ml/¼ tsp paprika
 1.5ml/¼ tsp ground cumin
 45ml/3 tbsp olive oil
 1 large onion, thinly sliced
 1 bay leaf
 400g/14oz can plum tomatoes,
 drained and roughly chopped
 150ml/¼ pint/⅔ cup chicken stock
 250ml/8fl oz/1 cup coconut milk
 salt and ground black pepper
 white rice or boiled potatoes, to serve

3 Add the rabbit to the oil remaining in
the pan, season and cook until golden.
Do this over a very low heat to avoid
burning the spices.

4 Return the onion slices to the pan
and add the bay leaf. Stir in the
tomatoes and stock and bring to the
boil. Lower the heat, cover and simmer
for 45 minutes.

VARIATION
This dish is often made with chicken
rather than rabbit. The ingredients
remain the same, but the cooking time
should be reduced by 15 minutes.

5 Stir in the coconut milk. Continue to
simmer, uncovered, for a further 15
minutes, until the rabbit is tender and the
sauce has thickened. Serve immediately
with white rice or boiled potatoes.

1 Wash the rabbit under cold water,
then pat the pieces dry with kitchen
paper. Combine the garlic, paprika and
cumin in a bowl and rub the mixture all
over the rabbit. Cover with clear film
(plastic wrap) and leave to marinate for
1 hour, or overnight in the refrigerator.

2 Heat the oil in a pan, add the onion
slices and cook for 5 minutes, until
tender. Remove the onion with a slotted
spoon and set aside.

PORK ROASTED <u>WITH</u> HERBS, SPICES <u>AND</u> RUM

IN THE CARIBBEAN, THIS SPICY ROAST PORK IS A FAVOURITE DISH THAT IS USUALLY COOKED ON A BARBECUE AND SERVED ON SPECIAL OCCASIONS AS PART OF A BUFFET.

SERVES EIGHT

INGREDIENTS
 2 garlic cloves, crushed
 45ml/3 tbsp soy sauce
 15ml/1 tbsp malt vinegar
 15ml/1 tbsp finely chopped celery
 30ml/2 tbsp chopped spring
 onion (scallion)
 7.5ml/1½ tsp dried thyme
 5ml/1 tsp dried sage
 2.5ml/½ tsp ground mixed spice
 (pumpkin pie spice)
 10ml/2 tsp curry powder
 120ml/4fl oz/½ cup rum
 15ml/1 tbsp demerara (raw) sugar
 1.6kg/3½lb boned loin of pork
 salt and ground black pepper
 spring onion (scallion) curls,
 to garnish
 creamed sweet potato, to serve
For the sauce
 25g/1oz/2 tbsp butter or
 margarine, diced
 15ml/1 tbsp tomato purée (paste)
 300ml/½ pint/1¼ cups chicken or
 pork stock
 15ml/1 tbsp chopped fresh parsley
 15ml/1 tbsp demerara (raw) sugar
 hot pepper sauce, to taste

1 In a bowl, mix the garlic, soy sauce, vinegar, celery, spring onion, thyme, sage, spice, curry powder, rum, and sugar. Add a little salt and pepper.

2 Open out the pork and slash the meat, without cutting through it completely. Place it in a shallow dish. Spread most of the spice mixture all over the pork, pressing it well into the slashes. Rub the outside of the joint with the remaining mixture, cover the dish with clear film (plastic wrap) and chill in the refrigerator overnight.

COOK'S TIP
In the Caribbean, pork is baked until it is very well done, so reduce the cooking time if you prefer meat slightly more moist. To get the full flavour from the marinade, start preparation the day before.

3 Preheat the oven to 190°C/375°F/ Gas 5. Roll the meat up, then tie it tightly in several places with strong cotton string to hold the meat together.

4 Spread a large piece of foil across a roasting pan and place the marinated pork loin in the centre. Baste the pork with a few spoonfuls of the marinade and wrap the foil around the meat.

5 Roast the pork in the oven for 1¾ hours, then slide the foil out from under the meat and discard it. Baste the pork with any remaining marinade and cook for a further 1 hour. Check occasionally that the meat is not drying out and baste with the pan juices.

6 Meanwhile, make the sauce. Transfer the pork to a warmed serving dish, cover with foil and leave to stand in a warm place for 15 minutes. Pour the pan juices into a pan. Add the butter or margarine, tomato purée, stock, parsley and sugar, with hot pepper sauce and salt to taste. Simmer until reduced.

7 Serve the pork sliced, with the creamed sweet potato. Garnish with the spring onion curls and serve the sauce separately.

PORK <u>WITH</u> PINEAPPLE

*THIS UNUSUAL DISH FROM MEXICO COMBINES THE SWEET, JUICY TASTE OF FRESH PINEAPPLE WITH
FIERY HOT CHILLIES, AND THE REFRESHING TANG OF COOL MINT.*

SERVES SIX

INGREDIENTS
 30ml/2 tbsp corn oil
 900g/2lb boneless pork shoulder or
 loin, cut into 5cm/2in cubes
 1 onion, finely chopped
 1 large red (bell) pepper, seeded and
 finely chopped
 1 or more jalapeño chillies, seeded
 and finely chopped
 450g/1lb fresh pineapple chunks
 8 fresh mint leaves, chopped
 250ml/8fl oz/1 cup chicken stock
 salt and ground black pepper
 fresh mint sprigs, to garnish
 boiled rice, to serve

1 Heat the oil in a large frying pan and
sauté the pork in batches until the
cubes are lightly coloured. Transfer the
pork to a flameproof casserole, leaving
the oil behind in the pan.

2 Add the chopped onion, red pepper
and the chillies to the oil remaining in
the pan. Sauté until the onion is tender,
then add to the casserole with the
pineapple. Stir to mix.

3 Add the mint, then cover the
casserole with a tight-fitting lid and
simmer gently for about 2 hours, or
until the pork is tender.

4 Season to taste, garnish the casserole
with fresh sprigs of mint and serve with
plain boiled rice. Serve immediately,
while still hot.

COOK'S TIP
If fresh pineapple is not available, use
pineapple chunks from a can. Make sure
it is canned in its own juice, however,
and not in syrup or other fruit juice.

PORK IN MILK

ITALIAN IMMIGRANTS FIRST TOOK THIS TUSCAN RECIPE TO ARGENTINA. IN PERU, RAISINS AND SEVERAL SWEET SPICES ARE ADDED, BUT FOR THIS VERSION ONLY CLOVES ARE USED, GIVING A SUBTLE FLAVOUR.

SERVES SIX

INGREDIENTS

1kg/2¼ lb pork loin, on the bone
25g/1oz/2 tbsp butter
15ml/1 tbsp olive oil
1 litre/1¾ pints/4 cups full-fat
 (whole) milk
3 whole cloves
4 garlic cloves, peeled but left whole
1 bay leaf
juice of 2 lemons
salt and ground black pepper
boiled potatoes, to serve

COOK'S TIP
The milk will curdle because of the addition of lemon juice. Don't be tempted to strain it, or you'll lose half the flavour. When you blend it, it will become perfectly smooth again.

1 Preheat the oven to 180°C/350°F/ Gas 4. Season the pork and select a roasting pan that will hold it snugly. Heat the butter and oil in the roasting pan over a medium heat. When the butter has melted, add the pork and baste it all over. Cook for 10–15 minutes, turning, until golden brown all over.

2 Pour in the milk and add the cloves, garlic, bay leaf and lemon juice. Cook in the oven for 1¾–2 hours.

3 Remove the roasting pan from the oven and transfer the pork loin to a serving platter to rest for 5 minutes. Skim the fat from the cooking liquid and, using a teaspoon, remove the cloves and bay leaf. Place the pan on the hob and boil over a high heat until the sauce is reduced by half.

4 Process the sauce in a food processor until smooth. Carve the pork and serve it with the sauce and boiled potatoes.

BAKED HAM WITH ORANGE AND LIME

THE DELICIOUS CITRUS GLAZE ON THIS HAM CONTRASTS BEAUTIFULLY WITH THE SWEETNESS OF THE MEAT FOR THIS PERFECT SUNDAY LUNCH DISH. PLAIN RICE AND BLACK BEANS, THOSE FAVOURITE LATIN AMERICAN SIDE DISHES, ARE THE OBVIOUS ACCOMPANIMENT.

SERVES EIGHT

INGREDIENTS

1 green gammon (unsmoked ham),
 about 2kg/4½ lb
grated rind of 1 orange
grated rind of 1 lime
1 bay leaf
3 fresh parsley stalks
6 black peppercorns
5 garlic cloves, crushed
15ml/1 tbsp dried oregano
2 fresh red chillies, seeded and
 finely chopped
juice of 1 orange
juice of 2 limes
30ml/2 tbsp soft brown sugar
ground black pepper

1 Put the gammon in a large pan and pour in cold water to cover. Add the orange and lime rind, the bay leaf, parsley and peppercorns. Bring to the boil over a high heat, cover and lower the heat so that the water is bubbling at a gentle simmer. Cook the gammon for about 2 hours.

2 Preheat the oven to 220°C/425°F/ Gas 7. When the gammon is cooked, remove the pan from the heat. Leave until the gammon is cool enough to handle, then transfer it to a chopping board. Carefully pull away the skin, leaving the fat on the meat.

3 Mix the crushed garlic, oregano, chopped chillies, orange and lime juice and sugar in a bowl and stir well to combine. Add a generous amount of ground black pepper. Rub the mixture all over the gammon, coating it evenly. Transfer to a roasting pan and bake for 20–25 minutes or until golden.

4 Slice the ham and serve. Alternatively, enjoy as part of a buffet or picnic.

POULTRY

Chicken is the meat most frequently eaten in the Caribbean and Latin America. The Caribbean Sunday roast is extremely popular, but for delicious weekday meals try thyme and lime chicken or chicken with okra. Colombian chicken hot-pot and carapulcra, *a chicken and pork dish from Peru, are both national dishes. Turkey and duck are also popular throughout the region.*

CUBAN CHICKEN PIE

THIS IS A GREAT FAMILY MEAL, PERFECT FOR A SUNDAY LUNCH. THE FILLING, WHICH INCLUDES CAPERS, OLIVES AND RAISINS, PROVIDES A FLAVOURSOME CONTRAST TO THE CRISP CORN TOPPING.

SERVES SIX

INGREDIENTS
 1 chicken, about 1.6kg/3½lb
 6 peppercorns
 1 bay leaf
 3 fresh parsley sprigs
 30ml/2 tbsp olive oil
 1 large onion, finely chopped
 2 hard-boiled eggs, chopped
 2 tomatoes, roughly chopped
 50g/2oz/½ cup pitted green olives,
 roughly chopped
 15ml/1 tbsp drained bottled capers
 65g/2½oz/scant ½ cup raisins
 salt and ground black pepper
For the topping
 500g/1¼lb/3⅓ cups drained canned
 or thawed frozen corn kernels
 90g/3½oz butter
 10ml/2 tsp caster (superfine) sugar
 3 eggs, lightly beaten
 salt

1 Put the chicken in a large, heavy pan and add enough water to cover. Add the peppercorns, bay leaf and parsley and bring to the boil over a high heat. Lower the heat, cover and simmer gently for 1 hour or until cooked through.

2 Allow the chicken to cool in the cooking liquid. When cold enough to handle, lift the chicken out of the pan and, using two forks, shred the flesh roughly. Discard the skin and bones.

3 Make the topping. Tip the corn kernels into a blender or food processor and purée until smooth. Melt the butter in a pan over a low heat. Stir in the puréed corn and sugar. Season generously with salt and cook, stirring, for 10 minutes, until the mixture thickens and comes away from the sides of the pan.

4 Remove from the heat and leave to cool for 10 minutes, then slowly stir in the beaten eggs, a little at a time. Set the topping mixture aside.

5 Preheat the oven to 180°C/350°F/ Gas 4. Heat the oil in a large frying pan and stir in the chopped onion. Cook gently for 5 minutes, until soft and translucent, and season with salt and black pepper to taste.

6 Stir in the chopped hard-boiled eggs, chopped tomatoes, olives, capers and raisins. Fold in the shredded chicken, making sure that it is well distributed throughout the mixture.

7 Spoon the pie filling into a 25 x 20cm/ 10 x 8in baking dish. Using a spoon, spread the corn topping evenly over the top of the chicken filling and bake for 45 minutes, until golden brown. Leave to stand for about 10 minutes before serving on warm plates.

VARIATION
Shortcrust pastry can be used instead of the corn topping.

CHICKEN WITH OKRA

SERVE THIS CLASSIC BRAZILIAN DISH FOR A FAMILY SUPPER. IT IS TOTALLY FUSS-FREE, TAKING VERY LITTLE TIME AND EFFORT TO PREPARE.

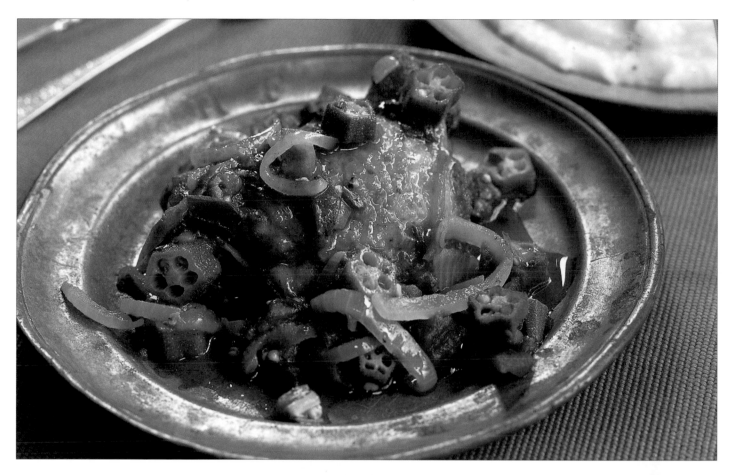

SERVES FOUR

INGREDIENTS
15ml/1 tbsp olive oil
4 chicken thighs
1 large onion, finely chopped
2 garlic cloves, finely crushed
2 fresh red chillies, seeded and
 finely chopped
120ml/4fl oz/½ cup water
350g/12oz okra
2 large tomatoes, finely chopped
salt
boiled white rice or polenta, to serve
hot chilli oil (optional)

COOK'S TIP
As okra cooks, the pods release a sticky juice, which coats and flavours the chicken. If you don't like this sticky texture, however, cook the pods whole, simply trimming off the tops but not cutting into the pods themselves.

1 Heat the oil in a wide pan over a low heat. Season the chicken thighs with salt and add them to the pan, skin side down. Cook until golden brown, turn them over and add the chopped onion.

2 Sauté for 5 minutes, until the onion has softened; then add the garlic and chopped chillies. Cook for a further 2 minutes. Add half the water to the pan and bring to the boil. Lower the heat, cover and cook for 30 minutes.

3 Trim the okra and slice into thin rounds. Add to the pan with the tomatoes. Season with salt and pour in the remaining water. Cover and simmer gently for about 10–15 minutes, or until the chicken pieces are tender and fully cooked. The chicken is ready when the flesh can be pulled off the bone easily.

4 Serve immediately with boiled white rice or polenta, and offer some hot chilli oil on the side.

COLOMBIAN CHICKEN HOT-POT

COLOMBIANS ARE JUSTIFIABLY PROUD OF THIS NATIONAL DISH. TRADITIONALLY, THREE NATIVE VARIETIES OF POTATOES ARE USED, EACH WITH A DIFFERENT TEXTURE, TO CREATE A TASTY THICK BROTH. THE ADDITION OF CORIANDER AND CORN PROVIDES A COMPLEMENTARY SWEETNESS.

SERVES EIGHT

INGREDIENTS
 1.6kg/3½lb chicken
 3 spring onions (scallions)
 2 bay leaves
 6 fresh coriander (cilantro) sprigs
 6 whole black peppercorns
 675g/1½lb floury potatoes, peeled
 and cut into 1cm/½in chunks
 675g/1½lb waxy potatoes, peeled
 and cut into 1cm/½in chunks
 675g/1½lb baby new potatoes or
 salad potatoes
 2 corn cobs, each cut into 4 pieces
 salt
 capers and sour cream, to serve
For the avocado salsa
 1 hard-boiled egg
 1 large ripe avocado
 1 spring onion (scallion), finely
 chopped
 15ml/1 tbsp chopped fresh
 coriander (cilantro)
 1 fresh green chilli, seeded and
 finely chopped
 salt

1 Put the chicken in a large pan or flameproof casserole and cover with water. Add the spring onions (scallions), bay leaves, coriander sprigs and peppercorns. Season, bring to the boil and skim the surface of the liquid.

2 Reduce the heat to a gentle simmer, cover and cook for 1 hour or until the chicken is tender and fully cooked. Remove from the heat and allow the chicken to cool in the cooking liquid.

3 Drain the chicken, reserving the cooking liquid to use as stock. Place the chicken on a board and cut it into 8 pieces. It should be so tender that the legs are easy to pull off.

4 Separate the thighs from the drumsticks. Use a knife to cut between the two breasts, then gently ease the meat off the bone. Cut the breasts in half, set the chicken pieces aside on a plate and discard the rest of the carcass.

5 Skim the fat from the top of the cooking liquid, then strain it into a clean pan. Bring to the boil. Add the floury and waxy potatoes and simmer for 15 minutes. Stir in the new potatoes or salad potatoes and corn and simmer for a further 20 minutes.

6 By this time, the floury potatoes will have broken up and they will have helped to thicken the liquid. The waxy potatoes should be soft and partly broken. The new or salad potatoes should be tender but still whole. Return the chicken pieces to the pan and reheat gently but thoroughly.

7 Meanwhile, make the fresh avocado salsa. Peel and roughly chop the hard-boiled egg. Using a fork, mash it in a small bowl.

8 Just before serving, cut the avocado in half lengthways and, using a teaspoon, scoop the flesh into a separate bowl. Mash well with a fork, then stir in the chopped hard-boiled egg until thoroughly combined. Add the spring onion, fresh coriander and chilli, mix well, then season to taste with salt.

9 Serve the chicken mixture in a heated casserole or earthenware dish, with bowls of hot tomato salsa, capers and sour cream on the side, if you like.

COOK'S TIP
The quality and flavour of the chicken stock in this dish will depend entirely on what kind of chicken you use. It is worth spending a bit more and buying the best bird you can find, preferably free range, corn-fed or organic. You will really taste the difference.

BARBECUED JERK CHICKEN

JERK SEASONING IS A BLEND OF HERBS AND SPICES THAT IS RUBBED INTO MEAT BEFORE IT IS ROASTED OVER CHARCOAL SPRINKLED WITH PIMIENTO BERRIES. IN JAMAICA, JERK SEASONING WAS ORIGINALLY USED ONLY FOR PORK, BUT JERKED CHICKEN TASTES JUST AS GOOD.

2 Make several lengthways slits in the flesh on the chicken pieces. Place the chicken pieces in a dish and spoon the jerk seasoning over them. Use your hands to rub the seasoning into the chicken, especially into the slits.

3 Cover with clear film (plastic wrap) and marinate for at least 4–6 hours or overnight in the refrigerator.

4 Preheat the grill (broiler) or prepare the barbecue. Shake off any excess seasoning from the chicken and brush the pieces with oil. Either place on a baking sheet and grill (broil) for 45 minutes, or cook on the barbecue for about 30 minutes. Whichever method you choose, it is important to turn the chicken pieces frequently. Serve hot with salad leaves.

SERVES FOUR

INGREDIENTS
 8 chicken pieces
 oil, for brushing
 salad leaves, to serve
For the jerk seasoning
 5ml/1 tsp ground allspice
 5ml/1 tsp ground cinnamon
 5ml/1 tsp dried thyme
 1.5ml/¼ tsp freshly grated nutmeg
 10ml/2 tsp demerara (raw) sugar
 2 garlic cloves, crushed
 15ml/1 tbsp finely chopped onion
 15ml/1 tbsp chopped spring
 onion (scallion)
 15ml/1 tbsp vinegar
 30ml/2 tbsp oil
 15ml/1 tbsp lime juice
 1 fresh hot chilli pepper, chopped
 salt and ground black pepper

1 Make the jerk seasoning. Combine the ground allspice, cinnamon, thyme, grated nutmeg, sugar, garlic, both types of onion, vinegar, oil, lime juice and chilli pepper in a small bowl. Use a fork to mash them together until a thick paste is formed. Season to taste with a little salt and plenty of ground black pepper.

COOK'S TIP
The flavour is best if you marinate the chicken overnight. If cooking on the barbecue, sprinkle the charcoal with aromatic herbs, such as rosemary or bay leaves, for even more flavour.

THYME AND LIME CHICKEN

LIMES GROWN IN LATIN AMERICA TEND TO BE PALER THAN THE ONES IN OUR SUPERMARKETS, BUT THEY ARE JUICY AND FULL OF FLAVOUR. THIS CARIBBEAN RECIPE, WHICH COMBINES THEM WITH FRAGRANT THYME, IS A GREAT VEHICLE FOR THEM.

SERVES FOUR

INGREDIENTS
 8 chicken thighs
 30ml/2 tbsp chopped spring
 onion (scallion)
 10ml/2 tsp chopped fresh thyme or
 5ml/1 tsp dried thyme
 2 garlic cloves, crushed
 juice of 2 limes or 1 lemon
 75g/3oz/6 tbsp butter, melted
 salt and ground black pepper
 cooked rice, to serve
To garnish
 lime slices
 fresh coriander (cilantro) sprigs

3 Spoon the remaining butter evenly over the top of the chicken pieces. Cover the dish tightly with clear film (plastic wrap) and leave to marinate for at least 3–4 hours in the refrigerator. For the best flavour, prepare the chicken the day before and leave to marinate overnight.

4 Preheat the oven to 190°C/375°F/ Gas 5. Remove the film and cover the chicken with foil. Bake for about 1 hour, then remove the foil and cook for a further 5–10 minutes, until the chicken turns golden brown. Garnish with lime slices and fresh coriander and serve with rice.

1 Put the chicken thighs skin-side down in a baking dish or roasting pan. Using a sharp knife, make a lengthways slit along the thigh bone of each. Mix the spring onion with a little salt and pepper and press the mixture into the slits.

2 Mix the thyme, garlic and lime or lemon juice in a small bowl. Add 50g/ 2oz/4 tbsp of the butter and mix well, then spoon a little of the mixture over each chicken thigh, spreading evenly.

CHICKEN, PORK AND POTATOES IN PEANUT SAUCE

THIS TRADITIONAL PERUVIAN DISH, KNOWN AS CARAPULCRA, IS MADE WITH PAPASECA (DRIED POTATOES), WHICH BREAK UP WHEN COOKED TO THICKEN THE SAUCE. THE SAME EFFECT IS ACHIEVED HERE BY USING FLOURY POTATOES, THE KIND THAT DISINTEGRATE WHEN COOKED FOR A LONG TIME.

SERVES SIX

INGREDIENTS
 75g/3oz/¾ cup unsalted peanuts
 60ml/4 tbsp olive oil
 3 chicken breast portions, halved
 500g/1¼lb boneless pork loin, cut
 into 2cm/¾in pieces
 1 large onion, chopped
 30–45ml/2–3 tbsp water
 3 garlic cloves, crushed
 5ml/1 tsp paprika
 5ml/1 tsp ground cumin
 500g/1¼lb floury potatoes, peeled
 and thickly sliced
 550ml/18fl oz/scant 2½ cups
 vegetable stock
 salt and ground black pepper
 cooked rice, to serve
To garnish
 2 hard-boiled eggs, sliced
 50g/2oz/½ cup pitted black olives
 chopped fresh flat leaf parsley

1 Place the peanuts in a large dry frying pan over a low heat. Toast for about 2–3 minutes, until golden all over. Watch them closely, shaking the pan frequently, as they have a tendency to burn. Leave to cool, then process in a food processor until finely ground.

2 Heat half the olive oil in a heavy pan. Add the chicken pieces, season with salt and ground black pepper and cook for 10 minutes, until golden brown all over. Transfer the pieces of chicken to a plate, using a slotted spoon.

3 Heat the remaining oil in the pan. When it is very hot, add the pork. Season and sauté for 3–4 minutes, until golden brown. Transfer to the plate containing the chicken pieces.

4 Lower the heat and stir the onion into the oil in the pan. Cook for 5 minutes, adding the water if it begins to stick. Stir in the garlic, paprika and cumin and cook for 1 minute more.

5 Add the potatoes, stir and cover the pan. Cook for 3 minutes. Add the peanuts and stock. Bring to the boil, and simmer gently for 20–30 minutes.

6 Return the chicken and pork to the pan and bring to the boil. Lower the heat, replace the lid and simmer for 6–8 minutes, until the meat is fully cooked. Avoid overcooking the meat or it will become tough and stringy.

7 Garnish the stew with the egg slices, black olives and chopped parsley. Serve with the rice.

COOK'S TIP
If you cannot locate unsalted peanuts, buy a pack of salted ready-roasted peanuts, wash them under cold running water, then pat dry and grind.

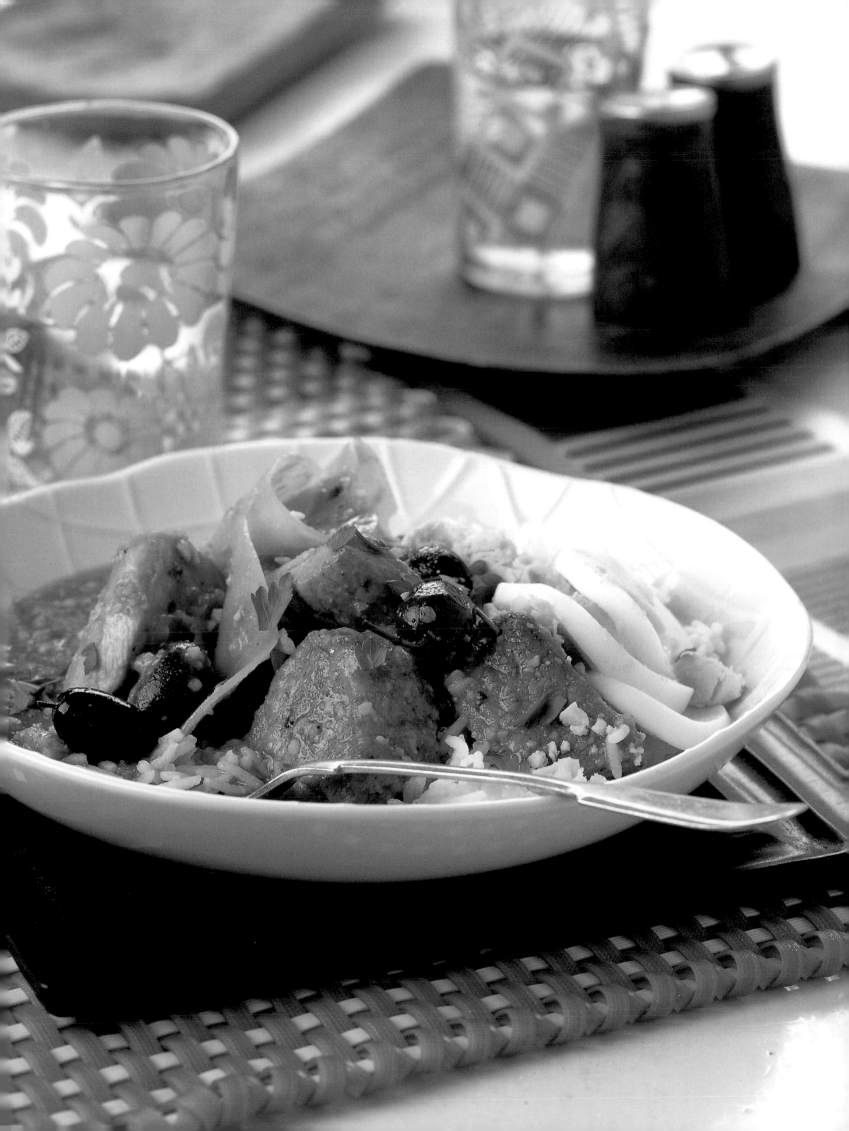

SPICY FRIED CHICKEN

THIS TRADITIONAL CARIBBEAN CRISPY CHICKEN DISH IS SUPERB EATEN HOT OR COLD. SERVED WITH A SALAD OR VEGETABLES, IT MAKES A DELICIOUS LUNCH AND IS ALSO IDEAL FOR PICNICS OR SNACKS.

SERVES FOUR

INGREDIENTS

4 chicken drumsticks
4 chicken thighs
10ml/2 tsp curry powder
2.5ml/½ tsp garlic granules or
 1 garlic clove, crushed
2.5ml/½ tsp ground black pepper
2.5ml/½ tsp paprika
about 300ml/½ pint/1¼ cups milk
oil, for deep frying
50g/2oz/½ cup plain
 (all-purpose) flour
salt
dressed salad leaves, to serve

1 Sprinkle the chicken pieces with curry powder, garlic, pepper, paprika and a little salt. Rub into the chicken, then cover and marinate for at least 2 hours, or overnight in the refrigerator.

2 Preheat the oven to 180°C/350°F/ Gas 4. Cover the chicken with milk and leave to stand for a further 15 minutes.

3 Heat the oil in a large pan or deep-fryer and tip the flour on to a plate. Dip the chicken pieces in flour and add to the oil, taking care not to overcrowd the pan. Fry until golden, but not fully cooked.

4 Remove the chicken pieces with a slotted spoon and place on a baking sheet. Continue until all the chicken pieces have been fried.

5 Place the baking sheet in the oven and bake the chicken for around 30 minutes. Serve hot or cold with dressed salad leaves.

SUNDAY ROAST CHICKEN

MUCH OF THE PREPARATION FOR THIS DISH IS DONE THE NIGHT BEFORE, MAKING IT IDEAL FOR A FAMILY LUNCH. THE CHICKEN IS SUCCULENT AND FULL OF FLAVOUR, WITH A RICH GRAVY.

SERVES SIX

INGREDIENTS

1.6kg/3½lb chicken
5ml/1 tsp paprika
5ml/1 tsp dried thyme
2.5ml/½ tsp dried tarragon
5ml/1 tsp garlic granules or 1 garlic clove, crushed
15ml/1 tbsp lemon juice
30ml/2 tbsp clear honey
45ml/3 tbsp dark rum
melted butter, for basting
300ml/½ pint/1¼ cups chicken stock
lime quarters, to garnish

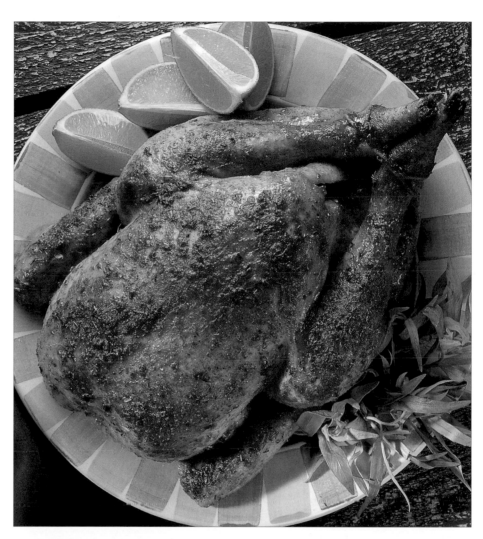

1 Place the chicken in a roasting pan and sprinkle with paprika, thyme, tarragon, garlic and salt and pepper. Rub the mixture all over the chicken, including underneath the skin. Cover with clear film (plastic wrap) and leave to marinate for at least 2 hours or overnight in the refrigerator.

2 Preheat the oven to 190°C/375°F/ Gas 5. Mix the lemon, honey and rum in a bowl. Stir well, then pour over and under the chicken skin, rubbing it in well to ensure the flavours are absorbed.

3 Spoon melted butter all over the chicken, then transfer to the oven and roast for 1½–2 hours, until fully cooked.

VARIATION
Extra herbs and rum can be used to make a richer, tastier gravy, if you like.

4 Transfer the chicken to a serving dish while you make the gravy. Pour the pan juices into a small pan. Add the chicken stock. Simmer for 10 minutes or until the gravy has reduced and thickened slightly. Adjust the seasoning and pour into a serving jug. Garnish the chicken with the lime quarters and serve.

PEANUT CHICKEN

THE RICH SAUCE FOR THIS POPULAR CARIBBEAN DISH IS BEST MADE WITH SMOOTH PEANUT BUTTER, ALTHOUGH IT CAN ALSO BE MADE WITH GROUND PEANUTS.

SERVES FOUR

INGREDIENTS
900g/2lb boneless chicken
 breast portions, skinned and
 cut into cubes
2 garlic cloves, crushed
2.5ml/½ tsp dried thyme
2.5ml/½ tsp ground black pepper
15ml/1 tbsp curry powder
15ml/1 tbsp lemon juice
25g/1oz/2 tbsp butter or margarine
1 onion, chopped
45ml/3 tbsp chopped tomatoes
1 fresh hot chilli, seeded
 and chopped
30ml/2 tbsp smooth peanut butter
450ml/¾ pint/scant 2 cups
 warm water
salt
fresh coriander (cilantro) sprigs,
 to garnish
fried plantain, to serve
okra, to serve

1 Put the chicken in a large bowl and stir in the garlic, thyme, black pepper, curry powder, lemon juice and a little salt. Cover and marinate in a cool place for 3–4 hours.

2 Melt the butter or margarine in a large pan. Add the onion, sauté gently for 5 minutes, then add the seasoned chicken. Fry over a medium heat for 10 minutes, turning frequently, and then stir in the tomatoes and chilli.

3 In a small bowl, blend the peanut butter to a smooth paste with a little of the warm water and stir this paste into the chicken mixture.

4 Gradually stir in the remaining water, then simmer gently for about 30 minutes or until the chicken is fully cooked. Add a little more water if the sauce begins to dry out. Garnish with sprigs of fresh coriander and serve hot with slices of fried plantain and okra.

BREAST OF TURKEY WITH MANGO AND WINE

FRESH TROPICAL MANGO AND WARM CINNAMON COMBINE TO GIVE A REAL TASTE OF THE CARIBBEAN.

SERVES FOUR

INGREDIENTS
4 turkey breast fillets
1 small ripe mango
1 garlic clove, crushed
1.5ml/¼ tsp ground cinnamon
15ml/1 tbsp finely chopped
 fresh parsley
15ml/1 tbsp crushed cream crackers
 (oyster crackers)
40g/1½oz/3 tbsp butter or margarine
1 garlic clove, crushed
6 shallots, sliced
150ml/¼ pint/⅔ cup white wine
salt and ground black pepper
diced fresh mango and chopped fresh
 parsley, to garnish

1 Cut a slit horizontally into each turkey fillet to make a pocket. Using a sharp knife, peel the mango and cut the flesh off the stone (pit). Finely chop enough of the flesh to make 30ml/2 tbsp and roughly dice the remainder.

2 Mix the garlic, cinnamon, parsley, cracker crumbs and finely chopped mango in a bowl. Add 15ml/1 tbsp of the butter or margarine with salt and pepper to taste and mash together.

3 Spoon a little of the mango mixture into each of the pockets in the turkey breast fillets and close, securing with a wooden cocktail stick (toothpick) if necessary. Season with a little extra ground black pepper.

4 Melt the remaining butter in a frying pan and sauté the crushed garlic and sliced shallots for about 5 minutes. Add the turkey fillets and cook for 15 minutes, turning once. Add the wine, cover and simmer for 5–10 minutes, until the turkey is cooked. Add the mango, heat, and serve garnished with parsley.

Peruvian Duck <u>with</u> Rice

Duck is very popular in Peru. In this recipe, the rice is cooked in the same liquid as the duck, so it absorbs the aromatic flavours of the herbs and spices.

SERVES SIX

INGREDIENTS

 2 fresh red chillies, seeded
 4 garlic cloves, roughly chopped
 5 fresh coriander (cilantro) stalks
 5ml/1 tsp ground cumin
 3 duck legs
 salt and ground black pepper
 1 large onion, finely chopped
 650ml/1 pint/2½ cups chicken stock
 250ml/8fl oz/1 cup red wine
 350g/12oz/1¾ cups long grain rice
 115g/4oz/1 cup frozen peas, thawed
 15ml/1 tbsp chopped fresh coriander
 (cilantro), to garnish

VARIATION

If you find duck too fatty for your tastes, try making this dish with chicken legs or rabbit. It will be just as delicious.

1 Put the fresh chillies, garlic cloves, coriander (cilantro) stalks and ground cumin in a blender or food processor and process to a thick paste.

2 Cut the duck legs in half to separate the thigh from the drumstick. Place in a large heavy pan with a tight-fitting lid. Place over a low heat. Season the duck with salt and ground black pepper. Cook until golden brown on all sides, set the duck aside and pour away most of the fat, leaving about 30ml/2 tbsp.

3 Add the onion to the pan and cook gently for 5 minutes. Stir in the chilli and coriander paste and cook for a further 2 minutes. Return the duck to the pan, pour in the stock and wine and bring to the boil. Cover, reduce the heat and simmer for 45 minutes.

4 Stir the rice into the pan, replace the lid and cook for 18–20 minutes. Stir in the peas and remove from the heat. Leave to stand for 5 minutes and serve with a scattering of chopped coriander.

Drunken Duck

This is a lovely dish for a dinner party. The duck and sweet potatoes cook in the red wine and warm spices, creating a rich, almost chocolate-like sauce.

SERVES FOUR

INGREDIENTS

 1 duck, about 2.25kg/5lb
 1 large onion, thinly sliced
 2.5ml/½ tsp crushed dried chillies
 2 garlic cloves, crushed
 1.5ml/¼ tsp ground cloves
 1.5ml/¼ tsp ground allspice
 2.5ml/½ tsp ground cinnamon
 800g/1¾lb sweet potatoes, peeled
 and cut into thick wedges
 250ml/8fl oz/1 cup red wine
 250ml/8fl oz/1 cup chicken stock
 salt and ground black pepper
 polenta or cooked rice, to serve

1 Preheat the oven to 200°C/400°F/ Gas 6. Season the inside and outside of the duck. Place the duck in a large flameproof casserole over a low heat and cook, turning occasionally, until the skin has released some of its fat and turned a rich golden brown. Transfer the duck to a plate.

2 Pour away most of the duck fat from the pan, leaving about 30ml/2 tbsp. Return the casserole to the heat, add the onion and crushed chillies and stir well to coat in the fat, incorporating any sediment on the bottom of the pan.

3 Cook for 5 minutes until the onion is soft and translucent. Stir in the garlic and spices and cook for 1 minute more.

4 Return the duck to the casserole, arrange the sweet potatoes around it and pour in the wine and stock. Bring to the boil and cover. Move the dish to the oven and cook for 1¼–1½ hours.

5 Skim the fat from the top of the sauce and serve with soft polenta or plain rice.

VEGETARIAN DISHES AND SALADS

Although vegetarianism is not widespread in the Caribbean and Latin America, root vegetables, corn and what might be considered exotic fruit and vegetables, such as heart of palm and okra are used extensively. The salads in this chapter can either be enjoyed as a light lunch, as an appetizer or as side dishes.

CORN SOUFFLÉ

LATIN AMERICAN SOUFFLÉS ARE QUITE DIFFERENT FROM THEIR FRENCH COUNTERPARTS. FOR EXAMPLE, THIS ONE WILL RISE ONLY SLIGHTLY, YET THE TEXTURE WILL STILL BE LIGHT AND AIRY.

SERVES SIX

INGREDIENTS
75g/3oz/6 tbsp butter
300g/11oz sweet potato, peeled
 and cubed
300g/11oz pumpkin, peeled
 and cubed
300g/11oz/scant 2 cups frozen corn
 kernels, thawed
3 spring onions (scallions),
 roughly chopped
150g/5oz Cheddar cheese, grated
5 eggs
salt and ground black pepper

1 Preheat the oven to 180°C/350°F/ Gas 4. Using 15g/½oz/1 tbsp of the butter, grease a 28 x 18cm/11 x 7in baking dish. Cook the sweet potato and pumpkin in a pan of lightly salted boiling water for 10 minutes, until tender. Drain and set aside.

2 Put 250g/9oz/1½ cups of corn kernals into a food processor. Add the chopped spring onions and process until smooth. Melt the remaining butter in a pan and stir in the corn and onion mixture. Cook, stirring, over a low heat, for about 1–2 minutes.

3 Add the cheese, stirring until it has melted. Season generously with salt and pepper. Remove from the heat.

4 Separate three of the eggs and add the remaining whole eggs to the bowl containing the yolks. Mix lightly, then stir the yolk mixture into the pan. Add the sweet potato, pumpkin and remaining corn. Whisk the egg whites until stiff, then fold them into the soufflé mixture.

5 Transfer the mixture to the prepared dish and place the dish in a roasting pan. Pour in hot water to come halfway up the side of the dish and bake for 35–40 minutes, until golden. If the soufflé still wobbles when shaken gently, cook for a further 5–10 minutes. Leave to cool, then serve.

COOK'S TIP
For the best results, whisk the egg whites with a pinch of salt in a clean glass or metal bowl. When they are very stiff and no longer slide around the bowl when it is moved, they are ready for use.

LAYERED POTATO BAKE WITH CHEESE

INSPIRED BY THE PERUVIAN SIDE DISH, OCOPA AREQUIPENA, THIS FAMILY-SIZED POTATO CAKE IN A SPICY CHEESE AND WALNUT SAUCE IS SUBSTANTIAL ENOUGH FOR A MAIN COURSE.

4 Add the potatoes to a pan of salted water and cover. Bring to the boil, then simmer for 10 minutes. Drain and refresh under cold water. Drain again and cut into 1cm/½in slices. Shell the eggs and cut them into slices.

5 Preheat the oven to 180°C/350°F/ Gas 4. Grease a 28 x 18cm/11 x 7in baking dish with butter. Arrange a layer of potatoes in the dish and generously spread with the prepared paste. Top with egg slices and a sprinkling of olives and pimiento strips. Continue layering until all the ingredients have been used, finishing with olives and pimientos.

6 Bake for 30 minutes, until the potatoes are very tender. Leave to cool for 5 minutes before serving.

SERVES SIX

INGREDIENTS
 105ml/7 tbsp olive oil
 1 large onion, chopped
 2 garlic cloves, crushed
 5ml/1 tsp crushed dried chillies
 130g/4½oz/generous 1 cup
 walnut halves
 130g/4½oz/generous ½ cup fresh
 cheese, such as ricotta
 105ml/7 tbsp warm water
 3 eggs
 450g/1lb large potatoes, peeled
 butter, for greasing
 65g/2½oz/scant ¾ cup pitted
 black olives
 4 pimientos, cut into strips
 salt

1 Heat 30ml/2 tbsp of the oil in a small pan over a low heat. Add the chopped onion and sauté gently for 5 minutes, until softened. Stir in the garlic and crushed dried chillies and cook for a further 2 minutes.

2 Put the walnuts in a blender or food processor. Blend until smooth, then add the cooked onion mixture, with the cheese and remaining olive oil. Season generously with salt and pour in the warm water. Blend to make a smooth paste. Set aside.

3 Put the eggs in a small pan of cold water. Bring to the boil, then lower the heat to a simmer. Cook for 10 minutes then cool in a bowl of cold water.

HEART OF PALM PIE

THE DELICATE CREAMY FILLING IN THIS PIE CONTRASTS BEAUTIFULLY WITH THE CRUMBLY PASTRY.
THIS RECIPE CAN ALSO BE USED TO MAKE SMALL BRAZILIAN EMPADINHAS — BABY SAVOURY PIES —
NOT TO BE CONFUSED WITH EMPANADAS, THE LITTLE TURNOVERS.

SERVES EIGHT

INGREDIENTS
 500g/1¼lb/5 cups plain
 (all-purpose) flour
 5ml/1 tsp salt
 175g/6oz/¾ cup butter
 75g/3oz/6 tbsp lard or white
 cooking fat
 1 egg yolk
 45ml/3 tbsp cold water
For the filling
 25g/1oz/2 tbsp butter
 1 large onion, finely chopped
 4 garlic cloves, crushed
 15ml/1 tbsp plain (all-purpose) flour
 200ml/7fl oz/scant 1 cup full-fat
 (whole) milk
 2 hard-boiled eggs, roughly chopped
 1 large tomato, peeled, seeded
 and cubed
 1 fresh red chilli, seeded and
 finely chopped
 2 x 400g/14oz cans heart of palm,
 drained and cut into 2cm/¾in
 slices
 15ml/1 tbsp chopped fresh flat
 leaf parsley
 salt and ground black pepper
To glaze
 1 egg yolk
 15ml/1 tbsp water

1 Place the flour, salt, butter and lard or cooking fat in a food processor and process until the mixture resembles fine breadcrumbs. With the motor still running, add the egg yolk and the cold water. As soon as the mixture comes together, transfer to a floured surface. Knead it lightly until smooth. Divide the pastry into two rounds, one slightly larger than the other, wrap both in cling film (plastic wrap) and place in the refrigerator while you make the filling.

2 Melt the butter in a frying pan over a low heat. Stir in the chopped onion and cook for 5 minutes until soft. Add the garlic and cook for a further 2 minutes.

3 Stir the flour into the pan and cook, stirring, for 1 minute. Remove from the heat and slowly pour in the milk, a little at a time, stirring to prevent any lumps from forming.

4 Return to the heat and cook, stirring constantly, for 2 minutes to make a thin white sauce. Remove from the heat and stir in the chopped hard-boiled eggs, cubed tomato, chilli, palm hearts and parsley. Season with salt and pepper.

5 Preheat the oven to 190°C/375°F/ Gas 5. Place a large baking sheet on the central shelf so that it heats up.

6 On a floured surface, roll out the larger piece of pastry and line the base and sides of a 23cm/9in round loose-based quiche pan. The pastry will be very crumbly, so it may tear in a few places. Should this happen, use your fingers to push the pastry together again. There should be no gaps.

7 Add the filling, then roll out the remaining pastry and use to top the pie. Do not worry about any small gaps in the pastry, as they add to the rustic character of the dish.

8 Make the glaze by mixing the egg yolk with the water. Using a pastry brush glaze the pastry, then place the quiche pan on the heated baking sheet and bake the pie for 45 minutes, until the pastry is golden.

9 Leave the pie to cool for 5 minutes on a wire rack before removing it from the pan and putting it on to a large plate. Serve warm or at room temperature.

COOK'S TIP
Cooking the pie on a heated baking sheet ensures that the pastry cooks thoroughly, avoiding a soggy base.

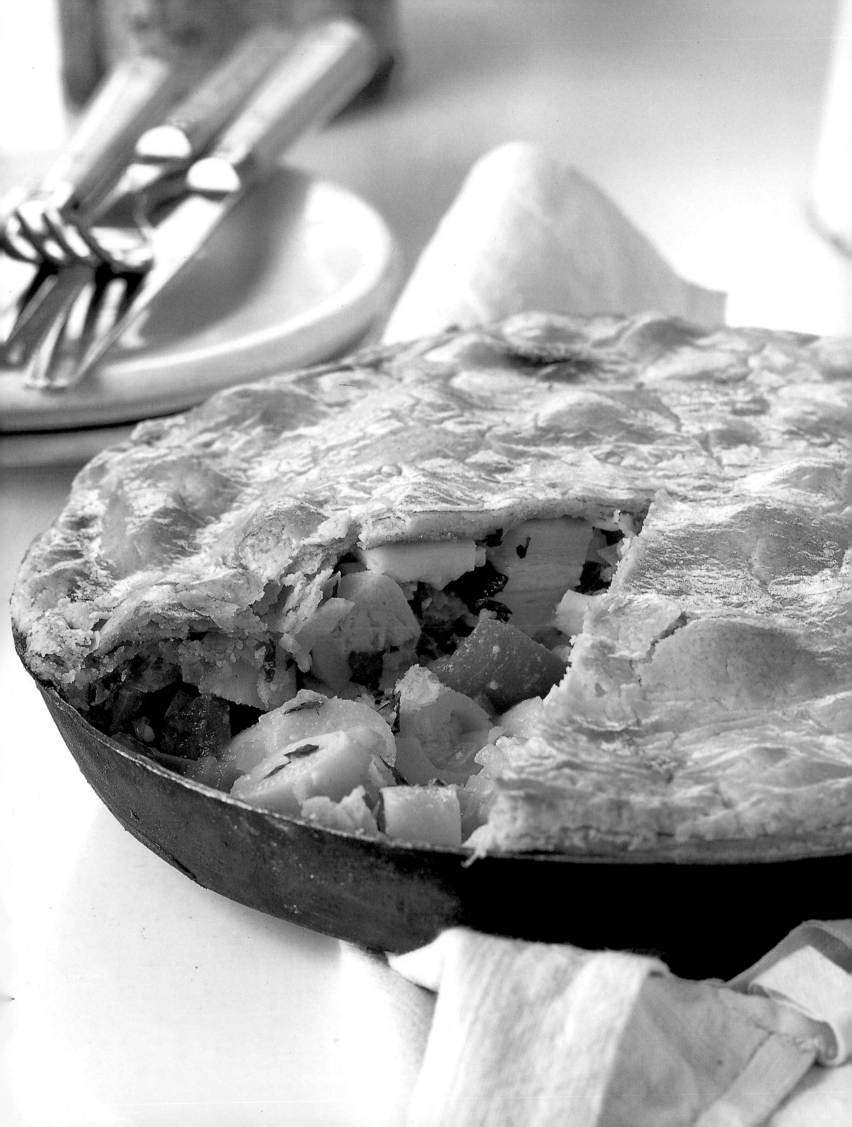

MACARONI CHEESE PIE

MACARONI CHEESE IS A FAVOURITE DISH ON THE ISLAND OF BARBADOS, WHERE IT IS OFTEN SERVED AS AN ACCOMPANIMENT, INSTEAD OF A STARCHY VEGETABLE SUCH AS POTATO. THIS TREATMENT MAKES AN EXCELLENT VEGETARIAN MAIN COURSE.

3 Stir in the mustard and cinnamon, with two-thirds of the cheese. Season to taste. Cook gently, stirring frequently, until the cheese has melted, then remove from the heat and whisk in the egg. Cover closely and set aside.

4 Heat the remaining butter or margarine in a small frying pan and cook the spring onion, chopped tomatoes and corn over a gentle heat for 5–10 minutes.

5 Tip half the cooked macaroni into a greased ovenproof dish. Pour over half the cheese sauce and mix well, then spoon the tomato and corn mixture evenly over the mixture.

6 Tip the remaining macaroni into the pan containing the cheese sauce, stir well and then spread carefully over the tomato and corn mixture.

SERVES FOUR

INGREDIENTS
 225g/8oz/2 cups macaroni
 40g/1½oz/3 tbsp butter or margarine
 20g/¾oz/3 tbsp plain
 (all-purpose) flour
 450ml/¾ pint/scant 2 cups milk
 5ml/1 tsp mild mustard
 2.5ml/½ tsp ground cinnamon
 175g/6oz mature (sharp) Cheddar
 cheese, grated
 1 egg, beaten
 15ml/1 tbsp butter or margarine
 25g/1oz/2 tbsp chopped spring
 onion (scallion)
 40g/1½oz/3 tbsp canned
 chopped tomatoes
 115g/4oz/⅔ cup corn kernels
 salt and ground black pepper
 chopped fresh parsley, to garnish

1 Heat the oven to 180°C/350°F/Gas 4. Cook the macaroni in a pan of salted boiling water for 10 minutes. Drain, rinse under cold water and drain again.

2 Melt 25g/1oz/2 tbsp of the butter in a pan and add the flour. Cook for 1 minute, then add the milk, whisking constantly. Heat until the mixture boils, then simmer gently for 5–10 minutes.

7 Top with the remaining grated cheese. Bake for about 45 minutes, or until the top is golden and bubbly. If possible, leave to stand for 30 minutes before serving, garnished with parsley.

RED BEAN CHILLI

SATISFYING, SPICY AND SIMPLE TO PREPARE, THIS VEGETARIAN CARIBBEAN VERSION OF THE CLASSIC MEXICAN CHILLI IS COMFORT FOOD AT ITS BEST. EXPERIMENT WITH DIFFERENT TYPES OF CHILLI PEPPERS, INCLUDING DRIED VARIETIES LIKE THE MEXICAN CHIPOTLES.

SERVES FOUR

INGREDIENTS

30ml/2 tbsp vegetable oil
1 onion, chopped
400g/14oz can chopped tomatoes
2 garlic cloves, crushed
300ml/½ pint/1¼ cups white wine
about 300ml/½ pint/1¼ cups
 vegetable stock
115g/4oz/1 cup red lentils
2 fresh thyme sprigs or 5ml/1 tsp
 dried thyme
10ml/2 tsp ground cumin
45ml/3 tbsp dark soy sauce
½ fresh hot chilli, seeded and
 finely chopped
5ml/1 tsp ground mixed spice
 (pumpkin pie spice)
15ml/1 tbsp oyster sauce (optional)
225g/8oz can red kidney
 beans, drained
10ml/2 tsp sugar
salt
boiled white rice with corn,
 to serve

1 Heat the oil in a pan and fry the onion for 2–3 minutes, until slightly softened.

2 Add the tomatoes and garlic, cook for about 10 minutes, then stir in the white wine and vegetable stock.

VARIATION
This vegetarian chilli can be adapted to accommodate meat-eaters by substituting either minced (ground) beef or lamb for the lentils.

3 Stir in the lentils, thyme, cumin, soy sauce, chilli, spice and oyster sauce, if using.

COOK'S TIP
Fiery chillies can irritate the skin, so always wash your hands thoroughly after handling them and avoid touching your eyes.

4 Cover and simmer for 40 minutes or until the lentils are cooked, stirring occasionally and adding more water if the lentils begin to dry out.

5 Stir in the kidney beans and sugar and cook for 10 minutes more. Season to taste and serve with boiled white rice and corn.

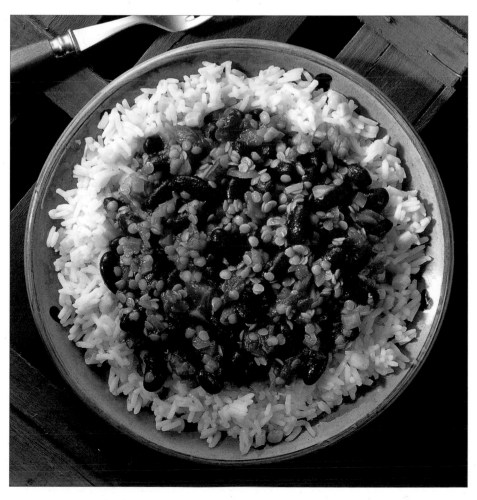

PEPPERS STUFFED <u>WITH</u> BEANS

STUFFED PEPPERS ARE A POPULAR MEXICAN DISH. A SPECIAL VERSION – CHILES EN NOGADA – IS SERVED ON 28 AUGUST TO MARK INDEPENDENCE DAY. THE GREEN PEPPERS ARE SERVED WITH A FRESH WALNUT SAUCE AND POMEGRANATE SEEDS TO REPRESENT THE COLOURS OF THE MEXICAN FLAG.

SERVES SIX

INGREDIENTS
 6 large green (bell) peppers
 2 eggs, separated
 2.5ml/½ tsp salt
 corn oil, for frying
 plain (all-purpose) flour, for dusting
 120ml/4fl oz/½ cup whipping cream
 115g/4oz/1 cup grated Cheddar cheese
 fresh coriander (cilantro) sprigs,
 to garnish
For the beans
 350g/12oz/1¼ cups dried red kidney,
 pinto or black haricot (navy) beans
 2 onions, finely chopped
 2 garlic cloves, finely chopped
 1 bay leaf
 1 or more serrano chillies
 120–150ml/8–10 tbsp corn oil
 2 tomatoes, peeled, seeded and
 chopped
 salt

1 Put the beans into a pan and add cold water to cover. Add half the chopped onion, half the garlic, the bay leaf and the chillies. Bring to the boil and boil vigorously for about 10 minutes. Transfer the beans and liquid into a large flameproof casserole or pan, then cover and cook over a low heat for 30 minutes.

2 Add 15ml/1 tbsp of the corn oil to the beans and cook for a further 30 minutes or until the beans are tender. Add salt to taste and cook for 30 minutes more.

3 Remove the beans from the heat. Heat the remaining oil in a small frying pan and sauté the remaining onion and garlic until soft. Add the tomatoes and cook for a few minutes more. Add the tomato and onion mixture to the beans and set aside.

4 Roast the peppers over a gas flame or under a medium grill (broiler), turning occasionally, until the skins have blackened and blistered. Transfer the peppers to a plastic bag, secure the top and leave for 15 minutes.

5 Meanwhile, heat 30ml/2 tbsp of the oil in a large frying pan. Add about 45ml/3 tbsp of the beans. Mash them with a wooden spoon or potato masher, gradually adding more beans and oil until they have formed a heavy paste.

6 Preheat the oven to 180°C/350°F/ Gas 4. Remove the peppers from the bag. Hold each pepper in turn under cold running water and rub off the skins. Slit the peppers down one side and remove the seeds and ribs. Stuff with the beans.

7 Beat the egg whites in a bowl until they stand in firm peaks. In another bowl, beat the yolks together with the salt. Fold gently into the whites.

8 Pour the corn oil into a large frying pan to a depth of about 2.5cm/1in and heat. Spread out the flour in a shallow bowl or dish.

9 Dip the filled peppers in the flour and then in the egg mix. Fry in batches until golden brown all over. Arrange the peppers in an ovenproof dish. Pour over the cream and sprinkle with the cheese. Bake for 30 minutes or until the topping is golden brown and the peppers are hot. Serve garnished with fresh coriander.

GREEN BEAN <u>AND</u> SWEET RED PEPPER SALAD

THIS FRESH MEXICAN SALAD LOOKS AND TASTES DELICIOUS, AND MAKES THE PERFECT SIDE DISH FOR A SUMMER PICNIC OR BARBECUE. TRY USING A COMBINATION OF GREEN, BLACK AND STUFFED OLIVES AS THE GARNISH, TO ADD COLOUR AND VARIETY.

SERVES FOUR

INGREDIENTS

 350g/12oz/2½ cups cooked green
 beans, quartered
 2 red (bell) peppers, seeded and
 chopped
 2 spring onions (scallions), white and
 green parts, chopped
 1 or more drained pickled serrano
 chillies, well rinsed, seeded
 and chopped
 1 iceberg lettuce, coarsely shredded,
 or mixed salad leaves
 olives, to garnish
For the dressing
 45ml/3 tbsp red wine vinegar
 135ml/9 tbsp olive oil
 salt and ground black pepper

1 Combine the cooked green beans, chopped peppers, chopped spring onions and chillies in a salad bowl.

2 Make the salad dressing. Pour the red wine vinegar into a bowl or jug (pitcher). Add salt and ground black pepper to taste, then gradually whisk in the olive oil until well combined.

3 Pour the salad dressing over the prepared vegetables and toss lightly together to mix and coat thoroughly.

4 Line a large platter with the shredded lettuce leaves and arrange the salad-dressed vegetables on top. Garnish with the olives and serve.

SPICY VEGETABLE CHOW MEIN

CHOW MEIN IS POPULAR IN GUYANA, WHERE IT IS USUALLY MADE WITH SHREDDED CHICKEN OR PRAWNS. THIS VEGETARIAN VERSION CAN BE ADAPTED TO SUIT ALL TASTES.

SERVES THREE

INGREDIENTS
225g/8oz egg noodles
30–45ml/2–3 tbsp vegetable oil
2 garlic cloves, crushed
1 onion, chopped
1 small red (bell) pepper, chopped
1 small green (bell) pepper, chopped
115g/4oz fine green beans, blanched
2 celery sticks, finely chopped
2.5ml/½ tsp five-spice powder
1 vegetable stock cube, crumbled
2.5ml/½ tsp ground black pepper
15ml/1 tbsp soy sauce (optional)
salt

COOK'S TIP
Shredded omelette or sliced hard-boiled eggs are popular garnishes for chow mein.

1 Cook the noodles in a large pan of salted boiling water for 10 minutes or according to the instructions on the packet, then drain and cool.

2 Heat the oil in a wok or large frying pan and stir-fry the garlic, onion, red and green peppers, beans and celery, tossing them together to mix.

3 Add the five-spice powder, vegetable stock cube and ground black pepper, stir well and cook for 5 minutes until the vegetables are just tender but still slightly crunchy.

4 Stir in the noodles and soy sauce, if using. Taste the chow mein and season with salt if required. Serve.

AUBERGINES STUFFED WITH SWEET POTATO

SLICES OF AUBERGINE ROLLED AROUND A SWEET POTATO AND CHEESE FILLING MAKE AN UNUSUAL CARIBBEAN SUPPER DISH, OR TRY THEM AS AN APPETIZER FOR A VEGETARIAN MEAL.

SERVES FOUR

INGREDIENTS
225g/8oz sweet potatoes, peeled
 and quartered
2.5ml/½ tsp chopped fresh thyme
75g/3oz Cheddar cheese, diced
25g/1oz/2 tbsp chopped spring
 onion (scallion)
15ml/1 tbsp each chopped red and
 green (bell) pepper
1 garlic clove, crushed
2 large aubergines (eggplant)
30ml/2 tbsp plain (all-purpose) flour
15ml/1 tbsp spice seasoning
olive oil, for frying
butter, for greasing
2 tomatoes, sliced
salt and ground black pepper
chopped fresh parsley, to garnish

1 Preheat the oven to 180°C/350°F/ Gas 4. Cook the sweet potatoes in a pan of boiling water for 15–20 minutes, until tender, then drain and mash.

2 Add the thyme, cheese, spring onion, peppers and garlic. Mix well and season.

3 Cut each aubergine lengthways into four slices. Mix the flour and spice seasoning on a plate and dust over each aubergine slice.

4 Heat a little oil in a large frying pan and fry each aubergine slice until browned, but not fully cooked. Drain and cool. Spoon a little of the potato mixture into the middle of each aubergine slice and roll up.

5 Butter two large pieces of foil and place four rolls on each. Top with slices of tomato. Wrap up the parcels and bake for 20 minutes. Serve hot, garnished with the parsley.

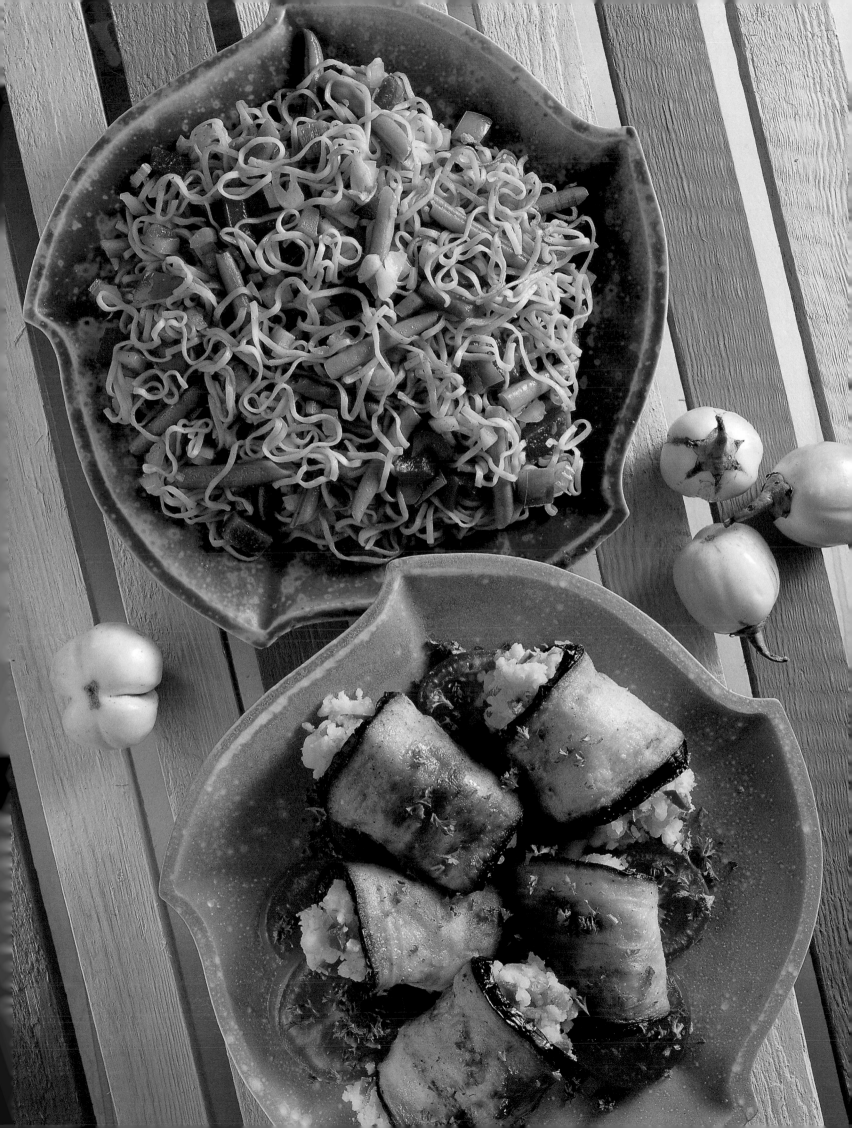

SPINACH PLANTAIN ROUNDS

THIS DELECTABLE WAY OF SERVING PLANTAINS IS POPULAR THROUGHOUT THE CARIBBEAN ISLANDS. THE PLANTAINS MUST BE FAIRLY RIPE, BUT STILL FIRM. THE ROUNDS CAN BE SERVED EITHER HOT OR COLD, WITH A SALAD, OR AS A VEGETABLE ACCOMPANIMENT.

SERVES FOUR

INGREDIENTS
2 large ripe plantains
oil, for frying
15g/½oz/2 tbsp butter or margarine
25g/1oz/2 tbsp finely chopped onion
2 garlic cloves, crushed
450g/1lb fresh spinach, chopped
pinch of freshly grated nutmeg
1 egg, beaten
wholemeal (whole-wheat) flour,
 for dusting
salt and ground black pepper

1 Using a small sharp knife, carefully cut each plantain lengthways into four pieces.

2 Heat a little oil in a large frying pan and fry the pieces of plantain on both sides until golden brown but not fully cooked. Lift out and drain on kitchen paper. Reserve the oil in the pan.

3 Melt the butter or margarine in a separate pan and sauté the onion and garlic for 2–3 minutes, until the onion is soft. Add the spinach and nutmeg, with salt and pepper to taste. Cover and cook for about 5 minutes, until the spinach has wilted. Cool, then tip into a sieve (strainer) and press out any excess moisture.

4 Curl the plantain pieces into rings and secure each ring with half a wooden cocktail stick (toothpick). Pack each ring with a little of the spinach mixture.

5 Place the egg and flour in two separate shallow dishes. Add a little more oil to the frying pan, if necessary, and heat until medium hot. Dip the plantain rings in the egg and then in the flour and fry on both sides for 1–2 minutes until golden brown. Drain on kitchen paper and serve.

PEPPERY BEAN SALAD

THIS PRETTY CARIBBEAN SALAD USES CANNED BEANS FOR SPEED AND CONVENIENCE. THE CONTRAST BETWEEN THE CRISP RADISHES AND PEPPERS AND THE SOFTER TEXTURE OF THE BEANS IS ONE REASON WHY IT WORKS SO WELL. THE TASTY DRESSING PLAYS A PART, TOO.

SERVES SIX

INGREDIENTS
 425g/15oz can kidney beans, drained
 425g/15oz can black-eyed beans
 (peas), drained
 425g/15oz can chickpeas, drained
 ¼ red (bell) pepper
 ¼ green (bell) pepper
 6 radishes
 15ml/1 tbsp chopped spring
 onion (scallion)
 sliced spring onion, to garnish
For the dressing
 5ml/1 tsp ground cumin
 15ml/1 tbsp tomato ketchup
 30ml/2 tbsp olive oil
 15ml/1 tbsp white wine vinegar
 1 garlic clove, crushed
 2.5ml/½ tsp hot pepper sauce
 salt

1 Drain the canned beans and chickpeas into a colander and rinse them thoroughly under cold running water. Shake off the excess water and tip them into a large salad bowl.

2 Core, seed and roughly chop the peppers. Trim the radishes and slice them thinly. Add to the beans with the chopped pepper and spring onion.

COOK'S TIP
For maximum flavour, it is best to allow the ingredients to marinate for at least 3–4 hours.

3 In a small bowl, mix the ground cumin, ketchup, olive oil, white wine vinegar and garlic. Add the hot pepper sauce and a little salt to taste and stir again until thoroughly mixed.

4 Pour the dressing over the salad and mix thoroughly with a fork. Cover with clear film (plastic wrap) and chill for at least 1 hour before serving, garnished with sliced spring onion.

AVOCADO AND GRAPEFRUIT SALAD

THIS IS A LIGHT, REFRESHING LUNCH-TIME SALAD. THE BUTTERY TEXTURE OF THE AVOCADOS,
COMBINES WITH THE TANGINESS OF THE GRAPEFRUIT TO MAKE THE PERFECT SUMMER DISH.
SERVE IT AS A LIGHT MAIN COURSE OR AS AN ACCOMPANIMENT TO BARBECUED MEATS.

SERVES FOUR

INGREDIENTS
 90ml/6 tbsp olive oil
 30ml/2 tbsp white wine vinegar
 1 pink grapefruit
 2 large ripe avocados
 1 cos or romaine lettuce, separated
 into leaves
 salt and ground black pepper

1 Using a balloon whisk or a fork, whisk the olive oil and white wine vinegar together in a large bowl, season to taste with salt and ground black pepper and vigorously whisk again.

VARIATIONS
Try other fruit combinations. Mango and strawberries go well together, as do papaya and limes.

2 Slice the top and bottom off the grapefruit. Peel the fruit by running a small knife all around it, between the peel and flesh. Make sure all the bitter pith is removed. Hold the grapefruit over the bowl containing the dressing and cut carefully between the membranes, so that all the segments fall into the bowl. Squeeze the remaining pulp over the bowl to extract all the juice.

3 Run a knife around the length of the avocados. Twist the sides in opposite directions to separate the halves. Use a large spoon to remove the stone (pit), then peel the halves. Slice the flesh and cover these with the dressing, to stop them from discolouring.

4 Tear the lettuce into pieces and add to the bowl. Toss to coat. Adjust the seasoning to taste and serve.

QUINOA SALAD WITH CITRUS DRESSING

QUINOA IS A TYPE OF GRAIN GROWN IN THE ANDES. A STAPLE FOOD OF THE REGION, IT HAS BEEN CULTIVATED SINCE THE TIME OF THE INCAS AND AZTECS. QUINOA IS PACKED WITH PROTEIN AND IS ALSO GLUTEN FREE, SO IT IS IDEAL FOR VEGETARIANS AND THOSE WHO ARE GLUTEN INTOLERANT.

SERVES SIX

INGREDIENTS
175g/6oz/1 cup quinoa
90ml/6 tbsp olive oil
juice of 2 limes
juice of 1 large orange
2 fresh green chillies, seeded and
 finely chopped
2 garlic cloves, crushed
½ cucumber, peeled
1 large tomato, seeded and cubed
4 spring onions (scallions), sliced
30ml/2 tbsp chopped fresh mint
15ml/1 tbsp chopped fresh flat
 leaf parsley
salt

COOK'S TIP
Quinoa can also be eaten plain as an accompaniment to meat or fish dishes.

1 Put the quinoa in a sieve (strainer), rinse thoroughly under cold water, then tip into a large pan. Pour in cold water to cover and bring to the boil. Lower the heat and simmer for 10–12 minutes, until tender. Drain and leave to cool.

2 Make a dressing by whisking the oil with the citrus juices. Stir in the chillies and garlic and season with salt.

3 Cut the cucumber in half lengthways and, using a teaspoon, scoop out and discard the seeds. Cut into 5mm/¼in slices and add to the cooled quinoa with the tomato, spring onions and herbs. Toss well to combine.

4 Pour the dressing over the salad and toss again until well mixed. Check the seasoning and serve.

OKRA AND TOMATO SALAD

FOR THIS SALAD THE OKRA IS COOKED AS LITTLE AS POSSIBLE, KEEPING IT CRUNCHY. SERVE AS A SIDE SALAD, OR STIR IN SOME BABY SPINACH FOR A MEMORABLE MAIN COURSE.

SERVES FOUR

INGREDIENTS
 60ml/4 tbsp olive oil
 15ml/1 tbsp red wine vinegar
 1 red onion, very thinly sliced
 3 tomatoes, peeled and seeded
 400g/14oz okra
 salt and ground black pepper

1 In a large bowl, whisk together the olive oil and red wine vinegar. Season with salt and ground black pepper. Toss the slices of red onion into the dressing and leave to marinate while you prepare and cook the okra.

2 Trim the tough stalks from the okra, but avoid cutting into the pods, otherwise you will release a sticky liquid. Cook the okra in a pan of lightly salted boiling water for 4–5 minutes, until just tender. Drain and dry on kitchen paper. Leave the small okra whole, but cut any larger ones diagonally in half.

3 Stir the cooked okra into the dressing, mix thoroughly and leave to marinate for about 20–25 minutes.

4 Cut the tomatoes into thin wedges and add them to the bowl. Gently toss them together with the okra. Season to taste with salt and ground black pepper and serve immediately.

TOMATO, HEART OF PALM AND ONION SALAD

THIS SIMPLE SALAD CAN BE ASSEMBLED IN MINUTES. IT IS AN EXCELLENT DISH FOR INTRODUCING ANYONE TO THE DELICATE FLAVOUR OF PALM HEARTS.

SERVES FOUR

INGREDIENTS
 4 beefsteak tomatoes
 1 small onion, thinly sliced
 400g/14oz can hearts of palm
For the dressing
 juice of 1 lime
 10ml/2 tsp Dijon mustard
 60ml/4 tbsp olive oil
 salt and ground black pepper

1 Cut the tomatoes into 1cm/½in slices and arrange on a large serving platter. Sprinkle the thin onion slices over the tomatoes and season to taste with salt and ground black pepper.

3 Make the dressing by whisking the lime juice, mustard and oil in a bowl. Season with salt and ground pepper. Drizzle over the salad and serve.

COOK'S TIP
If the tomatoes are not perfectly ripe, sprinkle the slices with a large pinch of caster (superfine) sugar, to help bring out their sweetness.

2 Drain the canned hearts of palm thoroughly, cut them into 1cm/½in slices and sprinkle the slices over the tomatoes and onions.

VARIATION
If you cannot get hearts of palm, this salad will be just as delicious using artichoke hearts instead.

SPICY POTATO SALAD

ADDING JUST A LITTLE CHILLI GIVES THIS CARIBBEAN SALAD A DELECTABLE SPICY FLAVOUR, WHICH IS BALANCED BY THE CREAMY DRESSING. IT MAKES A GOOD ACCOMPANIMENT TO GRILLED MEAT OR FISH.

SERVES SIX

INGREDIENTS
900g/2lb new potatoes, peeled
2 red (bell) peppers
2 celery sticks
1 shallot
2–3 spring onions (scallions)
1 fresh green chilli
1 garlic clove, crushed
10ml/2 tsp finely chopped fresh
 chives, plus extra to garnish
10ml/2 tsp finely chopped fresh basil
15ml/1 tbsp finely chopped
 fresh parsley
15ml/1 tbsp single (light) cream
15ml/1 tbsp mayonnaise
30ml/2 tbsp salad cream or
 extra mayonnaise
5ml/1 tsp mild mustard
2.5ml/½ tsp sugar

1 Cook the potatoes in a large pan of salted boiling water until tender but still firm. Drain and cool, then cut into 2.5cm/1in cubes and place in a large salad bowl.

COOK'S TIP
It is best to use waxy new potatoes for this dish, as older, floury ones may crumble or break up when boiled.

2 Cut the red peppers in half, cut away and discard the core and seeds, then cut into small pieces. Finely chop the celery, shallot and spring onions. Slice the chilli very thinly, discarding the seeds. Add the vegetables to the potatoes, with the garlic and chopped chives, basil and parsley.

3 Mix the cream, mayonnaise, salad cream or extra mayonnaise, mustard and sugar together in a small bowl. Stir until the mixture is well combined.

4 Pour the dressing over the potato and vegetable salad and stir gently to coat all the ingredients evenly. Garnish the salad with the extra chives just before it is served.

MANGO, TOMATO AND RED ONION SALAD

THIS SALAD MAKES A DELICIOUS APPETIZER AND IS OFTEN EATEN ON THE ISLANDS OF THE CARIBBEAN.
UNDER-RIPE MANGO CONTRIBUTES A SUBTLE SWEETNESS THAT GOES WELL WITH THE TOMATO.

SERVES FOUR

INGREDIENTS

1 firm under-ripe mango
2 large tomatoes or 1 beefsteak
 tomato, sliced
½ cucumber, peeled and
 thinly sliced
½ red onion, sliced into rings
1 garlic clove, crushed
30ml/2 tbsp sunflower or
 vegetable oil
15ml/1 tbsp lemon juice
2.5ml/½ tsp hot pepper sauce
salt and ground black pepper
sugar, to taste
chopped chives, to garnish

1 Using a sharp knife, cut a thick slice or "cheek" from either side of the mango stone. Peel away the skin and slice the flesh into thin strips. Peel the remaining mango, remove the rest of the flesh and slice it thinly.

2 Arrange a layer of tomato slices on a large serving plate or platter. Top with the cucumber slices, followed by the mango, and finish off with the thin slices of red onion.

3 Make the salad dressing. Crush the garlic clove into a small glass bowl. Add the oil, lemon juice, hot pepper sauce, salt, ground black pepper and sugar, if you like. Using a balloon whisk or a fork, whisk these ingredients together until thoroughly mixed.

4 Drizzle the dressing evenly over the salad and garnish with chopped chives. Serve immediately.

COOK'S TIP
Choose the freshest, ripest tomatoes available for the best flavour.

PERUVIAN SALAD

THIS IS A SPECTACULAR-LOOKING SALAD THAT COULD BE SERVED AS A SIDE DISH OR A LIGHT LUNCH. IN PERU, WHITE RICE WOULD BE USED, BUT BROWN RICE ADDS AN INTERESTING TEXTURE AND FLAVOUR.

SERVES FOUR

INGREDIENTS
225g/8oz/2 cups cooked long grain
 brown or white rice
15ml/1 tbsp chopped fresh parsley
1 red (bell) pepper
1 small onion, sliced into rings
olive oil, for sprinkling
115g/4oz green beans, halved
50g/2oz/½ cup baby corn
4 quail's eggs, hard-boiled and halved
25–50g/1–2oz Spanish ham, cut into
 thin slices (optional)
1 small avocado
lemon juice, for sprinkling
75g/3oz mixed salad leaves
15ml/1 tbsp capers
about 10 stuffed olives, halved
For the dressing
1 garlic clove, crushed
60ml/4 tbsp olive oil
45ml/3 tbsp sunflower oil
30ml/2 tbsp lemon juice
45ml/3 tbsp natural (plain) yogurt
2.5ml/½ tsp mustard
2.5ml/½ tsp granulated sugar
salt and ground black pepper

1 Make the dressing by placing all the ingredients in a bowl and whisking with a fork or whisk until smooth. Alternatively, place the ingredients in an empty jam jar, screw the lid on tightly and shake well.

2 Put the cooked rice into a large, glass salad bowl and spoon in half the dressing. Add the chopped parsley, stir well and set aside.

3 Cut the pepper in half, remove the seeds and pith, then place the halves, cut side down, in a small roasting pan. Add the onion rings. Sprinkle the onion with a little olive oil, place the pan under a hot grill (broiler) and cook for 5–6 minutes until the pepper blackens and blisters and the onion turns golden. You may need to stir the onion once or twice so that it cooks evenly.

4 Stir the onion in with the rice. Put the pepper in a plastic bag and knot the bag. When the steam has loosened the skin on the pepper halves and they are cool enough to handle, peel them and cut the flesh into thin strips.

5 Cook the green beans in boiling water for 2 minutes, then add the corn and cook for 1–2 minutes more, until tender. Drain both vegetables, refresh them under cold water, then drain again. Place in a large mixing bowl and add the red pepper strips, quail's eggs and ham, if using.

6 Peel the avocado, remove the stone (pit), and cut the flesh into slices or chunks. Sprinkle with the lemon juice. Put the salad leaves in a separate mixing bowl, add the avocado and mix lightly. Arrange the salad leaves and avocado on top of the rice.

7 Stir about 45ml/3 tbsp of the dressing into the green bean and pepper mixture. Pile this on top of the salad.

8 Sprinkle the capers and stuffed olives on top and serve the salad with the remaining dressing.

PUMPKIN SALAD

RED WINE VINEGAR BRINGS OUT THE SWEETNESS OF THE PUMPKIN. NO SALAD LEAVES ARE USED, JUST PLENTY OF FRESH PARSLEY. EATEN THROUGHOUT LATIN AMERICA, IT IS GREAT FOR A COLD BUFFET.

SERVES FOUR

INGREDIENTS
 1 large red onion, peeled and very
 thinly sliced
 200ml/7fl oz/scant 1 cup olive oil
 60ml/4 tbsp red wine vinegar
 675g/1½lb pumpkin, peeled and cut
 into 4cm/1½in pieces
 40g/1½oz/¾ cup fresh flat leaf
 parsley leaves, chopped
 salt and ground black pepper

VARIATIONS
Try replacing the pumpkin with sweet
potatoes. Wild rocket (arugula) or fresh
coriander (cilantro) can be used instead
of the parsley, if you prefer.

1 Mix the onion, olive oil and vinegar in
a large bowl. Stir well to combine.

2 Put the pumpkin in a large pan of
cold salted water. Bring to the boil, then
lower the heat and simmer gently for
15–20 minutes. Drain.

3 Immediately add the drained pumpkin
to the bowl containing the dressing and
toss lightly with your hands. Leave to
cool. Stir in the chopped parsley, cover
with clear film (plastic wrap) and chill.
Allow the salad to come back to room
temperature before serving.

SIDE DISHES AND SALSAS

Traditionally, Caribbean and Latin American meals consist of a meat, fish or poultry dish accompanied by rice, beans or potatoes and a combination of side dishes, such as rice and peas, or stir-fried kale. Salsa, whether hot and spicy or cool and refreshing, is served as a relish or stirred into dishes.

PLAIN RICE

RICE IS A STAPLE FOOD IN MANY PARTS OF LATIN AMERICA — IT IS EATEN AT MOST MEALS WITH ANYTHING AND EVERYTHING, AND IS OFTEN ACCOMPANIED BY BLACK BEANS.

SERVES FOUR

INGREDIENTS
 200g/7oz/1 cup long grain rice
 30ml/2 tbsp vegetable oil
 2 garlic cloves, crushed
 450ml/¾ pint/scant 2 cups water
 salt

COOK'S TIP
If the rice is still tough after steaming, add a little water, cover and return to the heat for a few minutes. If, instead, the rice is still sticky, return to the heat and cook over a very low heat with the lid off, until the excess moisture has evaporated.

1 Rinse the rice in a large bowl of cold water, then drain thoroughly in a fine sieve (strainer). Pour the oil into a heavy pan that has a tight-fitting lid. Heat gently, then add the garlic and cook, stirring, for 1 minute. Add the rice and stir for 2 minutes, until the grains are lightly toasted.

2 Pour in the water and season with salt. Bring to the boil, cover and lower the heat again to a very gentle simmer. Cook for 18 minutes, without lifting the lid. Remove from the heat and leave the rice to rest, covered, for 5 minutes. Transfer to a serving bowl and fluff up with a fork before taking to the table.

BLACK BEANS

YOU'LL FIND BEANS ON MOST LATIN TABLES, WHATEVER THE DAY OF THE WEEK OR OCCASION. THE RECIPE WILL VARY SLIGHTLY, DEPENDING ON THE COUNTRY, THE AVAILABILITY OF ADDITIONAL INGREDIENTS AND PERSONAL CHOICE. CHILLIES AND OTHER SPICES ARE OFTEN INCLUDED.

SERVES SIX

INGREDIENTS
 450g/1lb/2½ cups black turtle
 beans, soaked overnight in water to
 cover
 115g/4oz smoked streaky (fatty)
 bacon, in one piece
 1 bay leaf
 30ml/2 tbsp vegetable oil
 2 garlic cloves, crushed
 salt

COOK'S TIP
Do not season the beans until they are cooked, or they will become tough. As the sauce thickens, the beans have a tendency to stick, so stir frequently after returning the refried beans to the pan.

1 Drain the beans and put them in a large heavy pan. Cover generously with cold water. Add the bacon and bay leaf and bring to the boil. Skim the surface of the liquid, then lower the heat to a simmer. Cook for at least 1 hour or until the beans are tender, topping up the water if necessary.

2 Heat the oil in a pan over medium heat. Cook the garlic for 2 minutes. Add two ladles of cooked beans and fry for 2–3 minutes, breaking up the beans.

3 Tip the refried beans back into the saucepan and season. Simmer over a very low heat for 10 minutes, then serve.

COCONUT RICE

DELICIOUSLY MOIST AND FULL OF FLAVOUR, COCONUT RICE IS AN EXCELLENT ACCOMPANIMENT FOR ALL SORTS OF MAIN DISHES – THIS COLOMBIAN VERSION IS PARTICULARLY GOOD WITH FISH.

SERVES FOUR

INGREDIENTS

3 x 400ml/14fl oz cans coconut milk
5ml/1 tsp light brown sugar
200g/7oz/1 cup long grain rice
salt
15g/½oz/1 tbsp butter

1 Pour the coconut milk into a large pan that has a tight-fitting lid. Stir in the sugar. Bring to the boil and simmer until the liquid is reduced by half.

2 Add the rice to the pan, season with salt and bring to the boil. Lower the heat to a simmer and cook, stirring often, for 5 minutes.

COOK'S TIP
Canned coconut milk is available sweetened as well as plain – be sure to buy the unsweetened, plain type for savoury cooking.

VARIATION
This tasty side dish is equally good when made with other varieties of rice. Depending on preference, try using short-grain, medium-grain or basmati.

3 Stir the butter into the rice and cover the pan tightly. Simmer gently for a further 15 minutes, then remove from the heat. Leave covered for 5 minutes before transferring to a serving bowl.

TOASTED CASSAVA FLOUR <u>WITH</u> EGG <u>AND</u> BACON

BRAZILIAN COOKS MAKE GREAT USE OF FAROFA, FLAVOURED TOASTED CASSAVA FLOUR, SPRINKLING IT OVER MEAT OR FISH DISHES TO MOP UP THE JUICES. TRY THIS VERSION WITH RICE AND BEANS.

SERVES SIX

INGREDIENTS
 15g/½oz/1 tbsp butter
 90g/3½oz streaky (fatty) bacon,
 in one piece
 2 eggs, lightly beaten
 15ml/1 tbsp water
 225g/8oz/2 cups toasted
 cassava flour
 15ml/1 tbsp chopped fresh parsley
 salt

COOK'S TIP
Cassava flour resembles dried breadcrumbs. Look for it in Latin American or Portuguese stores, where it will be labelled *farinha de mandioca*. It is sometimes called cassava meal.

1 Melt the butter in a pan over a low heat. Dice the bacon and add to the pan. Sauté for 5 minutes, until golden.

2 Mix the eggs with the water in a cup or small bowl. Tip the mixture into the pan and stir until it starts to set. The eggs should have the consistency of soft scrambled eggs – do not overcook them.

3 Add the cassava flour and stir vigorously over the heat for 1 minute, until thoroughly combined. Remove from the heat and stir in the chopped parsley. Season to taste with salt and transfer to a bowl to serve.

RICE <u>AND</u> PEAS

IT MAY SEEM ODD THAT A DISH WITH KIDNEY BEANS AS A PRIMARY INGREDIENT IS CALLED RICE AND PEAS, BUT IN JAMAICA, WHERE IT ORIGINATED, FRESH PIGEON PEAS WERE ORIGINALLY USED. SINCE THE PEAS ARE SEASONAL, THE DISH IS MORE OFTEN MADE WITH DRIED KIDNEY BEANS.

2 Drain the beans and tip them into a large pan with a tight-fitting lid. Pour in enough water to cover the beans. Bring to the boil and boil for 10 minutes, then lower the heat and simmer for 1½ hours or until the beans are tender.

3 Add the thyme, creamed coconut or coconut cream, bay leaves, onion, garlic, allspice and pepper. Season and stir in the measured water.

SERVES SIX

INGREDIENTS
 200g/7oz/1 cup red kidney beans
 2 fresh thyme sprigs
 50g/2oz piece of creamed coconut or
 120ml/4fl oz/½ cup coconut cream
 2 bay leaves
 1 onion, finely chopped
 2 garlic cloves, crushed
 2.5ml/½ tsp ground allspice
 1 red or green (bell) pepper, seeded
 and chopped
 600ml/1 pint/2½ cups water
 450g/1lb/2½ cups long grain rice
 salt and ground black pepper

1 Put the red kidney beans in a large bowl. Pour in enough cold water to cover the beans generously. Cover the bowl and leave the beans to soak overnight.

4 Bring to the boil and add the rice. Stir well, reduce the heat and cover the pan. Simmer for 25–30 minutes, until all the liquid has been absorbed. Serve as an accompaniment to fish, meat or vegetarian dishes.

COU-COU

THIS TASTY OKRA AND MASHED CORN MEAL PUDDING IS A BAJAN NATIONAL DISH. TRADITIONALLY, IT IS SERVED WITH FRESH FLYING FISH COOKED IN A CARIBBEAN GRAVY, BUT IT CAN ALSO BE SERVED WITH ANY OTHER FISH, MEAT OR VEGETABLE STEW.

SERVES FOUR

INGREDIENTS

115g/4oz okra, trimmed and
 roughly chopped
225g/8oz/1½ cups coarse corn meal
600ml/1 pint/2½ cups water or
 coconut milk
25g/1oz/2 tbsp butter
salt and ground black pepper

COOK'S TIP
Adding unsweetened coconut milk instead of water will give your cou-cou a special, rich flavour.

1 Bring a pan of water seasoned with a little salt and pepper to the boil. Add the chopped okra and cook for about 10 minutes. Remove the okra with a slotted spoon and set it aside.

2 Pour away half the liquid from the pan, then return the pan to the heat. Return the okra to the pan, then gradually beat in the corn meal.

3 Cook on a very low heat, beating the mixture vigorously. Gradually add the measured water or coconut milk, beating after each addition to prevent the mixture from sticking to the pan and burning.

4 Cover and cook for about 20 minutes, heating occasionally. The cou-cou is cooked when the corn meal granules are soft. Cover with foil and then a lid to keep the mixture moist and hot until required. Spread with butter before serving.

BUTTERED SPINACH AND RICE

THE LAYER OF FRESH COOKED SPINACH IN THIS POPULAR CARIBBEAN DISH IS SAID TO HAVE BEEN THE RESULT OF A HAPPY ACCIDENT. IT WAS INTENDED FOR A SEPARATE DISH, BUT THE COOK FORGOT TO ADD IT SO SIMPLY USED IT TO TOP THE RICE INSTEAD.

SERVES FOUR

INGREDIENTS
40g/1½oz/3 tbsp butter or margarine
1 onion, finely chopped
2 fresh tomatoes, chopped
450g/1lb/2½ cups basmati
 rice, rinsed
2 garlic cloves, crushed
600ml/1 pint/2½ cups stock or water
350g/12oz fresh spinach, shredded
salt and ground black pepper
2 tomatoes, sliced, to garnish

COOK'S TIP
If you are unable to get fresh spinach, use frozen leaf spinach instead. Thaw and drain approximately 225g/8oz frozen spinach and cook on top of the rice for about 5 minutes. If you prefer, finely shredded spring greens (collards) make a delicious alternative to spinach.

1 Melt 25g/1oz/2 tbsp of butter or margarine in a large pan with a tight-fitting lid. Gently fry the onion for 3–4 minutes, until soft and translucent. Stir in the fresh chopped tomatoes.

2 Add the basmati rice and crushed garlic, gently cook for 5 minutes, then gradually add the stock or water, stirring constantly. Season to taste with plenty of salt and ground black pepper.

3 Cover and simmer gently for 10–15 minutes, until the rice is almost cooked, then reduce the heat to low.

4 Spread the spinach in a thick layer over the rice. Cover the pan and cook over a low heat for 5–8 minutes, until the spinach has wilted. Spoon into a serving dish, dot the remaining butter over the top and garnish with the sliced tomatoes. Serve immediately.

CREAMED SWEET POTATOES

SIMILAR TO TRADITIONAL MASHED POTATOES, THIS CARIBBEAN SPECIALITY USES WHITE SWEET POTATOES INSTEAD OF THE ORANGE VARIETY. THE GRATED NUTMEG ADDS AN EXTRA, IRRESISTIBLE SWEETNESS.

SERVES FOUR

INGREDIENTS
900g/2lb sweet potatoes
50g/2oz/¼ cup butter
45ml/3 tbsp single (light) cream
freshly grated nutmeg
15ml/1 tbsp chopped fresh chives
salt and ground black pepper

COOK'S TIP
If you cannot get white sweet potatoes, white yams make a good substitute, especially poona (Ghanaian) yam.

1 Peel the sweet potatoes under cold running water and place in a bowl of salted water to prevent them from discolouring. Cut them into large chunks and place in a pan of cold water. Cook, covered, for 20–30 minutes until tender.

2 Drain the potatoes and return them to the dry pan. Add the butter, cream, nutmeg, chives and seasoning. Mash with a potato masher and then fluff up with a fork. Serve warm as an accompaniment to a curry or stew.

COLOMBIAN CHEESY POTATOES

TENDER NEW POTATOES TOPPED WITH A CREAMY CHEESE AND TOMATO SAUCE MAKE A DELICIOUS SIDE DISH, WHICH IS GREAT SERVED WITH MEAT, POULTRY OR FISH DISHES.

SERVES SIX

INGREDIENTS

1kg/2¼lb new or salad potatoes
25g/1oz/2 tbsp butter
4 spring onions (scallions), thinly sliced
2 large tomatoes, peeled, seeded and chopped
200ml/7fl oz/scant 1 cup double (heavy) cream
90g/3½oz/1 cup grated mozzarella
salt and ground black pepper

1 Place the potatoes in a large pan of salted cold water. Cover and bring to the boil. Lower the heat and simmer for 18-20 minutes, until tender.

2 Meanwhile, melt the butter in a frying pan over a low heat, add the spring onions and cook gently, stirring occasionally, for 5 minutes, until softened. Stir in the tomatoes and cook for a further 2–3 minutes, stirring occasionally, until the tomatoes break up.

3 Drain the potatoes and put them in a warmed serving bowl. Add the cream to the onion and tomato mixture, bring to the boil, then add the cheese, stirring until it melts. Season with salt and pepper to taste. Pour the hot sauce over the potatoes and serve immediately.

CARIBBEAN POTATO SALAD

COLOURFUL VEGETABLES IN A CREAMY SMOOTH DRESSING MAKE THIS PIQUANT CARIBBEAN SALAD IDEAL TO SERVE ON ITS OWN OR WITH GRILLED OR COLD MEATS.

SERVES SIX

INGREDIENTS
 900g/2lb small waxy or salad
 potatoes
 2 red (bell) peppers, seeded
 and diced
 2 celery sticks, finely chopped
 1 shallot, finely chopped
 2 or 3 spring onions (scallions),
 finely chopped
 1 mild fresh green chilli, seeded and
 finely chopped
 1 garlic clove, crushed
 10ml/2 tsp finely snipped chives
 10ml/2 tsp finely chopped basil
 15ml/1 tbsp finely chopped parsley
 15ml/1 tbsp single (light) cream
 30ml/2 tbsp salad cream
 15ml/1 tbsp mayonnaise
 5ml/1 tsp Dijon mustard
 7.5ml/½ tbsp sugar
 snipped chives, to garnish
 chopped red chilli, to garnish

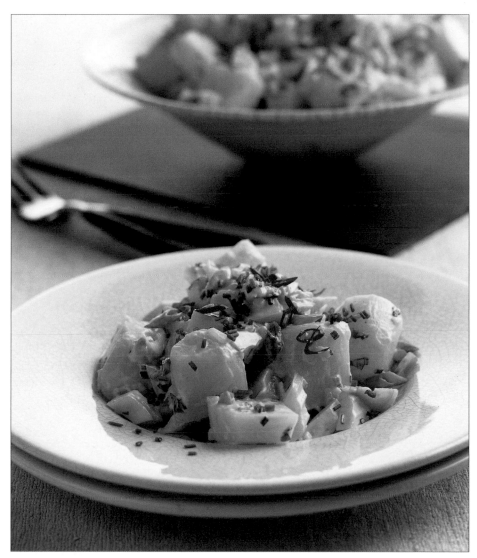

1 Cook the potatoes in a large saucepan of boiling water until tender but still firm. Drain and leave to one side. When cool enough to handle, cut the cooked potatoes into 2.5cm/1in cubes and place in a large salad bowl.

2 Add all the vegetables to the potatoes in the salad bowl, together with the chopped chilli, crushed garlic and all the chopped herbs.

3 Mix together the cream, salad cream, mayonnaise, mustard and sugar in a small bowl. Stir well until the mixture is thoroughly combined and forms a smooth dressing.

4 Pour the dressing over the potato mixture and stir gently to coat evenly. Serve immediately, garnished with the snipped chives and chopped red chilli.

VARIATIONS
Try adding other vegetables to this potato salad, such as tomatoes for flavour or lightly cooked green beans for a tasty crunch. Many traditional potato salads also include a coarsely chopped hard-boiled egg. This would work just as well in this Caribbean version, if you like.

OKRA FRIED RICE

OKRA WAS INTRODUCED TO MAINLAND SOUTH AMERICA AND THE ISLANDS OF THE CARIBBEAN BY THE AFRICAN SLAVES WHO WERE BROUGHT OVER TO WORK THE SUGAR PLANTATIONS. IT BECAME AN IMPORTANT AND MUCH-VALUED INGREDIENT.

SERVES FOUR

INGREDIENTS

15ml/1 tbsp butter or margarine
30ml/2 tbsp vegetable oil
1 garlic clove, crushed
½ red onion, finely chopped
115g/4oz okra, trimmed
30ml/2 tbsp diced green and red (bell) peppers
2.5ml/½ tsp dried thyme
2 fresh green chillies, finely chopped
2.5ml/½ tsp five-spice powder
1 vegetable stock (bouillon) cube
30ml/2 tbsp soy sauce
15ml/1 tbsp chopped fresh coriander (cilantro)
225g/8oz/2 cups cooked long grain white rice
salt and ground black pepper
fresh coriander, to garnish

1 Melt the butter or margarine in the oil in a frying pan or wok. Add the garlic and onion, and cook over a medium heat for 5 minutes, until the onion is soft but not browned.

2 Trim the okra, cutting off the stalks and points, then thinly slice the pods. Add to the pan or wok and cook gently for 6–7 minutes.

3 Add the green and red peppers, thyme, chillies and five-spice powder. Cook for 3 minutes, then crumble in the stock cube.

4 Add the soy sauce, chopped coriander and rice, and heat through, stirring well. Season with salt and pepper. Spoon into a dish and serve hot, garnished with the coriander sprigs.

AUBERGINES WITH GARLIC AND SPRING ONIONS

THIS IS A SUPERB WAY OF SERVING AUBERGINES. IT CAN BE MADE EVEN MORE DELICIOUS BY ADDING LITTLE STRIPS OF SMOKED SALMON AT THE LAST MINUTE AND LETTING THEM JUST WARM THROUGH.

SERVES FOUR

INGREDIENTS

45ml/3 tbsp vegetable oil
2 garlic cloves, crushed
3 tomatoes, peeled and chopped
900g/2lb aubergines (eggplants), cut into chunks
150ml/¼ pint/⅔ cup vegetable stock or water
30ml/2 tbsp soy sauce
60ml/4 tbsp chopped spring onion (scallion)
½ red (bell) pepper, seeded and chopped
1 fresh hot chilli, seeded and chopped
30ml/2 tbsp chopped fresh coriander (cilantro)
salt and ground black pepper

1 Heat the oil in a wok or frying pan and fry the garlic and tomatoes for 3–4 minutes. Add the aubergines and toss with the garlic and tomatoes.

2 Pour in the stock or water and cover the pan. Simmer gently until the aubergines are very soft. Stir in the soy sauce and half of the spring onions.

3 Add the red pepper and chilli to the aubergine. Season with salt and pepper to taste. Mix well.

4 Stir in the coriander and sprinkle with the remaining spring onion. Spoon the aubergine mixture into a dish and serve at once. Alternatively, allow to cool until warm before serving.

CASSAVA WITH A CITRUS SALSA

THIS DISH CONSISTS OF DICED CASSAVA IN A CLASSIC CUBAN SAUCE CALLED MOJO. WHEN THE COOKED CASSAVA IS COATED IN THE SHARP DRESSING, IT BECOMES IMBUED WITH THE DELICIOUS FLAVOURS OF FRESH ORANGE, LIME AND GARLIC.

SERVES FOUR

INGREDIENTS
 800g/1¾lb cassava, peeled and cut
 into chunks
 2 garlic cloves, crushed
 juice of 1 small orange
 juice of 1 lime
 45ml/3 tbsp olive oil
 15ml/1 tbsp chopped fresh flat
 leaf parsley
 salt

VARIATION
Mojo is also delicious with cooked pumpkin and sweet potatoes.

1 Cook the cassava in a large pan of salted boiling water for 20–25 minutes, until beginning to break up. Drain in a colander and then transfer to a large serving plate.

2 Mix the garlic, orange juice and lime juice in a bowl. Whisk in the oil, season with salt and stir in the parsley. Drizzle the dressing over the cooked cassava and serve.

STIR-FRIED SPRING GREENS

Spring greens are very popular in Brazil. They are eaten with meat and are the traditional accompaniment to feijoada. Garlic enhances their slightly bitter flavour, and they taste even better when cooked with bacon and chillies.

SERVES SIX

INGREDIENTS
 450g/1lb spring (collard) greens
 15ml/1 tbsp vegetable oil
 150g/5oz smoked streaky (fatty)
 bacon, in one piece
 2 garlic cloves, crushed
 1.5ml/¼ tsp crushed dried chillies
 salt

VARIATIONS
• If you cannot find spring greens, use curly kale or Savoy cabbage instead. These may not be as vibrant in colour, but the taste will be very similar.
• Cubed pancetta can be used instead of the bacon.

1 Cut off the hard stalks from the spring greens. Lay the leaves flat on top of each other and roll into a tight cigar-shape. Slice very thinly, using a sharp knife.

2 Heat the oil in a large frying pan over a low heat. Cut the bacon into small cubes and sauté in the oil for 5 minutes, or until golden brown. Lift the cubes out of the pan with a slotted spoon and drain on kitchen paper.

3 Increase the heat, add the crushed garlic and dried chillies to the oil remaining in the pan, and stir-fry for about 30 seconds.

4 Add the shredded spring greens and toss over the heat until just tender. Season to taste with salt, stir in the cooked bacon cubes and serve immediately.

CORN STICKS

THIS TRADITIONAL CARIBBEAN RECIPE PRODUCES PERFECT CORN BREAD IN A LOAF TIN. ALTERNATIVELY, IF YOU CAN FIND THE MOULDS, IT CAN BE USED TO MAKE ATTRACTIVE CORN STICKS.

MAKES FORTY

INGREDIENTS
225g/8oz/2 cups plain
 (all-purpose) flour
225g/8oz/2 cups fine corn meal
50ml/10 tsp bicarbonate of soda
 (baking soda)
2.5ml/½ tsp salt
60ml/4 tbsp demerara (raw) sugar
450ml/¾ pint/scant 2 cups milk
2 eggs
50g/2oz/4 tbsp butter or margarine

COOK'S TIP
Because there is such a lot of bicarbonate of soda used in this recipe, the corn meal mixture begins to rise as soon as the liquid is added, so make sure you bake straight away.

1 Preheat the oven to 190°C/375°F/ Gas 5 and grease either corn bread moulds, if you can find them, or a 900g/2lb loaf tin (pan).

2 Sift together the flour, corn meal, bicarbonate of soda, salt and sugar into a large bowl. In a separate bowl, whisk the milk and eggs, then stir into the flour mixture.

3 Melt the butter or margarine in a small pan and stir gradually into the corn meal mixture.

4 Carefully spoon the thick mixture into the moulds or tin. Bake the corn sticks for about 15 minutes. If using a loaf tin, you will need to bake for around 30–35 minutes, until the corn bread is golden and hollow sounding when tapped.

FRIED YELLOW PLANTAINS

WHEN PLANTAINS ARE YELLOW IT IS A SIGN THAT THEY ARE RIPE. THEY ARE OFTEN ADDED TO MEAT, FISH OR VEGETARIAN DISHES IN THE CARIBBEAN, OR SERVED AS A TASTY ACCOMPANIMENT.

SERVES FOUR

INGREDIENTS
2 yellow plantains
oil, for shallow frying
finely chopped chives, to garnish

1 Using a small sharp knife, trim the tops and tails of each plantain, then cut them in half.

2 Slit the skin along the natural ridges of each piece of plantain, and ease up using the tip of your thumb.

3 Peel away the entire plantain skin and discard. Thinly slice the plantains lengthways.

4 Heat a little oil in a frying pan and fry the plantain slices for 2–3 minutes on each side, until they are golden brown.

5 When the plantains are brown and crisp, drain on kitchen paper and serve sprinkled with chives.

COOK'S TIP
For the sweetest flavour, these gently fried plantain slices should be made using the ripest plantains available. The darker the skin, the riper the plantains are.

ARGENTINIAN BARBECUE SALSA

This combination of finely chopped vegetables and tart dressing is the perfect partner for all types of grilled meats, so it is not surprising to find bowls of fresh salsa creolla on the table whenever a barbecue or asado is being pepared. Similar barbecue salsas can also be found in Brazil, Uruguay and Paraguay.

SERVES SIX

INGREDIENTS
 2 fresh green chillies, seeded and
 very finely chopped
 1 garlic clove, crushed
 1 onion, very finely chopped
 1 large tomato, peeled, seeded and
 very finely chopped
 15ml/1 tbsp finely chopped fresh flat
 leaf parsley
 salt
 105ml/7 tbsp olive oil
 30ml/2 tbsp red wine vinegar

1 Combine the chopped chillies, crushed garlic, onion and tomato in a bowl. Stir in the chopped parsley and season to taste with salt.

2 Pour in the oil and vinegar and stir well. Allow the flavours to mingle for at least 1 hour before serving with grilled (broiled) or barbecued meats.

HOT CHILLI SALSA

Contrary to popular belief, Latin food is not intrinsically spicy. It is the hot chilli oils and salsas, added to dishes at the table, that fan the flames.

MAKES ONE SMALL JAR

INGREDIENTS
 10 fresh red chillies, roughly
 chopped
 1 large tomato, peeled and quartered
 2 garlic cloves
 juice of 1 lime
 60ml/4 tbsp olive oil
 salt

COOK'S TIP
Treat this salsa with extreme caution. Just the oil is enough to add serious heat to a dish, especially if the salsa has had a chance to age. A couple of drops of the oil are enough for most people!

1 Place the chillies, tomato and garlic in a food processor, then process the mixture until smooth.

2 Scrape the mixture into a small frying pan and place over a medium heat. Season with salt and cook, stirring, for 10 minutes, until the sauce is thick.

3 Remove from the heat and stir in the freshly squeezed lime juice. Transfer to a sterilized airtight jar and top with a thin film of olive oil before tightly screwing on the lid. As long as the sauce always has a film of oil on top, it will keep for ages at room temperature or in the refrigerator.

TAMARILLO SAUCE

THIS UNUSUAL PERUVIAN SAUCE MAKES A DELICIOUS DIP FOR SERVING WITH AREPAS — THOSE IRRESISTIBLE CORN MEAL GRIDDLE CAKES THAT ARE FREQUENTLY FILLED WITH SOFT WHITE CHEESE. ALTERNATIVELY, ITS DELICIOUS, HOT AND SPICY FLAVOUR CONTRASTS BEAUTIFULLY WITH THE NATURAL SWEETNESS OF FRESH GRILLED SEAFOOD.

SERVES FOUR

INGREDIENTS
 450g/1lb fresh tamarillos
 2.5ml/½ tsp ground ginger
 1.5ml/¼ tsp ground cinnamon
 1 fresh red chilli, seeded
 and chopped
 1 small onion, finely chopped
 5ml/1 tsp light brown sugar
 105ml/7 tbsp water
 30ml/2 tbsp olive oil
 salt

COOK'S TIP
If tamarillos are heavier than they look, they will be ripe and juicy.

1 Place the whole fresh tamarillos in a large pan of boiling water for about 30 seconds. Drain, refresh in cold water, then carefully remove the peel with a sharp knife and discard it. Roughly chop the tamarillos.

2 Place the ginger and cinnamon in a small heavy pan over a low heat. Stir the mixture for 30 seconds, until the spices release their aroma. Add the chopped tamarillos, chilli, onion, sugar and water.

3 Bring to the boil, lower the heat, cover and simmer for 20 minutes. Remove the lid and continue cooking until the sauce thickens. Stir in the oil and season with salt. Serve with grilled (broiled) seafood.

AVOCADO SALSA

*THERE ARE MANY VERSIONS OF AVOCADO SALSA, INCLUDING THE CLASSIC MEXICAN GUACAMOLE.
HERE THE INGREDIENTS ARE CHOPPED AND DICED, RATHER THAN MASHED, WHICH ADDS TEXTURE AND
ALLOWS ALL THE DELICIOUS FLAVOURS TO REMAIN DISTINCT. PREPARE THIS SALSA AT THE LAST
MINUTE TO AVOID THE AVOCADOS DISCOLOURING.*

SERVES FOUR

INGREDIENTS

1 large ripe avocado
juice of 1 lime
15ml/1 tbsp red wine vinegar
1 tomato, peeled, seeded
 and chopped
1 green (bell) pepper, seeded
 and diced
1 red onion, finely chopped
1 fresh red chilli, seeded and
 finely chopped
45ml/3 tbsp olive oil
salt

1 Prepare the avocado. Run a sharp
knife around the whole length of the
avocado, cutting right in until you
touch the stone (pit). Twist the two
sides of the split avocado in opposite
directions to separate the two halves.

2 Use a large spoon to remove the large
stone, then peel both halves of the
avocado. Dice the flesh and put it in a
bowl with the lime juice.

3 Stir the vinegar, tomato, pepper, onion
and chilli into the avocado and lime
juice mixture. Gradually add the olive
oil, mixing well.

COOK'S TIP
If there is any delay before serving this
salsa, add the avocado stone to the
mixture. This will prevent any
discoloration. Remember to remove the
stone before serving though.

4 Season to taste with salt and
serve with tortilla chips, or as an
accompaniment to meat, fish or poultry.

BREADS AND CAKES

European-style breads and cakes are available in most parts of the Caribbean and Latin America, but the recipes have evolved to reflect regional traditions, with corn meal often being used instead of wheat flour. The breads make good accompaniments while the cakes are often eaten for breakfast or as snacks.

CORN TORTILLAS

*TO MAKE THESE DELICIOUS MEXICAN SPECIALITIES, MAKE SURE YOU HAVE READY A TORTILLA PRESS
AND A SMALL PLASTIC BAG, CUT OPEN AND HALVED CROSSWAYS.*

MAKES ABOUT FOURTEEN

INGREDIENTS
 275g/10oz/2½ cups *masa harina*
 250–350ml/8–12fl oz/
 1–1½ cups water

COOK'S TIP
Tortillas are very easy to make but it is
important to get the dough texture right.
If it is too dry and crumbly, add a little
water; if it is too wet, add more *masa
harina*. If you misjudge the pressure
needed for flattening the ball of dough to
a neat circle on the tortilla press, just
scrap it off, re-roll it and try again.

1 Put the *masa harina* into a bowl and
stir in 250ml/8fl oz/1 cup of the water,
mixing it to a soft dough that just holds
together. If it is too dry, add a little more
water. Cover the bowl with a cloth and
set aside for 15 minutes.

2 Preheat the oven to 150ºC/300ºF/
Gas 2. Open the tortilla press and line
both sides with the prepared plastic
sheets. Preheat a griddle until hot.

3 Knead the dough lightly and shape
into 14 balls. Put a ball on the press
and bring the top down firmly to flatten
the dough out into a round.

4 Open the press. Peel off the top layer
of plastic and, using the bottom layer,
lift the tortilla out of the press. Peel off
the bottom plastic and flip the tortilla on
to the hot griddle.

5 Cook for 1 minute and turn over and
cook for a minute more. Wrap in foil and
keep warm. Repeat for the other tortillas.

FLOUR TORTILLAS

THESE ARE MORE COMMON THAN CORN TORTILLAS IN THE NORTH OF MEXICO, FROM SONORA TO CHIHUAHUA, WHERE WHEAT IS GROWN. FOR THE BEST RESULTS, USE A GOOD QUALITY PLAIN FLOUR.

MAKES ABOUT FOURTEEN

INGREDIENTS
 225g/8oz/2 cups plain
 (all-purpose) flour
 5ml/1 tsp salt
 15ml/1 tbsp lard or vegetable fat
 120ml/4fl oz/½ cup water

1 Sift the flour and salt into a large mixing bowl. Gradually rub in the lard or vegetable fat using your fingertips until the mixture resembles coarse breadcrumbs.

2 Gradually add the water and mix to a soft dough. Knead lightly, form into a ball, cover with a cloth and leave to rest for 15 minutes.

COOK'S TIP
Make flour tortillas whenever *masa harina* is difficult to find. To keep them soft and pliable, make sure they are kept warm until ready to serve, and eat as soon as possible.

3 Carefully divide the dough into about 14 portions and form these portions into small balls. One by one, roll out each ball of dough on a lightly floured wooden board to a round measuring about 15cm/6in. Trim the rounds if necessary.

4 Heat an ungreased griddle or frying pan over a moderate heat. Cook the tortillas for about 1½–2 minutes on each side. Turn over with a palette knife or metal spatula when the bottom begins to brown. Wrap in foil and keep warm in the oven until ready to serve.

DHAL PURI

KNOWN AS ROTI WHEN FILLED AND FOLDED, THESE TASTY FLAT BREADS CAN ALSO BE MADE WITH
WHITE FLOUR. A TRADITIONAL CARIBBEAN FAVOURITE, DHAL PURI ARE DELICIOUS WITH MEAT, FISH
OR VEGETABLE DISHES AND ARE IDEAL FOR MOPPING UP LEFTOVER SAUCES.

MAKES ABOUT FIFTEEN

INGREDIENTS
 450g/1lb/4 cups self-raising
 (self-rising) flour
 115g/4oz/1 cup wholemeal
 (whole-wheat) flour
 350ml/12fl oz/1½ cups cold water
 30ml/2 tbsp oil, plus extra for frying
 salt, to taste
For the filling
 350g/12oz/1½ cups yellow split peas
 15ml/1 tbsp ground cumin
 2 garlic cloves, crushed

1 Sift the dry ingredients into a bowl, then tip in the grain remaining in the sieve. Add the water a little at a time, and knead gently until a soft dough forms. Continue kneading until supple, but do not over-work the dough.

2 Add the oil to the dough and continue to knead it until it is completely smooth. Put the dough in a polythene bag or wrap in clear film (plastic wrap). Place in a cool room or in the refrigerator and leave to rest for at least 30 minutes, or overnight if possible.

3 To make the filling, put the split peas in a large pan, pour over water to cover and cook for about 10–15 minutes, until half cooked – they should be tender on the outside, but still firm in the middle. Allow the water to evaporate during cooking, until the pan is almost dry, but add a little extra water to prevent burning, if necessary.

4 Spread out the peas on a tray. When cool, grind to a paste, using a mortar and pestle or food processor. Mix with the cumin and garlic.

5 Divide the dough into about 15 balls, Slightly flatten each ball, put about 15ml/1 tbsp of the split pea mixture into the centre and fold over the edges.

6 Dust a rolling pin and a board with flour and roll out the dhal puri, taking care not to overstretch the dough, until they are about 18cm/7in in diameter.

7 Heat a little oil in a frying pan. Cook the dhal puris for about 3 minutes on each side until light brown. Serve as soon as the last one is cooked.

FRIED DUMPLINS

IN THE CARIBBEAN AND GUYANA THESE FRIED DUMPLINS ARE SIMPLY CALLED "BAKES". THEY ARE USUALLY SERVED WITH SALT FISH OR FRIED FISH, BUT CAN BE EATEN QUITE SIMPLY WITH BUTTER AND JAM OR CHEESE, WHICH CHILDREN ESPECIALLY LOVE.

MAKES ABOUT TEN

INGREDIENTS
 450g/1lb/4 cups self-raising
 (self-rising) flour
 10ml/2 tsp sugar
 2.5ml/½ tsp salt
 300ml/½ pint/1¼ cups milk
 oil, for frying

COOK'S TIP
Mix and knead the dough gently to avoid overworking it and making it tough. A quite light touch is all that is needed to make the dough smooth.

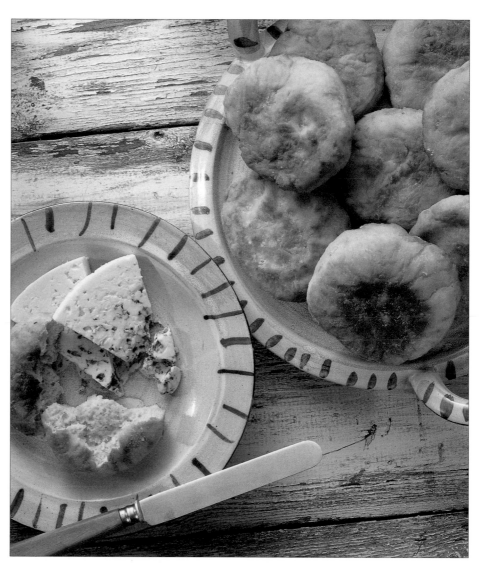

1 Sift the flour, sugar and salt into a large bowl, add the milk and mix and knead until a smooth dough forms.

2 Divide the dough into ten balls, kneading each ball with floured hands. Press the balls gently to flatten them into 7.5cm/3in rounds.

3 Heat a little oil in a non-stick frying pan over medium heat. Place half the dumplins in the pan, reduce the heat to low and fry for about 15 minutes, until they are golden brown, turning once.

4 Stand the dumplins on their sides for a few minutes to brown the edges, before removing them from the pan and draining thoroughly on kitchen paper. Serve immediately, while still warm.

CORN GRIDDLE CAKES

KNOWN AS AREPAS, THESE ARE A STAPLE BREAD IN SEVERAL LATIN AMERICAN COUNTRIES, PARTICULARLY COLOMBIA AND VENEZUELA. EAT THEM FILLED WITH SOFT WHITE CHEESE, AS HERE, OR PLAIN AS AN ACCOMPANIMENT. WITH THEIR CRISP CRUST AND CHEWY INTERIOR, AREPAS CAN BECOME STALE VERY QUICKLY, SO ARE BEST EATEN PIPING HOT.

MAKES FIFTEEN

INGREDIENTS

200g/7oz/1¾ cups *masarepa* (or
 masa harina)
2.5ml/½ tsp salt
300ml/½ pint/1¼ cups water
15ml/1 tbsp oil
200g/7oz fresh white cheese, such
 as queso fresco or mozzarella,
 roughly chopped

1 Combine the *masarepa* or *masa harina* and salt in a bowl. Gradually stir in the water to make a soft dough, then set aside for about 20 minutes.

2 Divide the dough into 15 equal-sized balls, then, using your fingers, flatten each ball into a circle, approximately 1cm/½in thick.

3 Heat 5ml/1 tsp of the oil in a large, heavy frying pan over a medium heat. Using a piece of kitchen paper, gently wipe the surface of the frying pan, leaving it just lightly greased.

4 Place five of the *arepas* in the frying pan. Cook for about 4 minutes, then flip over and cook for a further 4 minutes. The *arepas* should be lightly blistered on both sides.

5 Open the *arepas* and fill each with a few small pieces of fresh white cheese. Return to the pan to cook until the cheese begins to melt. Remove from the heat and keep warm.

6 Cook the remaining ten *arepas* in the same way, oiling the pan and wiping with kitchen paper in-between batches, to ensure it is always lightly greased. Serve the arepas while still warm so that the melted cheese is soft and runny.

COOK'S TIP
Masarepa is a flour made with the white corn grown in the Andes. Look for it in Latin American food stores. If not available, replace it with *masa harina*, the flour used to make tamales. The result will not be quite as delicate, but the *arepas* will be equally delicious.

VARIATION
Instead of cheese, try a delicious beef filling. Simply fry some minced (ground) beef in oil with ½ chopped onion, 1 small red chilli, finely chopped, 1 crushed garlic clove, ground black pepper and fresh thyme. When thoroughly cooked, stuff the mixture inside the *arepas*.

PARAGUAYAN CORN BREAD

THIS MOIST CORN MEAL BREAD IS SO RICH AND FLAVOURSOME THAT IT CAN EASILY BE EATEN ON ITS OWN. IT TASTES BEST WHEN EATEN WARM.

2 Pour in the milk and stir until heated, without allowing it to boil. Still stirring, add the corn meal in a steady stream. Continue to stir until the mixture is smooth.

3 Remove from the heat and stir in the cheese and remaining butter. When both have melted, season with salt and ground pepper.

4 Whisk the egg whites in a bowl until they hold their shape. Stir the egg yolks into the corn meal mixture, then gently fold in the egg whites.

5 Tip the mixture into the prepared loaf tin. Bake for 35–40 minutes, or until a skewer comes out clean when inserted in the bread. Turn out onto a wire rack to cool a little. Cut into slices and serve.

MAKES ONE LOAF

INGREDIENTS
 75g/3oz/6 tbsp butter
 1 large onion, finely chopped
 400ml/14fl oz/1⅔ cups full-fat
 (whole) milk
 225g/8oz/2 cups corn meal
 175g/6oz mozzarella cheese,
 roughly grated
 2 large eggs, separated
 salt and ground black pepper

1 Preheat the oven to 200°C/400°F/ Gas 6. Using 15g/½oz/1 tbsp of the butter, grease a loaf tin (pan). Melt a further 25g/1oz/2 tbsp of the butter in a large pan over a low heat and fry the onions for 5 minutes until softened.

COOK'S TIP
If you can't get hold of corn meal, use instant polenta instead.

MEXICAN "BREAD OF THE DEAD"

A CELEBRATORY LOAF MADE FOR ALL SOULS' DAY, WHEN MEXICANS PAY THEIR RESPECTS TO THE SOULS OF THE DEAD, IT IS TRADITIONALLY DECORATED WITH A DOUGH SKULL, BONES AND TEARS.

MAKES ONE LARGE LOAF

INGREDIENTS
3 star anise
90ml/6 tbsp cold water
675g/1½lb/6 cups unbleached
 white bread flour, plus extra
 for sprinkling
5ml/1 tsp salt
115g/4oz/½ cup caster
 (superfine) sugar
25g/1oz fresh yeast
175ml/6fl oz/¾ cup lukewarm water
3 eggs
60ml/4 tbsp orange-flavoured liqueur
115g/4oz/½ cup butter, melted
grated rind of 1 orange
icing (confectioners') sugar, for dusting

1 Grease a 26cm/10½in fluted round cake tin (pan). Place the star anise in a small pan and add the cold water. Bring to the boil and boil for 3–4 minutes, or until the liquid has reduced to 45ml/ 3 tbsp. Discard the star anise and leave the liquid to cool.

2 Sift the flour and salt together into a large bowl. Stir in the sugar and make a well in the centre.

3 In a jug (pitcher), dissolve the yeast in the lukewarm water. Pour into the centre of the flour and mix in, using your fingers, until a smooth, thick batter forms. Sprinkle over a little more flour, cover with clear film (plastic wrap) and leave the batter in a warm place for 30 minutes, or until the mixture starts to bubble.

4 Beat the eggs, the reserved liquid flavoured with star anise, orange liqueur and melted butter together. Gradually incorporate into the flour mixture to form a smooth dough.

5 Turn out the dough on to a lightly floured surface and gently knead in the orange rind. Knead for 5–6 minutes until smooth and elastic.

6 Shape the dough into a 26cm/10½in round and place in the prepared tin. Cover with lightly oiled clear film and leave to rise, in a warm place, for 2–3 hours, or until doubled in bulk.

7 Meanwhile, preheat the oven to 190°C/375°F/Gas 5. Bake the loaf for 45–50 minutes, or until golden. Turn out on to a wire rack to cool. Dust with icing sugar to serve.

VARIATION
Top the baked bread with orange-flavoured icing. Blend 60g/2oz/½ cup icing sugar and 15–30ml/1–2 tbsp orange liqueur. Pour the icing over the bread and let it dribble down the sides.

CARIBBEAN FRUIT AND RUM CAKE

THIS POPULAR CAKE IS EATEN AT CHRISTMAS, WEDDINGS AND OTHER SPECIAL OCCASIONS. IT IS KNOWN AS BLACK CAKE, BECAUSE THE TRADITIONAL RECIPE USES BURNT SUGAR.

MAKES ONE CAKE

INGREDIENTS
 450g/1lb/2 cups currants
 450g/1lb/3 cups raisins
 225g/8oz/1 cup pitted prunes
 115g/4oz/⅔ cup mixed (candied) peel
 5ml/1 tsp ground mixed spice
 (pumpkin pie spice)
 90ml/6 tbsp rum, plus more
 if needed
 300ml/½ pint/1¼ cups sherry, plus
 more if needed
 400g/14oz/1¾ cups soft dark
 brown sugar
 450g/1lb/4 cups self-raising
 (self-rising) flour
 450g/1lb/2 cups butter, softened
 10 eggs, beaten
 5ml/1 tsp natural vanilla
 essence (extract)

1 Wash the currants, raisins, prunes and mixed peel, then drain and pat dry. Place in a food processor and process until roughly chopped. Transfer to a large, bowl and add the the mixed spice, rum and sherry. Stir in 115g/4oz/½ cup of sugar. Mix well, then cover with a lid and set aside for anything from 2 weeks to 3 months – the longer it is left, the better the flavour will be.

2 Stir the fruit mixture occasionally, adding more alcohol, if you like, before replacing the cover.

3 Preheat the oven to 160°C/325°F/ Gas 3. Grease a 25cm/10in round cake tin (pan) and line with a double layer of greaseproof (waxed) paper or baking parchment.

4 Sift the flour into a bowl, and set it aside. In a large mixing bowl, cream the butter with the remaining sugar. Beat in the eggs until the mixture is smooth and creamy, adding a little of the flour if the mixture starts to curdle.

5 Add the fruit mixture, then gradually stir in the remaining flour and the vanilla essence. Mix well, adding 15–30ml/1–2 tbsp more sherry if the mixture is too stiff; it should just fall off the back of the spoon, but should not be too runny.

6 Spoon the mixture into the prepared pan, cover loosely with foil and bake for about 2½ hours, until the cake is firm and springy. Leave to cool in the pan overnight. Unless serving immediately, sprinkle the cake with more rum and wrap in greaseproof paper and foil to keep it moist.

COOK'S TIP
Although it is usual to roughly chop the dried fruits, they can be marinated whole if you prefer. If there is no time to marinate the fruit, simmer it gently in the alcohol mixture for about 30 minutes, and leave overnight.

APPLE AND CINNAMON CRUMBLE CAKE

THIS SCRUMPTIOUS CAKE, POPULAR IN THE CARIBBEAN, HAS LAYERS OF SPICY FRUIT AND CRUMBLE AND IS QUITE DELICIOUS WHEN SERVED WARM WITH FRESH CREAM.

MAKES ONE CAKE

INGREDIENTS
- 250g/9oz/1 cup plus 30ml/2 tbsp butter, softened
- 250g/9oz/1¼ cups caster (superfine) sugar
- 4 eggs
- 450g/1lb/4 cups self-raising (self-rising) flour
- 3 large cooking apples
- 2.5ml/½ tsp ground cinnamon

For the crumble topping
- 175g/6oz/¾ cup demerara (raw) sugar
- 125g/4¼oz/generous 1 cup plain (all-purpose) flour
- 5ml/1 tsp ground cinnamon
- 65g/2½oz/scant 1 cup desiccated (dry unsweetened shredded) coconut
- 115g/4oz/½ cup butter

1 Preheat the oven to 180°C/350°F/ Gas 4. Grease and base-line a 25cm/ 10in round cake tin (pan). To make the crumble topping, mix the sugar, flour, cinnamon and coconut in a bowl, then rub in the butter with your fingertips until the mixture resembles breadcrumbs. Set aside.

2 Put the butter and sugar in a bowl and cream with an electric mixer until light and fluffy. Beat in the eggs, one at a time, beating well after each addition, and adding a little of the flour if the mixture starts to curdle.

3 Sift in half the remaining flour, mix well, then add the rest of the flour and stir until smooth.

4 Peel and core the apples, then grate them coarsely. Place the grated apples in a bowl and sprinkle with the cinnamon and set aside.

5 Spread half the cake mixture evenly over the base of the prepared tin. Spoon the apples on top and sprinkle over half the crumble topping.

6 Spread the remaining cake mixture over the crumble and finally top with the remaining crumble topping.

7 Bake for 1 hour 10 minutes–1 hour 20 minutes, covering the cake with foil if it browns too quickly. Leave in the pan for about 5 minutes before turning out on to a wire rack. Serve when cool.

BARBADIAN COCONUT SWEET BREAD

OFTEN MADE AT CHRISTMAS TIME IN BARBADOS, THIS DELICIOUS COCONUT BREAD IS MOST ENJOYABLE WITH A CUP OF HOT CHOCOLATE OR A GLASS OF FRUIT PUNCH.

MAKES TWO SMALL LOAVES

INGREDIENTS
175g/6oz/¾ cup butter or margarine
115g/4oz/½ cup demerara
 (raw) sugar
225g/8oz/2 cups self-raising
 (self-rising) flour
200g/7oz/scant 2 cups plain
 (all-purpose) flour
115g/4oz desiccated (dry
 unsweetened shredded) coconut
5ml/1 tsp mixed spice (pumpkin
 pie spice)
10ml/2 tsp vanilla essence (extract)
15ml/1 tbsp rum (optional)
2 eggs
about 150ml/¼ pint/⅔ cup milk
15ml/1 tbsp caster (superfine)
 sugar, blended with 30ml/2 tbsp
 water, to glaze

1 Preheat the oven to 180°C/350°F/ Gas 4. Grease two 450g/1lb loaf tins (pans) or one 900g/2lb tin.

2 Place the butter or margarine and sugar in a large mixing bowl and sift in all of the flour. Rub the ingredients together with your fingertips until the mixture begins to resemble fine breadcrumbs.

3 Add the coconut, mixed spice, vanilla essence, rum, if using, eggs and milk. Mix together well with your hands. If the mixture is too dry, add more milk. Knead on a floured board until firm and pliable.

4 Halve the mixture and place in the loaf tins. Glaze with sugared water and bake for about 1 hour, or until a skewer inserted into the loaf comes out clean.

DUCKANOO

THIS TASTY CARIBBEAN CAKE, WHICH HAS ITS ORIGINS IN WEST AFRICA, IS STEAMED IN FOIL PARCELS TO RETAIN MOISTURE. IT CONSISTS MAINLY OF CORN MEAL AND COCONUT AND IS DELICIOUS WITH FRESH CREAM.

MAKES SIX

INGREDIENTS
 450g/1lb/3 cups fine corn meal
 350g/12oz fresh coconut, chopped
 600ml/1 pint/2½ cups fresh milk
 115g/4oz currants or raisins
 50g/2oz/¼ cup butter or margarine,
 melted
 115g/4oz/½ cup demerara (raw) sugar
 60ml/4 tbsp water
 1.5ml/¼ tsp freshly grated nutmeg
 2.5ml/½ tsp ground cinnamon
 5ml/1 tsp vanilla essence (extract)

1 Place the corn meal in a large bowl. Blend the coconut and the milk in a blender or food processor until smooth. Stir the coconut mixture into the corn meal, then add all of the remaining ingredients and stir well.

2 Take 6 pieces of foil and fold into 13 x 15cm/5 x 6in pockets leaving an opening on one short side. Fold over the edges of the remaining sides tightly to ensure that they are well sealed. This will prevent liquid seeping in.

3 Put one or two spoonfuls of the corn meal mixture into each foil pocket and fold over the final edge of foil to seal tightly.

4 Place the foil pockets in a large pan of boiling water. Cover and simmer for about 45–60 minutes. Lift the pockets out of the water and carefully remove the foil. Serve the duckanoo alone or with fresh cream.

CORN MEAL AND FENNEL SEED CAKE

BEING A STAPLE FOOD, CORN MEAL IS OFTEN USED IN BAKING. HERE IT MAKES A DELICIOUS TEA CAKE OR AFTER-SCHOOL SNACK FOR THE CHILDREN.

MAKES ONE LOAF

INGREDIENTS
40g/1½oz/3 tbsp unsalted (sweet)
 butter, softened
200g/7oz/1 cup caster
 (superfine) sugar
200g/7oz/1⅓ cups coarse corn meal
200g/7oz/1¾ cups plain
 (all-purpose) flour
350ml/12fl oz/1½ cups full-fat
 (whole) milk
10ml/2 tsp baking powder
5ml/1 tsp salt
4 eggs
5ml/1 tsp fennel seeds

COOK'S TIP
The cake batter will seem very runny
before baking. Don't let this worry
you; the result will be a well-risen,
moist cake.

1 Preheat the oven to 180°C/350°F/
Gas 4. Grease a 23 x 13cm/9 x 5in
loaf tin (pan) and line with baking
parchment.

VARIATION
A popular version of this cake is made
with the addition of grated fresh white
cheese. Stir 150g/5oz into the cake
batter before baking. The result will be
much creamier and even more moist.

2 Cream the butter and sugar in a food
processor until thoroughly combined.
Add the remaining ingredients to the
food processor and blend again to make
a thin cake batter.

3 Pour the batter into the prepared loaf
tin and bake for 40–45 minutes, or until
a skewer inserted in the centre of the
cake comes out clean. Allow to cool
slightly, then transfer to a wire rack.
Serve at room temperature.

BANANA BREAD

THIS IS MORE OF A CAKE THAN A BREAD, AND IS DELICIOUS EATEN ON ITS OWN FOR BREAKFAST OR AS AN AFTERNOON SNACK. IT ALSO MAKES AN IMPRESSIVE INFORMAL DESSERT WHEN TOASTED, BUTTERED AND SERVED WITH LASHINGS OF BRANDY CREAM.

MAKES ONE LOAF

INGREDIENTS
2 ripe bananas
115g/4oz/½ cup butter, softened,
 plus extra for greasing
75g/3oz/6 tbsp light brown sugar
2.5ml/½ tsp ground cinnamon
2.5ml/½ tsp ground ginger
large pinch of ground cloves
2 eggs, lightly beaten
175g/6oz/1½ cups self-raising
 (self-rising) flour
15ml/1 tbsp milk (optional)
50g/2oz/½ cup walnut pieces

1 Preheat the oven to 180°C/350°F/
Gas 4. Grease a 23 x 13cm/9 x 5in
loaf tin (pan) and line with baking
parchment. Mash the bananas with a
fork and set them aside.

2 Cream the butter with the sugar by
hand or in a food processor until light
and creamy. Add the spices, eggs and
flour and blend again until thoroughly
combined. The mixture should be thin
enough to fall reluctantly off a spoon.
If it is too thick, stir in the milk.

COOK'S TIP
Do not blend the banana in a food
processor – it will become too runny.

3 Fold the mashed bananas and walnut
pieces into the mixture, then tip it into
the prepared loaf tin. Bake the banana
bread for about 1 hour, or until a
skewer inserted in the centre comes out
clean. Transfer to a wire rack to cool.

DESSERTS

*The abundant supply of sweet and juicy tropical fruit available in
Latin America and the Caribbean means that dessert usually consists of fresh
fruit. Otherwise, desserts tend to be rice dishes based on eggs and sugar and are
usually of Spanish and Portuguese origin, where rich custard tarts and
crème caramels have always been popular.*

FRUITS OF THE TROPICS SALAD

CANNED GUAVAS DO NOT HAVE QUITE THE SAME FLAVOUR AS FRESH ONES, BUT ARE AN EXCELLENT INGREDIENT IN THEIR OWN RIGHT — DELICIOUS IN THIS CARIBBEAN FRUIT SALAD.

2 Chop the stem ginger and add it to the pineapple mixture.

3 Pour the ginger syrup into a blender or food processor. Add the remaining banana, the coconut milk and the sugar. Pour in the reserved guava syrup and blend to a smooth creamy purée.

SERVES SIX

INGREDIENTS

 1 medium pineapple
 400g/14oz can guava halves in syrup
 2 bananas, sliced
 1 large mango, peeled, stoned
 (pitted) and diced
 115g/4oz preserved stem ginger
 plus 30ml/2 tbsp of the syrup from
 the jar
 60ml/4 tbsp thick coconut milk
 10ml/2 tsp sugar
 2.5ml/½ tsp freshly grated nutmeg
 2.5ml/½ tsp ground cinnamon
 strips of coconut, to decorate

1 Remove the leafy top of the pineapple, saving it to decorate the serving platter if you like. Cut the pineapple lengthways into quarters, then remove the peel and core from each piece. Cube the pineapple, and place in a serving bowl. Drain the guavas, reserving the syrup, and chop. Add the guavas to the bowl with half the bananas and all the mango.

4 Pour the banana and coconut dressing over the fruit, add a little grated nutmeg and a sprinkling of cinnamon. Cover and chill.

5 Serve the salad chilled, decorated with fresh strips of coconut. If you are serving the mixture on a large platter, the pineapple top can be placed in the centre as a decoration.

COCONUT ICE CREAM

THIS HEAVENLY ICE CREAM, POPULAR THROUGHOUT THE CARIBBEAN, IS EASY TO MAKE AND USES STORECUPBOARD INGREDIENTS, SO IS PERFECT FOR EASY ENTERTAINING.

SERVES EIGHT

INGREDIENTS

400g/14oz can evaporated
 (unsweetened condensed) milk
400g/14oz can condensed milk
400g/14oz can coconut milk
freshly grated nutmeg
5ml/1 tsp almond essence (extract)
fresh lemon balm sprigs, lime slices
 and shredded coconut, to decorate

COOK'S TIP
If using an ice-cream maker, mix the ingredients in a jug (pitcher), chill in the freezer for 30 minutes. Pour into the ice-cream maker and churn as directed.

3 Remove the bowl from the freezer and whisk the mixture vigorously until it is light and fluffy and has almost doubled in volume.

4 Pour into a freezer container, then cover and freeze. Soften slightly before serving, decorated with lemon balm, lime slices and shredded coconut.

1 Mix the evaporated, condensed and coconut milk in a large freezerproof bowl until thoroughly combined.

2 Stir in the grated nutmeg and almond essence. Place the bowl in the freezer and chill the mixture for about 1–2 hours or until semi-frozen.

MANGO SORBET

THIS FOOLPROOF RECIPE IS INCREDIBLY EASY TO MAKE WITHOUT AN ICE-CREAM MAKER. A SMOOTH
TEXTURE AND FRUITY, CONCENTRATED FLAVOUR IS GUARANTEED.

SERVES SIX

INGREDIENTS
200g/7oz/1 cup caster (superfine) sugar
150ml/¼ pint/⅔ cup water
3 large ripe mangoes
juice of 1 lime
1 egg white

COOK'S TIP
Home-made sorbets (sherbets) tend to
set more solidly than bought versions, so
always transfer them to the refrigerator to
thaw slightly before serving.

VARIATION
The sorbet can be made with ripe papayas
instead of mangoes. Add the grated rind
of the lime as well as the juice.

1 Dissolve the sugar in the water in a
small pan over a low heat. Allow to cool.

2 Cut off a thick lengthways slice from
either side of each mango. Cut off any
flesh, peel and chop it roughly. Put the
mango flesh in a food processor or
blender and process until smooth.

3 Scrape into a freezerproof bowl and
stir in the syrup and lime juice. Freeze
for 2–4 hours until almost solid.

4 Scoop into a food processor and
blend until soft. Pour in the egg white
and blend until combined. Return to the
bowl, cover and freeze until firm.

COLOMBIAN PINEAPPLE CUSTARD

THESE PINEAPPLE CRÈME CARAMELS ARE THE PERFECT DINNER PARTY DESSERT. THEY ARE VERY EASY TO MAKE, ESPECIALLY IF YOU BUY PREPARED FRESH PINEAPPLE FROM THE SUPERMARKET.

MAKES SIX

INGREDIENTS
 350g/12oz peeled fresh
 pineapple, chopped
 150g/5oz/⅔ cup caster
 (superfine) sugar
 4 eggs, lightly beaten
For the caramel
 60ml/4 tbsp granulated sugar
 juice of 1 lime

1 Put the pineapple in a blender or food processor and process until smooth. Scrape the purée into a pan and add the sugar. Cook for 5 minutes or until reduced by one-third. The mixture should be thick but not jam-like, so add a little water if it is too thick. Transfer to a bowl and leave to cool.

COOK'S TIP
Avoid over-whisking the eggs. Gently stir them into the pineapple mixture without incorporating air.

2 Meanwhile make the caramel. Place the granulated sugar in a heavy pan over a medium heat. As the sugar starts to caramelize around the edges, shake the pan to mix the sugar, but do not stir. Remove the pan from the heat as soon as all the sugar has dissolved and the caramel has become golden brown. Immediately stir in the lime juice taking care not to burn yourself. The hot caramel will spit when the lime juice is added, but this will stop. Divide the caramel among six ramekins and turn them so that they are coated evenly.

3 Preheat the oven to 180°C/350°F/Gas 4. Stir the eggs into the cool pineapple mixture. Divide the mixture equally among the ramekins. Place the moulds in a roasting pan and pour in warm water to come halfway up their sides. Cover with foil and bake for 45 minutes, until set. Allow to cool.

4 Just before serving, unmould the custards directly on to dessert plates. Loosen the edges with a knife, invert a dessert plate on top of each mould and turn both over.

TAPIOCA PUDDING

THIS IS ONE OF THOSE DESSERTS THAT PROVOKES STRONG REACTIONS. MOST PEOPLE EITHER LOVE IT OR LOATHE IT, BUT IT IS VERY POPULAR THROUGHOUT LATIN AMERICA. FOR ITS MANY FANS, THERE IS NOTHING NICER THAN THIS CREAMY DESSERT STREWN WITH CRUNCHY CASHEWS.

<u>SERVES SIX</u>

INGREDIENTS
90g/3½oz/generous ½ cup tapioca
750ml/1¼ pints/3 cups full-fat
 (whole) milk
1 cinnamon stick, bruised
45ml/3 tbsp caster (superfine) sugar
30ml/2 tbsp chopped cashew nuts

1 Put the tapioca in a strainer and rinse under cold running water. Drain and tip into a heavy pan.

VARIATION
For coconut-flavoured tapioca pudding, simply replace the milk with the same quantity of coconut milk.

2 Pour in the milk and soak for 30 minutes. Place the pan over a medium heat and bring to the boil. Add the bruised cinnamon stick, then lower the heat and simmer gently for 30 minutes, or until most of the milk has been absorbed. Stir occasionally to prevent the tapioca from sticking.

3 Stir in the sugar and gently simmer for a further 10 minutes. Carefully remove the cinnamon stick and spoon the pudding into individual dessert bowls. Lightly toast the cashew nuts in a dry frying pan, taking care not to burn them, and scatter over the puddings. Serve warm rather than hot or cold.

FRIED BANANAS WITH SUGAR AND RUM

CHILDREN LOVE FRIED BANANAS, BUT THIS CARIBBEAN VERSION WITH RUM DELIVERS AN EXTRA KICK AND IS STRICTLY FOR GROWN-UPS. FRIED BANANAS CAN BE INCREDIBLY SWEET, BUT THE LIME JUICE CUTS THROUGH THE SWEETNESS WITH DELICIOUS RESULTS.

SERVES FOUR

INGREDIENTS
 50g/2oz/¼ cup caster
 (superfine) sugar
 45ml/3 tbsp rum
 65g/2½oz/5 tbsp unsalted
 (sweet) butter
 grated rind and juice of 1 lime
 4 bananas, peeled
 vanilla ice cream, to serve

1 Place the sugar, rum, butter, grated lime rind and lime juice in a large heavy frying pan over a low heat. Cook for a few minutes, stirring occasionally, until the sugar has completely dissolved.

COOK'S TIP
Avoid using bananas that are too ripe, otherwise they may break apart in the pan before they get a chance to colour.

2 Add the bananas to the pan, turning to coat them in the sauce. Cook over a medium heat for 5 minutes on each side, or until the bananas are golden.

3 Remove from the heat and cut the bananas in half. Serve two pieces of banana per person with a scoop of vanilla ice cream and a generous drizzle of the hot sauce.

COCONUT AND PUMPKIN COMPOTE

LATIN AMERICANS LOVE WHOLE PRESERVED FRUITS IN SYRUP. ALSO POPULAR ARE COMPOTES LIKE THIS ONE, TRADITIONALLY SERVED WITH FRESH CHEESE.

SERVES SIX

INGREDIENTS
 800g/1¾lb pumpkin, peeled
 and seeded
 450g/1lb/2¼ cups caster
 (superfine) sugar
 4 cloves
 350ml/12fl oz/1½ cups water
 115g/4oz/1⅓ cups desiccated (dry
 unsweetened shredded) coconut
 ricotta cheese, to serve

VARIATION
This preserve is more traditionally made without coconut. For pure pumpkin compote, leave out the coconut and double the quantity of pumpkin.

1 Cut the pumpkin into even-size pieces and place in a heavy pan. Add the sugar, cloves and water. Heat gently, without bringing to the boil, until the sugar has dissolved.

2 Increase the heat to medium. Simmer the mixture for 30–35 minutes, until the pumpkin is soft. Using a fork mash the cooked pumpkin until it is reduced to a rough purée.

3 Stir in the coconut and simmer for a further 15 minutes. The mixture should be thick but still liquid, so add more water if necessary. Leave to cool, then transfer to an airtight container and store in the refrigerator for up to 2 weeks.

4 Spoon the compote into a serving bowl and allow it to come to room temperature before serving with a fresh white cheese, such as ricotta.

DULCE DE LECHE

SPANISH IN ORIGIN, THIS TOFFEE-LIKE DESSERT IS A CHILDREN'S FAVOURITE THROUGHOUT LATIN AMERICA. LITERALLY TRANSLATED AS "CARAMELIZED MILK", IT IS TRADITIONALLY MADE WITH MILK AND SUGAR, BUT THIS VERSION IS MUCH QUICKER AND JUST AS DELICIOUS.

SERVES SIX

INGREDIENTS
 400g/14oz can condensed milk
 400g/14oz can evaporated
 (unsweetened condensed) milk

VARIATION
A classic trick to making low-maintenance *dulce de leche* is to cook a whole, closed can of condensed milk in a pan of boiling water for 30 minutes, but this must be done with care as the can could explode if not continuously immersed in water. South American cooks often add a can of condensed milk to the pan when cooking beans, so side dish and dessert cook together.

1 Combine the condensed and evaporated milk in a heavy pan. Place over a medium heat and bring to the boil. Reduce the heat slightly and cook, stirring constantly, for 30–35 minutes until thickened and toffee coloured. Use a relatively large pan, as the milk has a tendency to boil over.

2 Pour into a sterilized jar and seal. *Dulce de leche* will keep for months, but with time, the texture will alter and won't be as smooth.

3 Serve with ice cream, as a filling for pancakes or cakes, or even with a white cheese, such as ricotta.

CARIBBEAN SPICED RICE PUDDING

Some recipes from the Caribbean can be extremely sweet, particularly desserts. If this rice pudding is a little too sweet for your taste, simply reduce the sugar quantity and rely upon the natural sweetness of the fruit.

SERVES SIX

INGREDIENTS

 25g/1oz/2 tbsp butter
 1 cinnamon stick
 115g/4oz/½ cup soft brown sugar
 115g/4oz/⅔ cup ground rice
 1.2 litres/2 pints/5 cups milk
 2.5ml/½ tsp allspice
 50g/2oz/⅓ cup sultanas (golden
 raisins)
 75g/3oz mandarin oranges, chopped
 75g/3oz pineapple, chopped§

1 Melt the butter in a non-stick pan. Add the cinnamon stick and sugar. Heat over a medium heat until the sugar just begins to caramelize. Remove from the heat.

2 Carefully stir in the rice and three-quarters of the milk. Slowly bring to the boil, stirring all the time, being careful not to let the milk burn. Reduce the heat and simmer gently for about 10 minutes, or until the rice is cooked, stirring constantly.

3 Add the remaining milk, the allspice and the sultanas. Leave to simmer for 5 minutes, stirring occasionally.

4 When the rice is thick and creamy, allow to cool slightly, then stir in the mandarin and pineapple pieces.

JAMAICAN FRUIT TRIFLE

THIS TRIFLE IS ACTUALLY BASED ON A CARIBBEAN FOOL THAT CONSISTS OF FRUIT STIRRED INTO THICK VANILLA-FLAVOURED CREAM. THIS VERSION IS MUCH LESS RICH, REDRESSING THE BALANCE WITH PLENTY OF FRUIT, AND WITH CRÈME FRAÎCHE REPLACING SOME OF THE CREAM.

SERVES EIGHT

INGREDIENTS
 1 large pineapple, peeled and cored
 300ml/½ pint/1¼ cups double
 (heavy) cream
 200ml/7fl oz/scant 1 cup crème fraîche
 60ml/4 tbsp icing (confectioners')
 sugar, sifted
 10ml/2 tsp pure vanilla essence
 (extract)
 30ml/2 tbsp white or coconut rum
 3 papayas, peeled, seeded and chopped
 3 mangoes, peeled, stoned (pitted)
 and chopped
 thinly pared rind and juice of 1 lime
 25g/1oz/⅓ cup coarsely shredded or
 flaked coconut, toasted

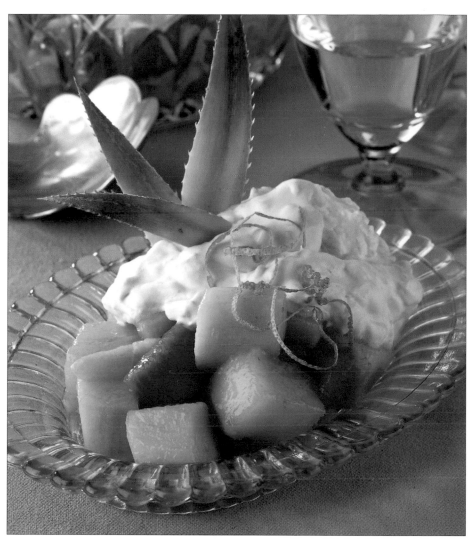

1 Cut the pineapple into large chunks, place in a food processor or blender and process briefly until chopped. Tip into a sieve placed over a bowl and leave for 5 minutes so that most of the juice drains from the fruit.

2 Whip the double cream to soft peaks, then fold in the crème fraîche, sifted icing sugar, vanilla extract and rum.

3 Fold the drained chopped pineapple into the cream mixture. Place the chopped papayas and mangoes in a large bowl and pour over the lime juice. Gently stir the fruit mixture to combine. Shred the pared lime rind.

4 Divide the fruit mixture and the pineapple cream among eight dessert plates. Decorate with the lime shreds, toasted coconut and a few small pineapple leaves, if you like, and serve at once.

COOK'S TIP
It is important to let the pineapple purée drain thoroughly, otherwise, the pineapple cream will be watery. Don't throw away the drained pineapple juice – mix it with fizzy mineral water for a refreshing drink.

BRAZILIAN COCONUT FLAN

THIS IS A SOMEWHAT UNCONVENTIONAL BUT VERY SUCCESSFUL RECIPE FOR QUINDAO, *A CLASSIC BRAZILIAN DESSERT MADE WITH NO FEWER THAN 18 EGG YOLKS. IT IS AVAILABLE AS A PACKET MIX THROUGHOUT LATIN AMERICA, BUT IT IS MUCH MORE DELICIOUS IF YOU MAKE YOUR OWN.*

SERVES TWELVE

INGREDIENTS
 150g/5oz/1⅔ cups desiccated (dry unsweetened shredded) coconut
 200ml/7fl oz/scant 1 cup full-fat (whole) milk
 40g/1½oz/3 tbsp unsalted (sweet) butter, softened
 400g/14oz/2 cups caster (superfine) sugar, plus extra for dusting
 18 egg yolks

1 Put the desiccated coconut in a bowl. Pour over the milk and leave to stand for about 15 minutes, or until all the milk has been absorbed.

2 Meanwhile, grease a 23cm/9in ring mould with some of the butter and then lightly dust with a sprinkling of caster sugar.

3 Put the remaining butter in a large bowl. Add the sugar and soaked coconut, and mix vigorously until thoroughly combined.

4 Using a wooden spoon, gently stir in the egg yolks, one at a time. When the ingredients are thoroughly combined, cover the bowl with a clean dishtowel and leave the mixture to stand in a cool place for about 1 hour.

5 Tip the coconut mixture into the prepared ring mould and place this in the centre of a large, deep roasting pan. Pour in enough warm water to come halfway up the outside of the mould. Place this bain marie and its pudding in a cold oven.

6 Heat the oven to 220°C/425°F/Gas 7 and bake the flan for about 1 hour, or until the surface is a dark golden, caramelized brown. Remove from the oven and leave to cool in the water in the roasting pan.

7 When the flan is cold, loosen the edges carefully with a palette knife. Cover with an upturned serving platter and turn the ring mould gently upside down. Gently lift off the ring mould, being careful not to let it touch the top of the flan. Serve cut in thick slices.

VARIATIONS
When available, use finely grated fresh coconut instead of desiccated. There is no need to soak the fresh coconut in the milk; just add both ingredients to the butter and sugar. For a more fragrant, even sweeter flan, try adding a whole vanilla pod to the egg and coconut mixture before it is left to stand. Make sure you remove it before cooking.

DRINKS

Nothing is more refreshing or nutritious than freshly squeezed fruit juice or coconut juice straight from the shell. Fruit bars serving these juices are found throughout the Caribbean and Latin America. The region is also famous for its cocktails, and every country has its favourite spirit – there's Brazilian cachaça, Peruvian pisco, Caribbean rum and Mexican tequila.

MANGO SHAKE

CHILDREN LOVE FRESH FRUIT SHAKES, AND WITH THE VARIETY OF TROPICAL FRUIT AVAILABLE THROUGHOUT THE REGION, THEY ARE SPOILT FOR CHOICE.

MAKES 1 LITRE/1¾ PINTS/4 CUPS

INGREDIENTS
 2 large ripe mangoes
 750ml/1¼ pints/3 cups full-fat
 (whole) milk
 juice of ½ lime
 caster (superfine) sugar, to taste

VARIATION
In Brazil, a similar drink is made with avocados. Simply use 2 ripe avocados in place of the mangoes. Until recently, Brazilians viewed avocados as fruit and would not have dreamed of eating them in savoury dishes. Once you have tasted this unusual, delicious variation, you will understand why.

1 Place each mango in turn on a board with the narrow side down. Cut off a thick lengthways slice, keeping as close to the stone (pit) as possible. Turn the mango around and repeat on the other side. Cut off the flesh that is still attached to the stone. Remove the peel and chop the flesh roughly.

2 Put the chopped mango in a blender or food processor and add the milk and lime juice. Process until smooth.

3 Pour the mango shake into a jug (pitcher), stir in sugar to taste and chill in the refrigerator. Serve in tall glasses with ice cubes.

PINEAPPLE AND MINT JUICE

THIS DRINK IS PERFECTLY REFRESHING ON A SUNNY DAY — THE MINT REALLY BRINGS OUT THE SWEETNESS OF THE FRUIT, AND ADDED SUGAR IS RARELY REQUIRED.

MAKES 1 LITRE/1¾ PINTS/4 CUPS

INGREDIENTS
 1kg/2¼lb pineapples
 10 fresh mint leaves
 crushed ice
 caster (superfine) sugar, to taste

VARIATION
To make a pineapple and mint granita, pour the juice into a shallow metal container and place in the freezer until almost firm. Break up the mixture using a fork and return it to the freezer. Repeat this procedure two or three times, until the mixture is semi-frozen, then serve.

1 Cut the top and base off each pineapple, then cut off the skin, being careful to remove all the "eyes". Discard the skin and cut the pineapple, including the core, into large chunks.

2 Blend the pineapple chunks with the mint leaves in a blender or food processor until smooth. Pour into a jug (pitcher) and stir in the crushed ice. Stir until the ice has dissolved slightly.

CASHEW NUT MILK

IN MAINLAND SPAIN AND MEXICO A SIMILAR DRINK — HORCHATA — IS MADE WITH ALMONDS, BUT THIS CUBAN VARIATION WITH CASHEWS IS EVEN MORE DELICIOUS. THE RESULT IS RICH AND CREAMY. IT IS GREAT FOR KIDS AND EVEN BETTER FOR ADULTS WHO NEED A HANGOVER CURE.

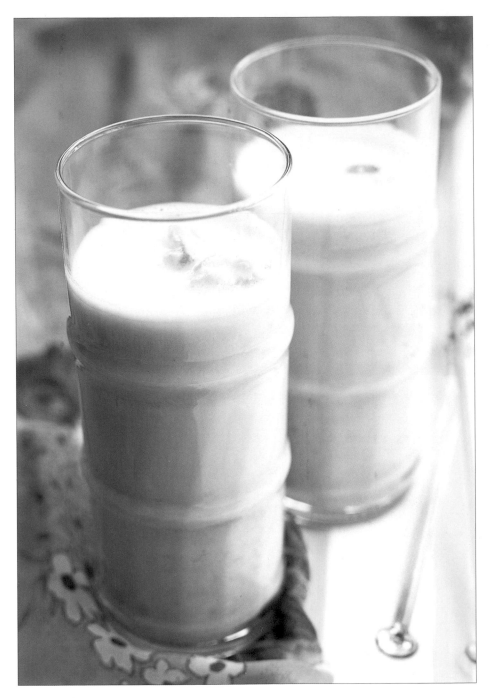

1 Finely grind the cashews in a food processor. Add the sugar and cinnamon and grind the mixture again to make a smooth paste.

2 With the motor still running, gradually pour in 900ml/1½ pints/3¾ cups of boiling water, until the drink becomes smooth and frothy. Scrape down the mixture occasionally, if necessary.

MAKES 1.2 LITRES/2 PINTS/5 CUPS

INGREDIENTS
 400g/14oz/3½ cups
 blanched cashews
 225g/8oz/generous 1 cup caster
 (superfine) sugar
 1.5ml/¼ tsp ground cinnamon

COOK'S TIP
For a smooth drink, make this the night before, allow it to stand in the refrigerator overnight, and strain before serving.

3 Pour the cashew nut milk into a jug (pitcher). Cover and chill in the refrigerator. Stir well before serving in tall glasses. Float ice cubes in each glass. As the ice melts, it will dilute the drink, giving it a lighter texture.

PASSION FRUIT BATIDA

BRAZILIAN BATIDAS CAN BE MADE WITH A VARIETY OF JUICES, SUCH AS LIME OR COCONUT MILK. DO NOT BE FOOLED BY THE FRUITY SWEETNESS: A SMALL GLASS OF BATIDA, SIPPED SLOWLY, IS MORE THAN ENOUGH TO GET THE PARTY STARTED.

MAKES TWO

INGREDIENTS
 8 passion fruit
 200ml/7fl oz/scant 1 cup *cachaça*
 30ml/2 tbsp caster (superfine) sugar
 3 ice cubes

1 Cut the passion fruit in half and scoop the flesh and seeds into a cocktail shaker or mixing jug (pitcher).

2 Add the remaining ingredients, including the ice cubes, and shake vigorously or stir thoroughly.

3 Strain into two cocktail glasses and serve the *batida* immediately.

VARIATIONS
• Two other flavours of *batida* that are also very popular are lime and coconut. Simply replace the passion fruit with 60ml/4 tbsp lime juice or coconut milk.
• If you are unable to find *cachaça*, replace with equal quantities of vodka.

PISCO SOUR

This cocktail, enjoyed in Peru, Bolivia, Ecuador and Chile, gets its name from the Peruvian brandy with which it is made. Give the cocktail a good shake to encourage the egg whites to foam up, and finish with the bitter, spicy taste of Angostura.

MAKES TWO

INGREDIENTS
 105ml/7 tbsp pisco
 10ml/2 tsp egg white
 30ml/2 tbsp caster (superfine) sugar
 juice of 1 lime
 6 ice cubes
 Angostura bitters

COOK'S TIPS
• Don't stir the cocktail after adding the Angostura bitters, so each sip tastes slightly different.
• If you prefer not to eat raw egg white, the drink can be made without it.

1 Chill two tumblers in the freezer for 10 minutes.

2 Combine all the ingredients, except for the Angostura bitters, in a cocktail shaker and shake vigorously for about 30 seconds.

3 Strain into the chilled glasses and shake 2–3 drops of the bitters on top. Serve immediately.

CAIPIRINHA

This Brazilian drink can be enjoyed at any time of day — on the beach while snacking on seafood, as an aperitif before a meal and even with steak at a barbecue. As any tourist to Brazil will know, once you have tasted it, you are hooked for life!

MAKES TWO

INGREDIENTS
 2 limes
 30ml/2 tbsp caster (superfine) sugar
 105ml/7 tbsp *cachaça*
 crushed ice

VARIATION
Use the same recipe to make *caipiroska*, with vodka replacing the cachaça, or *caipirissima*, using white rum.

1 Wash the limes thoroughly, scrubbing the rind to remove any artificial wax coating that might have been applied, then cut into large chunks.

2 Place the lime chunks in two cocktail tumblers and divide the sugar equally between them. Pound the sugar and lime together with a pestle. The skill lies in being vigorous enough to extract the juice and oil from the rind, yet delicate enough not to break the glass.

3 Top with the crushed ice and divide the cachaça equally between the glasses. Stir vigorously and serve.

MOJITO

A REFRESHING CUBAN COCKTAIL, THIS INCORPORATES RUM, MINT AND LIME. TAKE YOUR TIME DRINKING IT AND THE FLAVOUR OF THE MINT WILL GRADUALLY INTENSIFY.

MAKES ONE

INGREDIENTS
 juice of 1 lime
 15ml/1 tbsp caster (superfine) sugar
 4 fresh mint sprigs
 75ml/5 tbsp white rum
 crushed ice
 90ml/6 tbsp soda water (club soda)

COOK'S TIPS
• If you don't have a refrigerator that delivers crushed ice or a blender with sufficiently tough blades, put the ice in a freezer bag, wrap it in a dishtowel and beat it against the kitchen work surface – it's noisy, but it works.
• Shaking the cocktail bruises the mint leaves, releasing their flavour. If you do not have a cocktail shaker, bruise the mint leaves by hand before adding them.

1 Mix the lime juice and sugar in a cocktail shaker and shake until the sugar has dissolved.

2 Add three of the mint sprigs, the rum and some crushed ice and shake vigorously. Pour into a tall glass, top with the soda water and decorate with the remaining mint.

CUBA LIBRE

THIS SIMPLE COCKTAIL HAS ALWAYS BEEN VERY POPULAR, BUT SINCE CASTRO TOOK POWER IN 1959 ITS NAME IS SEEN AS POLITICALLY INCORRECT. CUBAN EXILES HAVE SARCASTICALLY RENAMED IT MENTIRITA, MEANING "LITTLE LIE".

MAKES ONE

INGREDIENTS
 crushed ice
 45ml/3 tbsp white rum
 75ml/5 tbsp cola
 1 lime wedge, optional

COOK'S TIPS
Rum is made by fermenting and distilling the thick brown liquid (molasses) that is left behind after extracting sugar from sugar cane.

1 Spoon the crushed ice into a tall glass and top with the white rum.

2 Pour in the cola and decorate with a wedge of lime. Serve immediately.

DEMERARA RUM PUNCH

THE INSPIRATION FOR THIS PUNCH CAME FROM THE RUM DISTILLERY AT PLANTATION DIAMOND ESTATE IN GUYANA, WHERE SOME OF THE FINEST RUM IN THE WORLD IS MADE, AND THE TANTALIZING AROMAS OF SUGAR CANE AND RUM PERVADE THE AIR.

SERVES FOUR

INGREDIENTS
 150ml/¼ pint/⅔ cup orange juice
 150ml/¼ pint/⅔ cup
 pineapple juice
 150ml/¼ pint/⅔ cup mango juice
 120ml/4fl oz/½ cup water
 250ml/8fl oz/1 cup dark rum
 a shake of angostura bitters
 freshly grated nutmeg
 25g/1oz/2 tbsp demerara
 (raw) sugar
 1 small banana
 1 large orange

1 Pour the orange, pineapple and mango juices into a large punch bowl. Stir in the water.

2 Add the rum, angostura bitters, nutmeg and sugar. Stir gently for a few minutes until the sugar has dissolved.

3 Slice the banana thinly and stir the slices gently into the punch.

4 Slice the orange and add to the punch. Chill and serve in tumblers with ice.

VARIATIONS
You can use white rum instead of dark, if you prefer. To make a stronger punch, simply add more rum.

CARIBBEAN CREAM STOUT PUNCH

THIS FAIRLY UNUSUAL PUNCH, MADE USING STOUT, CONDENSED MILK AND SHERRY, IS A WELL-KNOWN "PICK-ME-UP" THAT IS POPULAR ALL OVER THE CARIBBEAN. WITH A SWEET, HEADY AROMA OF VANILLA, IT SOOTHES AND REVIVES TIRED MINDS AND BODIES.

SERVES TWO

INGREDIENTS
 475ml/16fl oz/2 cups stout
 300ml/½ pint/1¼ cups evaporated
 (unsweetened condensed) milk
 75ml/5 tbsp condensed milk
 75ml/5 tbsp sherry
 2 or 3 drops vanilla
 essence (extract)
 freshly grated nutmeg

1 Mix together the stout, evaporated and condensed milks, sherry and vanilla essence in a blender or food processor, or whisk together in a large mixing bowl, until creamy.

2 Add a little grated nutmeg to the stout mixture and blend or whisk thoroughly again for a few minutes.

3 Chill for at least 45 minutes, or until really cold, before ladling into small glasses to serve.

NUTRITIONAL INFORMATION

The nutritional analysis below is per portion, unless otherwise stated.

p68 Cassava Chips Energy 453Kcal/1900kJ; Protein 3g; Carbohydrate 56.4g, of which sugars 1.4g; Fat 25.6g, of which saturates 3.8g; Cholesterol 0mg; Calcium 30mg; Fibre 2.6g; Sodium 4mg

p69 Cheese Tamales Energy 197Kcal/825kJ; Protein 3.3g; Carbohydrate 21.2g, of which sugars 0.3g; Fat 11.6g, of which saturates 5.8g; Cholesterol 21mg; Calcium 80mg; Fibre 0.0g; Sodium 560mg

p70 Plantain and Sweet Potato Chips Energy 396Kcal/1658kJ; Protein 1.7g; Carbohydrate 51.5g, of which sugars 12.6g; Fat 21.7g, of which saturates 2.5g; Cholesterol 0mg; Calcium 11mg; Fibre 2.8g; Sodium 11mg

p70 Coconut King Prawns Energy 186Kcal/774kJ; Protein 11.2g; Carbohydrate 3.1g, of which sugars 2.6g; Fat 14.5g, of which saturates 8.4g; Cholesterol 182mg; Calcium 111mg; Fibre 1.7g; Sodium 443mg

p72 Tamales de Picadillo Energy 188Kcal/785kJ; Protein 7.8g; Carbohydrate 14.7g, of which sugars 3.0g; Fat 11.3g, of which saturates 4.4g; Cholesterol 26mg; Calcium 13mg; Fibre 0.4g; Sodium 175mg

p73 Mixed Tostadas Energy 253Kcal/1068kJ; Protein 14.7g; Carbohydrate 32.8g, of which sugars 3.4g; Fat 7.9g, of which saturates 2.8g; Cholesterol 25mg; Calcium 192mg; Fibre 3.0g; Sodium 424mg

p74 Cheesy Eggs Energy 167Kcal/693kJ; Protein 9.9g; Carbohydrate 0.1g, of which sugars 0.1g; Fat 14.2g, of which saturates 4.7g; Cholesterol 240mg; Calcium 108mg; Fibre 0g; Sodium 179mg

p75 Crab Cakes Energy 240Kcal/997kJ; Protein 5.9g; Carbohydrate 13.3g, of which sugars 8.9g; Fat 18.6g, of which saturates 8.7g; Cholesterol 58mg; Calcium 58mg; Fibre 2.8g; Sodium 197mg

p76 Pan-fried Squid Energy 250Kcal/1043kJ; Protein 32.8g; Carbohydrate 2.6g, of which sugars 0.1g; Fat 9.2g, of which saturates 1.5g; Cholesterol 500mg; Calcium 33mg; Fibre 0g; Sodium 475mg

p76 Fried Whitebait with Cayenne Pepper Energy 328Kcal/1359kJ; Protein 12.2g; Carbohydrate 3.3g, of which sugars 0.1g; Fat 29.7g, of which saturates 5.9g; Cholesterol 0mg; Calcium 538mg; Fibre 0.1g; Sodium 144mg

p78 Black Eyed Bean and Shrimp Fritters Energy 136Kcal/570kJ; Protein 7.7g; Carbohydrate 14.7g, of which sugars 1.6g; Fat 5.5g, of which saturates 0.7g; Cholesterol 10mg; Calcium 33mg; Fibre 2.3g; Sodium 83mg

p79 Beef Empanadas Energy 138Kcal/579kJ; Protein 6.6g; Carbohydrate 12.7g, of which sugars 0.8g; Fat 7.1g, of which saturates 3.1g; Cholesterol 23mg; Calcium 20mg; Fibre 0.7g; Sodium 102mg

p80 Nut Brittle Energy 239Kcal/1005kJ; Protein 6.5g; Carbohydrate 29.3g, of which sugars 27.2g; Fat 11.5g, of which saturates 2.2g; Cholesterol 00mg; Calcium 22mg; Fibre 1.5g; Sodium 2mg

p80 Coconut Sweets Energy 40Kcal/168kJ; Protein 0.1g; Carbohydrate 7.4g, of which sugars 7.4g; Fat 1.2g, of which saturates 1.1g; Cholesterol 0mg; Calcium 3mg; Fibre 0.3g; Sodium 1mg

p84 Vermicelli Soup Energy 128Kcal/537kJ; Protein 4.4g; Carbohydrate 10.5g, of which sugars 5.7g; Fat 8.0g, of which saturates 2.1g; Cholesterol 6mg; Calcium 86mg; Fibre 1.9g; Sodium 101mg

p84 Tomato Soup Energy 78Kcal/327kJ; Protein 2.1g; Carbohydrate 10.0g, of which sugars 9.0g; Fat 3.6g, of which saturates 0.6g; Cholesterol 0mg; Calcium 26mg; Fibre 2.8g; Sodium 103mg

p86 Creamy Heart of Palm Soup Energy 441Kcal/1824kJ; Protein 4.9g; Carbohydrate 13.1g, of which sugars 7.1g; Fat 41.4g, of which saturates 24.5g; Cholesterol 99mg; Calcium 91mg; Fibre 4.5g; Sodium 219mg

p87 Peanut and Potato Soup with Coriander Energy 259Kcal/1076kJ; Protein 8.1g; Carbohydrate 14.5g, of which sugars 6.1g; Fat 19.2g, of which saturates 3.7g; Cholesterol 0mg; Calcium 30mg; Fibre 3.0g; Sodium 141mg

p88 Fish and Sweet Potato Soup Energy 125Kcal/528kJ; Protein 11.6g; Carbohydrate 16.7g, of which sugars 5.0g; Fat 1.7g, of which saturates 0.3g; Cholesterol 20mg; Calcium 44mg; Fibre 8.4g; Sodium 223mg

p88 Caribbean Vegetable Soup Energy 195Kcal/820kJ; Protein 3.8g; Carbohydrate 33.7g, of which sugars 16.0g; Fat 5.9g, of which saturates 3.4g; Cholesterol 13mg; Calcium 52mg; Fibre 3.4g; Sodium 62mg

p90 Crab, Coconut and Coriander Soup Energy 232Kcal/972kJ; Protein 23.8g; Carbohydrate 7.4g, of which sugars 6.5g; Fat 12.2g, of which saturates 3.7g; Cholesterol 90mg; Calcium 188mg; Fibre 1.0g; Sodium 937mg

p91 Chilli Clam Broth Energy 141Kcal/595kJ; Protein 8.8g; Carbohydrate 11.0g, of which sugars 4.1g; Fat 4.3g, of which saturates 0.7g; Cholesterol 31mg; Calcium 74mg; Fibre 1.2g; Sodium 403mg

p92 Chunky Prawn Chupe Energy 259Kcal/1089kJ; Protein 23.2g; Carbohydrate 26.8g, of which sugars 7.3g; Fat 7.3g, of which saturates 1.1g; Cholesterol 233mg; Calcium 125mg; Fibre 3.7g; Sodium 1.4g

p92 Corn Soup Energy 561Kcal/2330kJ; Protein 5.6g; Carbohydrate 39.2g, of which sugars 16.3g; Fat 43.6g, of which saturates 26.3g; Cholesterol 107mg; Calcium 54mg; Fibre 2.6g; Sodium 577mg

p94 Beef and Cassava Soup Energy 332Kcal/1400kJ; Protein 27.3g; Carbohydrate 28.6g, of which sugars 8.7g; Fat 7.8g, of which saturates 3.1g; Cholesterol 78mg; Calcium 62mg; Fibre 2.4g; Sodium 295mg

p95 Lamb and Lentil Soup Energy 530Kcal/2225kJ; Protein 57.0g; Carbohydrate 35.2g, of which sugars 2.8g; Fat 18.8g, of which saturates 8.0g; Cholesterol 167mg; Calcium 57mg; Fibre 3.0g; Sodium 180mg

p98 Baked Sea Bass with Coconut Energy 227Kcal/961kJ; Protein 38.2g; Carbohydrate 5.4g, of which sugars 4.6g; Fat 6.1g, of which saturates 0.9g; Cholesterol 95mg; Calcium 125mg; Fibre 0.5g; Sodium 326mg

p98 Pan-Fried Sea Bream with Lime and Tomato Salsa Energy 208Kcal/870kJ; Protein 28.1g; Carbohydrate 2.5g, of which sugars 2.5g; Fat 9.5g, of which saturates 1.4g; Cholesterol 69mg; Calcium 21mg; Fibre 0.8g; Sodium 97mg

p100 Halibut with Peppers and Coconut Milk Energy 279Kcal/1175kJ; Protein 23.8g; Carbohydrate 19.9g, of which sugars 7.5g; Fat 12.3g, of which saturates 5.6g; Cholesterol 41mg; Calcium 48mg; Fibre 2.3g; Sodium 122mg

p101 Prawn and Potato Omelette Energy 195Kcal/814kJ; Protein 16.0g; Carbohydrate 9.0g, of which sugars 3.4g; Fat 10.8g, of which saturates 2.5g; Cholesterol 320mg; Calcium 85mg; Fibre 1.2g; Sodium 659mg

p102 Salmon in Mango and Ginger Sauce Energy 718Kcal/2999kJ; Protein 56.8g; Carbohydrate 32.6g, of which sugars 32.3g; Fat 40.9g, of which saturates 11.9g; Cholesterol 164mg; Calcium 79mg; Fibre 2.5g; Sodium 359mg

p102 Fried Snapper with Avocado Energy 294Kcal/1223kJ; Protein 27.0g; Carbohydrate 0.9g, of which sugars 0.3g; Fat 20.2g, of which saturates 3.5g; Cholesterol 90mg; Calcium 31mg; Fibre 1.7g; Sodium 146mg

p104 Trout in Wine Sauce with Plantain Energy 324Kcal/1353kJ; Protein 22.0g; Carbohydrate 17.6g, of which sugars 6.1g; Fat 16.2g, of which saturates 5.2g; Cholesterol 83g; Calcium 28mg; Fibre 0.6g; Sodium 139g

p105 Eschovished Fish Energy 210Kcal/879kJ; Protein 28.0g; Carbohydrate 5.4g, of which sugars 4.7g; Fat 8.5g, of which saturates 1.1g; Cholesterol 69mg; Calcium 28mg; Fibre 0.8g; Sodium 91mg

p106 Sea Bass Ceviche Energy 183Kcal/776kJ; Protein 30.6g; Carbohydrate 9.7g, of which sugars 8.9g; Fat 2.8g, of which saturates 0.4g; Cholesterol 101mg; Calcium 51mg; Fibre 1.0g; Sodium 171mg

p107 Mackerel Escabeche Energy 576Kcal/2393kJ; Protein 38.5g; Carbohydrate 8.4g, of which sugars 1.5g; Fat 43.3g, of which saturates 8.2g; Cholesterol 108mg; Calcium 40mg; Fibre 0.6g; Sodium 127mg

p108 Marinated Red Mullet Energy 338Kcal/1408kJ; Protein 29.9g; Carbohydrate 12.3g, of which sugars 7.2g; Fat 19.1g, of which saturates 2.8g; Cholesterol 69mg; Calcium 60mg; Fibre 3.9g; Sodium 636mg

p109 Cod Caramba Energy 307Kcal/1286kJ; Protein 20.6g; Carbohydrate 18.5g, of which sugars 7.1g; Fat 14.1g, of which saturates 6.9g; Cholesterol 78mg; Calcium 119mg; Fibre 2.7g; Sodium 720mg

p110 Pumpkin and Prawns with Dried Shrimp Energy 210Kcal/877kJ; Protein 17.5g; Carbohydrate 8.7g, of which sugars 6.9g; Fat 11.9g, of which saturates 4.3g; Cholesterol 187mg; Calcium 147mg; Fibre 3.0g; Sodium 1g

p111 Salt Fish and Ackee Energy 292Kcal/1225kJ; Protein 38.4g; Carbohydrate 7.7g, of which sugars 6.2g; Fat 12.2g, of which saturates 4.3g; Cholesterol 80mg; Calcium 78mg; Fibre 2.4g; Sodium 494mg

p112 Jamaican Fish Curry Energy 695Kcal/2921kJ; Protein 39.5g; Carbohydrate 69.7g, of which sugars 11.2g; Fat 30.7g, of which saturates 19.3g; Cholesterol 51mg; Calcium 112mg; Fibre 3.3g; Sodium 216mg

p114 King Prawns in a Coconut and Nut Cream Energy 496Kcal/2072kJ; Protein 46.5g; Carbohydrate 18.1g, of which sugars 6.4g, Fat 26.8g, of which saturates 12.5g; Cholesterol 448mg; Calcium 254mg; Fibre 2.3g; Sodium 2.8g

p115 Stuffed Crab Energy 162Kcal/680kJ; Protein 15.9g; Carbohydrate 8.7g, of which sugars 3.5g; Fat 7.3g, of which saturates 3.7g; Cholesterol 129mg; Calcium 162mg; Fibre 0.9g; Sodium 475mg

p116 Crab and Corn Gumbo Energy 274Kcal/1144kJ; Protein 9.8g; Carbohydrate 24.2g, of which sugars 6.8g; Fat 11.4g, of which saturates 4.1g; Cholesterol 31mg; Calcium 77mg; Fibre 3.4g; Sodium 349mg

p117 Creole Fish Stew Energy 172Kcal/724kJ; Protein 17.8g; Carbohydrate 5.8g, of which sugars 5.1g; Fat 8.7g, of which saturates 1.9g; Cholesterol 45.8mg; Calcium 59mg; Fibre 1.8g; Sodium 222mg

p118 Cuban Seafood Rice Energy 326Kcal/1379kJ; Protein 28.4g; Carbohydrate 40.9g, of which sugars 1.1g; Fat 6.6g, of which saturates 1.2g; Cholesterol 286mg; Calcium 112mg; Fibre 0.5g; Sodium 1.2g

p120 Chilean Squid Casserole Energy 260Kcal/1089kJ; Protein 19.9g; Carbohydrate 17.2g, of which sugars 3.5g; Fat 8.1g, of which saturates 1.3g; Cholesterol 267mg; Calcium 42mg; Fibre 1.5g; Sodium 333mg

p121 Chilean Seafood Platter Energy 205Kcal/863kJ; Protein 32.7g; Carbohydrate 3.5g, of which sugars 0.5g; Fat 6.8g, of which saturates 1.1g; Cholesterol 267mg; Calcium 146mg; Fibre 0.4g; Sodium 1.6g

p124 The Gaucho Barbecue Energy 839Kcal/3501kJ; Protein 88.1g; Carbohydrate 3.8g, of which sugars 1.1g; Fat 52.5g, of which saturates 22.5g; Cholesterol 249mg; Calcium 63mg; Fibre 0.4g; Sodium 1.2g

p125 Beef Stuffed with Eggs and Spinach Energy 318Kcal/1328kJ; Protein 39.0g; Carbohydrate 3.4g, of which sugars 2.8g; Fat 16.7g, of which saturates 4.6g; Cholesterol 161mg; Calcium 103mg; Fibre 1.6g; Sodium 299mg

p126 Carbonada Criolla Energy 505Kcal/2124kJ; Protein 46.1g; Carbohydrate 33.6g, of which sugars 11.4g; Fat 18.3g, of which saturates 6.1g; Cholesterol 125mg; Calcium 44mg; Fibre 3.6g; Sodium 175mg

p128 Peppered Steak in Sherry Cream Sauce Energy 427Kcal/1780kJ; Protein 38.1g; Carbohydrate 8.4g, of which sugars 3.3g; Fat 23.3g, of which saturates 10.7g; Cholesterol 115mg; Calcium 40mg; Fibre 7.4g; Sodium 142mg

p129 Oxtail and Butter Beans Energy 773Kcal/3240kJ; Protein 88.0g; Carbohydrate 29.6g, of which sugars 6.2g; Fat 34.4g, of which saturates 0.2g; Cholesterol 275mg; Calcium 92mg; Fibre 4.8g; Sodium 522mg

p130 Black Bean Chilli con Carne Energy 374Kcal/1575kJ; Protein 39.0g; Carbohydrate 27.9g, of which sugars 7.4g; Fat 12.6g, of which saturates 4.1g; Cholesterol 83mg; Calcium 60mg; Fibre 4.7g; Sodium 111mg

p131 Mexican Spicy Beef Tortilla Energy 595Kcal/2516kJ; Protein 30.3g; Carbohydrate 91.2g, of which sugars 11.5g; Fat 14.7g, of which saturates 4.7g; Cholesterol 53mg; Calcium 153mg; Fibre 4.0g; Sodium 379mg

p132 Feijoada Energy 779Kcal/3262kJ; Protein 58.0g; Carbohydrate 49.9g, of which sugars 3.8g; Fat 39.9g, of which saturates 13.5g; Cholesterol 142mg; Calcium 135mg; Fibre 7.3g; Sodium 1.5g

p134 Spicy Meatballs with Tomato Sauce Energy 552Kcal/2296kJ; Protein 29.9g; Carbohydrate 21.8g, of which sugars 6.0g; Fat 39.0g, of which saturates 11.6g; Cholesterol 132mg; Calcium 75mg; Fibre 2.0g; Sodium 268mg

p135 Scrambled Eggs with Chorizo Energy 322Kcal/1335kJ; Protein 20.3g; Carbohydrate 5.7g, of which sugars 0.6g; Fat 24.3g, of which saturates 7.6g; Cholesterol 472mg; Calcium 101mg; Fibre 0.3g; Sodium 687mg

p136 Hearty Beef Stew Energy 515Kcal/2158kJ; Protein 62.6g; Carbohydrate 13.0g, of which sugars 6.7g; Fat 22.9g, of which saturates 10.9g; Cholesterol 186mg; Calcium 70mg; Fibre 1.5g; Sodium 245mg

p137 Caribbean Lamb Curry Energy 338Kcal/1409kJ; Protein 30.8g; Carbohydrate 3.2g, of which sugars 2.3g; Fat 22.6g, of which saturates 10.1g; Cholesterol 128mg; Calcium 29mg; Fibre 0.5g; Sodium 229mg

p138 "Seasoned-up" Lamb in Spinach Sauce Energy 331Kcal/1380kJ; Protein 35.6g; Carbohydrate 4.0g, of which sugars 3.1g; Fat 19.4g, of which saturates 6.7g; Cholesterol 125mg; Calcium 80mg; Fibre 1.2g; Sodium 241mg

p138 Lamb Pelau Energy 652Kcal/2726kJ; Protein 32.1g; Carbohydrate 96.3g, of which sugars 5.7g; Fat 15.0g, of which saturates 7.3g; Cholesterol 97mg; Calcium 51mg; Fibre 1.0g; Sodium 231mg

p140 Spiced Roast Leg of Lamb Energy 470Kcal/1962kJ; Protein 37.2g; Carbohydrate 22.6g, of which sugars 6.5g; Fat 24.9g, of which saturates 9.1g; Cholesterol 117mg; Calcium 38mg; Fibre 7.4g; Sodium 651mg

p141 Rabbit in Coconut Milk Energy 301Kcal/1260kJ; Protein 29.9g; Carbohydrate 10.8g, of which sugars 9.2g; Fat 15.7g, of which saturates 4.0g; Cholesterol 68mg; Calcium 73mg; Fibre 1.5g; Sodium 236mg

p142 Pork Roasted wtih Herbs, Spices and Rum Energy 410Kcal/1712kJ; Protein 42.4g; Carbohydrate 3.9g, of which sugars 3.8g; Fat 21.4g, of which saturates 8.2g; Cholesterol 132mg; Calcium 16mg; Fibre 0.1g; Sodium 577mg

p143 Pork with Pineapple Energy 492Kcal/2041kJ; Protein 28.7g; Carbohydrate 12.9g, of which sugars 12.2g; Fat 36.4g, of which saturates 12.6g; Cholesterol 92mg; Calcium 30mg; Fibre 1.2g; Sodium 136g

p144 Pork in Milk Energy 472Kcal/1957kJ; Protein 27.2g; Carbohydrate 7.5g, of which sugars 7.5g; Fat 37.1g, of which saturates 15.9g; Cholesterol 103g; Calcium 209mg; Fibre 0g; Sodium 159g

p144 Baked Ham with Orange and Lime Energy 348Kcal/1448kJ; Protein 43.8g; Carbohydrate 0.6g, of which sugars 0.6g; Fat 18.8g, of which saturates 6.3g; Cholesterol 58g; Calcium 18mg; Fibre 0g; Sodium 2201g

p148 Cuban Chicken Pie Energy 521Kcal/2814kJ; Protein 39.8g; Carbohydrate 35.2g, of which sugars 20.1g; Fat 25.6g, of which saturates 10.8g; Cholesterol 324g; Calcium 62mg; Fibre 2.5g; Sodium 0.19g

p149 Chicken with Okra Energy 122Kcal/511kJ; Protein 10.8g; Carbohydrate 9.7g, of which sugars 7.9g; Fat 4.8g, of which saturates 1.0g, Cholesterol 32g; Calcium 162mg; Fibre 5.1g; Sodium 0.04g

p150 Colombian Chicken Hot-pot Energy 368Kcal/1559kJ; Protein 29.2g; Carbohydrate 49.6g, of which sugars 6.5g; Fat 7.2g, of which saturates 1.8g; Cholesterol 107; Calcium 29mg; Fibre 3.7g; Sodium 0.19g

p152 Barbecued Jerk Chicken Energy 460Kcal/1924kJ; Protein 59.7g; Carbohydrate 2.2g, of which sugars 2.2g; Fat 23.6g, of which saturates 6.4g; Cholesterol 254g; Calcium 26mg; Fibre 0.0g; Sodium 0.21g

p153 Thyme and Lime Chicken Energy 495Kcal/2053kJ; Protein 31.6g; Carbohydrate 0.4g, of which sugars 0.4g; Fat 40.8g, of which saturates 16.7g; Cholesterol 212g; Calcium 24mg; Fibre 0.1g; Sodium 0.25g

p154 Chicken, Pork and Potatoes in Peanut Sauce Energy 405Kcal/1697kJ; Protein 41.1g; Carbohydrate 18.2g, of which sugars 4.1g; Fat 19.0g, of which saturates 3.8g; Cholesterol 105g; Calcium 40mg; Fibre 2.5g; Sodium 0.44g

p156 Spicy Fried Chicken Energy 345Kcal/1442kJ; Protein 35.5g; Carbohydrate 6.7g, of which sugars 1.0g; Fat 19.8g, of which saturates 4.5g; Cholesterol 177g; Calcium 54mg; Fibre 0.2g; Sodium 0.17g

p157 Sunday Roast Chicken Energy 348Kcal/1455kJ; Protein 37.5g; Carbohydrate 7.8g, of which sugars 7.8g; Fat 18.8g, of which saturates 8.8g; Cholesterol 155mg; Calcium 18mg; Fibre 0.0g; Sodium 200mg

p158 Peanut Chicken Energy 326Kcal/1374kJ; Protein 55.5g; Carbohydrate 4.2g, of which sugars 3.1g; Fat 9.8g, of which saturates 4.5g; Cholesterol 171mg; Calcium 25mg; Fibre 0.9g; Sodium 190mg

p158 Breasts of Turkey with Mango and Wine Energy 351Kcal/1476kJ; Protein 49.9g; Carbohydrate 9.0g, of which sugars 6.4g; Fat 10.4g, of which saturates 6.0g; Cholesterol 135mg; Calcium 29mg; Fibre 1.5g; Sodium 190mg

p160 Peruvian Duck with Rice Energy 527Kcal/2207kJ; Protein 17.6g; Carbohydrate 55.2g, of which sugars 2.8g; Fat 24.6g, of which saturates 7.2g; Cholesterol 58mg; Calcium 62mg; Fibre 1.8g; Sodium 100mg

p160 Drunken Duck Energy 693Kcal/2895kJ; Protein 24.7g; Carbohydrate 45.5g, of which sugars 14.9g; Fat 41.7g, of which saturates 12.5g; Cholesterol 106mg; Calcium 91mg; Fibre 5.6g; Sodium 220mg

p164 Corn Soufflé Energy 385Kcal/1605kJ; Protein 15.2g; Carbohydrate 25.3g, of which sugars 8.7g; Fat 25.5g, of which saturates 13.7g; Cholesterol 246mg; Calcium 246mg; Fibre 2.5g; Sodium 480mg

p165 Layered Potato Bake with Cheese Energy 442Kcal/1831kJ; Protein 12.2g; Carbohydrate 16.3g, of which sugars 4.1g; Fat 36.9g, of which saturates 7.2g; Cholesterol 132mg; Calcium 137mg; Fibre 2.4g; Sodium 610mg

p166 Heart of Palm Pie Energy 566Kcal/2361kJ; Protein 10.8g;

Carbohydrate 57.1g, of which sugars 6.3g; Fat 34.2g, of which saturates 18.2g; Cholesterol 139mg; Calcium 164mg; Fibre 4.4g; Sodium 430,g

p168 Macaroni Cheese Pie Energy 609Kcal/2553kJ; Protein 25.1g; Carbohydrate 60.0g, of which sugars 9.9g; Fat 31.6g, of which saturates 18.6g; Cholesterol 135mg; Calcium 494mg; Fibre 2.4g; Sodium 560mg

p169 Red Bean Chilli Energy 291Kcal/1224kJ; Protein 12.7g; Carbohydrate 35.7g, of which sugars 11.0g; Fat 6.5g, of which saturates 0.8g; Cholesterol 0mg; Calcium 86mg; Fibre 6.1g; Sodium 1.2g

p170 Peppers Stuffed with Beans Energy 528Kcal/2201kJ; Protein 26.1g; Carbohydrate 32.3g, of which sugars 6.8g; Fat 33.6g, of which saturates 12.1g; Cholesterol 118mg; Calcium 286mg; Fibre 10.1g; Sodium 360mg

p171 Green Bean and Sweet Red Pepper Salad Energy 283Kcal/1168kJ; Protein 3.0g; Carbohydrate 11.0g, of which sugars 8.5g; Fat 25.4g, of which saturates 3.6g; Cholesterol 0mg; Calcium 74mg; Fibre 5.5g; Sodium 120mg

p172 Spicy Vegetable Chow Mein Energy 414Kcal/1740kJ; Protein 12.4g; Carbohydrate 62.5g, of which sugars 8.5g; Fat 14.4g, of which saturates 2.7g; Cholesterol 23mg; Calcium 74mg; Fibre 4.7g; Sodium 266mg

p172 Aubergines Stuffed with Sweet Potato Energy 249Kcal/1013kJ; Protein 8.1g; Carbohydrate 24.6g, of which sugars 7.9g; Fat 13.1g, of which saturates 5.1g; Cholesterol 15mg; Calcium 186mg; Fibre 5.0g; Sodium 170mg

p174 Spinach Plantain Rounds Energy 266Kcal/1113kJ; Protein 5.9g; Carbohydrate 30.8g, of which sugars 7.6g; Fat 14.1g, of which saturates 3.6g; Cholesterol 65mg; Calcium 207mg; Fibre 3.6g; Sodium 205mg

p175 Peppery Bean Salad Energy 248Kcal/1046kJ; Protein 14.0g; Carbohydrate 35.4g, of which sugars 6.5g; Fat 6.5g, of which saturates 0.9g; Cholesterol 0mg; Calcium 122mg; Fibre 11.0g; Sodium 660mg

p176 Avocado and Grapefruit Salad Energy 351Kcal/1448kJ; Protein 2.5g; Carbohydrate 5.4g, of which sugars 4.0g; Fat 35.7g, of which saturates 6.4g; Cholesterol 0mg; Calcium 28mg; Fibre 4.1g; Sodium 80mg

p177 Quinoa Salad with Citrus Dressing Energy 225Kcal/938kJ; Protein 4.1g; Carbohydrate 22.1g, of which sugars

3.1g; Fat 13.9g, of which saturates 2.1g; Cholesterol 0mg; Calcium 40mg; Fibre 3.0g; Sodium 10mg

p178 Okra and Tomato Salad Energy 154Kcal/639kJ; Protein 3.7g; Carbohydrate 7.9g, of which sugars 6.6g; Fat 12.3g, of which saturates 1.9g; Cholesterol 0mg; Calcium 174mg; Fibre 5.2g; Sodium 15mg

p178 Tomato, Heart of Palm and Onion Salad Energy 152Kcal/632kJ; Protein 2.8g; Carbohydrate 8.7g, of which sugars 7.7g; Fat 12.0g, of which saturates 1.8g; Cholesterol 0mg; Calcium 38mg; Fibre 3.9g; Sodium 16mg

p180 Spicy Potato Salad Energy 184Kcal/776kJ; Protein 3.9g; Carbohydrate 30.0g, of which sugars 7.0g; Fat 6.2g, of which saturates 1.0g; Cholesterol 6mg; Calcium 32mg; Fibre 3.7g; Sodium 100mg

p181 Mango, Tomato and Red Onion Salad Energy 93Kcal/390kJ; Protein 1.0g; Carbohydrate 10.1g, of which sugars 9.5g; Fat 5.8g, of which saturates 0.7g; Cholesterol 0mg; Calcium 17mg; Fibre 2.1g; Sodium 6mg

p182 Peruvian Salad Energy 226Kcal/945kJ; Protein 6.2g; Carbohydrate 23.1g, of which sugars 4.6g; Fat 12.7g, of which saturates 2.6g; Cholesterol 78mg; Calcium 59mg; Fibre 3.3g; Sodium 570mg

p183 Pumpkin Salad Energy 384Kcal/1583kJ; Protein 2.2g; Carbohydrate 8.7g, of which sugars 6.5g; Fat 38.1g, of which saturates 5.5g; Cholesterol 0mg; Calcium 84mg; Fibre 3.0g; Sodium 10mg

186 Plain Rice Energy 241Kcal/1018kJ; Protein 3.7g; Carbohydrate 42.9g, of which sugars 0g; Fat 7.3g, of which saturates 1.1g; Cholesterol 0mg; Calcium 26mg; Fibre 0.2g; Sodium 0mg

p186 Black Beans Energy 319Kcal/1347kJ; Protein 20.7g; Carbohydrate 40.6g, of which sugars 2.2g; Fat 9.4g, of which saturates 2.4g; Cholesterol 12mg; Calcium 62mg; Fibre 6.2g; Sodium 250mg

p188 Coconut Rice Energy 337Kcal/1435kJ; Protein 5.5g; Carbohydrate 69.4g, of which sugars 15.8g; Fat 6.2g, of which saturates 3.1g; Cholesterol 8mg; Calcium 120mg; Fibre 0.3g; Sodium 400mg

p189 Toasted Cassava Flour with Egg and Bacon Energy 218Kcal/918kJ; Protein 8.4g; Carbohydrate 29.2g, of which sugars 0.6g; Fat 8.3g, of which saturates 3.2g; Cholesterol 93mg; Calcium 67mg; Fibre 1.2g; Sodium 230mg

p190 Rice and Peas Energy 449Kcal/1903kJ; Protein 13.9g; Carbohydrate

83.3g, of which sugars 4.4g; Fat 9.1g, of which saturates 5.7g; Cholesterol 0mg; Calcium 82mg; Fibre 6.3g; Sodium 10mg

p191 Cou-Cou Energy 264Kcal/1115kJ; Protein 1.2g; Carbohydrate 52.7g, of which sugars 0.8g; Fat 6.8g, of which saturates 4.1g; Cholesterol 16mg; Calcium 56mg; Fibre 1.2g; Sodium 80mg

p192 Buttered Spinach and Rice Energy 520Kcal/2169kJ; Protein 11.5g; Carbohydrate 95.4g, of which sugars 4.6g; Fat 9.7g, of which saturates 5.3g; Cholesterol 21mg; Calcium 184mg; Fibre 2.7g; Sodium 190mg

p192 Creamed Sweet Potatoes Energy 313Kcal/1321kJ; Protein 4.4g; Carbohydrate 51.1g, of which sugars 13.4g; Fat 11.6g, of which saturates 6.8g; Cholesterol 27mg; Calcium 74mg; Fibre 9.6g; Sodium 170mg

p194 Colombian Cheesy Potatoes Energy 448Kcal/1882kJ; Protein 11.5g; Carbohydrate 55.8g, of which sugars 6.5g; Fat 21.4g, of which saturates 13g; Cholesterol 52mg; Calcium 166mg; Fibre 3.8g; Sodium 150mg

p195 Caribbean Potato Salad Energy 167Kcal/705kJ; Protein 3.7g; Carbohydrate 30.2g, of which sugars 7.1g; Fat 4.3g, of which saturates 0.7g; Cholesterol 4mg; Calcium 24mg; Fibre 3.5g; Sodium 90mg

p196 Okra Fried Rice Energy 305Kcal/1286kJ; Protein 4.7g; Carbohydrate 50.6g, of which sugars 1.9g; Fat 10.7g, of which saturates 3.1g; Cholesterol 8mg; Calcium 35mg; Fibre 0.5g; Sodium 65mg

p196 Aubergines with Garlic and Spring Onions Energy 132Kcal/551kJ; Protein 3.2g; Carbohydrate 9.3g, of which sugars 8.7g; Fat 9.5g, of which saturates 1.3g; Cholesterol 0mg; Calcium 36mg; Fibre 5.7g; Sodium 550mg

p198 Cassava with a Citrus Salsa Energy 305Kcal/1294kJ; Protein 3g; Carbohydrate 57.2g, of which sugars 2.2g; Fat 8.9g, of which saturates 1.4g; Cholesterol 0mg; Calcium 31mg; Fibre 2.6g; Sodium 0mg

p199 Stir-Fried Spring Greens Energy 111Kcal/459kJ; Protein 6.3g; Carbohydrate 2.5g, of which sugars 2g; Fat 8.5g, of which saturates 2.3g; Cholesterol 16mg; Calcium 159mg; Fibre 2.6g; Sodium330mg

p200 Corn Sticks Energy 64Kcal/272kJ; Protein 1.4g; Carbohydrate 11.7g, of which sugars 1.9g; Fat 1.7g, of which saturates 0.9g; Cholesterol 15mg; Calcium 36mg; Fibre 0.2g; Sodium 160mg

p201 Fried Yellow Plantains Energy 267Kcal/1126kJ; Protein 1.5g; Carbohydrate 47.5g, of which sugars 11.5g; Fat 9.2g, of which saturates 1g; Cholesterol 0mg; Calcium 6mg; Fibre 2.3g; Sodium 0mg

p202 Argentinian Barbecue Salsa Energy 132Kcal/543kJ; Protein 0.7g; Carbohydrate 3.2g, of which sugars 2.6g; Fat 13g, of which saturates 1.9g; Cholesterol 0mg; Calcium 10mg; Fibre 0.8g; Sodium 0mg

p202 Hot Chilli Salsa Energy 441Kcal/1820kJ; Protein 3.8g; Carbohydrate 5.8g, of which sugars 5.8g; Fat 45g, of which saturates 6.4g; Cholesterol 0mg; Calcium 40mg; Fibre 1.5g; Sodium 20mg

p204 Tamarillo Sauce Energy 112Kcal/468kJ; Protein 0.7g; Carbohydrate 15.5g, of which sugars 15.2g; Fat 5.7g, of which saturates 0.8g; Cholesterol 0mg; Calcium 9mg; Fibre 2.2g; Sodium 0mg

p205 Avocado Salsa Energy 190Kcal/786kJ; Protein 1.9g; Carbohydrate 5.6g, of which sugars 4g; Fat 18g, of which saturates 3.2g; Cholesterol 0mg; Calcium 20mg; Fibre 3g; Sodium 10mg

p208 Corn Tortillas Energy 70Kcal/296kJ; Protein 0.1g; Carbohydrate 18.1g, of which sugars 0g; Fat 0.1g, of which saturates 0g; Cholesterol 0mg; Calcium 3mg; Fibre 0g; Sodium 10mg

p209 Flour Tortillas Energy 64Kcal/272kJ; Protein 1.5g; Carbohydrate 12.5g, of which sugars 0.2g; Fat 1.3g, of which saturates 0.5g; Cholesterol 1mg; Calcium 23mg; Fibre 0.5g; Sodium 140mg

p210 Dhal Puri Energy 237Kcal/1004kJ; Protein 9.2g; Carbohydrate 40.8g, of which sugars 1.1g; Fat 5.2g, of which saturates 0.6g; Cholesterol 0mg; Calcium 120mg; Fibre 2.8g; Sodium 120mg

p211 Fried Dumplins Energy 205Kcal/868kJ; Protein 5g; Carbohydrate 36.3g, of which sugars 2.8g; Fat 5.4g, of which

saturates 0.9g; Cholesterol 2mg; Calcium 194mg; Fibre 1.4g; Sodium 270mg

p212 Corn Griddle Cakes Energy 87Kcal/366kJ; Protein 2.2g; Carbohydrate 12.5g, of which sugars 0.2g; Fat 3.5g, of which saturates 1.9g; Cholesterol 9mg; Calcium 50mg; Fibre 0g; Sodium 260mg

p214 Paraguayan Corn Bread Energy 232Kcal/971kJ; Protein 6.0g; Carbohydrate 24.7g, of which sugars 3.4g; Fat 12.8g, of which saturates 7.6g; Cholesterol 80mg; Calcium 128mg; Fibre 0.3g; Sodium 340mg

p215 Mexican "Bread of the Dead" (per loaf) Energy 4071Kcal/17154kJ; Protein 86.6g; Carbohydrate 660.6g, of which sugars 146.2g; Fat 123.5g, of which saturates 67g; Cholesterol 949mg; Calcium 1080mg; Fibre 20.9g; Sodium 2.9g

p216 Caribbean Fruit and Rum Cake (per cake) Energy 10871Kcal/45678kJ; Protein 146.1g; Carbohydrate 1526.5g, of which sugars 1192.2g; Fat 448g, of which saturates 254.6g; Cholesterol 3.3g; Calcium 2987mg; Fibre 49.8g; Sodium 5.92g

p217 Apple and Cinnamon Crumble Cake (per cake) Energy 7217Kcal/30269kJ; Protein 89.9g; Carbohydrate 929.9g, of which sugars 500.3g; Fat 374.7g, of which saturates 233.7g; Cholesterol 1.7g; Calcium 2062mg; Fibre 34.1g; Sodium 4.22g

p218 Barbadian Coconut Sweet Bread (per cake) Energy 4078Kcal/17076kJ; Protein 59.2g; Carbohydrate 473.7g, of which sugars 154.2g; Fat 229.5g, of which saturates 156.9g; Cholesterol 609mg; Calcium 1373mg; Fibre 28.9g; Sodium 2.06g

p219 Duckanoo Energy 827Kcal/3499kJ; Protein 7.3g; Carbohydrate 161.4g, of which sugars 57.9g; Fat 21.5g, of which saturates 15g; Cholesterol 36mg; Calcium 224mg; Fibre 2.4g; Sodium 220mg

p220 Corn meal and Fennel Seed Cake Energy 514Kcal/2170kJ; Protein 10.4g; Carbohydrate 94.7g, of which sugars 38.2g; Fat 12.9g, of which saturates 6.3g; Cholesterol 179mg; Calcium 163mg; Fibre 1.1g; Sodium 630mg

p220 Banana Bread (per loaf) Energy 2444Kcal/10218kJ; Protein 41.4g; Carbohydrate 259.4g, of which sugars 124.4g; Fat 144.9g, of which saturates 67.1g; Cholesterol 714mg; Calcium 782mg; Fibre 9.4g; Sodium 1.5g

p224 Fruits of the Tropics Salad Energy 154Kcal/658kJ; Protein 1.3g;

Carbohydrate 39.0g, of which sugars 38.1g; Fat 0.4g, of which saturates 0.1g; Cholesterol 0mg; Calcium 31mg; Fibre 4.1g; Sodium 40mg

p225 Coconut Ice Cream Energy 253Kcal/1065kJ; Protein 8.6g; Carbohydrate 34.5g, of which sugars 34.5g; Fat 9.9g, of which saturates 6.2g; Cholesterol 35mg; Calcium 305mg; Fibre 0g; Sodium 220mg

p226 Mango Sorbet Energy 176Kcal/753kJ; Protein 1g; Carbohydrate 45.6g, of which sugars 45.4g; Fat 0.2g, of which saturates 0.1g; Cholesterol 0mg; Calcium 13mg; Fibre 2g; Sodium 10mg

p227 Colombian Pineapple Custard Energy 214Kcal/908kJ; Protein 5.3g; Carbohydrate 40.5g, of which sugars 40.5g; Fat 4.6g, of which saturates 1.3g; Cholesterol 156mg; Calcium 38mg; Fibre 0.7g; Sodium 60mg

p228 Tapioca Pudding Energy 190Kcal/799kJ; Protein 6.1g; Carbohydrate 25.2g, of which sugars 13.8g; Fat 7.9g, of which saturates 3.7g; Cholesterol 18mg; Calcium 156mg; Fibre 0.2g; Sodium 70mg

p229 Fried Bananas with Sugar and Rum Energy 290Kcal/1213kJ; Protein 1.3g; Carbohydrate 36.4g, of which sugars 34.1g; Fat 13.7g, of which saturates 8.6g; Cholesterol 35mg; Calcium 10mg; Fibre 1.1g; Sodium 100mg

p230 Coconut and Pumpkin Compote Energy 429Kcal/1811kJ; Protein 2g; Carbohydrate 82.9g, of which sugars 82.2g; Fat 12.2g, of which saturates 10.4g; Cholesterol 0mg; Calcium 51mg; Fibre 4g; Sodium 100mg

p230 Dulce de Leche Energy 323Kcal/1357kJ; Protein 11.3g; Carbohydrate 42.7g, of which sugars 42.7g; Fat 13g, of which saturates 8.1g; Cholesterol 47mg; Calcium 387mg; Fibre 0g; Sodium 210mg

p232 Caribbean Spiced Rice Pudding Energy 304Kcal/1288kJ; Protein 8.6g; Carbohydrate 53.9g, of which sugars 37.4g; Fat 7.6g, of which saturates 4.5g; Cholesterol 20mg; Calcium 266mg; Fibre 0.4g; Sodium 110mg

p233 Jamaican Fruit Trifle Energy 400Kcal/1664kJ; Protein 2.2g; Carbohydrate 29.1g, of which sugars 28.9g; Fat 30.4g, of which saturates 19.4g; Cholesterol 80mg; Calcium 70mg; Fibre 3.9g; Sodium 20mg

p234 Brazilian Coconut Flan Energy 334Kcal/1398kJ; Protein 5.6g;

Carbohydrate 36.6g, of which sugars 36.6g; Fat 19.4g, of which saturates 11.2g; Cholesterol 312mg; Calcium 62mg; Fibre 1.7g; Sodium 50mg

p238 Mango Shake Energy 667Kcal/2793kJ; Protein 26.9g; Carbohydrate 76.2g, of which sugars 75.3g; Fat 29.9g, of which saturates 19.1g; Cholesterol 105mg; Calcium 922mg; Fibre 7.8g; Sodium 330mg

p238 Pineapple and Mint Juice Energy 113Kcal/485kJ; Protein 2g; Carbohydrate 26.6g, of which sugars 25.3g; Fat 0.7g, of which saturates 0g; Cholesterol 0mg; Calcium 98mg; Fibre 3g; Sodium 10mg

p240 Cashew Nut Milk Energy 805Kcal/3397kJ; Protein 29.4g; Carbohydrate 136.6g, of which sugars 133g; Fat 19.2g, of which saturates 2.4g; Cholesterol 0mg; Calcium 192mg; Fibre 2.4g; Sodium 390mg

p241 Passion Fruit Batida Energy 151Kcal/631kJ; Protein 0.8g; Carbohydrate 9.6g, of which sugars 9.6g; Fat 0.1g, of which saturates 0g; Cholesterol 0mg; Calcium 4mg; Fibre 1g; Sodium 10mg

p242 Pisco Sour Energy 187Kcal/783kJ; Protein 2.9g; Carbohydrate 15.8g, of which sugars 15.8g; Fat 0g, of which saturates 0g; Cholesterol 0mg; Calcium 3mg; Fibre 0g; Sodium 60mg

p242 Caipirinha Energy 176Kcal/736kJ; Protein 0g; Carbohydrate 15.8g, of which sugars 15.8g; Fat 0g, of which saturates 0g; Cholesterol 0mg; Calcium 2mg; Fibre 0g; Sodium 0mg

p244 Mojito Energy 226Kcal/941kJ; Protein 0g; Carbohydrate 15.8g, of which sugars 15.8g; Fat 0g, of which saturates 0g; Cholesterol 0mg; Calcium 2mg; Fibre 0g; Sodium 0mg

p244 Cubre Libre Energy 130Kcal/542kJ; Protein 0g; Carbohydrate 8.1g, of which sugars 8.1g; Fat 0g, of which saturates 0g; Cholesterol 0mg; Calcium 4mg; Fibre 0g; Sodium 0mg

p246 Demarara Rum Punch Energy 237Kcal/993kJ; Protein 1.4g; Carbohydrate 24.1g, of which sugars 24.1g; Fat 0.3g, of which saturates 0g; Cholesterol 0mg; Calcium 20mg; Fibre 0mg; Sodium 10mg

p247 Caribbean Cream Stout Punch Energy 466Kcal/1950kJ; Protein 16.8g; Carbohydrate 37.7g, of which sugars 37.7g; Fat 17.9g, of which saturates 11.2g; Cholesterol 65mg; Calcium 556mg; Fibre 0g; Sodium 340mg

INDEX